# ENGLISH MISERICORDS

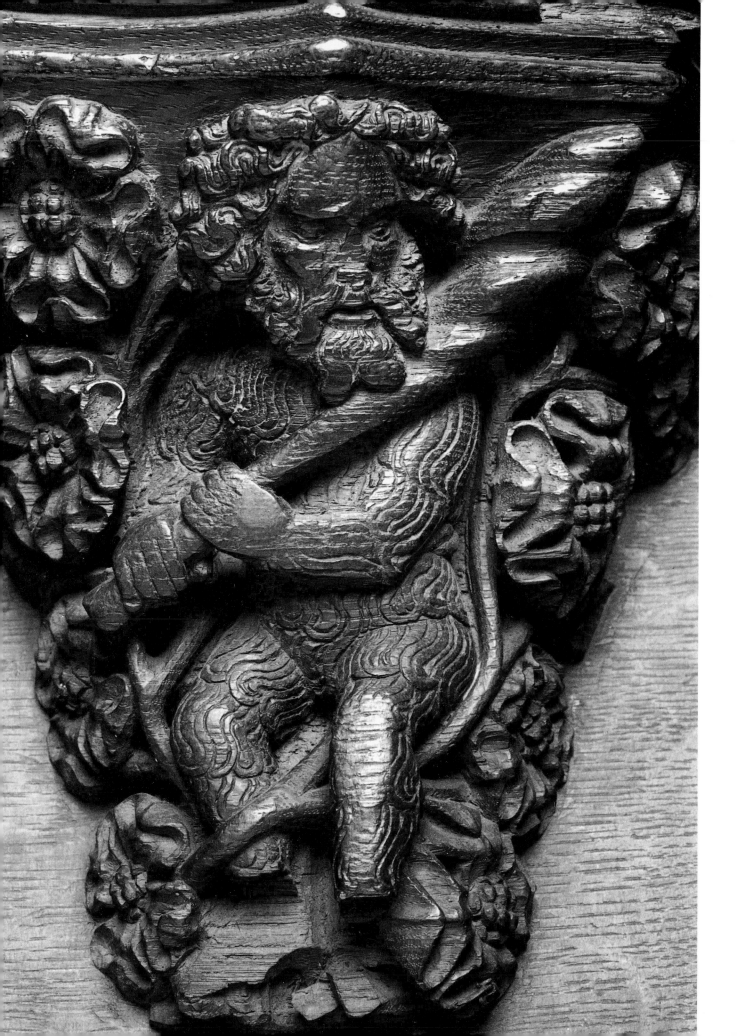

CHRISTA GRÖSSINGER

# THE WORLD UPSIDE-DOWN
## ENGLISH MISERICORDS

HARVEY MILLER PUBLISHERS

HARVEY MILLER PUBLISHERS
Knightsbridge House, 197 Knightsbridge, 8th Floor, London SW7 1RB

*An imprint of G+B Arts International*

**British Library Cataloguing in Publication Data**

A catalogue record for this book is available from the British Library

ISBN 1872501982 (cloth bound)
ISBN 1872501648 (paperback)

*Frontispiece. North Walsham, St Nicholas. A Wild man with club in a rosebush. This shows the characteristics of the Wild Man: bearded and burly, his body covered with hair. He steps out of a rosebush holding a large club, this represents his great strength and the roses his passionate love.*

Composition by Jessie Lessiep, London
Jacket and monochrome origination by Quantock Studio, Sidcup
Printed by Clifford Press Ltd., Coventry
Manufactured in Great Britain

# Contents

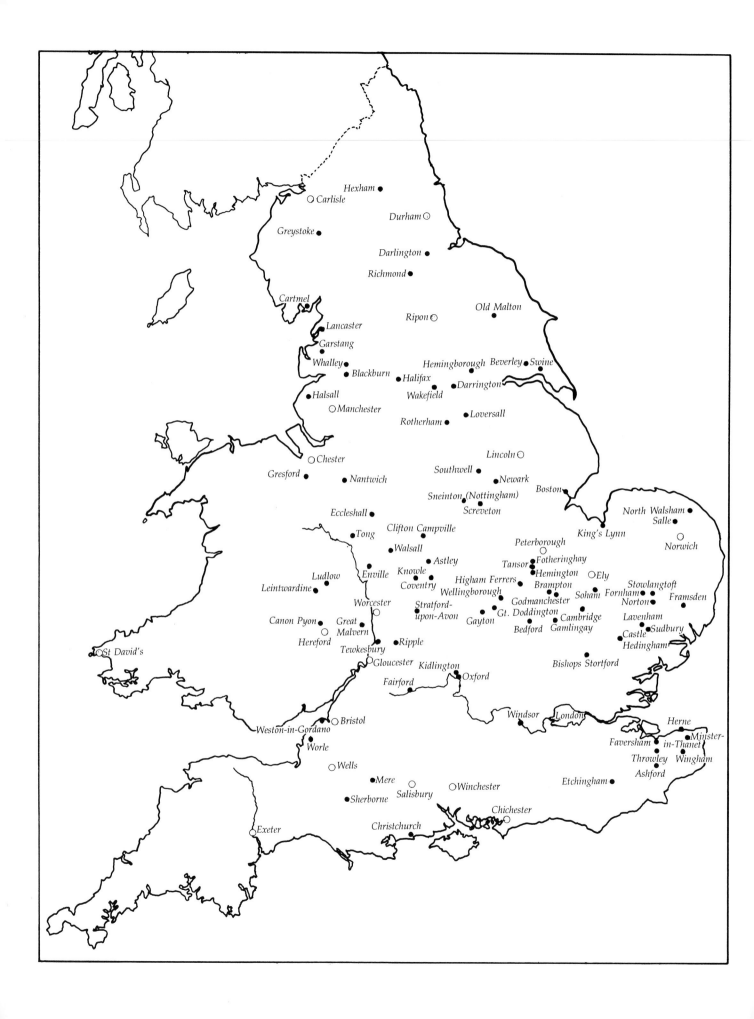

Hexham
Carlisle
Durham
Greystoke
Darlington
Richmond
Cartmel
Old Malton
Lancaster
Ripon
Garstang
Whalley
Hemingborough  Beverley  Swine
Blackburn
Halifax  Darrington
Halsall
Wakefield
Manchester
Rotherham  Loversall
Chester
Lincoln
Gresford
Southwell
Nantwich
Newark
Boston
Sneinton (Nottingham)
Eccleshall
Screveton
North Walsham
Salle
Tong  Clifton Campville
King's Lynn
Peterborough
Walsall
Norwich
Astley
Tansor  Fotheringhay
Ludlow
Enville
Knowle
Hemington  Ely
Leintwardine
Coventry
Higham Ferrers  Brampton  Stowlangtoft
Worcester
Wellingborough
Soham  Fornham  Norton  Framsden
Canon Pyon
Great
Stratford-
Godmanchester
Lavenham
Malvern
upon-Avon
Gt. Doddington
Cambridge
Castle  Sudbury
Hereford
Gayton
Bedford  Gamlingay
Hedingham
St David's
Ripple
Tewkesbury
Bishops Stortford
Gloucester  Kidlington
Fairford  Oxford
Bristol
Weston-in-Gordano
Windsor  London
Herne
Worle
Faversham
Minster-
in-Thanet
Wells
Throwley  Wingham
Mere
Ashford
Salisbury  Winchester
Etchingham
Sherborne
Chichester
Christchurch
Exeter

# Preface

INCREASINGLY, misericords are gaining in popularity, and most of the recent books written about them reflect this, concentrating on a selection of photographs with short captions and introductions to themes, such as M. Laird's, *English Misericords* (1986). A number of cathedrals and churches issue booklets listing their misericords, e.g. Chester and Wells Cathedral; and Norwich Cathedral has just produced a detailed booklet on its misericords by Martial Rose (1994). Surveys of misericords in particular areas of England were published many years ago by Crossley and Ridgway on Lancashire, Wales and Monmouthshire, in 1918 and 1947, and by J. C. D. Smith on the West Country, in 1969.

It is my aim to write more comprehensively on English misericords, uniting the scholarly and more popular aspects—probably an impossible task! In England, we are fortunate in having G. L. Remnant's *A Catalogue of Misericords in Great Britain* (1969), which, although not always correct, catalogues the misericords alphabetically, by counties and towns, and also has an iconographical index, and a very good introduction by M. D. Anderson. Anderson's own *History and Imagery in British Churches* (1971) examines themes popular in the Middle Ages and puts them into their social and historical context; it also includes appendices on, for instance, subjects in the *Biblia Pauperum*, the Labours of the Months and animals, both real and mythical, all relevant to the study of misericords.

I have visited all the cathedrals, though not all the village churches containing misericords, making a selection of those with an interesting style or iconography. Nevertheless, the selection is extremely far-reaching and I have included many village churches never previously mentioned, giving an exceptional insight into the craftsmanship of the countryside. As I am dealing with misericords, rather than the choir-stalls as furniture, the main emphasis of my book is on the iconography, the last study of which was written by Francis Bond in 1910. Bond's scholarly monograph, *Wood Carvings in English Churches, I. Misericords*, is still a standard reference book, with good photographs, now out of print. The book is divided into themes, a large part being dedicated to the beasts of the *Physiologus*. Part II of the present book, in particular, can be compared with Bond's; however, I am putting the iconography of the misericords into a wider historical context, and highlighting some of the themes, such as that on Wild Men and Wild Women. Above all, I stress the combination of humour and moral teaching which has a close association with the subjects depicted in the margins of illuminated manuscripts, on which Michael Camille has written in *Image on the Edge* (1992). In this connection, the use of models by the carvers is of great interest to me, giving an insight into their working practices. The question of sources was first examined by Anderson. Isabel Mateo Gómez has written in *Temas profanos en la escultura gótica española: las sillerías*

1. *Location map of misericords mentioned in the text.*

*Españolas de coro* (1979), on Spanish misericords, comparing their motifs to manuscripts and prints, where possible.

A large element of Part I of this book deals with the development of style of the misericords, including the Renaissance misericords in King's College Chapel, Cambridge, usually omitted, and with their stylistic connections, regionally or across the whole country. This is an aspect which has been thoroughly studied by C. Tracy in *English Gothic Choir-Stalls. 1200–1400* and *English Gothic Choir-Stalls, 1400–1540)* for the stall-work around the misericords; his interest, however, lies in style not in iconography, so that misericords are considered only for their depictions of foliage. Misericords which have lost their stall-work are not included.

On the Continent, D. and K. Kraus have written on the French and Spanish misericords: *The Hidden World of Misericords* (1976), deals with France, and has large illustrations, short texts, and a map with the locations of misericords; in *The Gothic Choir-Stalls of Spain* (1986), the authors have concentrated on their rediscovery and renovation of the Oviedo Stalls. More recent books on choir-stalls in Germany are by U. Bergmann and H. Schindler. Bergmann's book *Das Chorgestühl des Kölner Domes*, is a detailed, scholarly examination of the Cologne choir-stalls in two volumes, whereas Schindler's *Chorgestühle* is a slim volume, a survey from the earliest stalls to the latest in the twentieth century. The principal representative for research on Netherlandish misericords is J. Verspaandonk, who has a wide knowledge of iconography, in particular of proverbs. He has published a number of articles and a series of small books, *Misericorde-reeks* (1972–93), on particular misericords, with the text in several languages. I have taken the Continental misericords into account, pointing out their similarities to and their differences from English misericords, in order to bring out the uniqueness of the latter.

Most of all, I believe that the book excels in its photographic reproductions, taken by Peter Burton and Michael Pollard, photographers at the Department of History of Art at the University of Manchester, who were willing to tour the country with me, often for several days at a time, and crawl along the choir-stall seats, working in cramped and badly-lit conditions. Many thanks to them, and also to the British Academy, from whom I received a grant which enabled me to finance the photographic tours.

Considering the enormous number of misericords, it was extremely difficult to make a selection; not everything could be illustrated, so that the reader will have to picture examples from my descriptions. Nevertheless, I would like to thank Elly Miller for her generous allowance of illustrations, which are the book's major attraction. I am much indebted to Isabel Hariades and Jean-Claude Peissel who worked with great dedication, checking my inconsistencies and giving shape to the material; Jean-Claude also arranged the design and layout of the book and its illustrations. Access to the cathedrals and churches to inspect and photograph the misericords was always kindly given and I would like to acknowledge all those who helped me in this way as well as the vicars and church-wardens with whom I had many interesting conversations during my research. Furthermore, I would like to acknowledge the help of Malcolm Jones who is always a great source of

scholarly knowledge, and Kenneth Varty, with whom all matters concerning Reynard the fox can be discussed. Most of all, Jan Verspaandonk is always willing to examine in detail the iconography of misericords, put forward well-considered ideas and make available his large collection of books. Last, not least, Elaine Block keeps the enthusiasm for misericords going, and has formed the Society 'Misericordia International', to which all interested in misericords are welcome.

*To Thomas and Susi, Jan and Leif*

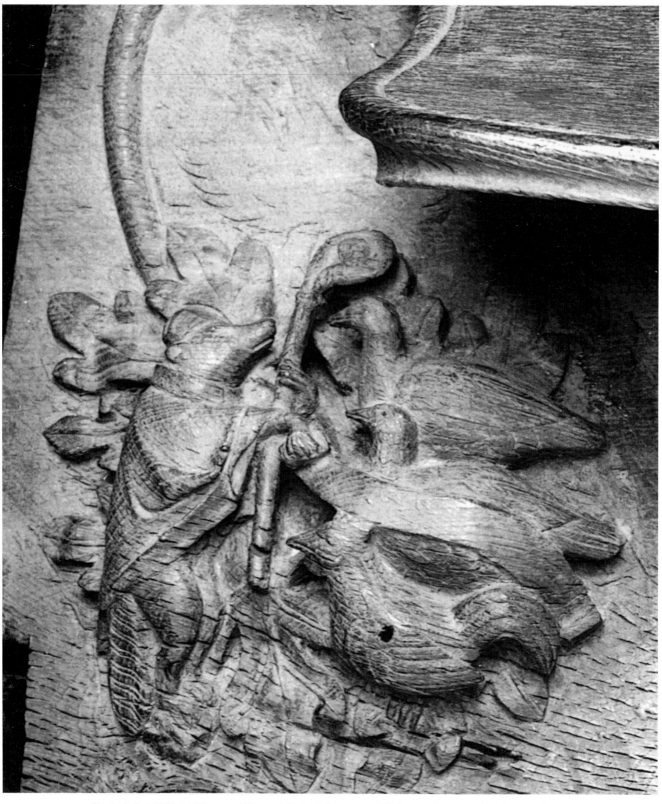

**2.** *Ely Cathedral, 1339–41. The story of Reynard the fox, left supporter. The fox preaches to a cock and geese, who listen intently to his words—indicated by the scroll. He is dressed as a bishop and holds a crozier, indicating his cunning and ability to deceive. This is also a satire on the clergy who lead their trusting parishioners astray (see also Pls. 7, 87).*

# Introduction

MISERICORDS are carved, wooden brackets on the underside of the hinged seats of the choir-stalls situated behind the screen in monastic and collegiate churches and cathedrals. They are thus part of a larger ensemble of carving, including the elaborately carved backs of the stalls with their canopies, pinnacles and bosses, the stall ends, poppy heads and stall elbows.[1] They were first introduced as a concession to monks and canons who were too old and weak to stand; seats could be tipped up, enabling the monks to rest on the bracket, the upper ledge of the misericord, and give the appearance of standing while really sitting. This was of enormous benefit to the monks who according to the Rule of St Benedict were required to say the Divine Offices eight times daily, standing up.[2] The term 'misericord' appropriately derives from the Latin *misericordia* meaning mercy or pity. The backs of the stalls with their canopies protected the monks from cold draughts at night, and the stall elbows acted as arm rests.

The arrangement of the choir-stalls followed the east-west axis of the choir, turning at right angles at the west end to form the 'returned stalls', and the actual seating in the choir reflected the hierarchy of the chapter: the south-west stall was reserved for the Dean or Abbot and the north-west stall for the Precentor or Prior, depending on whether it was a secular cathedral or a monastery. The Chancellor and the Treasurer had their seats at the east end, on the south and north side respectively.[3] Upper and lower rows further segregated the higher ranks of clergy from the lower, and often, the seats of the dignitaries were wider and more lavishly decorated.

Misericords are first mentioned in the eleventh-century *Constitutiones* of Hirsau[4] as fitted on seats of the upper rows, only used by the old and weak monks, who had previously been allowed crutches, and they must have been in use in England by the twelfth century, because the Canterbury wooden choir-stalls were destroyed by fire in 1174, as described by the monk Gervaise. It is not known whether the undersides of the early misericords mentioned were carved, as is the case with the earliest surviving ones in England: fragments in Hemingborough, Kidlington, Durham Cathedral and Westminster Abbey, and complete sets in Exeter and Salisbury Cathedrals, all from the thirteenth century (Pls. 4–6).[5] From the thirteenth century also come the earliest remaining examples on the Continent, and it is interesting that the French architect, Villard de Honnecourt (active *c.* 1225–50), should have found choir-stalls of sufficient importance to make sketches of them, *c.* 1235, showing them from the side: the seat itself and two choir-stall ends carved with foliage (Pl. 3). The misericords are not visible, but the exuberance of the carving is proof of the medieval desire for all-encompassing decoration, and it is the most richly foliated choir-stall end which Villard de Honnecourt recommends as a pattern.[6] On the Continent the choir-stall ends were often more lavishly

3. *Villard de Honnecourt, c. 1235. Drawings of two views of choir-stalls.*

**4.** *Kidlington, St Mary the Virgin. This early thirteenth-century misericord demonstrates the beginnings of misericord carving with very simple trefoil ornament in the centre and as supporters.*

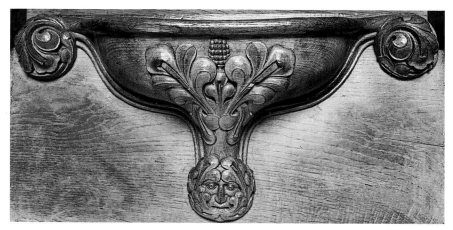

**5.** *Salisbury Cathedral, thirteenth century. The trefoil foliage is similar to thirteenth-century stone sculpture; it has become more prominent than in Kidlington, showing a foliate mask topped by leaves and a grape motif. The bulk of the wood is still much in evidence.*

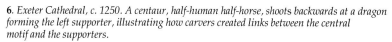

**6**. *Exeter Cathedral, c. 1250. A centaur, half-human half-horse, shoots backwards at a dragon forming the left supporter, illustrating how carvers created links between the central motif and the supporters.*

**7.** *Ely Cathedral, 1339–41. The story of Reynard the fox. The Ely misericords are the first to have elaborate narrative scenes in the supporters related to the central scene, thus extending the narrative across the whole misericord. In the centre, the fox with a goose in his jaws is chased by a housewife with her symbol, the distaff, helped by a labourer who has been working in the fields, in the right supporter. For the left supporter, see Pl. 2. This story is also told in Chaucer's 'Nun's Priest's Tale'.*

decorated than the misericords, and the example by Villard de Honnecourt has been compared with those in Xanten (Lower Rhine, Germany).[7]

Manuscripts like the French Psalter of Henry VI (BL MS Cotton Domitian A.XVII), *c.* 1430, portray Poor Clares on f. 73v and Friars on f. 122v, sitting in the choir saying their prayers, and it is thought that one of the reasons for dividing the religious community from the laity by screens was to protect them from distraction and disturbance during services.[8] If that were so, the misericords with their seemingly humorous subject matter could have been the only distraction, and they can be compared to drolleries in the margins of manuscripts. The themes carved on misericords are generally taken from romances, burlesques, everyday life, with much satire especially of the clergy, and a great number of monstrous hybrids based on the Bestiary (Pls. 9–11). Thus, misericords, although an intrinsic part of church decoration, represent profane, rather than religious subject matter; many of the scenes do, however, have moral implications, and the temptations of the devil are forever present. The themes are much concerned with the shortcomings of human nature, and the carvings are part of the vernacular world, giving an insight into the concerns, traditions and especially the humour of people in the Middle Ages. Profane art must have been very much part of life in the Middle Ages, judging from the surviving wall-paintings in the very few castles, palaces and houses still extant, such as the mid fourteenth-century Palace of the Popes in Avignon, with its scenes of outdoor life; similarly, paintings on the walls of the Torre d'Aquila in Trento (north Italy) depict the Labours of the Months, *c.* 1400. From the same period, Runkelstein Castle, South Tyrol, has depictions of romances and pleasurable pursuits of the nobility, whereas a house in the centre of Vienna has its walls decorated with the story of 'Neithart', contrasting the behaviour of the nobility with that of rude peasants. Due to their high survival rate, misericords, have become the most accessible representatives of profane medieval art today.

The representations on a set of choir-stalls rarely concentrate on one subject; themes are strewn pell-mell throughout the misericords with dragons and other

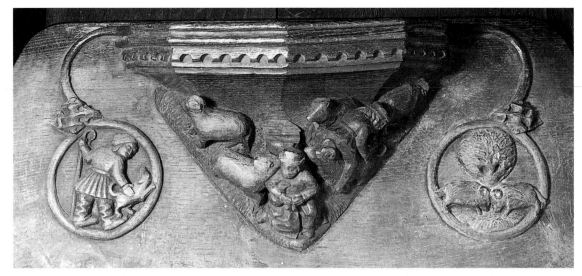

**8**. *Beverley Minster, 1520. In the centre, sheep-shearing. This takes place to the right of the centrally-placed figure. The shepherd straddles the sheep, its head and horns appearing between his legs; he keeps a pot of tar, used for accidental cuts to the sheep, by his right hand. The figure sitting in the centre foreground is playing the bagpipes, parts of which are missing. The Beverley misericords are remarkable for their agricultural scenes and for the depiction of the working relationship between humans and animals; here seen in the left supporter where the shepherd, in heavy boots and with his crook, pats his excited dog. The right supporter shows two rams butting in front of a tree, probably representing the sign of Aries.*

**9**. *Chichester Cathedral. A centaur-type creature playing a tabor. Half-human beasts like this illustrate human nature subjugated by animal passions, emphasized here by the inclusion of a second head under its tail.*

**10**. *Chichester Cathedral. Two dragons or asps embracing, standing on a human head; they look very cheerful, and their tails are swallowed by heads issuing from the supporters.*

**11**. *Chichester Cathedral. A bodyless head supporting the seat.*

monstrous beasts acting not only as space fillers, but also serving as an admonition against the devil. Thus, there is little consistency in the arrangement of the imagery, nor in the juxtaposition of sacred and profane subjects.

Misericords existed in most West-European countries before the Reformation except in Italy, where the only medieval examples are in Aosta, in the mountainous area of north Italy. A large number of remaining misericords are to be found in the colder countries, north of the Alps: Switzerland, France, Germany, the Netherlands, Belgium and England; some examples also survive in Spain. English misericords differ from the Continental examples in that the basic design, already established by the thirteenth century, is unique to England, consisting of a principal carving in the centre with subsidiary carvings in the supporters, emanating from either side of the bracket (Pls. 4-7). On the Continent, in general, supporters were traditionally not included. One major exception is the misericords in Barcelona Cathedral, 1391–94, yet none of the documents relating to their construction reveal direct English influence, so that the reason for this anomaly remains a mystery.[9]

A close iconographic relationship between centre and supporters can be established on English misericords. A good early example is a misericord in Exeter Cathedral, where the arrow shot by a centaur in the centre hits the dragon that forms the supporter. From the beginning of the fourteenth century, many-figured subsidiary scenes are enacted in the supporters, as in Ely Cathedral (Pls. 6, 7). On Continental misericords, the narrative is confined to the centre, often with one or two large figures as participants in a story, whereas in England many small figures may constitute a scene, filling out the narrative. The inclusion of supporters allowed for a reading of the stories across the whole body of a misericord, as if moving the eye along the margin of a Book of Hours. In this connection it is interesting to note that the greatest expansion of marginal drolleries in manuscripts at the beginning of the fourteenth century, so closely related to misericords, took place in England, in East Anglia, where the Ely misericords are the first to include expanded narratives in the supporters.

In general, the subject matter of misericords is similar in all countries, concentrating on secular scenes of humour and admonition, yet different aspects of the same theme were often emphasised. This can be demonstrated by examples of some of the major themes, such as the *Power of women*. In the Netherlands and France, this is represented as the Battle for the Trousers, for instance in Hoogstraten, but in England the woman beating the man, with her distaff, ladle or washing-beetle is preferred (Pls. 12, 13). Thus, whereas on the Continent the woman is fighting to get hold of the trousers, in England she is already wearing them! The popular stereotyped housewife in the Netherlands was *Mad Meg*, the ultimate virago. Even the devil was not able to stand up to her, for she tied him down on a cushion, rendering him powerless. On English misericords, by contrast, the gossiping nature of housewives was highlighted by showing them in church tempted by the devil *Tutivillus* (Pl. 14).

Another common theme dealt with differently is that of *Reynard the fox*. In England, scenes of the fox preaching, running off with the goose and being chased

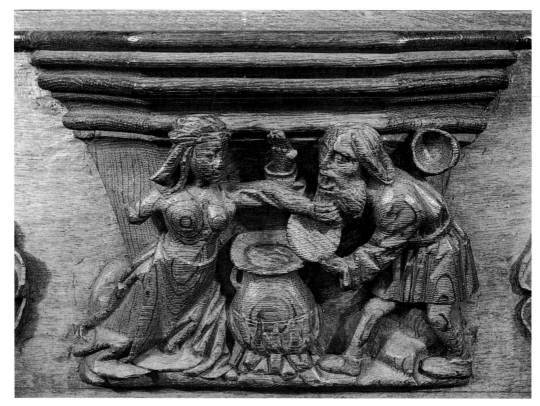

**12.** *Bristol Cathedral, c. 1520. The battle of the sexes. A woman grabs a man by his beard and flings a bowl at him, because he has tried to steal food from the pot. This scene illustrates the theme of the World upside-down: the woman subjugates the man, having taken hold of his beard, sign of his virility, because he has entered the kitchen, her realm. Her power and fury are well expressed in her movement and the billowing of her dress.*

**13.** *Hoogstraten (Belgium), St Catherine. The battle for the trousers. This is the Continental version of the battle of the sexes, where men and women fight for supremacy, and the woman wears the trousers. The scene depicted on English misericords is more usually that of the woman beating a man.*

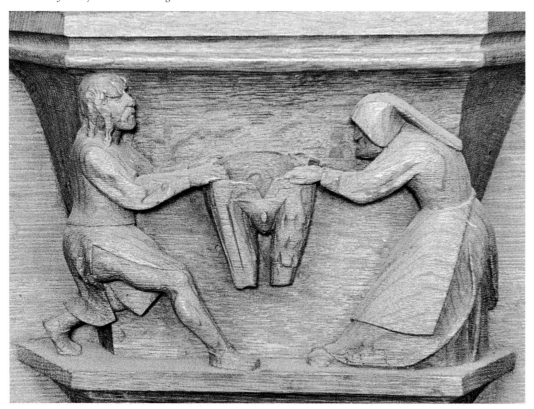

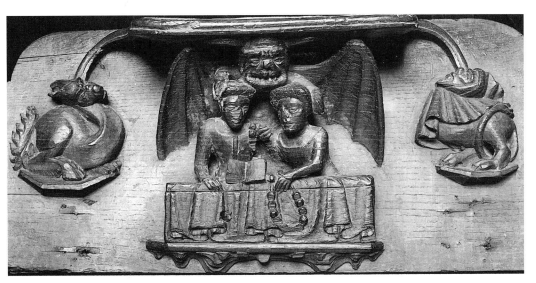

**14**. *Enville, St Mary. The devil Tutivillus glowers at two women, enveloping them with evil thoughts. They are in church, indicated by the book and the rosary, but these objects are only there for show, for they are gossiping and not paying attention to the service, and thus sinning. It is Tutivillus' job to take down their names which he will present to God on the Day of Judgement. The monsters in the supporters are reminders of the beasts of Hell.*

by the housewife were much more popular than on the Continent, where the *Fox and crane* from Aesop's fable was more likely to be represented (Pl. 7). Proverbs and puns, also found on English misericords, e.g. St George's Chapel, Windsor Castle and Beverley Minster, *c.* 1520, had a particularly strong tradition in the Netherlands, culminating in Bruegel's painting *Proverbs* in 1559. Some are still universally known today, like *Falling between two stools* on a misericord in Amsterdam, Oude Kerk (Pl. 15), or *Casting pearls before swine* as shown in Kempen (Lower Rhine), except that on the Continent the pearls are roses. Representative single figures, such as the *Pedlar*, the *Cripple*, the *Beggar* or the *Birdcatcher* in Breda (Netherlands), are real-life portraits from street life (Pl. 16).

**15**. *Amsterdam, Oude Kerk. This misericord illustrates the proverb 'falling between two stools' i.e. someone incapable of making a choice fails altogether.*

**16**, *(overleaf). Breda (Netherlands),* Grote Kerk. The bird-catcher is announcing his arrival. He is carrying a large birdcage filled with birds on his back, and a wide-brimmed hat in his left hand with which to trap the birds; his purse and knife are fastened to his belt. In general, carvers on the Continent concentrate on one large figure as central motif rather than many small figures as on English misericords.

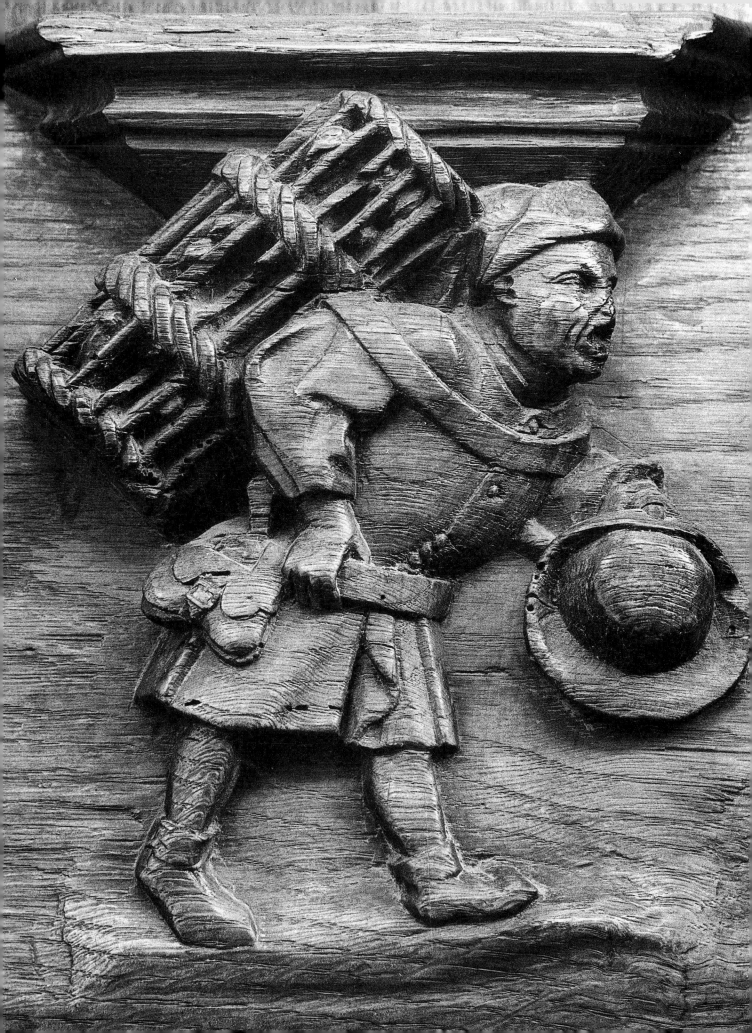

Scatological subject matter is a common factor in the decoration of misericords of all countries. This usually takes the form of an attack on the clergy, because of its unchaste and debauched life-style. Here, the Spanish misericords are in the forefront, with an unexpectedly liberal attitude towards scenes of obscenity. In the Netherlands the hypocritical monk wearing glasses, and holding a book and a rosary became the stock character. The ape too had an international reputation for foolishness and carnal lust, and in Great Malvern Priory (Worcs.) bellows are stuck up his bare bottom (Pl. 17), whereas in the Collegiate Church of Notre-Dame, Villefranche-de-Rouergue (Aveyron), it is a clyster, the bellows to fan his passions, the clyster to douse them.

On the Continent, above all in the Netherlands and in Germany, much of the carver's labour was expended on the choir-stall ends, covering them in intricate scenes of the martyrdom of saints or scenes from the Scriptures. Thus, the side panels in Bolsward, St Martin (Netherlands), have elaborate scenes of the martyrdom of saints and Old Testament scenes, such as Judith cutting off the head of Holofernes and, in the former Cistercian church of Maulbronn (Germany), there are also scenes from the Old Testament. In Germany, the choir-stalls at Ulm Minster (1469–74) carved by Jörg Syrlin are famous for their busts of Prophets, Sibyls and ancient philosophers. Not only do these have portrait features, but also the artist is thought to have included himself. In England, side panels are only rarely richly carved with intricate scenes like those in Manchester Cathedral, where the *Lathom Legend*, discussed in Chapter 3, is found on the end panel of the Dean's stall; this refers to the family of James Stanley, under whose wardenship the choir-stalls were carved. The poppy-heads, too, are small, with foliate finials or small figures or beasts.

Stylistically, misericords in England and on the Continent show general period characteristics, rather than specific analogies. The finely cut drapery and the gracefully bending figures of some of the Cologne Cathedral misericords, 1308–11,

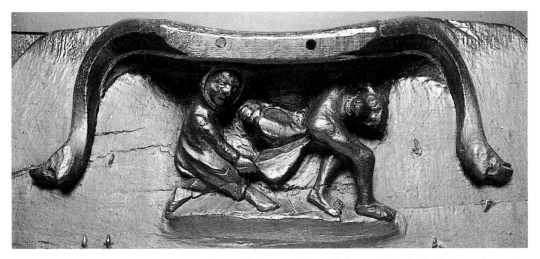

**17.** *Great Malvern Priory. A man rushes towards an apish demon and thrusts bellows up his backside. The human bottom is the seat of carnal passions, which in this case are being fanned. Beaked, long-necked birds hang from the supporters.*

**18, 19.** *Cologne Cathedral (Germany). Left, dancing woman seen from the back, spreading her gown. Some of the carvings are notable for their elegant style.*
**19**. *Cologne Cathedral (Germany). Female bell-ringer, half kneeling, and supporting the bracket of the misericord.*

**20.** *Wells Cathedral. Figure bending over backwards, supporting the bracket of the misericord. The style is elegant, the fine pleats of the clothing modelling the body beneath.*

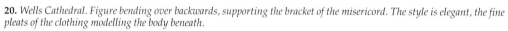
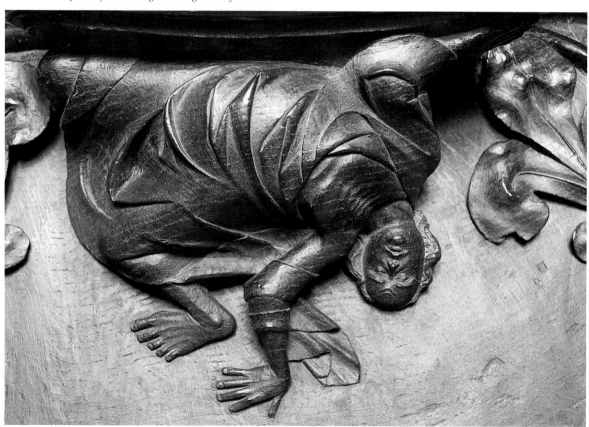

can be compared to those in Wells Cathedral, *c.* 1335 (Pls. 18–20), although the Cologne examples are stylistically superior, in particular in the figures seen from the back. The Cologne choir-stalls are thought to have been influenced by Notre-Dame, Paris,[10] where the choir-stalls no longer exist, and this opens up the question of whether the best of the Wells misericords, too, could have been influenced by Paris, possibly via the Court in London. The physical and economic ties between England and the Netherlands would lead one to expect close stylistic affinities between the misericords of both countries. However, English misericords retain their distinctive quality, even when the involvement of Netherlandish carvers is documented, as at Windsor Castle and in Westminster Abbey.[11] Only the representation of proverbs, difficult to identify, may be an indication of Netherlandish influence on the Windsor misericords; in Westminster Abbey the misericords testify to the use of German prints by the carvers who have copied engravings by Albrecht Dürer and Israhel van Meckenem. By the sixteenth century, prints had become available to artists, whereas in the fifteenth century, patterns had been disseminated through sketchbooks and manuscripts. Prints by German artists, such as Dürer and the 'Master bxg', were pillaged for motifs and used by artists and craftsmen working in different media. Thus, the design of the *Woman wheeled in a three-wheeled barrow* by 'Master bxg' was the basis of a misericord in Ripon Cathedral, a stall-end in Baden-Baden and a stone frieze on the Town Hall of Wroclaw (Breslau) (Pls. 21, 22). By this time with the help of prints, new ideas travelled faster and carvers were able to increase and supplement their repertory more easily.

Although English carvers were quick to use Continental prints as patterns when they did become available, English misericords remained unique and the supporters were typical of their Englishness. Busy scenes such as the *Fox chase* in Ely Cathedral, from the early fourteenth century, and *Sheep shearing* in Beverley Minster, from the early sixteenth century (Pls. 7, 8), require close scrutiny and an eye

**21, 22** (*left*). *Master bxg (German, working in the second half of the fifteenth century), engraving. A drunken woman carried in a three-wheeled barrow by a peasant in tattered clothing. The woman holds a flask and a barren branch which is a symbol of Carnival. The misogyny expressed here is typical of the time: the woman had probably been revelling, and now incapable of working in the fields, has to be wheeled there. This can be deduced from a contemporary French manuscript which depicts the same scene as part of the Labours of the Months, in which the woman holds a flail. This engraving became extremely popular, and was used by many artists as a model.*
**22** (*right*). *Ripon Cathedral. A woman in a three-wheeled barrow. This was copied from the engraving by Master bxg and must have been one of the first such uses of Continental prints in England.*

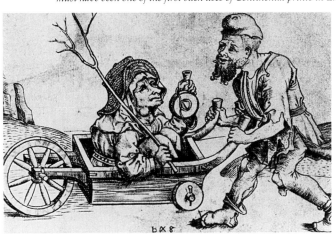 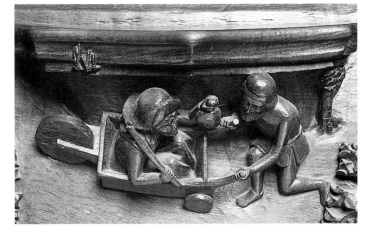

eager to decipher the story because they contain so many small figures which spread from the central carving to the supporters. Furthermore, the influence of the Renaissance in Beverley Minster is felt not so much in the elegance of style, as in a new individual approach to human feeling, demonstrated by the intimate relationship between human beings and their animals (Pls. 8, 23). At the same time, there are anecdotal observations, such as the bear licking its paw, or being muzzled and even embraced on the supporters of the misericord where the bear is pulled away in a basket; dogs, in particular, seem close to their masters, nuzzling up to them, jumping up and barking in excitement at the prospect of a hunt (Pl. 24), and often leading the way. There are many scenes of farmyard work, like chopping logs, fanning the fire with bellows, or churning butter, comparable to the Labours of the Months in illuminated manuscripts, and many of these snatches of realism are not without humour, as when the dog is being used as a bagpipe to be played on by an ape, or the bear dances to the bagpipes played by an ape, and the mice to the fiddle played by a cat. In their combination of human activity and foolish behaviour, these representations on misericords are among the forerunners of genre scenes, and point towards the Avercamps and Jan Steens of Dutch seventeenth-century art.

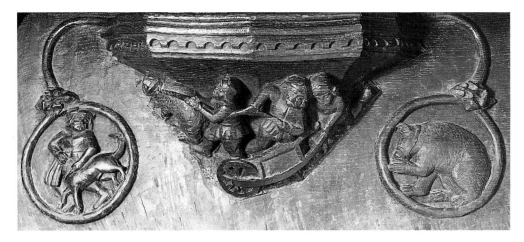

**23.** *Beverley Minster, 1520. In the centre, a bear is being dragged into a wheelbarrow by two men with a rope, while the third man holds the barrow. In the left supporter, a large dog nuzzles up to a man, putting its head under the flap of his coat. This is another example of the close relationship between humans and animals in Beverley Minster misericords. The right supporter shows a bear licking its paw. This looks like observation from nature, but there were models of bears drawn from different angles available from the engravings by the Master of the Playing Cards, which could have been the source of this carving.*

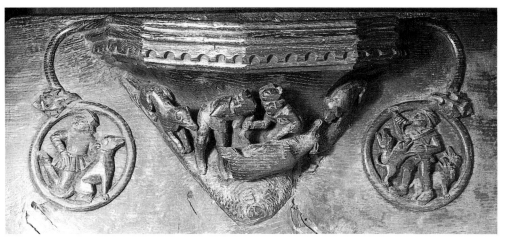

**24.** *Beverley Minster. In the centre, a hunt has come to a successful end: a stag is being disembowelled and the dogs are awaiting their reward. In the left supporter a dog is sitting, held by his master, while in the right supporter, the dogs jump and bark in excitement while the hunter blows his horn.*

# 1

# The Carvers
# and their Workshops

MANY OF THE FOURTEENTH-CENTURY and later choir-stalls in cathedrals replace earlier sets of the twelfth and thirteenth centuries, as in Ely Cathedral or Lincoln Cathedral which had twelfth-century stalls, erected after the destruction of the Minster by an earthquake in 1185.[1] The collapse of part of Ripon Cathedral's central tower in 1458 destroyed the Minster's twelfth-century choir. Peterborough Abbey and Gloucester Cathedral had thirteenth-century stalls, and St George's Chapel, Windsor, fourteenth-century ones. However, it is not known whether the early seating had historiated misericords. Of original thirteenth-century choir-stalls still in existence, Salisbury Cathedral's, c. 1245, is the earliest set, and contains misericords decorated with trefoil motifs (Pl. 5). Exeter Cathedral no longer has its original stall-work but has retained its misericords which are the earliest surviving set with a figurative narrative, c. 1250.[2] Often, the renewal of the choir-stalls came about when old Norman churches were rebuilt, or the choir was refurbished and the stalls considered too old-fashioned, as in Wells Cathedral, where the choir-stalls including the seats were considered *ruinosi et deformes* by the mid 1320s.[3]

Usually, choir-stalls were part of a larger programme of carpentry work under the direction of a master-carpenter. Of these masters, usually only those working for the Court rather than for parish churches are known. Furthermore, the actual involvement of a master-carpenter with the choir-stalls and the misericords is not documented. A number of misericords in Exeter Cathedral have concentric circles incised, and in St Lawrence, Ludlow, there are three-pronged sprays of flowers, which may be the marks of an individual master (Pls. 25, 26). The best information we have on choir-stalls relates to those of the thirteenth century in Westminster Abbey, for which Henry III ordered timber in 1252–53.[4] The master-carpenter in 1255 was Master Alexander, his assistant was Master Odo and Jacob was the *Junctor*. Interesting correspondence concerning the construction of the Winchester choir-stalls survives in the form of a letter sent by Bishop Woodlock of Winchester to Bishop Salmon of Norwich in 1308, asking for an extension of stay for William Lyngwode from Norfolk, who erected and probably designed the choir-stalls. In Wells Cathedral the master-carpenter at the time of the construction of the misericords was John Strode and his assistant Bartholomew Quarter.[5] The most famous master-carpenter in the fourteenth century was William Hurley, in the employ of Edward III and responsible for the choir-stalls at St Stephen's Chapel, Westminster, in 1351. He is also mentioned in Ely Cathedral, for the first time in 1334–35.[6] William Hurley's successor in fame was Hugh Herland who is recorded as working at the Palace of Westminster in a junior capacity in 1364.[7] This was the time when the

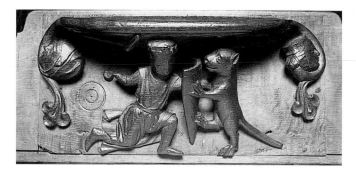

**25.** *Exeter Cathedral, c. 1250. In the centre, a crowned knight in chain mail fights a leopard. Heads grow out of the supporters. The armour is a good representation of thirteenth-century battle dress, and the head-dress of the woman in the right supporter is the fashionable 'barbette'. Note the concentric circles found on several misericords which may be a carver's mark.*

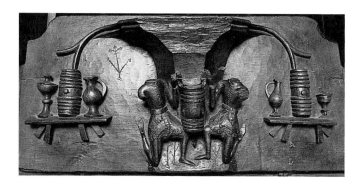

**26.** *Ludlow, St Lawrence. This misericord is dedicated to wine. In the centre, two men pay homage to a barrel of wine, while in each supporter, a beaker and a flask flank a barrel on a table. Sprigs of flowers are engraved into the wood and are probably carver's marks as in Exeter Cathedral.*

choir-stalls in St Katherine's, London, Coventry (formerly Carmelite Friary), Lincoln and Chester were carved; these are all closely related and show courtly influence (see pp. 46–50, below). It is thought, however, that they were by a London workshop which succeeded a team of Midlands and North Country craftsmen and not by Hugh Herland.[8] The master-carver documented for St George's Chapel, Windsor, at the time of the construction of the present choir-stalls, 1477–83, was William Berkeley, and two Flemings are recorded for the carvings made for the rood screen there. The other royal commission, *c.* 1512, was for the choir-stalls for Henry VII's Chapel, Westminster Abbey, where the woodwork was in the hands of Flemish masters under English supervision.[9] At the end of the fifteenth and the beginning of the sixteenth century, many northern ecclesiastical establishments had choir-stalls constructed. Of these, the misericords most closely related in design, shape, size and iconography were those of Ripon Cathedral, 1489–94, Manchester Cathedral, *c.* 1506 and Beverley Minster, 1520–24. Associated with these is the name of William Bromflet from Ripon who exerted his influence well into the sixteenth century. He was mayor of Ripon in 1511, worked in Bridlington in 1519 and was employed extensively in Ripon Cathedral around 1520–21.[10] Once more, however, there is no documented evidence of his work on the choir-stalls themselves.

Thus, although a number of master-carpenters are known, the carvers of the misericords, specifically, are never mentioned. Even in the case of King's College Chapel, Cambridge, a royal foundation, where the choir-stalls were carved in true

**27.** *Hanover, the monk on this choir-stall end is recognizable from his girdled habit and tonsure. He is carving using a chisel and mallet while his other tools—a pot of lime, gouges, compass and set-square—are tidily fastened to the wall beside him. It is interesting that the late thirteenth-century carver of these choir-stalls should be a monk, or possibly a lay-brother.*

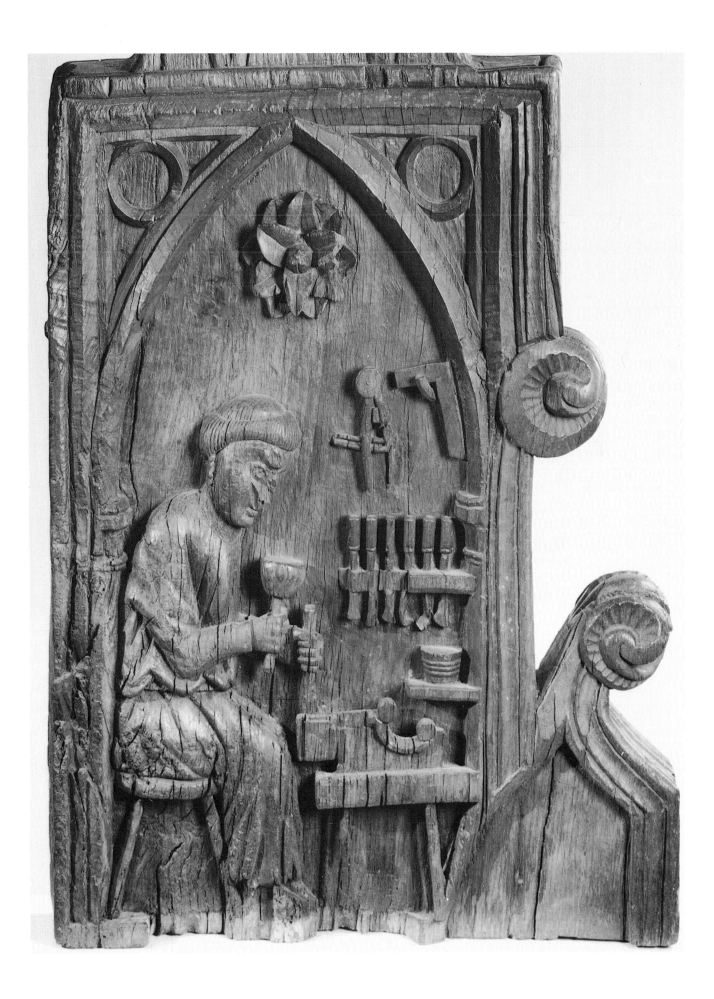

Renaissance style between 1533 and 1538, no names are documented. The master-carpenters probably designed the choir-stalls overall, and handed patterns in the form of drawings and, later, prints to the misericord carvers. From stylistic evidence it can be ascertained that several hands were usually working on the larger sets of misericords, e.g. Exeter, Chichester, Gloucester, Wells and Lincoln Cathedrals. Taking Wells Cathedral choir-stalls with 68 misericords as an example, it has been calculated that the money requested from the dignitaries for the construction of the stalls would allow for two master-carpenters and one assistant for three years.[11]

In spite of the dearth of named carvers, some are pictured at work on the choir-stalls themselves. The best example is on a thirteenth-century German choir-stall end, showing a monk in his workshop carving a choir-stall seat (Pl. 27).[12] Carvers carving rosettes, probably for misericords, and using mallets, chisels and gouges are found on misericords in St Nicholas Church, Great Doddington, and All Hallows, Wellingborough, both in Northamptonshire, also referred to in the section on Trades and Crafts (Pl. 28, and p. 169).

The better quality misericords are invariably found in the larger centres, such as the Cathedrals of Lincoln and Manchester, where money was available to hire the best carvers, who were in touch with the up-to-date metropolitan style or created new schools with radiating influence. The influence of the Lincoln misericords, for example, reached Nantwich via Chester, the quality deteriorating on the way, as we shall see later in this chapter, in the discussion of stylistic links. Villages, in particular in more isolated areas, e.g. Weston-in-Gordano in Somerset, have rather crude carvings and must have employed a local carpenter (Pl. 205). However, even small settlements in Norfolk and Suffolk have very good quality misericords, probably because they were relatively close to London, on trade routes, and had the wealth and pride to build large churches with excellent furnishings (Pls. 185, frontispiece, 219, 259).

28. *Wellingborough, All Hallows. A carver sitting at a table carves a rose, flanked by two hawks. He is well dressed, wears a hat, dainty boots and a jerkin with puffed sleeves and broad shoulders; his tools consist of a mallet, a chisel and gouges. There is a very similar example in Great Doddington, also, in Northamptonshire, where the carver is less elegantly dressed, and has fewer tools at his disposal.*

**29**. *Lincoln Cathedral. An example of the first stages of making a misericord. It is carved out of a single plank of oak and the seat, bracket and supporters have already been blocked in.*

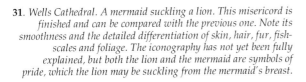

**30**. *Wells Cathedral. Unfinished misericord of a mermaid. The body has been cut out, but many parts are only roughly hewn, in particular her arms; the left one is still joined to her tail, and the junction between arms and hands is abrupt; also, the eyes have not yet been finished. The supporters, too, are still rough, showing that the carver must have worked on them in tandem with the central figure.*

**31**. *Wells Cathedral. A mermaid suckling a lion. This misericord is finished and can be compared with the previous one. Note its smoothness and the detailed differentiation of skin, hair, fur, fish-scales and foliage. The iconography has not yet been fully explained, but both the lion and the mermaid are symbols of pride, which the lion may be suckling from the mermaid's breast.*

The wood used for the construction of misericords was oak, and they were originally hinged to the stalls with wooden pivots which fitted in sockets cut into the elbows.[13] The measurements of misericords vary considerably, but an average height of 30cm and width of 64 cm can be expected. Misericords were hewn out of a single block and a seat with only the outlines of the wooden block carved out and some of the moulding for the bracket can be seen in Lincoln Cathedral, with no indication yet of the figural design (Pl. 29). Most interesting is a later stage in the working process found on a number of unfinished misericords in Wells Cathedral, e.g. a monkey holding an owl, a cat and a mouse, the head and shoulders of a bishop and a mermaid (Pl. 30). Their bodies have been carved out but are roughly chiselled, lacking detail and smoothness. Thus, the bishop's eyes have no pupils or eyelashes but are only indicated, and the cheeks and forehead look lumpy. The mermaid can be compared with a finished example suckling a lion (Pl. 31); in contrast, her arms in particular are thick and roughly hewn, and her face very uneven. It is interesting, however, that the carvings in the supporters are as advanced as those in the centre, and must have been worked on in tandem.

The depth of the bracket on which the monks would lean is usually approximately 15 cm, but the monks of Winchester Cathedral only had 10cm available for the comfort of their bottoms, whereas those of New College, Oxford were allowed 17.5 cm! Some misericords retain much of the bulk of the wood underneath the

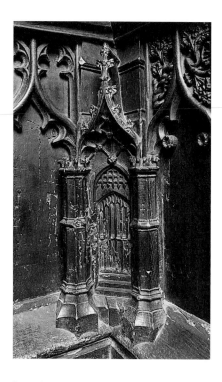

**32**. *King's Lynn, St Margaret. Junction of stalls where the lateral stalls, running along the axis of the choir, meet the returned stalls, running north to south, at the west end of the choir. In King's Lynn, the junction is totally hidden by the carving of a portcullis, topped by an ogee arch.*

brackets, e.g. in St Mary of Charity, Faversham, where the figures are heavy and bulging, such as the *Half-length angel with shield*, or the *Bagpipe player* (Pl. 33). This defeats the purpose of misericords, as they are top-heavy and refuse to remain in an upright position.

The junction where lateral and return stalls meet at right angles is usually carved in order to disguise the join. If the two standards are carved out of one piece of wood, the junction is often bridged by one large head, as in Lincoln Cathedral, or by beasts like the bat at St Gregory, Sudbury; if there is a gap, two heads, beasts or decorative foliage can face each other across it: two monks' heads in cowls in St Peter and St Paul, Salle (Norfolk), or a muzzled bear and a dragon in All Saints, Gresford, (Clwyd). In St Margaret's, King's Lynn, the junction consists of an elaborate gateway with portcullis, topped by an ogee arch (Pl. 32).

**33**. *Faversham, St Mary of Charity. Jester playing the bagpipes. Because of the great bulk of the wooden block used to carve such a foreshortened figure, this misericord is quite top-heavy. The pendulous flowers with great seed-heads were popular at the end of the fifteenth and beginning of the sixteenth century.*

*34. Boston, St Botolph. Stall elbow—a handrest projecting on either side of the seat. The examples in Boston, in particular, are known for their narrative scenes; this one depicts a man, with his dog and carrying a bag over his shoulder, arriving before the city gates.*

Stall elbows are often decorated with foliage or flowers, animals and human forms, most frequently heads or angels. Sometimes there are scenes, such as the *Lathom Legend* in Manchester Cathedral (see below Chapter 3), where the eagle stands over the stolen, swaddled child in its nest. The elbows in St Botolph, Boston, Lincs., are particularly interesting: a fox and an ape with urine flask, a fox catching a goose, a cat catching a mouse, a big fish eating a small one or a beggar with begging bowl (Pl. 34). Elbows also include a repertory of bawdy scenes, as in St Andrew's, Norton, where a young boy's dress is being lifted to expose his bare bottom.

### The Stylistic development of Misericords

Roughly speaking, the style of misericords develops from very simple floral motifs, from hard, bulbous designs reminiscent of stone sculpture to extended narrative, and a more flowing, 'painterly' style. The early thirteenth-century misericords in St Mary the Virgin, Kidlington, demonstrate most succinctly the beginnings of a very simple ornament (Pl. 4). Having carved away the wood underneath the bracket on one of the misericords, only a pillar-like buttress remains as a support. Other misericords there hide the buttress with a simple foliate motif, and thus begins the attempt to break up the heavy, bulging block of wood underneath the seat. All the curving brackets end in small foliate supporters. A single misericord from the thirteenth-century remains in the church of the Blessed Virgin Mary, Hemingborough, where the simple trefoil foliage follows the outlines of the block underneath, which, however, has been cut away to leave space behind the curving tendrils. Here too, the brackets end in a trefoil leaf on each side. The same method is used for the mid thirteenth-century misericord in Christchurch Priory where the simple motifs have developed into two entwined dragons whose foliate tails with heads at their ends extend into the supporters (Pl. 35). Both style and motif can be

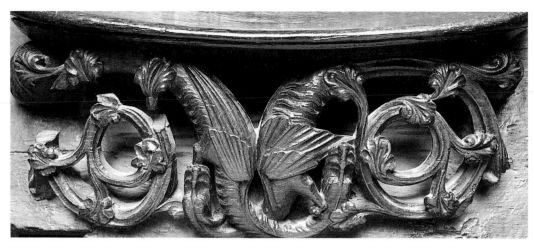

**35.** *Christchurch, The Priory. This is one of the few remaining thirteenth-century misericords (c. 1250). It shows two dragons with foliate tails entwined. Their tails end in heads below the bracket, possibly indicators of future supporters. The wood behind the beasts has been carved out so that their shapes flow easily and are comparable in both style and subject matter to initials in manuscripts, such as the twelfth-century Bury Bible.*

compared with the choir arcades of St Mary's, Stone Kent, of the mid thirteenth century, where similar dragons have trefoil-leaf tails. In Salisbury Cathedral, the bulging block of wood underneath the bracket is still visible, but is decorated with bosses of trefoil leaves that sprout into bouquets of foliage. The supporters are bosses of trefoil foliage (Pl. 5). These decorations are very symmetrical and based on the trefoil leaf motif, with slight variations; they may be more or less bulbous, fruit may be included or the bottom bosses may consist of foliate human or animal masks. Stylistically, the foliage can be compared to stone sculpture of that period in Salisbury Cathedral itself.

A major change came about with the misericords in Exeter Cathedral, *c.* 1350. Stylistically the figures are still reminiscent of stone sculpture and the foliage is of the trefoil type, (Pl. 36) for which parallels can be found in tomb sculpture, such as that of Bishop Marshall (1194–1206) in the Cathedral itself. However, a whole new repertory of figures and narrative has been created. Above all, the figures, animals and foliate designs really support the brackets: e.g. a man, in breeches only, holding up the bracket on his shoulders with his arms outstretched and head askew, or a

**36.** *Exeter Cathedral. Male and female bird-sirens facing a fleur-de-lis.*

man on one knee, putting a weight. Many of the motifs are symmetrically arranged: harpies, birds, fish and hands, around a central decorated stem, thus disguising the construction of the misericord. By the later thirteenth century, we also find interaction between figures and beasts and even between the centre and the supporters, as in the case of the centaur shooting backwards at the dragon in the supporter (Pl. 6). The supporters themselves now contain heads and dragons besides foliage.

With Winchester Cathedral we come to the fourteenth-century examples. Here, the supporters have grown to a size larger than the central carvings, and many of them contain foliage which can be identified for the first time (Pls. 37, 49). The central carvings are very hard and compact, consisting of more head than body and contorted bodies at that. The carvers seem to have taken much delight in drilling, for the eyes have deep holes for pupils with incised almond-shaped eye-sockets; even nostrils are deeply pierced and many of the mouths are open, and full of expression. Many bodies crouch or are contorted in order to support the seats, and some tumble down from them as though hanging on to the brackets. One male figure physically lifts the seat with his hands, grinding his teeth with the effort.

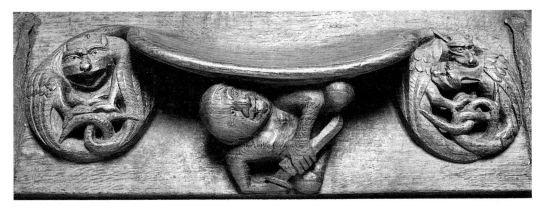

*37. Winchester Cathedral. Contorted man lying on his side supporting the bracket. He draws his sword from its scabbard and puts out his tongue. The left supporter shows a winged double-bodied monster, while the right supporter shows two long-eared dragons fighting. The Winchester Cathedral misericords are unusual in that the supporters are larger than the central carving. The style of the central motifs, with deeply-pierced eyes, in particular, is reminiscent of stone sculpture.*

*38. Chichester Cathedral. Two totally interlocked men cartwheel over a horse. Animal heads as supporters.*

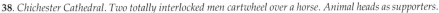

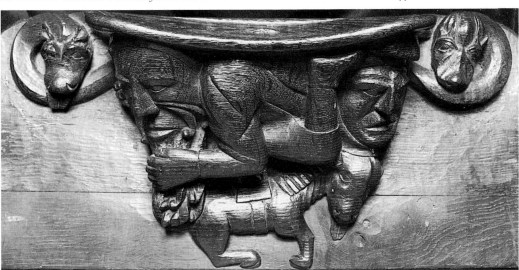

Judging from such examples, the carvings on these early misericords are very functional and are comparable to stone corbels. Comparisons can be found in much earlier stone carvings such as the early thirteenth-century figures on the capitals in the south transept of Wells Cathedral showing a contorted man drawing a sword, and a woman beating a man with a stick. The question therefore arises whether the early carvers evolved from sculpting in stone or were equally adept at carving in both materials. Some of the foliage on the misericords in St Mary's Hospital, Chichester, for example, can be compared with that on the north east chancel door there, and the heads in the Chichester Cathedral misericords compare very well with sculpture of the 1320s in Winchelsea Parish Church.[14] Two bosses in the sacristy of Chichester Cathedral are particularly close to the misericords both in style and iconography, and must be by the same master or masters (Pl. 38).[15] As for the knobbly, bulbous foliage found on the Chichester Cathedral misericords, e.g. vine leaves and grapes, they are typical of sculpture of *c*. 1330, such as found on the Southwell Minster screen.

Ely Cathedral misericords, 1339–41, mark the next stage in development. Although many figures are actively supporting the seat above them, they have become more elegant, enveloped in swathes of drapery, through which the knees protrude. Their poses and gestures are forceful and in tune with their facial expressions. Above all, scenes have more narrative content and have been placed within a setting of trees, turrets or canopies, and extended across the whole misericord into the supporters (Pls. 7, 39). This gives the impression of story-telling, of being able to read misericords in the same way as the marginalia of manuscripts, e.g. the *Fox running off with the goose*. Religious scenes, too, have been introduced, such as Old Testament scenes and legends of Saints (Pls. 88, 177). The iconographic repertory has increased considerably to include moral teachings and everyday life occupations. Such an influx of sophisticated style and iconography must point to a master mind in possession of the newest ideas and patterns; it must also be remembered that at this time East Anglia was famous for its output of lavishly decorated manuscripts.[16]

**39.** *Ely Cathedral. This misericord has been interpreted either as the fall of pride or as the legend of St Withburga. In the story of St Withburga, the man falling off his horse is an evil landlord who hunted and killed the hinds, seen in the left supporter, that had provided milk for the nuns. As a punishment, he is killed falling off his horse. In the right supporter, St Withburga prays for his soul. The attempt at a three-dimensional building is noteworthy.*

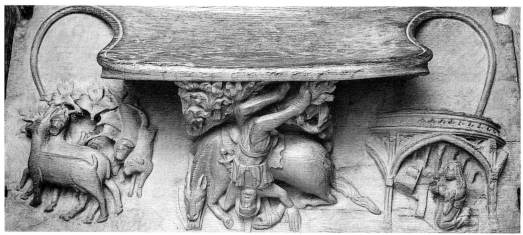

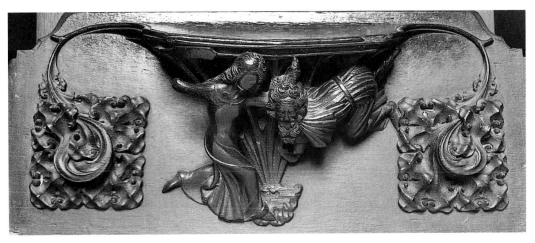

**40**. *Lincoln Cathedral. The battle of the sexes depicted in the traditional English manner, the woman pulling the man by his hair, the emblem of his virility, and belabouring him with her distaff or, as in this example, washing beetle. She seems to be lifting him right off the ground, and her dress swirls around her expressing her power and passion.*

Lincoln Cathedral choir-stalls are of the utmost importance in the second half of the fourteenth century because, as M. D. Anderson says, the Lincoln carvers were the first to realise the full potentialities of their medium, and achieved complete mastery of their craft, with their understanding of the scope of mortised and tenoned wood construction.[17] This can also be seen in the sophisticated style of the misericords, where figures move convincingly, their bodies show underneath the drapery, attention is given to details and architectural settings are three-dimensional (Pl. 40).[18] The Lincoln style no longer gives the impression of hacking away at wood but is flowing and painterly. The fourteenth century was the great period of development for misericords in England and those in Lincoln formed a climax. From then on, there are no spectacular changes for a whole century, and the style of misericords follows the prevalent fashion of the arts generally. Thus, Carlisle Cathedral misericords have soft, curving forms, typical of the so-called International Gothic style. Even the dragon in *St Michael fighting the dragon* has become pliant, the spear is bent, St Michael's dress of feathers merges with the dragon's body and the his wings frame the whole composition (Pl. 41).

**41.** *Carlisle Cathedral. St Michael fighting the dragon. The Archangel is dressed in feathers, as he would have been in Mystery Plays. The devil in the shape of a dragon lies helpless at his feet, speared through his gaping jaws. The style of the early fifteenth century, is expressed in curved, flowing lines.*

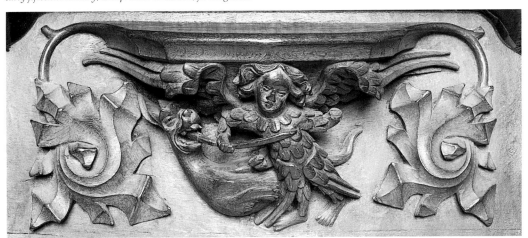

Experimentation again took place at Ripon Cathedral but affected the stall-work more than the misericords. The work has been attributed to three hands[19] and associated with the Bromflet family, whose influence was also felt in Manchester Cathedral and Beverley Minster. The major innovation in Manchester Cathedral, *c.* 1506, concerns the canopies, no longer topped by gothic pinnacles but by a horizontal tester, heralding the Renaissance. Misericords develop in the surrounding of the narrative with additional props; in the *Chasing of the fox*, for instance, a house is now included with a child looking out, or in the *Sow playing the bagpipes and piglets dancing*, the numbers of piglets have been increased and a trough added (Pls. 81, 161). This development is taken up in Beverley Minster and Bristol Cathedral (Pl. 82). In the latter, the wealth of nude figures conveys the spirit of the Renaissance.[20]

Two sets of misericords which follow tradition, yet stand out at the end of the fifteenth and the beginning of the sixteenth centuries are those in St George's Chapel, Windsor, 1477–83, and Henry VII's Chapel, Westminster Abbey, *c.* 1512. Both are more sophisticated and forward-looking than other misericords of the period, and both are royal commissions. Most remarkable is the Sovereign's stall in Windsor Castle which depicts a historical event: the *Meeting of Edward IV and Louis XI* in France on the Bridge of Picquigny on 29 August 1475 (Pl. 42). In King Henry VII's Chapel the knowledge of Renaissance form and ornament dominates for the first time. Nude, classical figures, dolphins and *putti* make their appearance: *Two wild men fighting*, nude and muscular, no longer the hairy, angular beings of earlier examples; a very sensuous *Mermaid* or a *Satyr fighting a lion*. In particular, the *Wild family* demonstrates the new style in the modelling, the movements, the different views of the figures; above all, the northern forest has been exchanged for a backdrop of southern vineyards (Pl. 43). There are also misericords with foliate masks inspired by the most up-to-date Renaissance ornament ultimately derived from the decoration of the *Domus Aurea* and the Vatican Loggia in Rome, and which in the 1550s became well known through the engravings of the Netherlandish artist Cornelis Floris.

The demise of medieval misericords came about with the pure Renaissance creations of the choir-stalls in King's College Chapel, Cambridge, 1533–38, where three types of decoration dominate: those covered in foliage only, those with heads of humans or animals, framed by wings or foliage, most of these without supporters, and eight returned stalls with scenes in flamboyant Renaissance style. These returned stalls with their classical half human-half animal, satyr-like creatures, heads in roundels, and symmetry of arrangement, are typical of the Antique vocabulary (Pls. 44, 45). The style is vivacious, with mythological beasts in the centre bounding towards the figures or animals in the supporters, linked with ribbons or foliage. The carvings in the supporters are complementary, showing back and front views, turning right and left. Thus, while the Reformation was in progress, the King's College misericords introduce the Renaissance style proper, totally foreign to the concept of English misericords, and an isolated example of Italianate work in England. The carvers are not known, although the kitchen

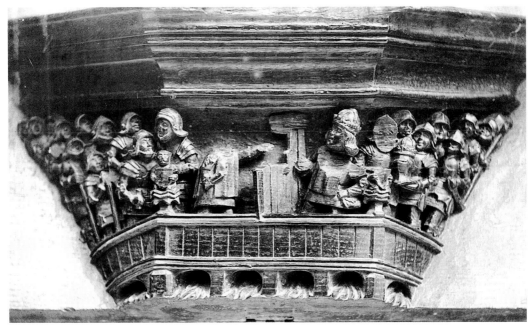

**42**. *Windsor Castle, St George's Chapel. This is the Sovereign's Stall which shows the meeting of Edward IV and Louis XI of France on the bridge at Picquigny on 29 August, 1475. The Kings with their retinues are separated by a wooden barrier, both wear armour with short surcoats. There are eleven armed men on the left and nine on the right, and the King on the left stretches out his hand to the other. The supporters, not pictured here, show on the left, the King of France coming out of a castellated gateway preceded by three men, and on the right, the King of England in the opening of his tent which is surmounted by the banner of St George; he wears a crown and holds an orb and a sceptre and is accompanied by four attendants.*

**43**. *London, Westminster Abbey, King Henry VII's Chapel, c. 1520. A wild man and woman sit peacefully, playing with their children, creating an idyllic image of life in tune with nature. The fact that they are nude rather than covered in fur, and that the dense oak forest has given way to grape vines, is an indication of the new spirit of the Renaissance.*

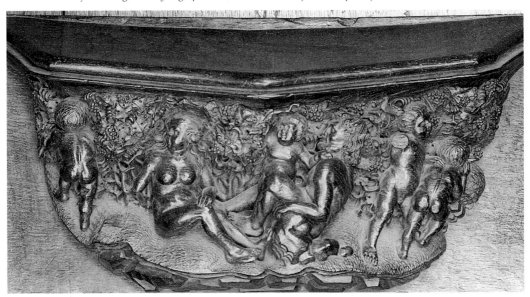

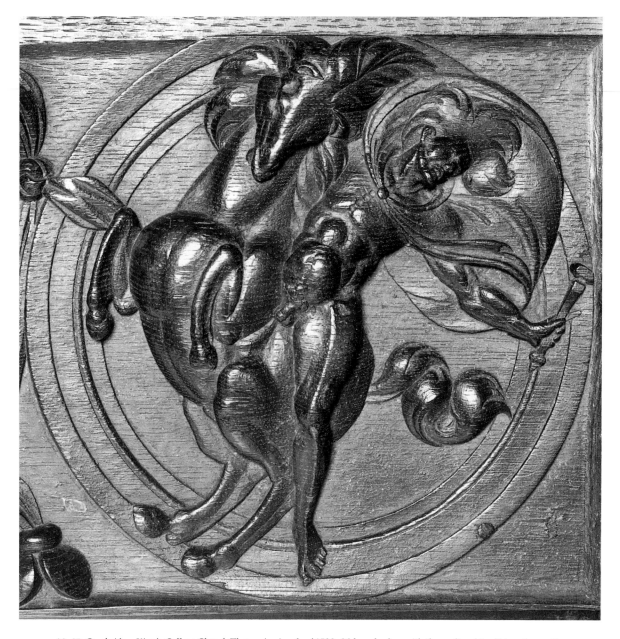

**44, 45.** *Cambridge, King's College Chapel. These misericords of 1533–38 have broken with the medieval tradition of narrative carving and represent pure Renaissance ornament.* **44,** *(top). Right supporter of the Vice-Provost's stall, showing the front view of a muscular nude man in flowing cloak on a rearing horse. The left supporter is the rear view of the same subject, and the central carving is very similar to Pl.* **45,** *(below). In the centre, a ram's head is placed between two satyrs with wings; each holds a lion, in the supporters, by a ribbon and by its tail.*

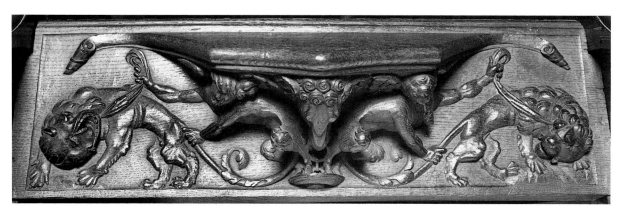

accounts mention 'Philippus sculptor' and 'five other strangers' in company with the Cambridge carpenters William Buxton and John Kale. Were there then Continental artists working on the choir-stalls? According to the building accounts, very little can be ascribed to foreign hands at the time of Henry VIII, for the palaces were devised and largely adorned by the Officers of the King's Works who were English. Nevertheless, the Cambridge screen and stalls can be seen as an exception and it is possible that some of the artists who had worked for Cardinal Wolsey were still in England till at least 1536 and could have been responsible for this woodwork.[21] France, much influenced by the Italian Renaissance was to influence England after the fall of Wolsey, but there are no French stalls comparable to the Cambridge ones.[22]

## The Supporters

As has been seen, English misericords partake in the general development towards the Renaissance, but retain their English characteristics, of which the supporters are the most unique part. Because of this they require closer scrutiny. There are some misericords in England without supporters, e.g. in Gloucester Cathedral, St Mary's, Wingham, (Kent), St Mary's, Swine, (Yorks), St Mary's, Old Malton, (Yorks) and St Andrew's, Soham, (Cambs) (Pl. 214). In Gloucester Cathedral cusped arches frame the narrative which often consists of one reclining figure or two running figures (Pl. 270). The thirteenth-century misericord in Christchurch Priory, already mentioned, may represent an early stage in the development of supporters (Pl. 35), because the foliate tails of two entwined dragons form a screen across the breadth of the misericord, and human heads at their ends are indicators of future supporters. The creation of supporters in England may stem from a desire for balanced, harmonious and flowing forms covering whole surfaces, as in the façades of Wells or Lichfield Cathedrals, comparable to the shafts of initials in manuscripts. As we have seen, supporters allowed for an extension of the narrative, the addition of motifs, and interaction and movement between the centre and the sides. At first they were insignificant, consisting of a small trefoil leaf at the end of each bracket as in Hemingborough or Kidlington (Pl. 4); they increased in size in Exeter Cathedral and became even larger than the central part in Winchester Cathedral (Pls. 37, 49). Their subject-matter, hitherto mainly of foliage, heads and dragons, progressed with greater figural and scenic content in Ely Cathedral. From then on variations on common subject matter increased, with additions of lions' heads, angels, heraldic devices and monsters of all shapes. Most interesting are those supporters which are used consciously, pulling them into the narrative in imaginative ways, the first being the example mentioned from Exeter Cathedral (Pl. 6). Similar examples are in St Botolph, Boston, where a mounted knight in the centre charges at a dragon in the supporter and spears it, or in Norton, where St Edmund is shot by archers standing in the supporters. There are various ways in which supporters become part of the overall design or story: in St Mary's, Enville, soldiers standing in supporting gate-houses flank the main gate in which *Yvain* is trapped, or the bear's chain in the *Bear-baiting* scene reaches across to the left supporter where it is made

secure by a sitting man (Pls. 224, 271); in Boston, a dog's leash is tied to a supporter; dragons' tails spiral upwards into the brackets in St Mary's, Nantwich; on one misericord, a bearded man with powerful, hunched shoulders grabs the heads of two dragons whose tails curve around from the sides of the brackets in St Mary's Hospital, Chichester, and on another, two dragons rise out of the mouth of a lion towards the ends of the brackets. Most fascinating are the supporters of two misericords in St Mary's, Framsden (Suffolk), where gloved hands take hold of the supporter-branches (Pl. 46). Often, supporters are used like branches on which to hang objects, shields in particular, e.g. in St Margaret's, King's Lynn, New College Chapel, Oxford or Holy Trinity and King Henry VIII's School in Coventry (Pl. 47). A cooking-pot over a fire and two flitches of bacon are tied to the supporter-branches in Ludlow (Pl. 253). Supporters can be hooks for fetterlocks, as in two Northamptonshire churches: St Mary's, Tansor and Hemington, St Peter and St Paul. In the church of the Assumption and St Nicholas, Etchingham (Sussex), a key hangs from each supporter (Pl. 48). In Manchester Cathedral and Beverley Minster all the tendrils of the supporters are tied together at the edge of the bracket with a small leaf (Pls. 81, 82). Figures can balance on the supporters' curving branches, e.g. in New College Chapel, and in Lincoln Cathedral, the Angel of the *Annunciation* steps off the supporter to greet the Virgin standing on one opposite. In another example there, the stems issuing from the brackets form headbands for heads in profile (Pl. 63). In Southwell Minster, the supporters are branches with large leaves, but instead of descending from the sides of the brackets, they are held by the figures, growing out of the *Green man's* mouth (Pl. 241), or out of the embracing couple's skirts. Sherborne Abbey has supporters, but in some cases the central scene overlaps into their spaces, for example, a monkey eats from the large acorn-laden oak branches that cover the whole space, or the shoulders of the grimacing face extend into the supporters and cover up the foliage (Pl. 236), or again, as in the Last Judgement, where leaves are carved behind the rainbow and the rising dead appear in the supporters. In the supporters too, carvers experimented with plants seen from unusual angles, in particular roses or columbines seen from behind, as in Ripon and Manchester Cathedrals or St Martin's, Herne (Pls. 80, 97).

Thus, apart from using them as a decorative platform for flora and fauna or as an extension of the central story, carvers found innumerable ways in which supporters became part of a play with form and narrative, leading to most imaginative solutions.

### Links Between Groups Of Misericords

Having discovered a pattern for the general stylistic development of misericords and established connections between sets of misericords from different regions, we can speculate about the movement of carvers or their patterns. It is often difficult to separate different hands working on one set of misericords, because of the strong adherence to the style of a particular workshop. The smaller and more isolated the community, the more individual, albeit crude, the style of local carvers unable to travel for experience to the important centres. Regional styles developed in their

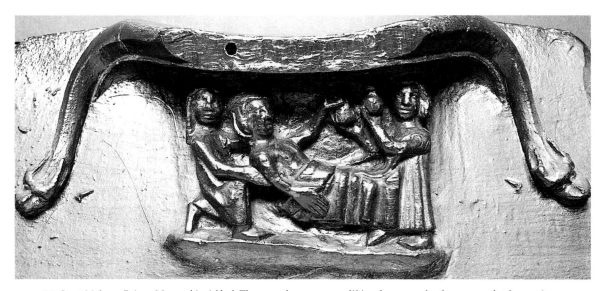

**58.** *Great Malvern Priory. Man on his sickbed. The scene shows a woman lifting the man under the arms, so that he can sit up for the doctor's visit. The doctor stands at the foot of the bed and lifts a urine glass in order to diagnose the illness, while at the same time receiving a bulging bag of money from the patient. This scene can be compared with a similar one in Tewkesbury Abbey.*

Tewkesbury has a misericord with two *Mermaids* facing, while in Great Malvern the subject becomes a *Mermaid and a merman*; animal bodies with human heads appear in both places, as well as misogynistic scenes. As regards the latter, it is interesting to find the same scenes in Fairford, *c.* 1500: a *Woman beating a man* and a *Woman threatening a man who touches her shoe*. The first is treated in identical manner in Tewkesbury, the second is a slight variation on the same theme in Great Malvern (Pls. 129, 130). These carvings therefore illustrate the manner in which patterns are borrowed and how neighbouring sets of misericords provided inspiration, even many years later.

A closer connection exists between those misericords in Great Malvern which depict the *Labours of the months* and the same in Worcester Cathedral. Not only are the style and iconography the same but also the very shape of the misericords with their brackets and supporters (Pls. 246, 248). The figures, the hair-style, the clothes are as in Worcester Cathedral, except that one man instead of three is occupied with the seasonal tasks; they are stockier in build and there is little emphasis on ornamental detail. The close relationship with Worcester is not confined to the *Labours of the months* but extends to the other misericords of this type. In particular, *Musician angels* in both places can be compared: both are seated on a bench, the drapery across their knees is pleated in the same manner, their smiling faces are framed by spiralling curls and a feather from the upper part of their wings swings outwards. The only difference is the way they hold their instrument; the angel in Worcester holds his tightly to his chest, whereas it is held in a more natural, relaxed position by the Malvern angel.

The figures in the supporters of the Worcester angel have broad, thick-necked faces with stylised, spiralling curls, of which there are many other examples in Worcester, both male and female. Similar faces can be found in Great Malvern, as supporters and central carvings. A mannerism of the Malvern carver is that he often

**55**. *Wells Cathedral. Man riding backwards, wearing nothing but a pair of drawers and a close-fitting coif on his head. Having to ride backwards was a great humiliation, often used as a punishment for sexual offences. This motif is also found on misericords in Hereford Cathedral and All Saints, but the Wells example has the most convincing depiction of rider and horse.*

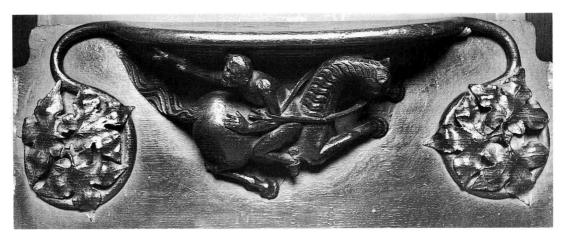

**56**. *Hereford Cathedral. Man riding backwards, as in Wells Cathedral, but here, completely bare except for his spurs. He has put his left arm through the horse's bridle, but his body does not show the same exertion in trying to hold on as in Wells.*

**57**. *Hereford, All Saints. Man riding backwards, nude and with spurs, and with his left arm through the bridle, as in Hereford Cathedral. The master of All Saints must have used the Cathedral misericord as his model and added a beard to the figure. These three misericords illustrate how patterns travelled and changed according to the understanding and ability of the individual carver.*

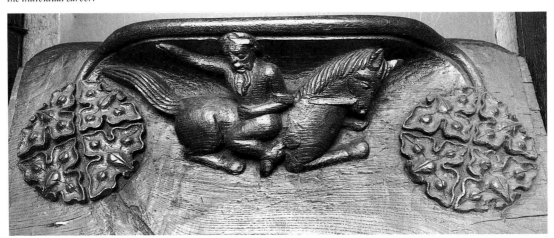

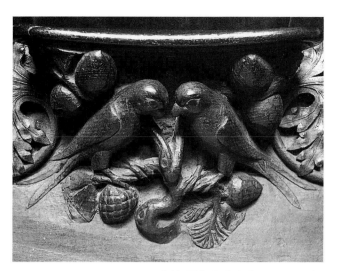 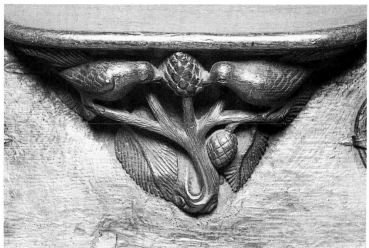

**53, 54** *(left). Wells Cathedral. Two parrots facing each other, perched on a conifer branch (c.1330–40).*
**54.** *Right, Hereford Cathedral. Two birds perched on a conifer branch, pecking at a pine cone between them, 1340s.*
*The comparison with Pl. 53, shows that the Hereford carver must have been inspired by the Wells misericord, which is better differentiated and more three-dimensional.*

species of leaves but contained within branches that curve in the opposite direction. The central scenes in Hereford are separated from the supporters, whereas in Wells they merge. *Two birds in a pine tree* in both Cathedrals can be compared (Pls. 53, 54); the similarities can also be seen in other examples with slight differences for instance in the bat which in Wells has claws, better differentiated and moulded wings and a more powerful body. A large number of compositions must have been inspired by Wells; this is most obvious when considering otherwise rare subject matter such as the *Mermaid suckling a lion* or the *Man riding facing backwards* (Pls. 55, 56). However, the Hereford master did not copy slavishly, often creating variants on a common theme.

The misericords in All Saints, Hereford, *c.* 1380, show some borrowing from the Cathedral, but are much cruder in execution. The *Man riding facing backwards* is certainly copied from the Cathedral (Pl. 57). However, other carvings in All Saints can be compared to those in the Cathedral only in a general manner; they show a predilection for symmetrical arrangements of animals and mermaids facing each other, of beasts back to back, or of a face between two leaves. What is here demonstrated is the acquaintance of one set of misericords with another across county borders. That motifs are copied by carvers according to ability and transformed into a new period style, is best seen in the transmission of the *Man riding facing backwards* from Wells Cathedral to Hereford, All Saints.

A more haphazard relationship can be established between Tewkesbury Abbey, Great Malvern Priory and St Mary's, Fairford. The Tewkesbury misericords, after the remodelling of the new choir 1331–40, have been badly damaged. Their provincial style, as well as the composition, is akin to a number of misericords in Great Malvern Priory, *c.* 1350–80.[25] Exactly the same pattern is used for the *Sickbed* scene (Pl. 58), but in Tewkesbury, the figures are larger and more three-dimensional.

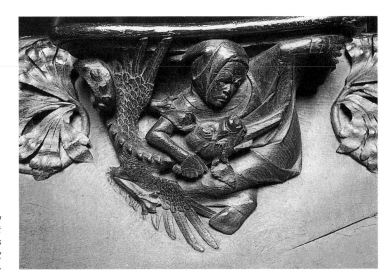

**51**. *Wells Cathedral. A contorted man kills a dragon by thrusting his sword through the back of its head so that it comes out of its jaws. There are at least two hands responsible for the Wells misericords, this one being more angular than that in Pl. 52.*

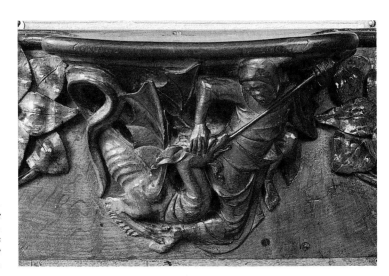

**52.** *Wells Cathedral. Left-handed man fighting a dragon. The man twists his body to turn back and hold down the dragon's head while the spear goes through its jaws. Compared to the contortions of the man in Pl. 51, this figure is more elegant in its movements, with its body showing through the pleated drapery.*

ments balanced. Thus, the contorted *Man drawing his sword* in Winchester can be compared with a *Man stabbing the head of a dragon* in Wells which is curled up and probably by a different hand from the more advanced carving there of the *Left-handed man killing a dragon* (Pls. 37, 51, 52). The many veiled female heads in Winchester can equally be distinguished from those in Wells Cathedral where the drapery has become almost transparent and the facial features are much more smoothly modelled and even idealised.

The Wells carvers, in particular the hand responsible for the *Flight of Alexander* and the *Left-handed man killing a dragon,* demonstrate how expert carvers can use their experience of prototypes to create something new which may in turn influence other artists. This certainly happened at Hereford Cathedral in the 1340s,[24] where style and iconography are based on the Wells misericords. The supporters in both cathedrals have foliage displaying the same quality of naturalism and the same

own way, whereas styles associated with the metropolis or larger centres were more likely to spread, the best known case being the Lincoln patterns which travelled as far as Nantwich. Stylistic influence was most enduring where a whole team of carvers travelled to set up a workshop in a particular place. But links found in the architectural woodwork of the choir-stalls did not always have parallels in the carvings of the misericords, because the presence of an overall master carpenter would have been rather restricting, whereas individual carvers probably had more freedom.

Some misericords reflect a close stylistic and iconographic relationship with other examples in different regions, in those neighbouring or at greater distances, and I would like to consider these in greater detail. Sometimes the connections span different periods, as in the case of Winchester Cathedral, *c.* 1308, and Wells Cathedral, 1335–40. The Winchester misericords were the first to include identifiable foliage and domestic animals, and this was carried a stage further in Wells Cathedral, pointing to a knowledge by the Wells carver of the earlier set.[23] The *Cat having caught a mouse* and an *Ape holding an owl* are found in both places, but in Wells, although unfinished, the animals have grown in size, their bone structure has become more powerful and their movements more lifelike (Pls. 49, 50). This is the case with all the animals, for instance, the rabbit or the dog. In the same manner the foliage has become softer and more lush. Both similarities and differences can be discerned in the treatment of human figures: although Wells, like Winchester, has contorted figures, bending over, legs up, supporting the bracket, their bodies are of more realistic proportions, enveloped in finely pleated drapery, their move-

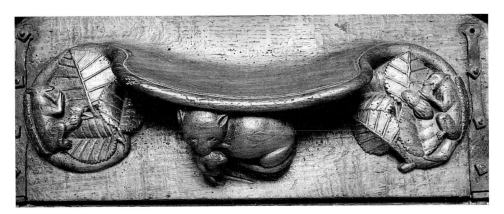

**49**. *Winchester Cathedral. In the centre, a cat has caught a mouse; in the supporters, squirrels eat nuts, sitting on hazel branches. The Winchester misericords, c. 1308–10, are known for their early identifiable flora and fauna, later developed in Wells Cathedral, c. 1330–40.*

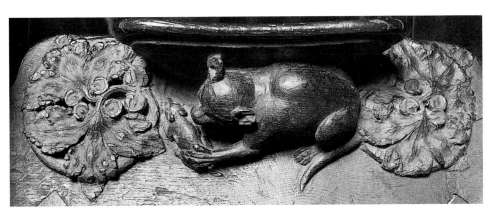

**50**. *Wells Cathedral. Cat having caught a mouse. Many of the motifs in Wells Cathedral have their sources in Winchester Cathedral, cf. Pl. 49. The cat here is larger, looks more life-like, and seems to be playing with the mouse.*

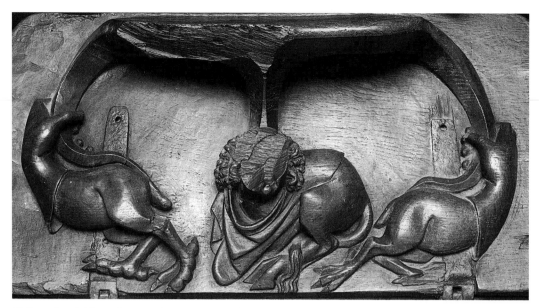

**46**. *Framsden, St Mary. The centre shows a mutilated, draped centaur. In the supporters, gloved hands forming the upper bodies of animals with clawed feet clasp the ends of the brackets.*

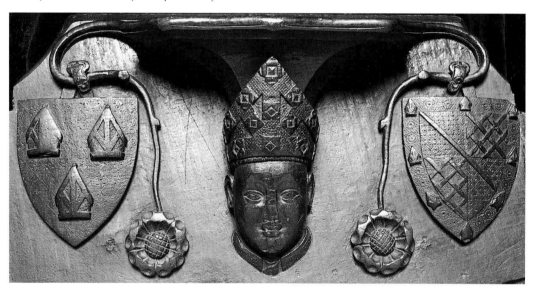

**47**. *King's Lynn, St Margaret. The head of Henry Despencer, Bishop of Norwich. He is flanked by the arms of the See of Norwich, in the left supporter, and, in the right supporter, his own arms. The coats of arms are suspended from branches ending with roses, descending from the bracket.*

**48**. *Etchingham, The Assumption and St Nicholas. Floriated column in the centre, with, in the supporters, keys on chains hanging from the bracket.*

reverses the top curl, so that it curves downwards and not upwards as in Worcester (Pl. 248). Extremely close are the *Wyverns* and the *Basilisks*, (Pls. 59, 60) down to the clump-like claws rather than the talons prescribed for a basilisk.

The misericords in Great Malvern Priory with a particularly close relationship to Worcester are generally dated to *c.* 1480, that is almost one hundred years after the Worcester misericords. The similarities described, however, argue for a close connection between the carver of the Malvern misericords and the Worcester workshop. The fashions depicted also point to the end of the fourteenth century, and it is impossible to imagine a conscious historicism at the end of the fifteenth century, a period when much stained glass by the most up-to-date artists was created for the Priory Church. Thus, these Great Malvern misericords must date from about the time of the Worcester ones, *c.* 1400.

The Worcester style did not stop in Great Malvern but travelled into neighbouring Warwickshire to St Mary's, Astley, where a college was founded in 1340 by Sir Thomas Astley.[26] The shape of the misericords there is the same, and so is the style of the foliage and the dress, e.g. the *Bust of a woman* in the centre of one misericord has the square veiled head-dress which is also the fashion in Worcester. Different are a number of misericords which have ribbed vaulting springing from a rose or

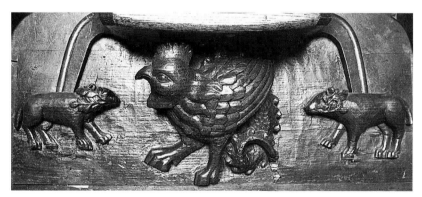

**59, 60** *(left). Worcester Cathedral. In the centre, a basilisk (also called cockatrice) which originates in the Physiologus. This hatches from the egg of a seven-year-old cock, laid in a dunghill and incubated by a serpent or toad. It has the head, feet and wings of a cock and a serpent's tail. It kills with its glance, darting venom from its eyes, but it can be killed itself if its glance is reflected back at it with a polished shield or a mirror. The example in Worcester Cathedral digresses from the description of the Physiologus, for the beast has claws rather than cock's feet. According to Remnant, the animals in the supporters are weasels with sprigs of rue in their mouths, which give immunity from the basilisk's deadly glance.*
**60**. *Right, Great Malvern Priory. A basilisk, probably copied from Worcester Cathedral, Pl. 59, as it too has claws for feet.*

**61, 62** *(left). Worcester Cathedral. A boar with large tusks, standing on a corbel-type pedestal. Most imaginatively, the lion mask in each supporter can be viewed from four sides.*
**62**. *Astley, St Mary. A boar, very similar to the one in Worcester Cathedral, Pl. 61, without its pedestal. The very shape of the bracket is the same, too, establishing a connection between the two places.*

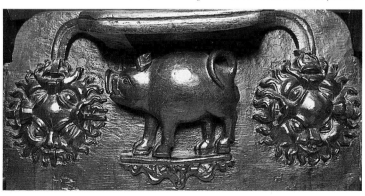
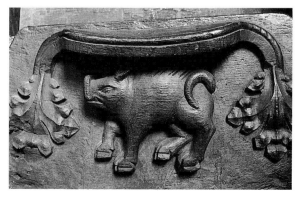

a small head, yet the head is of the Worcester type in miniature. There are no figural compositions, but busts in the supporters are of the Worcester/Malvern type. Of the animals, the *Boar* with tusks and curly tail is the same in Worcester and Astley (Pls. 61, 62). It is repeated in another example in Astley facing the other way, and also a *Dog* walking to the left is of similar build to the boars. A *Lioness* with tongue out and tail coming up from between her legs is the same in Great Malvern and Astley, and is also found as a *Lion* in Astley, having had a furry collar added. The *Basilisk* and the *Wyvern* are based on the same model in all three places, although in Astley the wyvern has bird's wings, rather than the membrane-type bat wings of Worcester and Great Malvern. Remnant dates the Astley misericords to the beginning of the fourteenth century because of the founding of the college then.[27] However, for the reasons given, they too must belong to the time of the Worcester workshop which seems to have been very prolific at the end of the fourteenth and the beginning of the fifteenth century. Some of the carvers must have received commissions in the surrounding areas, for not only were the same patterns used but the same style applied, which would point to a carver well versed in that vocabulary. Judging from his repetitions of vaulted corbels, boars, and the small distinction between his lions or his dog, the Astley carver must have had a restricted choice of patterns and little imagination.

Among the misericords in Mere (Wilts.), St Michael the Archangel, there are four, some with modern additions, which came to the church in 1949, having been bought originally from a local antique collector. These hark back to the Worcester style as regards their shape, supporters and types of angels represented. There is the familiar angel sitting playing the viol and heads of angels in the supporters. The hair has become more dishevelled and wavy, but the impression is of an origin associated with the Worcester area in the fifteenth century.

One of the most important connections established in the fourteenth century is between Lincoln, *c.* 1370, Chester, 1380s, and Nantwich, *c.* 1390; it was first examined by M. D. Anderson, who argued that the Lincoln and Chester stalls might have been made by the same group of craftsmen.[28] Without doubt, the misericords in Lincoln and Chester are extremely closely related in shape, iconography and style. Sixteen of the central designs in Chester are based on Lincoln patterns, as well as additional motifs in the supporters. Six of these patterns were further transmitted to Nantwich, St Mary, as well as some not found in Lincoln but common to Chester and Nantwich. *Tristan and Isolde* from the Arthurian Romance are only found on misericords in Lincoln and Chester, but other chivalrous tales are also popular, such as that of the *Wild man* (Pls. 222, 223), discussed in 'The World of Chivalry' (see pp. 144–147). The dissemination of style and pattern can be exemplified by the portrayal of a *Crowned head facing, flanked by profile heads*, found in all three churches (Pls. 63–65). In all comparisons, the Chester carvings are very close to those in Lincoln, whereas those in Nantwich have moved away stylistically, yet nevertheless demonstrating full knowledge of the Chester misericords and through these the original Lincoln patterns. The differences between Lincoln and Chester are often very slight; there is a shift in the fashion of clothing, in the style of the foliage,

**63–65** *(top). Lincoln Cathedral. A crowned head with flowing beard and hair is flanked by two heads in profile in the supporters; the fillets round these heads are tied to the brackets. The design of this misericord (1370s) travelled as far as Nantwich, in Cheshire (1390s) via Chester Cathedral (1380s).*

**64** *(centre). Chester Cathedral. Same subject as above. The style of the heads is harsher than in Lincoln, which makes them look more forceful, especially as the size of the profile heads has increased. A large number of patterns from Lincoln appear in Chester, indicating the movement of some of the carvers.*

**65** *(below). Nantwich, St Mary. Another version of the same subject. The ultimate destination of the Lincoln pattern is reached in Nantwich, where the heads are least differentiated. At the same time, although they are copied from the same pattern, the profile heads have individual expressions.*

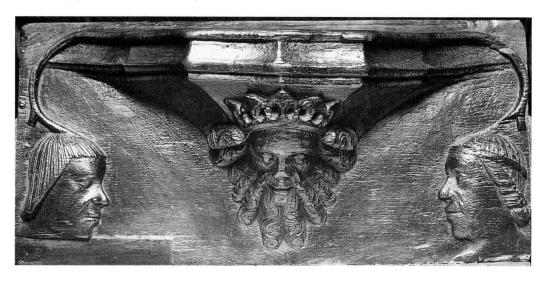

or in details like the inclusion of clumps of earth as a base for animals and figures. In general, the Lincoln figures are more sculptural, the body showing through the drapery more prominently. The *Coronation of the Virgin* or *Yvain trapped by the portcullis* only have very minor differences, so that the possibility of at least one of the Lincoln carvers moving to Chester becomes very strong, and even convincing in the carving of the *Cranes* (Pls. 66, 67). The differences are almost imperceptible, for even the feathers and the foliage are treated in the same manner. The same hand may also have been responsible for the *Wild men* in both Cathedrals. William Newhall, the King's chief carpenter, was in Chester between 1377 and 1411 which is the period during which the misericords were being carved; William and Hugh Herland, the King's Master carpenters, who were thought to have been the origin-ators of the developed type of canopied choir-stalls, may have influenced the

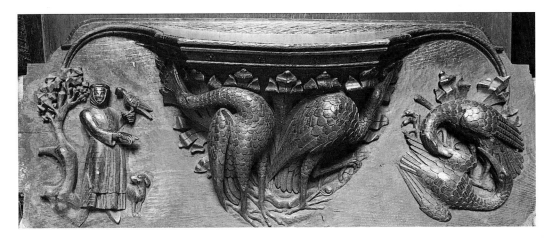

**66, 67** (above). Lincoln Cathedral. In the centre, two cranes stand back to back moving their long necks elegantly. In the left supporter, a woman falconer; in the right supporter, two cranes fighting. Falconry was one of the main occupations of the nobility.
**67** (below). Chester Cathedral. Exactly the same subject as in Pl. 66. The treatment of the foliage and feathers is so close, that one of the carvers originally employed on the Lincoln misericords may have travelled to work on the Chester Cathedral set. In the supporters, composite monsters, the one on the left: a bearded human head, the one on the right: a lion head.

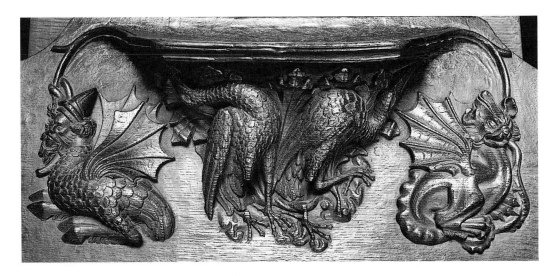

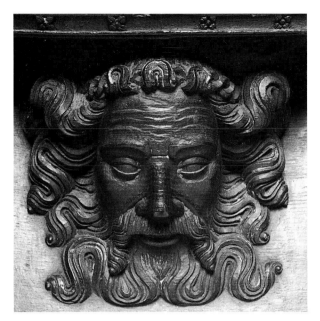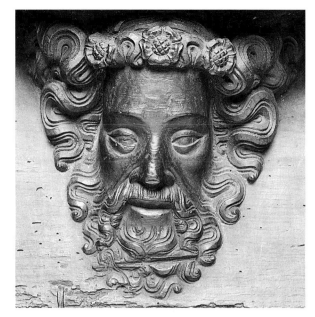

**68, 69** (left). Lincoln Cathedral. Head of a bearded and moustached man wearing a fillet over which his hair curls. The hair and face are quite stylised.
69 (right). Loversall, St Katherine. Head of a bearded and moustached man with flowing hair, very similar to the one in Pl. 68. The fillet with its ornaments of roses is more prominent in this example. It shows the extent of the Lincoln influence.

Lincoln and Chester misericord.[29] What can be seen, however, is that the majority of Chester carvings testify to the possession of Lincoln patterns, and one or two Lincoln carvers, rather than a whole team, may have moved to Chester; in Nantwich however, the style is more provincial. Many of the monstrous beasts and lions found in Lincoln and Chester are also traditional inhabitants of the margins of manuscripts or sketchbooks, and, as C. Tracy points out, it is difficult to say whether certain motifs are signatures of particular craftsmen or a commonly employed convention.[30]

The style of the Lincoln misericords was not restricted to Chester, but can also be found in the misericords from Roche Abbey, now in Loversall, St Katherine (Yorks), and in Coventry, Holy Trinity.[31] Only two misericords remain in Loversall, one of a *Foliate mask*, the other of the *Head of a bearded man*, crowned with a circlet of roses. Both these images are found in Lincoln, with no easily recognizable difference, and the foliage in the supporters is also of the same type (Pls. 68, 69). Foliage, birds and lions' heads in Lincoln also have connections with Coventry, and bearded heads facing or in profile, and a foliate mask show similarity.

The source of the Lincoln style can be traced back to London, where in the Foundation of St Katherine (Stepney), the misericords, *c.* 1360, show connections with both Lincoln and Coventry.[32] In all three sets of misericords the stems of the supporters have short shoots, and apart from the foliage and the treatment of feathers on birds, bearded, curly-haired heads can be compared, in particular the bearded man in profile wearing a knotted headband seen on misericords in Coventry and St Katherine's (Pls. 70, 71). Another significant detail which links the

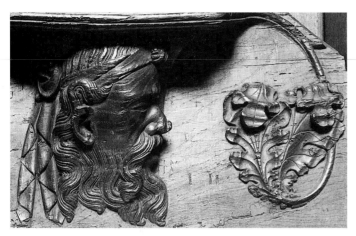 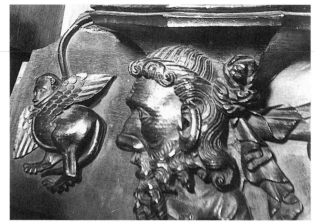

**70, 71** *(left). Coventry, Holy Trinity Church. Bearded and moustached man in profile facing right, with a kerchief bound over his brow.*
**71** *(right). London, Foundation of St Katherine, Stepney. Bearded and moustached man in profile facing left, with a kerchief bound over his brow. The design is the same as in Pl. 70, but much more forceful, with the muscles visible. It probably originated at the Court in London.*

last two places is the insertion of clearly marked pupils in the eyes, whereas the eyes in Lincoln remain empty and sightless. However, some of the coats of arms and the dress in Coventry point to a date after 1400. One of the shields now in Holy Trinity Church is that of John FitzAlan, Earl of Arundel, 1434, and in the supporters of the *Cockatrices back to back*, the women's head-dresses with high, dagged collars, date the misericords to after 1400. All these details may reflect the extensive period of influence of St Katherine's.

As we have seen, the second half of the fourteenth century was a major period for the construction of choir-stalls with far-reaching influences; and the misericords in St Margaret's, King's Lynn, can be added to the sphere of influence emanating from St Katherine's in London; here, the sculptural heads bear the closest resemblance to the London carvings.[33] A detail which may be of significance is the dimple, which appears in both places: on the chin of the bust of a woman; on the head of Bishop Henry Despencer (Bishop of Norwich, 1370–1407); on an elbow portraying the head of a monk in King's Lynn, and more importantly, on an elbow of a bishop's

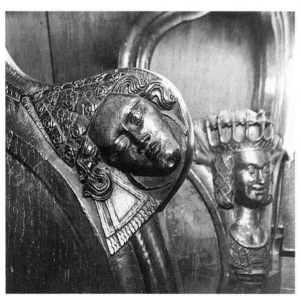

**72**. *London, Foundation of St Katherine, Stepney. A stall-elbow showing a bishop's head with a deeply drilled dimple in his chin which can be compared with others on some of the misericords in St Margaret, King's Lynn, for instance, the head of Henry Despencer, Pl. 47.*

head in St Katherine's London (Pls. 47, 72). The pattern on the latter's mitre is the same as that on the head of Henry Despencer. His inclusion and the style would date the King's Lynn misericords to the 1370s.

London, therefore, was probably the catalyst for carvers in the regions further north, especially if the King's carpenters were active outside the London Court. Important centres like Lincoln would pick up new ideas from the metropolis, such as courtly themes of Romances and wild men, there they would be developed and disseminated further afield.

Much more easy to explain is the relationship between the misericords of New College Chapel, Oxford, and Winchester College Chapel, both founded by William of Wykeham, who became Bishop of Winchester in 1366. Both Colleges were built by William Wynford: New College in two stages, 1379–86 and *c.* 1398–1402, and Winchester College, 1387–94, on a smaller scale than New College but as an integral part of the building. Only 18 misericords remain in Winchester College Chapel in contrast to 62 in New College Chapel, yet even they make a comparison in iconography and style possible. In general, the foliage is of the same style, with leaves that curl upwards or into pellets. Thick lips, big noses, deeply lined foreheads and stylised, corkscrew curls characterise the heads. The *Harpy* in New College is like the *Winged female monster* with a snake's tail in Winchester College, and both are slightly smiling. The *Tumblers* and *Three men with daggers* in New College (Pls. 73, 75) wear the same padded jackets as the *Crouching man holding a candle and drawing a dagger* in Winchester College (Pl. 74), only that the padding is incised in the first and gives a real impression of quilted material in the second.

*73. Oxford, New College Chapel. Two acrobats with two heads but four bodies which join up. They are cartwheeling above a smiling face, and the bottom acrobat holds a dagger in his extended hand. The figures wear tight-fitting garments of quilted material with closely-set buttons down the front and the lower part of the sleeves; the belts are tied low and the shoes are very pointed: a late fourteenth-century fashion. There is a close relationship between misericords in New College and Winchester College.*

*74. Winchester College Chapel. A curly-headed man in a quilted tunic; he holds a dagger and a candle, which makes him rather suspect, especially as he seems to huddle in the shadow of the seat. That he is up to no good is emphasized by the little devils balancing on the supporters, the one on the right pointing him out to the spectator. In type and style, this man can be compared with the acrobats in Pl. 73, except that the quilting of his outfit is raised and not incised.*

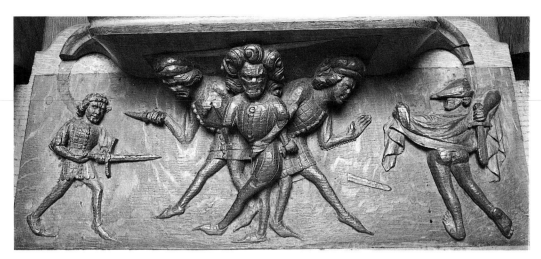

**75**. *Oxford, New College Chapel. Three men, in the centre, fighting two men in the supporters. They seem extremely shady characters with their threatening stances, in particular the little man in the right supporter with his face concealed under his cap. It is possible that the man on the right of the central group is lifting his hand in a conciliatory gesture. As in the acrobats, Pl. 73, the configuration of these men is most interesting.*

**76**. *Winchester College Chapel. A crippled beggar. His legs are totally deformed and he walks on wooden blocks. Although people would give alms to beggars in the Middle Ages, they were generally despised, because many of them would fake their deformity and poverty, as illustrated in Sebastian Brant's 'Ship of Fools', where the beggar has a wooden leg, and manages to disguise his perfectly good leg. This cripple has a bulging purse attached to his belt, and may be quite well off. The ape in the right supporter is dressed in fool's costume, and urinates into a horn, while looking back at the cripple, intimating some foolish association between them. In the left supporter, the ominous little man already seen Pl. 75, is back, this time swinging an enormous scimitar.*

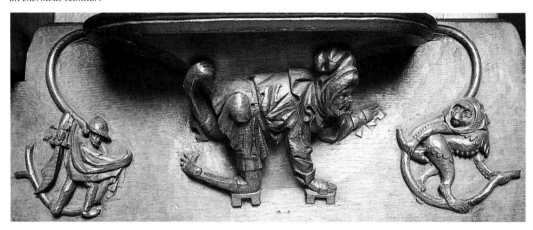

Again, the curly-haired figures are very similar. A most impressive figure in Winchester College is the *Shepherd*, with mighty shoulders enveloping the lambs (Pl. 258). A parallel in New College is the so-called *Jack and the beanstalk*, who also wears large gloves and seems to squash tiny sheep in his hands. Bean plants weave through his arms and these are similar to the convolvulus in the supporters of the *Shepherd*. In New College there is another such figure holding large leaves, with his knees drawn up, rather like the *Shepherd* in Winchester College. Both sets of misericords have little figures balancing on the branches of the supporters which can sprout into flowers, as those on the left of the *Shepherd* in Winchester College and on the left of the *Ape in a shell* in New College. Closest of all are small supporting figures seen from the back, hiding a sword in New College and a scimitar in Winchester (Pls. 75, 76). Both sets of misericords must have been created under one

guiding hand, the New College ones at the very end of the fourteenth century and those in Winchester College *c.* 1400, when the high-necked, buttoned coat seen in the *Bust of a curly-haired man* was in fashion.

In the fifteenth century important choir-stalls were being constructed in the north of England beginning with Carlisle Cathedral and St Cuthbert's, Darlington, in the first quarter of the century. The misericords in Carlisle were carved during the period of office of Bishop Strickland (1400–19) and the Darlington stalls have the coat of arms of Thomas Langley, Bishop of Durham (1406–38). In both places, the misericords have the same rounded style and treatment of details like feathers, except that the Darlington carvings are more bulky. Unfortunately, the medieval misericords in Durham Cathedral were destroyed[34] so that it is impossible to tell whether these were in any way connected.

The misericords in Whalley (Lancs.), St Mary and Blackburn Cathedral (Lancs) are exactly the same both in the fashioning of the supporters and also stylistically because they originally belonged to the same set of choir-stalls made for Whalley Abbey and removed from there in 1537. One of the misericords in Whalley has the initial W W which refers to the abbacy of William of Whalley (1418–34). Two scenes of the story of the fox are now split, the *Fox preaching* being located in Blackburn and the *Fox making off with the goose* in Whalley.

The misericords in Tansor and Hemington are said to have come from Fotheringay College, *c.* 1425, all in Northamptonshire, and there are two broken misericords now attached to the cover of the font in Fotheringay church; but although hawks and fetterlocks are motifs used in both Tansor and Hemington (Pl. 77), the style is more refined in Tansor, and the seats and supporters are different. Fetterlocks and hawks are also found in Ludlow, *c.* 1415–25,[35] where the manner of tying the fetterlocks to the supporters is the same as in Tansor. Additional motifs in both Ludlow and Tansor are *Busts of women* some in fancy head-dresses and others with Ostrich feathers, three in Ludlow, four in Tansor. A *Mermaid* of the same pattern with dolphins in the supporters is found in Hemington. Some motifs travelled as

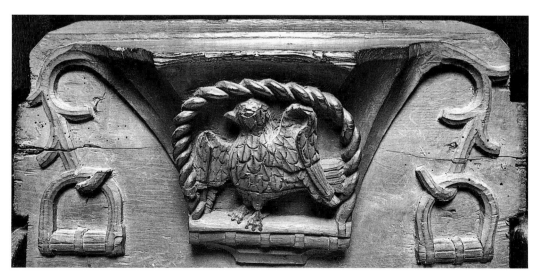

*77. Hemington, St Peter and St Paul. A hawk in a fetterlock—the badge of the House of York. Perches hooked on to branches in the supporters.*

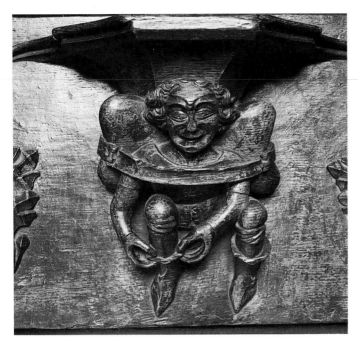 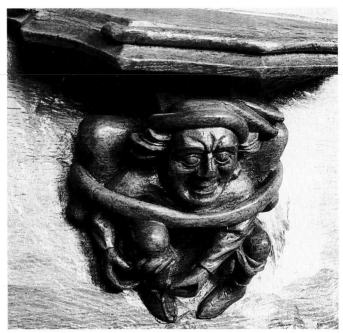

**78, 79** *(left). Ludlow, St Lawrence. A pedlar pulling on his right boot. He has a pack tied to his back, which according to Peter Klein in his guide to the Misericords, may be a bale of good quality woollen material known as 'Ludlow Whytes'.*
**79** *(right). Oxford, All Souls College Chapel. A pedlar pulling on his right boot. The carver here has used the same pattern as in Ludlow, Pl. 78.*

far as Oxford, to All Souls, 1442, where the seats, brackets and supporters are also the same as in Ludlow. Here, again, we can see the *Hawk* and the *Fetterlocks* tied on to the stems of the supporters as well as the *Ostrich feathers*. Other related subjects are the men jumping on one leg, draped or bearded heads, a tippler filling a flagon from a barrel, and a *Pedlar pulling on his boot* (Pls. 78, 79). This last representation is found only in Ludlow and All Souls, and is close enough to be based on the same pattern. The hawk and fetterlock are Yorkist badges and included in all the above sets of misericords, thus uniting them politically, and illustrating the movement of people and ideas.

The most important period of activity in the North was towards the end of the fifteenth and the beginning of the sixteenth century, inaugurated by the choir-stall carvings in Ripon Cathedral, *c.* 1488–94.[36] These started a chain of influence that reached the misericords of the 1490s in Durham Castle Chapel, in Manchester Cathedral, *c.* 1506, and Beverley Minster, *c.* 1520. Apart from stylistic similarities, some iconographic patterns are common to all three, e.g. the *Man wheeling a woman in a three-wheeled barrow* in Ripon (Pl. 22) which has become a two-wheeled barrow in Durham and Beverley, and the *Pig playing the bagpipes to piglets dancing*, with varying numbers of piglets and a trough added in Manchester and Beverley (Pls. 80–82). The misericords in Richmond (Yorks.), St Mary, *c.* 1515, can also be brought into this sphere of influence, for there too, the popular pattern of the *Pig playing the bagpipes to the piglets dancing* is repeated, and the dragons and the antelope, too, show similarity.

Working at about the same period and not too distant from each other geographically, carvers must have been influenced by each other's style and icono-

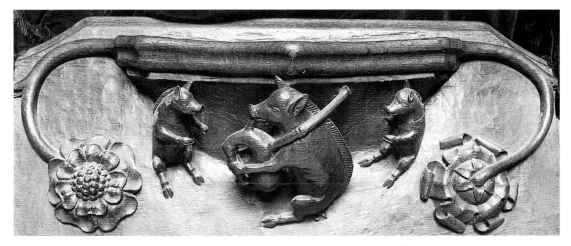

**80**. *Ripon Cathedral, A sow playing the bagpipes to two dancing piglets. The pig is a symbol of lust and gluttony; the bagpipes were associated with them because they were made from pigs' bladders, and they were, therefore, considered a 'low' instrument that aroused animal passions. Above all, they were played at fairs, and are a parody of merrymaking. Note the rose seen from the back, in the right supporter.*

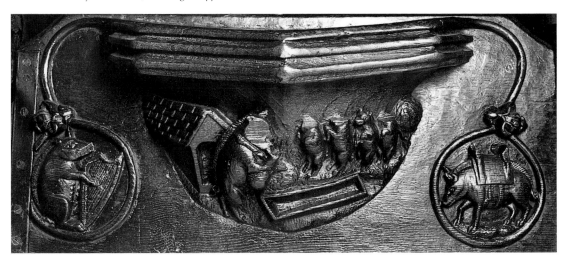

**81**. *Manchester Cathedral. In the centre, a sow playing the bagpipes to four dancing piglets. Compared with Pl. 80, a hut and a trough have been added. In the left supporter, a pig plays a harp, generally the instrument of angels. In the right supporter, a pig carries a pack-saddle.*

**82**. *Beverley Minster. A sow playing the bagpipes to four dancing piglets. This misericord is similar to that in Manchester Cathedral, Pl. 81, in reverse, except that one of the piglets is now behind the sow and there is no hut. A number of scenes are repeated in Beverley Minster and Manchester Cathedral, pointing to a common use of patterns.*

graphical patterns, so forming what might be called a 'regional style'. The misericords in Manchester Cathedral have the same period foliage and flowers as in Ripon Cathedral, but the scenes display a much more sophisticated and detailed narrative with a greater number of participants. The real relationship is not between Manchester and Ripon but between Manchester and Beverley Minster: the seats are the same shape, the stems of the supporters form a roundel and are tied together with a leaf, the only difference being that the bracket moulding is crenellated in Beverley Minster. The innovations introduced in the Manchester misericords, *c.* 1506, are repeated in Beverley Minster: apart from the trough in the *Pig playing the bagpipes to the piglets dancing*, a house has been added to the *Fox chase* (Pl. 161). Many scenes have the same iconography, e.g. *Apes rifling the pedlar's pack*, *Hunters disembowelling a stag*, a *Woman beating a man*, or a *Wild man fighting a dragon* (Pls. 24, 145). Both places have *Bear-baiting*, but in Beverley bears are seen in a number of variations (Pl. 23). In Beverley Minster, the emphasis on details is even greater, e.g. in the *Elephant and castle*, the elephants are of the same type but there a little monkey drives it on. Many agricultural activities are depicted, and there are more episodes to one theme, e.g. not just the *Fox chase* but also the *Fox preaching* and the *Fox hanged* (Pls. 159, 163, 167).

In surveying the misericords in the North of England from the end of the fifteenth and the beginning of the sixteenth centuries similarities can be found, and models which began their lives in Ripon are shared with Manchester Cathedral and Beverley Minster, which will be discussed more fully in Chapter 2. The Ripon misericords are the first to make use of German prints as patterns, which means that the same iconography occurring in different places no longer pre-supposes a direct influence. Closest to Ripon stylistically are the misericords in Durham Castle Chapel and Richmond, whereas Manchester Cathedral and Beverley Minster form a new group.

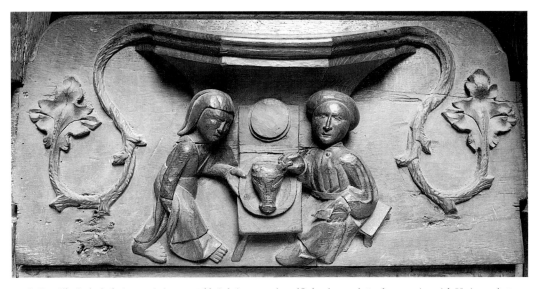

**83.** *St David's Cathedral. A man sitting at a table is being served a calf's head on a platter by a serving girl. He is comfortably seated, wearing slippers, while she approaches barefooted and in an apron; he grips the ear of the calf with one hand and has a knife (partly destroyed) in the other. The meaning of this scene is an enigma, but may have sexual connotations.*

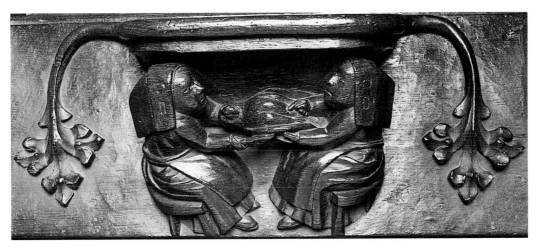

**84.** *Fairford, St Mary. Two women sitting on stools, facing each other with a large fowl between them; one points at the bird, the other has a knife ready. Are they about to pluck it? Is it a proverb? The women are dressed in the fashion of the beginning of the sixteenth century.*

An interesting close relationship traversing longer distances exists between the misericords of St David's Cathedral, of the 1490s, and Fairford, *c.* 1500. The foliage and people with rather round heads are of the same type, e.g. two men sitting on the ground eating in Fairford seem to be lifted from the *Boat-builders* in St David's, although the figures in Fairford are more robust and dressed in the fashion of the early sixteenth century (Pl. 264). A number of motifs are the same, such as a grotesque mask or an angel bearing a blank shield, and a man lying asleep, representing *Sloth* which is based on the same pattern, only adding a table and a dish in Fairford. Also closely related because of the arrangement of the composition and the unusual subject matter which may refer to a proverb are the scenes of two *Women plucking a fowl* in Fairford and a *Man and woman with a calf's head* on a platter between them with the man pulling the calf's ear (Pls. 83, 84). There is a kinship in the subject matter in that many of the scenes are of domestic occupations with a satirical or a moral input, for instance misogynistic depictions in Fairford of the women beating the men, and in St David's the fat *Bigorne* swallowing up another obedient husband (see Chapter 4, n.9).

Stylistically, the misericords in Fairford are later than in St David's but the iconographic patterns used in Fairford go back to the fourteenth century, since the *Woman beating the man* appears to be exactly the same as in Tewkesbury Abbey (Pls. 129, 130). It is possible that the carvers in St David's originally came from the Gloucestershire area, and returned there to carve the Fairford misericords.

As demonstrated by the examples given, a direct influence can often be perceived in choir-stalls of similar dates carved for the more important foundations, whereas the smaller parishes must have employed, according to their financial means, their local, less expert carvers, who may have been sent to look at neighbouring centres but retained their individual styles. The overall picture given is not so much of regional groups, as of important centres radiating influence, often over long distances and periods, with a gradual deterioration before new ideas are born and disseminated.

**85**. *Pepysian model book, Cambridge, Magdalene College, Pepys MS. 1916, fol. 19v, c. 1380. A sheet with drawings of animals from the Bestiary, both natural and exotic, as well as episodes from Reynard the fox, and human figures in different poses, to be used as patterns. Drawings like these would have been an essential part of every workshop.*

# 2

# Misericords and their Models

ALTHOUGH THE ENORMOUS number and variety of compositions on misericords is most impressive, the carvers did not usually invent these but used patterns from which to copy or on which to base their representations. This fact can be more easily proven after the introduction of printing, when woodcuts and engravings are now known to have been the sources for misericords. Thus, if prints were used as patterns from the second half of the fifteenth century, why not manuscripts for the earlier periods? It is impossible to prove the direct relationship between a specific manuscript and a set of misericords, but there are many illustrated manuscripts which just precede or are contemporary that point to a stylistic relationship, and raise the possibility of a carver having had access to a specific manuscript.

From the very outset, the shape of a misericord with its bracket, when turned on its side, can be compared with the initial of a manuscript.[1] A good example is the thirteenth-century misericord in Christchurch Priory, (Pl. 35) with its pattern closely related to an initial 'C' in the Bury Bible.[2] Animal masks sprouting foliage, as in Exeter Cathedral, can be traced back to Anglo-Saxon manuscripts, e.g. the letter 'B' in the tenth century Ramsey Psalter (BL Harley MS 2904, f. 4).[3] In Winchester Cathedral, some of the supporters can be likened to historiated initials in manuscripts; the little men cutting branches, in particular, have parallels in figures similarly occupied in the illustration for March in a twelfth-century manuscript (BL MS Cotton Vitellius CXII, f. 121v). Examples in manuscripts can be quoted as sources for many of the motifs on misericords, and although we do not know to what extent carvers turned directly to manuscripts for their inspiration, they must have known some of the illustrated bestiaries for this popular subject matter. Most illustrated English bestiaries are from the thirteenth century and they provided the basic patterns for many years. For example, a *Female centaur with her right arm raised after shooting an arrow from her bow* is found on a misericord in Exeter Cathedral and in a thirteenth-century manuscript (BM MS Sloane 278, f. 47); the *Bird harpies* in Exeter Cathedral also have analogies in bestiaries. The *Fox feigning death* and the *Hunter deceiving a tigress with a mirror after stealing her cub* in Chester Cathedral are rare depictions of this subject matter and must have been taken from a Bestiary such as Oxford, Bodleian Library, MS Ashmole 1511, ff. 23 and 12 (Pls , 203, 213); the *Hyena devouring a corpse* on a misericord in Carlisle Cathedral is also found in this manuscript on f. 22 (Pl. 86).

The mid thirteenth-century Rutland Psalter (BL MS Add. 62925) is the first to have fully-developed marginal illuminations which supply comparative material to much later misericords. It is, however, early fourteenth-century East Anglian

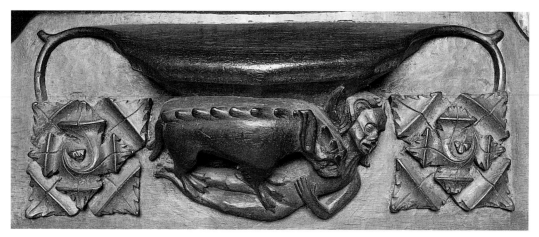

**86**. *Carlisle Cathedral. A hyena killing, or devouring a man. The moral, as given in the Bestiary, is a warning against a corrupt life on which the devil will feast. This scene can be found in illuminated bestiaries of the thirteenth century, when they were very popular in England.*

manuscripts with their well-developed illuminated borders alive with naked climbing figures, musicians, half-human, half-animal creatures and monsters, that can be most closely related to misericords. The same playfulness pervades the drolleries in the margins of these manuscripts and the carvings on the misericords. The Ely Cathedral misericords, especially, because of the extension of their narrative into the supporters, can be compared with marginal illuminations. Thus the left supporter of the *Fox chase* which shows the *Fox preaching* is the same as in the Gorleston Psalter (BL MS Add. 49622, f. 128; Pls. 2, 7, 87). Furthermore, there are connections with the Smithfield Decretals (BL MS Royal 10 E.IV), a law book written in Italy but illuminated in England in the second quarter of the fourteenth century, and the Taymouth Hours (BL MS Yates Thompson 13), *c*. 1325. There is the same attempt in misericords and the Smithfield Decretals at rendering perspective, and popular scenes such as *Samson and the lion* and the *Fox chase* are similarly depicted. Two partly damaged misericords at Ely can even be reconstructed with the help of the Smithfield Decretals: St Eustace kneeling before the stag with the Crucifix in its antlers (f. 230) and St Eustace's children being carried off by a lion and a wolf, while he is trying to ferry them across water (ff. 232v and 233). Although this episode from the life of St Eustace was known, extant illustrations of it from this period are very rare. Therefore, while many comparisons between manuscripts and misericords are of a general nature, this scene could point to a closer connection. General analogies between the Ely misericords and the Taymouth Hours concern *Samson and the lion*, a *Man falling off his horse*, *Archers* and *Grotesques*. Of the Old Testament scenes, the *Temptation* is almost identical, (f. 20v), except that Adam

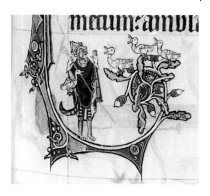

**87**. *Gorleston Psalter, London, BL, Add. MS. 49622, f. 128.*
*A fox preaching. This scene of a fox dressed as a Bishop preaching can be compared with the left supporter of the Fox chase in Ely Cathedral, Pl. 7.*

and Eve have exchanged places on either side of the tree; but the gestures have been retained, so that Adam on the misericord has Eve's gestures of the manuscript, and Eve those of Adam. In both cases, the serpent has a young woman's head and the tree has triangular leaves with apples balanced on them. One of the scenes carved with great attention to detailed narrative in Ely Cathedral is the *Dance of Salome* and the subsequent *Beheading of St John the Baptist* (Pls. 88–9186,) to which, once more, the Taymouth Hours offer a close comparison (ff. 106v, 107 and 107v). The manuscripts may have been produced in London, so that with the presence of William Hurley, the master-carver to Edward III, documented in Ely five times between 1334 and 1350, contact with London would have been opened up and new ideas could have been transmitted from recent manuscripts into the designs of the Ely misericords.

Some of the misericords in Lincoln Cathedral showing agricultural scenes can be used to demonstrate the difficulties in trying to adapt elaborate scenes, possibly gleaned from manuscripts, into the space of a misericord. The Luttrell Psalter (BL MS Add. 42130), illuminated for Sir Geoffrey Louterell of Irnham in Lincolnshire, 1335–40, provides a good example. In Lincoln, two men plough the field with the help of two oxen and two horses (Pl. 257). In the Luttrell Psalter there are four oxen

88–91 *(above). Ely Cathedral. The beheading of St John the Baptist. The story moves from left to right, starting with the Dance of Salome before Herod, her mother Herodias and another guest at a banquet; she is accompanied by a harpist, and somersaults in medieval fashion. After her dance, she is allowed a wish, whereupon she asks for the head of St John who is in prison. In the centre, he is being pulled out of the prison tower and Salome is ready to receive his head in a bowl. In the right supporter, she then presents the Baptist's head to her mother. These scenes are so close to those in Pls. 89–91 that the carver must have seen that manuscript or one very close to it which served as model to both carver and illuminator.*
89. *The Taymouth Hours, BL MS. Yates Thompson 13, ff.. 106v, 107, 107v; Pl. 89–91. Salome dancing, below left. Dancing includes tumbling and there is a company of three sitting at the table; here there is no musician.*
90 *(below, centre). The beheading of St John the Baptist. In the manuscript there is room for Salome to stand, whereas in the carving, the drama is made more vivid with Salome kneeling to receive the Baptist's head.*
91 *(below, right). Salome presents the Baptist's head to her mother. The scene is more crowded on the misericord where Salome goes down on her knees, as is proper for a presentation scene.*

on f. 170, and one man handles the plough while the other directs the animals. In order to include all these participants on the misericord the carver had to make both humans and animals move in a circle. The space is even more restricted in the supporters, where in the right-hand one, two sacks of corn and a man sowing are depicted. Similarly a man is sowing seeds on f. 170v of the Psalter and a sack of corn stands by his side. In the left supporter the earth is being turned by a harrow pulled by a horse, and this has its parallel on f. 171 of the manuscript where, however, there was enough space to include a youth slinging stones. In Lincoln, this youth has been moved to the supporter of the misericord of the *Youth riding a goose*, where sacks of corn are added as a reminder of the sowing season. Other scenes, such as the *Annunciation* or Christ being shown in contemporary pilgrim's dress after the Resurrection, can be compared with the Luttrell Psalter (Pl. 179). For *Romance scenes*, the Lincoln carver probably found patterns in contemporary tapestries and embroideries which were the popular medium for this subject matter e.g. an embroidered tablecloth in Erfurt Cathedral and a tapestry in the Victoria and Albert Museum, both German, *c.* 1370. Apart from narrative scenes, the margins of the Luttrell Psalter are strewn with monstrous creatures, of the type used on many misericords.

The Worcester misericords, exceptional for their *Old Testament* scenes, had their sources in twelfth-century designs such as the wall-paintings that once existed in the Chapter House at Worcester which were in medallions underneath small Norman windows, two to each bay.[4] Close comparisons can be found in the late thirteenth-century Eton College Apocalypse (MS 177) and the Peterborough Psalter of *c.* 1300 (Brussels, Bibl. Royale MS 9961). The Eton College manuscript is an Apocalypse with twelve full-page compositions inserted by a thirteenth-century hand of which ten are thematically the same as the Worcester misericords.

The comparisons between the misericords and the Eton manuscript (f. 4) are especially close in the *Circumcision of Isaac* (Pls. 92, 93). The *Presentation of Samuel* (f. 3v) can also be compared, but in the manuscript, Samuel's mother does not carry a flagon and there is no candle standing on, nor lamp hanging over the altar (Pls. 94–95). The other Old Testament scenes also show similarity, but there are some differences: for instance in the *Sacrifice of Isaac*, Abraham is more frontal in the misericord and only the hand of the angel taking hold of the sword is visible. In the scene of the *Brazen serpent*, powerful, dragon-headed snakes slither over each other in the supporters, while in the centre, the serpent with dragon's head and bird's body stands on a pedestal, surrounded by Moses with the Tablets of the Law and two companions.

The Peterborough Psalter had its types and anti-types arranged four to a page with verses underneath which are identical with those in Gunton's *History of Peterborough Cathedral* of 1686. These describe the remaining paintings on the back of the choir-stalls of *c.* 1160. The illuminator of the Psalter may therefore have copied the choir-stall paintings.[5] Again, there are many points of comparison between the manuscript and the Worcester misericords, and the scene of *Isaac bearing the faggots* is closer to this Psalter than to the Eton manuscript, because Isaac

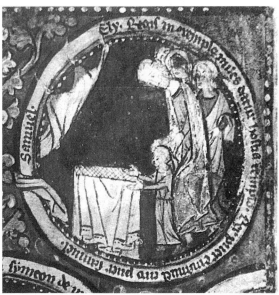

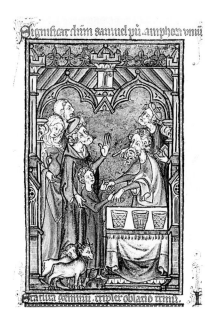

92–96 (top left). Worcester Cathedral. The circumcision of Isaac from the Old Testament (Gen. 21), a scene rarely depicted. Even more unusual is the child turning back towards his mother's breast, while standing on the altar; the priest, whose horns identify him as Moses, is about to carry out the circumcision. The Old Testament scenes in the Worcester misericords of the 1390s, have parallels in thirteenth-century manuscripts, such as Eton MS. 177, Pls. 93 and 95, and the Peterborough Psalter, Pl. 96. Iconographically, they are seen as typological precursors to the New Testament.

93. Eton MS.177, fol 4. Circumcision of Isaac. Compare this with Pl. 92; the difference in the dates of the works can be seen in the changes of the styles of dress of the figures.

94 (centre left). Worcester Cathedral. Presentation of Samuel in the Temple (I Samuel 1:24–28). The Temple is characterized by the altar with a candle and a suspended oil lamp, and Samuel's mother carries a flagon.

95 (centre right). Eton MS.177, fol. 3v. Presentation of Samuel in the Temple. Here, a drawn-back curtain reveals the Temple, but there are neither candle nor lamp by the altar, and Samuel's mother, squeezed into the corner, does not carry a flagon.

96 (right). Peterborough Psalter, Brussels, Bib Royale, MS. 9961, fol. 12v. Presentation of Samuel in the Temple. Here, as on the Worcester misericord, Samuel's mother carries a flagon, but two oxen have been added as offerings, and Samuel is being received by priests from the other side of the altar.

carries a bundle of faggots diagonally crossed over one another and Abraham holds a torch. Also, Samuel's mother in the *Presentation of Samuel* carries a flagon (Pl. 96). By the late fourteenth century, when the Worcester misericords were being carved, the typological iconography was widespread, yet the carver based himself on the iconography of the twelfth and thirteenth centuries, for such scenes as those of *Isaac*, the *Presentation of Samuel* and the *Brazen serpent* were very rarely found in the fourteenth century.[6] The iconography of the *Temptation* too is based on twelfth and thirteenth-century prototypes, for instance, Eve taking the apple out of the mouth of the devil and handing it to Adam, as shown in the St Albans Psalter, 1114–46 (Hildesheim, St Godehard, f. 17), or in another English psalter from the thirteenth century (BL Add. MS 38116, f. 9). Even the face of the devil, rather dragon-like with long ears, can be compared with the same in the latter manuscript which has further analogies with the Worcester misericords in having the *Expulsion* next to the *Temptation* and only separated from it by a pillar, and also *Eve spinning and Adam digging* beneath the scene of the *Temptation*. That supports the interpretation of the misericord depicting a woman spinning and a man digging as Adam and Eve rather than as one of the *Labours of the months*. These are only a few of the specific similarities between misericords and manuscripts. East Anglian manuscripts of the early fourteenth century in particular furnish a wealth of analogies. Many of the comparisons, of course, centre on the seemingly humorous depictions, the drolleries scattered inconsistently over the margins of manuscripts and misericords. But only the more sophisticated carvers working on important stalls would have been able to draw on manuscript illuminations directly, whereas many of the designs probably travelled via sketchbooks and sketches made individually of other examples of misericords or architectural sculptures seen in the vicinity. The Pepysian model-book of *c*. 1370–90 (Cambridge, Magdalene College, MS Pepys 1916) made in England, contains painted, shaded and outline drawings mainly of single figures and of animals and birds. Although some of the birds look like nature studies, their outlines are clear enough for easy copying.[7] One of its pages (f. 19v) has outline drawings of animals copied both from bestiaries and from nature: the fox escaping with its prey, the ape, the elephant and fighting figures (Pl. 85), all of which have an equivalent on misericords, and the standing figures enveloped in abundant drapery of *c*. 1400 (f. 4v) can be compared with the prophets on the Worcester misericords.

The Pepysian model-book is a unique English survival but there must have been others now lost. The end of the fourteenth and beginning of the fifteenth centuries was a period of travelling and exchange, and a number of sketchbooks survive to testify to the transmission of ideas by these means. Thus, similarities can be seen between the nature studies in the Pepysian model-book and in Giovanni de' Grassi's sketchbook (Bergamo, Bibl. Comunale MS VII. 14), *c*. 1380.[8] That these sketchbooks lived on in the woodcuts and engravings of the second half of the fifteenth century is proven by the *Letters of the alphabet* in Giovanni de' Grassi's sketchbook, many of which were copied by Master E. S. in his engraved *Letters of the Alphabet*, *c*. 1466–67. These images include Wild Men combatting with lances,

shields and clubs forming the letter 'K', which can be compared with Wild Men on misericords considered below (p. 145).[9] The work of Master E. S. was subsequently copied by later engravers, thus ensuring the continuity of many patterns. With the advent of printing, artists, including misericord carvers, were able to avail themselves of this new medium, through which patterns could be disseminated much more quickly because of the large number of reproductions and the comparatively low cost of woodcuts. The early production of engravings was concentrated in Germany, where the technique had developed in goldsmiths' workshops, from making trial impressions. One of the earliest masters was the Master of the Playing Cards, *c.* 1450, named after his suits of playing cards of Wild Men, Birds, Quadrupeds—such as stags and bears—and Plants. Only cards specially prepared and with backing cards would have been used as real playing cards, whereas most of the extant prints are transparent and were intended as patterns, as testified by their appearance in the margins of manuscripts, on carvings and in other engravings. The stag scratching its nose with its hind leg, in the right supporter of the *Stag hunt* and a bird that scratches its head, in the right supporter of the *Hawk flying after the bat* in Beverley Minster and Godmanchester, are closely modelled on the same images on two playing cards, and many of the flowers, too, derive from the same source.[10] Playing cards remained a source of inspiration providing patterns of animals, birds, plants, wild men, helms and coats of arms, and although the two sets produced by the Master E. S. do not survive as complete, they can be reconstructed through copies by Israhel van Meckenem.[11] In the sixteenth century playing cards developed narrative scenes, and artists like Erhard Schön, *c.* 1528, and Peter Flötner, *c.* 1538–40, created playing cards with extremely bawdy subject matter of the scatological type.

The earliest set of misericords to copy Continental engravings is at Ripon Cathedral, and they illustrate the speed with which new patterns could be disseminated.[12] The most striking example is the very exact copy of an engraving by the Master bxg showing a woman wheeled in a very distinctive three-wheeled barrow (Pls. 17, 22). The prints by Master bxg were extremely popular and copied in different media over wide areas. An engraving by the same master of a *Woman carted off in a wicker basket*, shows a man heaving the rope over his shoulder; he may have been the model for a bear shown transported in this manner in Beverley.

The *Biblia Pauperum*, one of the most popular wood-block books provided patterns for many religious scenes, above all, for those from the Old Testament. Four scenes in Ripon Cathedral have been copied from it: *Samson carrying the gates of Gaza*, *Jonah cast into the sea*, *Jonah cast up by the whale* and *Caleb and Joshua carrying the grapes from the Promised Land* (Pls. 97, 98). The figures, their movements and gestures, the whale and the boat are all extremely faithful to their model, and even the scroll which in the woodcuts emanates from the prophets unfolds behind and below Caleb and Joshua in Ripon (Pl. 178). In Manchester Cathedral and Beverley Minster only the representation of *Caleb and Joshua carrying the grapes from the Promised Land* occurs[13] and, typical of the Beverley master, a dog leading the way has been added.

**97, 98** (left). *Ripon Cathedral. Jonah cast overboard into the jaws of the whale. This was seen as an Old Testament parallel to the Entombment of Christ, for as Matthew writes (12:40), 'For as Jonah was three days and three nights in the belly of the whale, so shall the Son of Man be three days and three nights in the heart of the earth'. This scene, like others from the Old Testament, was copied from the 'Biblia Pauperum'. In the supporters, columbines seen from the side.*

**98** (right). *'Biblia Pauperum', wood-block. Jonah cast overboard into the jaws of the whale. As this print shows, it was faithfully copied by the Ripon carver, even as far as the detail of the ship's rigging and crow's nest.*

**99, 100** (above). *Manchester Cathedral. The Rabbits' revenge. This is a World upside-down situation: the hunter, characterised by his hunting horn, has been tied to a spit by the rabbits who are roasting him over the fire. The dogs are already in the cauldrons, and the one on the right is being seasoned by a rabbit.*

**100**, (below). *Israhel van Meckenem, (died 1503), engraving. The Rabbits' revenge. This engraving was faithfully copied by the Manchester carver, Pl. 99.*

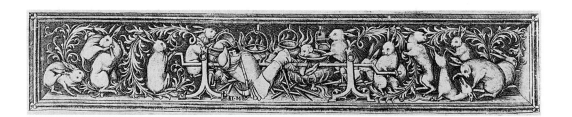

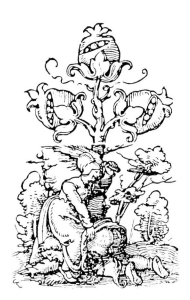
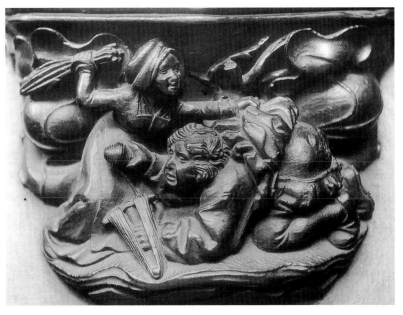

**101, 102** *(left). Erhard Schön (working after 1491–1542). Playing card, woodcut. Woman birching a man. As on the misericord, Pl. 102, the man is on the ground, his trousers down, his bottom exposed to birching. Both the artist and carver must have had a common model. Satirical prints on women were very popular at the beginning of the sixteenth century.*
**102** *(right). London, Westminster Abbey, King Henry VII's Chapel. Woman birching a man. The man is being subjugated by a woman by being stripped of his trousers and made to do the woman's work, in this case, winding wool. This role reversal is a typical World upside-down situation.*

Other Old Testament scenes based on the *Biblia Pauperum* are found on misericords in Henry VII's Chapel, Westminster Abbey, such as *David slaying Goliath*, greatly exaggerating the difference in size between David and Goliath.

Misericords of the first quarter of the sixteenth century, above all, show the direct influence of Continental prints, thus indicating that this new source of inspiration was being taken up by many carvers, in particular those working in centres on or close to trade routes—such as Manchester, Beverley, London and Bristol. The artists whose prints were most widely disseminated were Israhel van Meckenem from Westphalia (1440/50–1503) and Albrecht Dürer from Nuremberg (1471–1528). Israhel van Meckenem was also a prolific copyist of the work of his predecessors such as Master E. S., Martin Schongauer and Hans Holbein the Elder, so that their work can be reconstructed through his copies, and remained influential. The closest copy of an engraving by van Meckenem is the *Rabbits' revenge* in Manchester Cathedral (Pls. 99, 100). He also engraved four pairs of apes on one sheet, of which the *Family of apes* was copied in Henry VII's Chapel, Westminster Abbey. Meckenem's prints on the theme of the *Battle of the sexes* were popular; in one a woman violently beats a man with her distaff, while he has given up his trousers, and in another, the woman puts on the trousers while the man is made to wind wool. Two misericords in Westminster Abbey, *c.* 1520, are based on these, but the one where the woman beats the man's bare bottom with rushes must derive from the same model as Erhard Schön's Playing Card of *c.* 1528 (Pls. 101,102).[14] Many of the misericords in Westminster Abbey use prints as patterns, some by Albrecht Dürer, such as *Samson killing the lion* and the *Unequal couple,* where money is exchanged for sexual favours (Pl. 103).

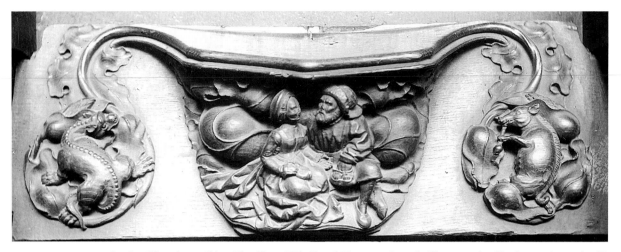

**103**. *London, Westminster Abbey, King Henry VII's Chapel. The unequal couple. The woman is selling her services to the old man; he is dipping his hand into his purse, she is holding her left hand out to receive the money, and holds her purse in her right hand to put it away. Her dress is low cut, exposing her breasts, and the man is putting his arm around her. This is another popular moralising image of the period, and was an exact copy of an engraving by Albrecht Dürer. In the right supporter, a pig, symbol of lust, plays them a tune, in the left one: a dragon, creature of hell, winds its way through foliage.*

The special interest of the misericords in Bristol Cathedral is that they are unique in depicting five scenes from the *Romance of Reynard the fox* of which the first translation into english was published by William Caxton in 1481 as *The history of Reynard the foxe* (for the iconography, see Chapter 8). However, this prose translation had no illustrations. The oldest extant illustrated English edition was printed in 1501–05 by Pynson, but only a fragment with one woodcut remains. It is likely that an earlier illustrated edition existed because fragments survive from the workshop of Wykyn de Worde that may go back to even older sources.[15] This makes it difficult to discover whether the visual sources of the Bristol carver were from English, Netherlandish or German editions. One of the episodes of the legend found on one of the misericords is that of *Bruin the bear caught in a cleft log* which is illustrated in the Low German edition *Reynke de Vos*, 1498, based on a Netherlandish source, and in a copy of originals by Wynkyn de Worde.[16] The Bristol misericord is closer to the Low German version than to the English one in the number of men attacking the bear, two from behind and one from the front, and in their gestures. The *incunabulum*, however, has no illustration of *Tibert the Cat attacking the priest and his household*, of which there are two versions in Bristol. The only comparable illustration is a woodcut that originates from the workshop of Wynkyn de Worde which shows the cat going for the priest's genitals as told in the story (Pls. 164, 166). Woodcut illustrations for the scene of *Reynard led to the gallows* are found in both the Low German and English editions, and the representation on the misericord is again slightly closer to the Low German version in the prominence of the royal lions and the placing of the cat on top of the gallows. That showing *Bruin the bear and Isengrin the wolf dancing with joy at the announcement of the fox's death* seems to be unique because the Anglo-Flemish accounts do not even mention it.[17] In this case, therefore, the carver may have based himself on a print of dancing animals and added the ape beating the drum. In depictions such as the one in the Bristol misericords, Reynard is hanged, whereas in the original narrative and also in the

woodcut illustrations, he is reprieved, promising to do penance as a pilgrim. A traditional pattern, therefore, must have been available to the carver.

Not only did the Bristol carver use prints for the *Romance of Reynard the fox* but also for many of the other scenes copying profusely from the margins of books printed in Paris by Thielmann Kerver, *c.* 1500, which must have reached Bristol via London. This, together with the predilection for nude figures, makes Bristol into a provincial centre of Renaissance ideals. A woodcut illustration from the margins of one of these books copied in reverse, shows three naked men chased by a dragon with a second face in its belly (Pls. 104, 105).[18] That the carver was not too familiar with Renaissance figures, however, is brought out by his inability to master their anatomy.[19] Further woodcuts were copied for three other misericords in Bristol: the *Mermaid between two devilish monsters, Two men running to attack each other* and an *Ape astride a mule, a sack for a saddle, followed by a nude man holding on to its tail and wielding a stick* (Pl. 106).[20] In the print the animal is an exotic quadruped and the man a hairy wild man. This representation is also found as a coloured drawing in an English pattern-book of *c.*1520–30 (Oxford, Bodleian Library, MS Ashmole 1504, f. 23v), where the animal has become a donkey, and the scene has been placed between an ape playing the drum and pipe, and a fox playing the bagpipes. Considering the date of this pattern-book, *c.* 1520–30, both the misericord, *c.* 1520, and the drawing were probably copied from a common model, and it is not certain

*104. Thielmann Kerver, woodcut from the bottom margin of a Book of Hours. A two faced dragon chasing three nude boys. This woodcut was the model used by the Bristol carver Pl. 105.*

*105. Bristol Cathedral. A two-faced dragon chasing three nude boys. The Bristol misericords illustrate the carvers' acquaintance with Renaissance prints, and, in particular, the woodcuts of Thielmann Kerver. Many of the supporters have heads or figures popping out of flower pods, here, a face licking its nose, on the left, and an ape playing the lute on the right.*

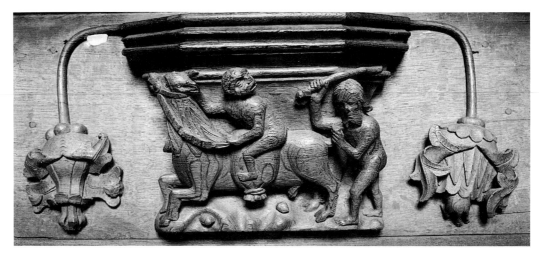

**106**. *Bristol Cathedral. An ape, riding on a horse using a sack for a saddle, is pursued by a nude man holding on to the horse's tail and swinging a club. The meaning of this scene is not clear; it too has been copied from a marginal print by Thielmann Kerver, where the animal is an exotic quadruped. The presence of the ape, prone to carnal passions, and the man in the nude and in close contact with the horse's tail, must indicate foolish, sinful behaviour.*

at what stage the strange beast was transformed into a more realistic animal. The pattern-book is known to have been partly copied from German engravings, e.g. Dürer and the Grotesque Alphabet of 1464, and as shown, must also have looked towards French sources. Thielmann Kerver himself re-used his woodcuts again and again in different books, indicating that patterns were distributed singly, rather than in book form. In Beverley Minster, too, one of the misericords has the scene of the *Ape astride a mule with a man following*; the designs of the *Dragon with a second head in its belly, in pursuit of nude figures*, and the *Ape on a beast, with a nude man behind holding on to its tail*, were faithfully copied from Thielmann Kerver's book onto two misericords in St Michael and All Angels, Throwley, Kent, retaining the wild beast (Pl. 107). Only slight variations occur: one nude boy, not three, is chased by the dragon, and the background flower with an enormous seedpod on the misericord of the *Nude man running after the ape on the beast* has become rather obtrusive, although it is a true copy.[21] All this illustrates the amount of copying practised at

**107**. *Throwley, St Michael and all Angels. An ape riding an exotic quadruped, followed by a nude man. Enough of this carving remains to see that the subject matter is similar to that in Bristol Cathedral, Pl. 106; this in fact is an exact copy of the Thielmann Kerver print, including the plant with seed pod in the background. The same carver also copied the Dragon with two faces pursuing three nude boys from Thielmann Kerver's print.*

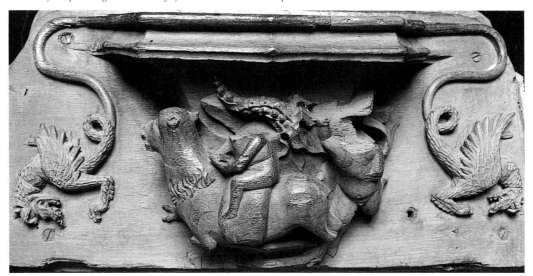

**108**. *Master P.W. (working late fifteenth and early sixteenth century). Round playing card with designs of Columbines from different viewpoints, made to be used as patterns by artists, see Manchester and Ripon Cathedrals, Pl. 97. He engraved five suits of Playing cards: Columbines, Roses, Pinks, Parrots and Hares.*

**109**. *Israhel van Meckenem. A sheet of ornamental flowers. These types of flowers were very popular c. 1500, and can be seen in the supporters of the Bristol and Manchester misericords, Pl. 106.*

this time, the changes made to the patterns and the many ways in which prints could be disseminated over wide areas.

The dissemination of patterns of animals, birds, tumblers and flowers was greatly accelerated by playing cards which were copied repeatedly. The so-called 'Master of the Power of Women' copied the playing cards of the 'Master of the Playing Cards', and 'Master PW of Cologne' made a series of round playing cards also based on the early models. The columbines and roses depicted from different angles, from the side and from the back, as seen on the misericords at Ripon, Manchester and Beverley Minster, were picked from such patterns (Pls. 97, 108). Artists like Master E. S., Martin Schongauer and Israhel van Meckenem engraved ornamental sheets of plants, of which those with bulbous leafy bodies and large seed heads like funnels about to spill their seeds became very popular at the beginning of the sixteenth century, and it is these that are found in profusion on the Bristol misericords (Pls. 106, 109). The prick-marks on the plants of the Bristol misericords are unusual and bring to mind the use of pricking; Hans Holbein the Younger, for instance, uses this method in his portrait drawings. Is this therefore another indication of copying by the carver?

By the beginning of the sixteenth century, the availability of printed books and single prints had greatly helped to augment the carvers' repertory. Not only were they now able to copy this visual material, but they could pick and choose required motifs and combine them to create new variations on a theme. Later, however, the misericords in King's College Chapel, Cambridge, 1533–38, already engulfed by the Reformation, appear to break with the traditionally bawdy and humorous narratives characteristic of marginal art, and an elegant, classically-inspired design is introduced based on ornamental, decorative patterns of great sophistication.

**110**. *Ely Cathedral. Detail of Pl. 116. Tutivillus stretching the scroll with his teeth.*

# 3

# The Clerics as Audience

CLOSED OFF FROM GENERAL VIEW, behind the choir screen, the stalls with their misericords were part of the furnishings of the choir, the most sacred space of the church, in close proximity to the altar and the Holy Sacrament. Yet not only was profane subject-matter the norm for misericords, but it could be shockingly obscene. Monsters, half-human, half-animal, have free rein, and many are the popular stories of the Fox, the Mermaid, the Woman, all behaving most foolishly and sinfully. These, however, are harmless compared with scatological themes that treat bare bottoms, defecating and farting. On misericords in All Souls College, Oxford, 1442 or St Mary's, Swine, we see a man with his face between his upturned legs and thus on top of his lower face, i.e. his bottom. In St George's Chapel, Windsor, 1477–83, monks bare their bottoms, evacuating demons (Pls. 111, 112). One of the reasons for such carvings being allowed in the sanctuary of the church is their position, low down in a marginal space below the 'bottom line': real bottoms—that part of the human anatomy associated with the deadliest of vices, the vilest of passions—are in contact with them. On a fourteenth-century misericord in Malvern Priory a man uses bellows to fan the flames of passion of an ape, representative of foolish man and the symbol of sensuality, and on a French one in St Pierre, Saumur, or on one of the fifteenth century in St Nicholas Church, Kalkar, on the Lower Rhine, a man puts his nose right up to the real posterior that will be resting on the bracket of the misericord.

In spite of the overall sacredness of the church choir, lower spaces were exempt from spiritual subject-matter, and the lower parts of walls surrounding the altar were often decorated with ornamental borders, curtains or secular scenes. A good example is in San Jacopo, Termena (Tramin), North Italy, where six evangelists are painted in the left apse, whereas below them in the base zone are monstrous, mythical creatures, half-human, half-animal. Similarly, at the other end of the scale, profane subject-matter was permitted in the heights of buildings: gargoyles, corbels and bosses, tantalizingly out of clear view, especially in High Gothic cathedrals. Gothic sculptures were carved with great attention to detail, even though this could not always be appreciated from a distance, as were the brackets of misericords, fulfilling the practical purpose of giving support to the cleric, and yet carved with decorations which might seem unnecessary. In the late Middle Ages, however, churches strove for overall decoration and the predominant style in the fourteenth century has been called 'decorated' for that reason. The smallest of churches represented the Kingdom of God on earth and the decoration was not only created for the eyes of man, but more for God whose gaze could penetrate all spaces.[1] Thus, if possible, no hard, bare surfaces were left uncovered, the minutest detail adding

111. *Windsor Castle, St George's Chapel. Monks, identifiable by their tonsures, expose their bare bottoms, out of which well faeces which turn into demon lions. One ape-like monk holds a turd in his hands as if it were a relic. Thus, the sinful, animal nature of the monks comes to light, and the demon in their bowels, their lust and lechery will out, and takes on animal form.*

112. *Swine, St Mary. Man with upturned legs, showing his cleavage.*

to the splendour and glory of the Church. Examples of very elaborate ornament are found in the Lady Chapel, Ely Cathedral, of the 1330s, and in the presbytery of Wells Cathedral, as well as on sculptures such as the Easter sepulchres at Hawton and Heckington, or the Percy tomb in Beverley Minster. The misericords in Ely Cathedral, 1339–41, followed the trend of the Lady Chapel in their experimentation with increased narrative and overall decoration (Pls. 7, 88). Indeed, misericords formed part of the whole decorative programme of the church; they surrounded the choir, like the margins of illuminated manuscripts that frame the page and the holy scene within it. Thus, all the arts complemented one another to form a unified vision, and all used common motifs.

Although placed in the restricted domain of the choir, it is likely that misericords were carved by craftsmen from outside the monastic community, their subject-matter reflecting the preoccupations of the lay community. This iconographic tradition, however, was not alien to the clergy, especially as monasteries had a large number of lay brothers who did much of the manual work and who were in contact with the outside world. There would have been a repertory of favourite subjects specific to the marginal arts acceptable to church and parishioners alike, and the carvers would have had a store of patterns to choose from. In the early fifteenth century, in places like Worcester Cathedral, and later at St Mary's, Ripple, in the early sixteenth century, where the programme of the carvings is very consistent in subject-matter, the choice was probably stipulated by the church patrons. The personal involvement of church patrons with the design of misericords becomes clear from the inclusion of coats of arms, found on many of the misericords in Norfolk. Punning heraldry too is popular, for example at Beverley Minster, 1520, where Chancellor Wight (weight *sic*!) has been immortalised by his shield with the text of his name and profession in the centre of the misericord, and in the left supporter by a man weighed down by the heavy scales he bears, hardly able to raise his foot from the ground. It is impossible to determine whether the abbot always had a say in the choice of the carvings he would sit on. Many seats have been moved around, and no specific iconography for abbots' seats can be established. The more appropriate, religious subjects found under former abbots' seats are the *Pelican in her piety* in Beverley Minster or the *Ascension of Christ* in Lincoln Cathedral. In Manchester Cathedral, the personality of Warden James Stanley (1485–1506), in whose period of office the stalls were constructed, are very much in evidence, as are his family connections. Both the stall end at the entrance of the choir and the Dean's misericord illustrate the *Lathom legend* which tells the legend of Sir Thomas Lathom, who as a baby, had been carried off by an eagle and taken to its nest, from which he was later rescued. His daughter Isabel married Sir John Stanley, who adopted the Lathom arms and crest and founded the branch of the family to which Warden Stanley belonged (Pl. 113). Other misericords refer to the Isle of Man, with its three-legged coat of arms. Such distinctive misericords would certainly have been carved according to the precise wishes of the patrons. Another imaginative example of this kind is to be found in Norwich Cathedral, where one of the misericords shows a monk reading a book inscribed above with R C for

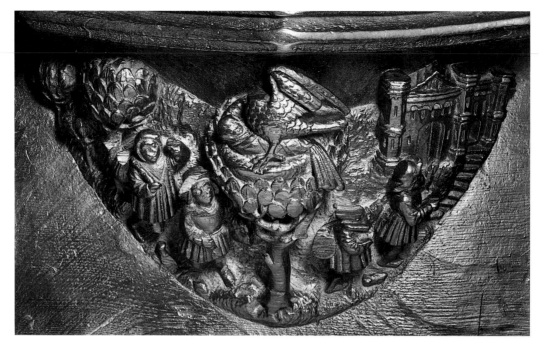

113. *Manchester Cathedral. The Lathom legend. The story depicted here tells of Sir Thomas Lathom who, as a baby in swaddling clothes, was abducted by an eagle who stands over him in its nest. However, men working in the woods (on the left), notice what had occurred, and (on the right) walk towards the castle gate to tell of their discovery .*

Richard Courtenay. In the left supporter, he is shown as Bishop of Norwich (1413–15) tending his sheep, and in the right supporter as Chancellor of Oxford (1411) feeding his scholars. The close association between carver and patron is especially sophisticated at St George's Chapel, Windsor, where the Sovereign's stall depicts the *Meeting of Edward IV and Louis X*, and where the seat is wider than usual (Pl. 42).[2]

It is documented that the prebendaries in Wells Cathedral were asked to pay for their stalls, and perhaps in that case, they were allowed to dictate the subject-matter or choose from the carvers' patterns. The request for payment, however, was a likely reason for the fact that many of the Wells misericords were left unfinished. Considering the enormous number of misericords with their large variety of subject-matter, the choice of carvings in general must have been left to the individual carvers, probably the master carver who had in his possession sheets of patterns.

Once the misericords were installed, how much interest did the clergy take in the subject-matter beneath them? That is to say, how closely did they relate to the scenes below their posteriors? After all, St Bernard of Clairvaux had been very worried about the contamination of his monks' spiritual life by the sculpted hybrid monsters encountered in the cloisters which are so much like the carvings on misericords. He called them 'ridiculous monsters, in that marvellous and deformed comeliness, that comely deformity', and asked: 'To what purpose are those unclean

apes, those fierce lions, those monstrous centaurs, those half-men, those striped tigers, those fighting knights, those hunters winding their horns?' He saw them as obstacles to meditation: 'In short, so many and so marvellous are the varieties of divers shapes on every hand, that we are more tempted to read, in the marble than in our books, and to spend the whole day in wondering at these things rather than in meditating the law of God.'[3] It must be remembered too, that in the Middle Ages, at a time when few people could read, the power of images was extremely strong, and much of the Church's teaching was transmitted through pictures. The choir with the main altar was a place for mystical visions, and among the most popular themes in the late Middle Ages was *Christ as the Man of Sorrows* or the *Mass of St Gregory*. In the midst of this often overwrought spirituality, the misericords, low down and lewd, must have provided an escape, as light relief. They gave comfort to the human body and were on the down-to-earth side of humanity, keeping the spiritual side in touch with its opposite, base side. Like the marginal drolleries of Books of Hours, which often act as a humorous comment on, or distraction from, the holy scene in the miniature, so the misericords can help to alleviate the seriousness of the Holy Offices. Did these apparently light-hearted scenes there-fore, common to misericords and the margins of manuscripts, have a message with special relevance for the clergy?

The huge cast of dragons, grotesques and hybrid monsters, half-human, half-animal represent the two sides of human nature, the animal with its undisciplined passions usually dominating the spiritual side. Thus, many carvings of this type were admonitions against the temptations of the flesh to which the clergy in particular were prone. Animals were also used to satirize the Church, as seen on a misericord in Worcester Cathedral. There, the right supporter of the misericord with *Three men mowing* shows the wolf in clerical robes performing a mock mass by placing its paws on a sheep's head on the altar (Pl. 247). A parallel to this can be found in the margin of a fourteenth-century English manuscript (Cambridge, Trinity College, MS B.11.22, f. 4) where an ape in bishop's cloak and mitre lifts the skull of a sheep as at the Elevation of the Host, assisted by a cat holding an aspergillum with which to bless the congregation with holy water. Another such satire on the corruption of the Church is found in St George's Chapel, Windsor, where the right supporter of the misericord with *Two dogs gnawing a bone* shows an ape wearing a stole and chained by the neck to a clog, blessing a cat before him. The fox, above all, personified the preacher as a cunning hypocrite catching souls, not for Christ but for the devil. A misericord in Beverley Minster is a good example (Pls. 159, 163). In Ludlow, a misericord shows the fox wearing a bishop's mitre while preaching to the geese from a pulpit. The fox in disguise is the image most frequently used on misericords to mock the clergy, in particular the mendicant friars. The friars would gain the ears and souls of human beings with their persuasive patter, only to lead them to hell and damnation, for they had come to be known for their lechery and gluttony, rather than the chastity, poverty and humility required of them by their Orders (Pl. 213; see Chapter 8 for the icono-graphy of the fox). It is interesting to note that the remaining sets of early miseri-

cords, e.g. in Exeter Cathedral, are from the same period as the rise of the Mendicant Orders, who went out to preach in the vernacular, and drew on literary sources and popular traditions for their sermons which were still written in Latin. They attacked all injustices and satirized human vanity of all classes; they even re-proached senior clergy such as the bishops for their sins, and as early as the thirteenth century, the *Speculum Historiale* of Vincent of Beauvais mentions the Pope-ass in connection with the bestial life of Pope Benedict IX. The itinerant friars, however, came to be despised for their lack of moral constancy, and they were pictured as fawning on the rich rather than admonishing them for their loose living. Chaucer gives a most damning description of the Friar and the Pardoner as unscrupulous in extracting money and gifts from the credulous poor by their eloquence; the same view is expressed on the misericords, showing the deceitful fox preaching to the geese, or, as on a misericord in Chester Cathedral, corrupting a nun at a clandestine meeting.

Women were a great temptation to the monks, with their vows of celibacy, and many are the sermons that tell of the immoral relationships of the clergy.[4] Misogyny was widespread in the Middle Ages and men liked to hear preachers attacking women for their 'horns', (as in the Ludlow misericord, Pl. 193), their long-flowing trains, their pride and their passion. Women were known as gossips and they would even interrupt sermons, a case in point being a high-ranking lady in the thirteenth century who had invited a Dominican friar expressly to preach in her chapel against the sin of her sex and then continually interrupted him![5] The many misericords of Woman as virago may reflect the clergy's special love/hate relation-ship with women because of the threat to their celibacy. However, the theme may also have been acknowledged with humour, for the relationship between men and women was a traditional type of humorous story in art and sermons. The fact that the clergy could take satire with good humour is demonstrated by an early sixteenth-century drawing by Hans Baldung Grien, which shows a lurid, lascivious scene of three naked witches sent as a New Year's greeting to a cleric. Certainly, although secluded behind the choir screen, the clergy, like the hermits in the desert, were not safe from the temptations of the world. Everywhere, the devil might be lurking, and having chosen a life of chastity, poverty and humility, it was only too easy to stray from that path. A misericord in St George's Chapel, Windsor, portrays *Three monks wheeled straight into the mouth of hell* in a wheelbarrow pushed along by a demon and steered by the fox (Pl. 114). Two misericords in Henry VII's Chapel, Westminster Abbey, show a monk first being attacked by a winged devil (Pl. 115) and then carried piggy-back to Hell, while a woman, with whom the monk probably had illicit dealings, is waving her arms about in the left supporter.

Active among the choir-stalls was the devil *Tutivillus*, frequently found carved on misericords as most attentive to the words of the clergy or the talk of the parishioners. His mission was to catch the misspoken or slurred words of priests trying to get through mass too quickly, or the idle chatter of the parishioners during mass. Tutivillus would record the gossip on scrolls and present it to God as evidence against the person's soul on the Day of Judgement. Jacques de Vitry is the

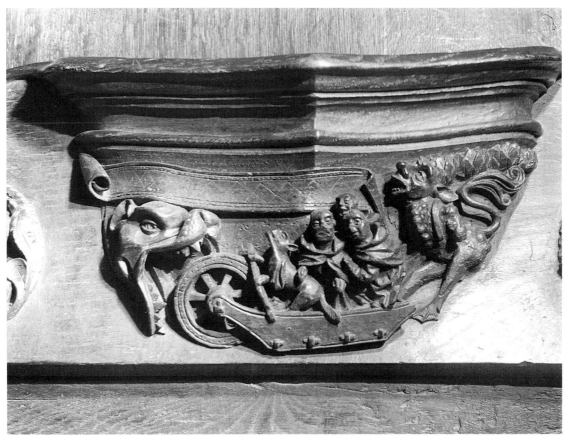

114. *Windsor Castle, St George's Chapel. Three monks wheeled into the mouth of hell. The wheelbarrow is pushed by a monstrous devil and is steered by the cunning fox, with whom the monks are identified. A number of misericords in St George's Chapel show a wicked delight in satirizing the clergy.*

115. *London, Westminster Abbey, King Henry VII's Chapel. In the centre, a monk attacked by a winged devil, while in the left supporter, an ape gleefully beats a drum, and in the right supporter, two cocks fight. The monk too was probably given to the temptation of money, because a money bag is visible by his left arm .*

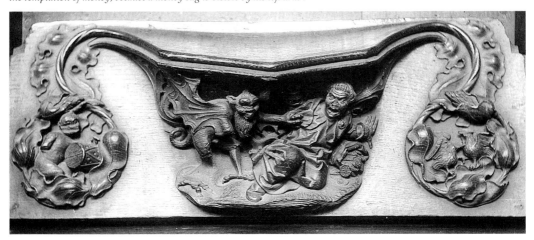

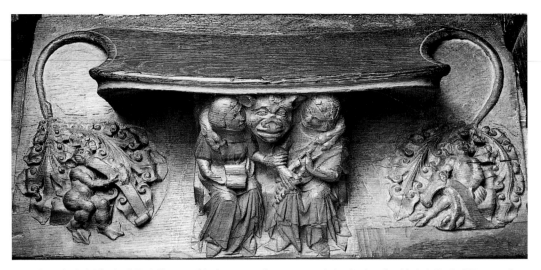

**116**. *Ely Cathedral. The devil Tutivillus puts his claws around two women sitting in church with their Book of Hours and rosary. However, they are not attending to their prayers, and in the right supporter, Tutivillus writes down their gossip on a parchment scroll; in the left supporter, as the scroll is not long enough to contain it all, he has to stretch it with his teeth (Pl. 110). On the Day of Judgement, the women's sins will be presented to God and they will be damned. See, Pl. 14 for another example of this subject.*

oldest source for Tutivillus and sermon compilers in England are known to have drawn on his sermons.[6] He also mentions the fact that the devil's parchment was not long enough to contain all the words recorded, so that he had to stretch it, as seen on a misericord in Ely Cathedral (Pl. 110, 116). Tutivillus' supremacy in the monks' choir is best represented in St Nicholas, Kalkar, 1505–8, where he reclines on top of a stall end, his inkstand at the ready, looking out for any monk who may be becoming inattentive or drowsy. The earliest example of Tutivillus overlooking the choir is in the Cathedral in Bonn, Germany, *c.* 1220–1225, where he sits on the back of a winged, mythical beast, at the entrance to the choir. He has a counterpart—an angel on the other side of the entrance, who observes the pious at prayer and takes down their thoughts. A drawing by Albrecht Dürer (Rennes Museum) gives a good insight into the activities of the devils and angels in the choir. The angels inspire the clergy with good thoughts; they hold crucifixes, and statues of the Virgin and Child up to them, whereas the devils produce nude women, tankards and all the worldly temptations. Jacques de Vitry does not mention women in his *exemplum*, but his cast of devil and priest was soon increased as in Robert of Brunne's *Handlyng Synne*, compiled in English in 1303, where the much-elaborated story does include women.[7] These are generally the victims of Tutivillus' temptations on English misericords, e.g. in the Foundation of St Katharine, Stepney, *c.* 1365, where the devil writes on tablets, or in New College Chapel, Oxford, and in St Mary's, Enville, where menacing devils look over the women's shoulders (Pl. 14). The most famous case of Tutivillus recording was that of the dishonest *Ale-wife* in Ludlow Parish Church which is unique among the surviving misericords and derives from the Last Judgement in the Chester Mystery Plays (Pl. 117).8 In the Chester cycle, the dishonest Ale-wife is the only soul left in Hell

after the *Harrowing of Hell* by Christ and the demon Secundus offers to marry her. The late fifteenth-century *Last Judgement* over the crossing arch in St Thomas', Salisbury, also has the *Ale-wife* standing next to a devil at the mouth of hell; the significance of this tale is noted by M. D. Anderson: 'To a preacher denouncing the results of drunkenness, an ale-wife was the mother of many sins and a dishonest one worthy even to be the bride of a demon'.[9] It is in the *Towneley Play* that Tutivillus tells us his name and is identified (line 212) as a 'courte rollar'. There too he is in charge of idle and wicked words generally and carries a sack of scrolls, i.e. sins. One of the devils, describing the evils of womankind, says that he bears more rolls than he is able to carry.

Thus, a strong connection between misericords and mystery plays emerges, for they all have their basis in *exempla* and medieval tracts. The character *Tutivillus* may be particular to the choir-stalls, but he addresses both the clergy and the parishioners, functioning on both sides of the screen. His power lies in being able to deceive and take people unawares. Women are selected as most prone to the temptations of the devil, their garrulousness stemming from Eve. Not only are they easily tempted by the devil, but they themselves represent the greatest temptation and distraction to the clergy behind the choir screen.

Devils and demons are also associated with excrement, farts and vile odours, and monks were often the butt of a crude sense of humour, involving bare bottoms and other scatological matter. Also, the arse with its orifice is the opposite of the face with its mouth and can express an even more potent form of derision than when pulling a face and sticking out a tongue at somebody. In St George's Chapel,

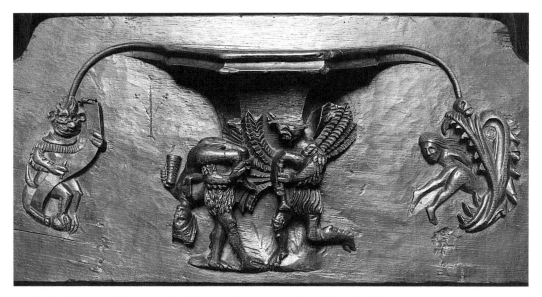

**117**. *Ludlow (Shrops.), St Lawrence. The dishonest Ale-wife carted off to hell by a devil. She is nude, apart from her horned head-dress. She is carried slung over the devil's shoulder and is welcomed to hell by another devil playing the bagpipes. The tankard, with which she used to give short-measure is still in her hand, and her nudity indicates the disreputable life in taverns which were equated with brothels. In the left supporter, the devil Tutivillus is writing down her sins, which will condemn her, and in the right supporter, she is cast into the jaw of Hell.*

Windsor, all the evil that may be inside a monk has been materialised into demonic forces (Pl. 111). Preachers often referred to excrement as an image of mortal sin,[10] and through sin, man defiles the sanctuary (soul) of his temple (body).[11] The very stench of hell was believed to be part of the everlasting punishment in hell fire.[12] People did believe in the reality of demons, and thus, the devil and demons on misericords must have had a powerful effect on the imagination of the clergy. The clergy were therefore surrounded by criticism and warnings in the form of misericords, for even the scatological carvings were didactic rather than comical; but they probably accepted the criticism, with good humour. The Church was able to recognize its failings and humanity, even its baseness as long as the institution of the Church was not being threatened. Many of the *Last Judgement* renderings show the Pope or members of the Church among the first to enter the Mouth of Hell or being carted off to Hell by demons. St Bernard, as already mentioned, had condemned the anthropomorphic and zoomorphic imagery of Romanesque sculpture so similar to that on misericords, as an obstacle to the monks' meditation on matters spiritual. Although his diatribe applies to an earlier period and to monks in cloisters specifically, it also illustrates the power of images, a power still alive during the centuries of misericord carvings. Laughter and fear are always closely related and the devil in particular was both feared and laughed at. On the whole, sinful human life was seen as an inversion of the world of God, and as absurd, and the misericords gave expression to this view. Did the monks laugh at the absurdity expressed in the misericords, at scenes such as the *Hare roasting the hunter* in Manchester Cathedral, the *Cat hanged by mice* in Malvern Priory, or the *Jester playing bagpipes on the cat* in St Botolph's, Boston (Pls. 99, 120, 153)? Surely, they must have laughed at the *Ale-wife carted off to hell by the devil* in Ludlow for getting her comeuppance having given short measure and led a dissolute life (Pl. 117). And if the Fox preaching to the geese stood specifically for the itinerant friar, then the monks and canons could well laugh with self-righteousness and point a finger at the wrong-doings of others.

Did the use of satire in ecclesiastical art first encourage pulpit satire or vice versa?[13] Certainly, misericords, sermons and the marginal arts had much in common, and it is thought that the far-ranging homogeneity of marginal subject-matter and the rapidity of its expansion may be ascribed in large part to a development in the history of preaching in the first half of the thirteenth century.[14] The drunken man, for example, frequently found on misericords, probably had his prototype in the satires of the pulpit.[15] As with Eyckian paintings which combine realism with symbolism and have many layers of meaning, misericords cannot always be clearly interpreted; they often remain ambiguous in their meanings, for instance the nude, winged figure rising out of a whelk shell and fighting a dragon, basically represents good fighting evil, but needs further explanation (Pl. 118). There is no accompanying text with misericords to help with interpretations, and scrolls as in St Mary's, Whalley, are rarely used (Pl. 122). The situation is similar with marginal illuminations, because although they surround text, the connection is seldom immediately clear. There were, however, iconographic conventions which people knew, just as

common symbols were understood, and anecdotes or *exempla* were common property. Due to the general illiteracy, story-telling and speaking aloud were of great importance, and monsters were created out of people's collective imagination, monsters that were both fearsome and comical. Everything was given deeper symbolic meaning and visual images could be meditated upon or enjoyed as pictorial puzzles. The misericords, as part of the moralizing imagery, expressed the Church's more human nature, parodying human foibles and folly, and serving the bodily needs of the clergy during long, tedious hours of prayer.

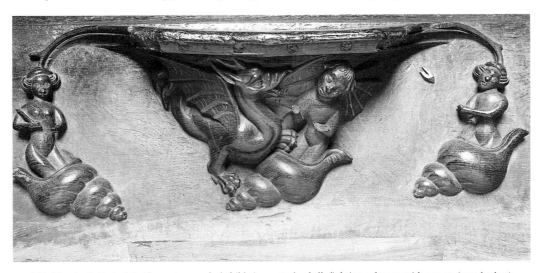

**118**. *Lincoln Cathedral. In the centre, a naked child rises out of a shell, fighting a dragon with a spear (now broken). Both supporters depict small naked figures emerging from shells. This scene is also found in Manchester Cathedral and Beverley Minster (where the central figure is dressed, and the subject matter may not have been understood). The meaning is probably the battle between Good and Evil, which starts from birth.*

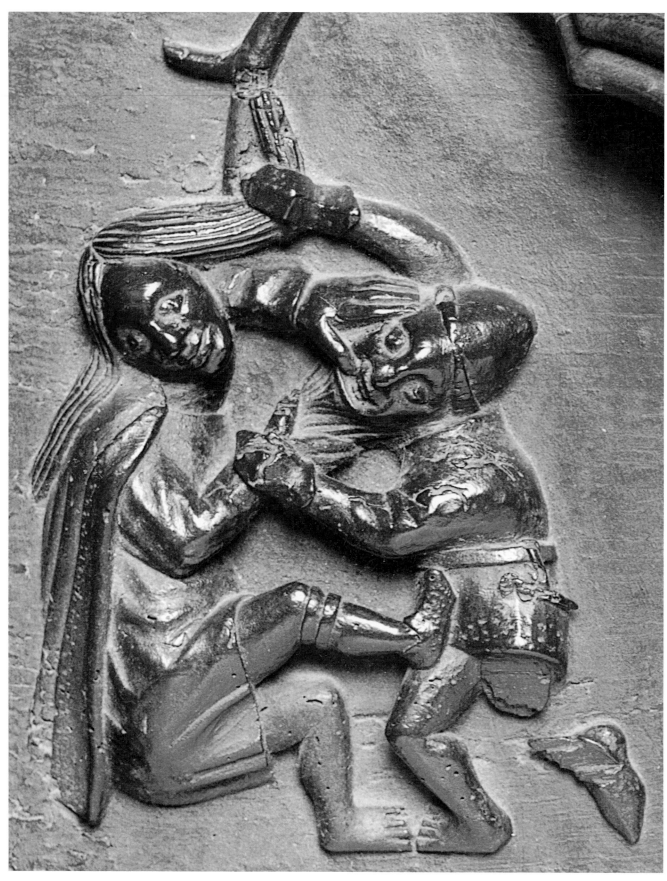

**119**. *Stratford-upon-Avon, Holy Trinity. Detail of Pl. 134, left supporter. Woman and soldier fighting.*

# 4

# The World Upside-down

MUCH OF THE HUMOUR on misericords is unleashed by behaviour that goes against the norm, by topsy-turvy situations which invert the natural state of affairs of the world and upset the divinely rational order. The theme goes back to Antiquity;[1] the early Christians saw the destruction of the rational order through the fall of Lucifer and Adam and Eve, resulting in sin and disorder. A moral ingredient is therefore added to the humour of the topsy-turvy situation. Proverbs too illustrate the world upside-down and have a moral message, often combining a play on words with comments on human foibles. In the painting *Proverbs* of 1565 (Berlin-Dahlem, Staatliche Museen), Pieter Bruegel the Elder depicted the symbol of the world turned on its head, with the cross pointing downwards, thus equating the world here with Folly. The foolish behaviour of human beings such as jesters brings the world upside-down into focus, whereas more clear-cut examples concern animals taking over the roles of human beings, as we have seen in Worcester Cathedral (Pl. 247), and in St George's Chapel, Windsor Castle, where a chained ape in a stole blesses a cat. This mockery of the Church seems quite outrageous, and illustrates to what extent licence was given to the carvers of the misericords. The hunter turned hunted is illustrated on a misericord in Manchester Cathedral, where *Hares roast a hunter* (Pl. 99). In spite of the ridiculous juxtaposition of hares and hunter, the detailed and deliberate actions of the hares here create a sense of fear that animals might take revenge on humans.[2] The animal world too can be turned upside-down, giving those that are usually the victims great power over their oppressors, as in Worcester Cathedral, Malvern Priory or St Stephen's, Sneinton, where the fox rides a hound (Pls. 120, 247). A typical example of the inverted world, still well known as a proverb, is *Putting the cart before the horse*, in Beverley Minster, *c.* 1520 (Pl. 121). The first English attestation of this proverb in literature is exactly contemporary:[3] 'that teycher setteth the cart before the horse that preferreth imitacyon before preceptes'.[4] This proverb is a genuine upside-down situation, where, as William Coupe says, the inversion is independent of the will of the individual concerned.[5] He distinguishes this from what he calls a perverted situation as the result of the will of the individual, thus making him a fool. The right supporter of the Beverley misericord depicts such a foolish situation, for although it looks as though a woman was milking a cow, there is no sign of an udder.[6] The woman is therefore trying to do the impossible, that is to say, *Milking a bull*, a 'world upside-down' motif that goes back to classical times. Another image of the world upside-down in depicting the foolishness of man is the *Shoeing of the goose* in Beverley (Pl. 163). That this represents a foolish, because useless, activity is made clear on a misericord of the same subject in St Mary's,

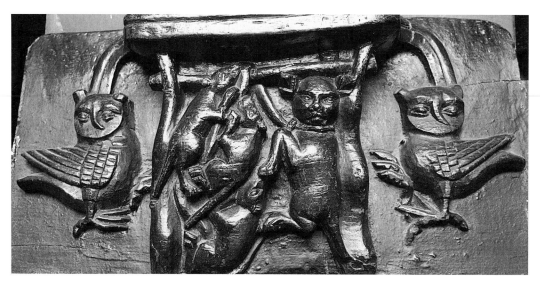

**120**. *Great Malvern Priory. A cat is hanged by mice. This again is a World upside-down situation where the victims are the victors. The owls in the supporters are creatures of the night and associated with the cat.*

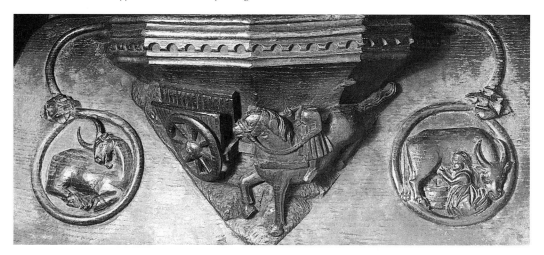

**121**. *Beverley Minster. In the centre, the proverb 'Putting the cart before the horse'. This is an example of the inversion of the natural, sensible, order. Yet another is shown in the right supporter where a woman is trying to milk an ox, which has no udder. In the left supporter, an ox is lying licking its back.*

**122**. *Whalley, St Mary. Here, the nonsensical attempt to shoe a goose is shown, with an accompanying inscription: 'Who so melles hy[m] of y al me[n] dos let hy[m] cu[m] heir and shoe ye ghos', meaning that meddling in other people's affairs never succeeds, in short: 'mind your own business'. Most interesting is the detailed depiction of a blacksmith's workshop, with the anvil, the bellows, and other tools.*

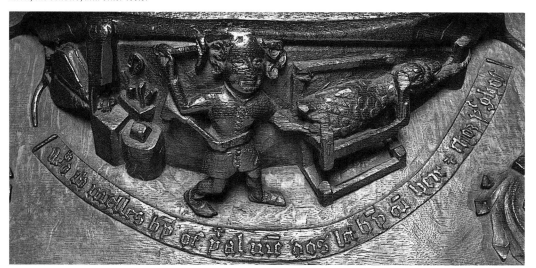

Whalley, which has an accompanying text (Pl. 122). The proverb 'he who sups with the devil needs a long spoon' is illustrated in St George's, Windsor. A horned and winged demon eats from a dish on a table, close to a cooking-pot, and sitting opposite him is an old man who ladles food out of a dish with a very long ladle and blesses it.

There is something wrong with the world too, if man behaves like a coward and runs away from animals like the hare. In Beverley Minster, in the left supporter of the misericord of the *Figure rising from a shell fighting two dragons*, a man stabs a snail with exaggerated force, while in the right supporter, a man puts his head into a sack. Here, the valour of the figure in the centre is mocked by the cowardice of the men in the supporters. The interesting motif of the snail here refers to the Lombards who became proverbially known as cowards, in remembrance of their flight before Charlemagne in 772.[7]

The misericords in Beverley Minster are noted for their fools making rude gestures; one such image illustrates a proverbial saying (Pl. 123).[8] The infectiousness of foolishness, often expressed by the mimicry of apes, can also be seen in the proverb *Two fools under one cap*, as in St Martin's, Worle (Pl. 124). These examples demonstrate that proverbs are an effective vehicle for the transmission of moral lessons in humorous garb, and they add to the satirical content of misericords at the turn of the fifteenth and sixteenth centuries.

A major theme of the topsy-turvy world is that of *The power of women*, where the roles of men and women are reversed and women wear the trousers. Women were divided into either good or bad, into those in the image of the Virgin or as descendants of Eve. Most women, and certainly those depicted on misericords, had the characteristics of Eve: rebellious, vain, lustful and gossiping. Preachers and moralists like Thomas Aquinas (1225/6–1274) explained women's irrational, emotional behaviour as a result of an excess of humidity in their bodies which made them damp, i.e. unsteady and changeable in mood, and therefore easily swayed by the devil. Certainly, the ideal of the Virgin was practically impossible to attain, and

**123**. *Beverley Minster. The bust of a jester who has one finger in the corner of his open mouth and the other on his left eyebrow. There are two geese in the supporters. This has been interpreted by Malcolm Jones as the saying: 'Shall I stand still, like a goose or a fool, with my finger in my mouth?'.*

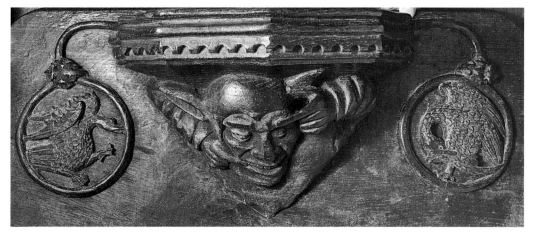

*124. Worle, St Martin. Two heads under one cowl which probably refers to 'Two fools under one cap'.*

the ordinary housewife portrayed on misericords is the undisciplined virago rather than the docile and humble Griselda. The dearth of good wives is expressed by the mythical monster *Bigorne* (Fillgut) growing fat on a large supply of good husbands, as in Carlisle and Worcester Cathedrals, whereas his counterpart *Chichefache* (Pinch Belly), feeding on obedient wives, is quite emaciated, and does not appear on misericords (Pl. 125).[9] Having been disobedient at the Temptation, Eve listened to the devil, and failed to recognise his deception; forever after woman, as Eve's descendant on earth, is tainted, remaining an easy target, in particular for the devil Tutivillus (Pls. 14, 116). As shown on misericords, the devil found a comfortable abode in women's horned head-dresses, inspiring them to sin: St Mary's, Minster-in-Thanet (Pl. 126). Above all, women were unruly and of violent temper; one of the most popular images on misericords is that of a *Woman beating a man*. Grabbing a man by his hair or beard, she belabours him with a washing beetle, ladle or distaff.

*125. Carlisle Cathedral. Bigorne swallowing a good husband. There are several examples of these on misericords, but none of its counterpart 'Chichefache' who lives on good wives, for there is a dearth of them.*

**126**. *Minster-in-Thanet, St Mary. In the centre, the bust of a woman wearing a large horned head-dress. This was considered the height of vanity and pride, and as the carving shows, the devil found a comfortable abode between the horns, and was thus able to inspire her with evil thoughts. The supporters show lion masks, frequently found on misericords.*

The distaff, tool and emblem of the housewife, thus becomes a weapon, and for a man to be pulled by his hair or beard, the symbol of his virility, meant the utmost humiliation and loss of honour. In Ely Cathedral a man tries to ward off the attack of a woman who scratches his face and bites his thumb (Pl. 127), and in St Botolph, Boston, the hunter's bow and arrow are of no use against the woman who has locked her hand into his jaws and swings her distaff over her shoulder. In Sherborne Abbey, the woman lords over the man, a motif already in evidence in *Phyllis riding Aristotle* (Pl. 128). No sign of the obedient housewife, referring in all things to her husband, on misericords! In many cases the washing-beetle is the weapon, as in Carlisle Cathedral, where the woman takes hold of the man by his beard, and in Lincoln and Chester Cathedrals, Tewkesbury Abbey and St Mary's, Fairford (Pls. 40, 129, 130). In Henry VII's Chapel, Westminster Abbey, two misericords show the

**127**. *Ely Cathedral. A man and woman fighting; the woman tries to scratch the man's face and bite his thumb. Lions in the supporters.*

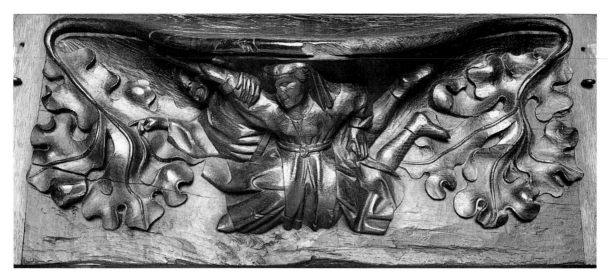

128. *Sherborne Abbey. A woman beating a man. She has flattened him, and seems to be sitting on him, which would associate the subject matter with Phyllis riding Aristotle. In that story even the scholarly, old Aristotle could not resist the temptations of a woman, and was made a fool of.*

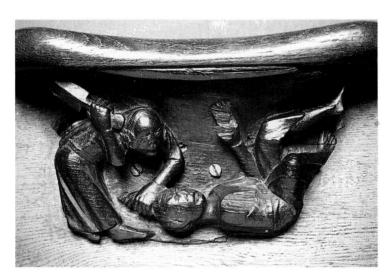

129. *Tewkesbury Abbey. A woman beating a man with a washing beetle. She has grabbed him by his hair and flung him to the ground. This very popular scene of the Power of woman is found in nearly every larger set of stalls in England.*

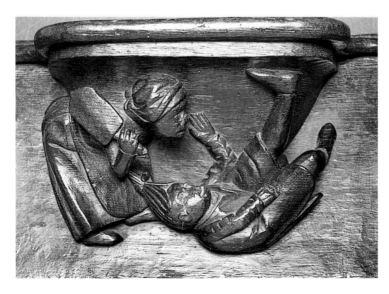

130. *Fairford, St Mary. A woman beating a man with a washing beetle. The same pattern as in Tewkesbury Abbey was used here, Pl. 129.*

*Battle of the sexes.* On one, the woman beats the man, who is already on the ground, with a large distaff, while jesters in the supporters grin and make rude gestures in mockery. On the other, the man on the ground has his bared bottom birched, while he holds a winding frame and spindle (Pl. 102). This comes closer to the *Battle for the breeches* often found on prints and misericords on the Continent, as already mentioned (see p. 15; Pls. 13, 101). The role reversal is more explicit in this case, for the man has been forced to do the woman's work, his trousers have been pulled down, and his submission is total. On English misericords, however, there is no actual fight for the breeches, and only the man using a woman's utensil, as above, or a spindle as in St Mary's, Nantwich, indicate the hen-pecked husband. Again, on English misericords marital discord tended to erupt in the kitchen over a cooking pot, as in Nantwich, where the kitchen is indicated by the woman using a ladle against the man, by a boar stealing a bird from a spit in the left supporter, and a dog with his head in the pot in the right supporter. In St Botolph, Boston, too, marital discord is imminent, although the couple appear to be sitting peacefully on either side of the cauldron hanging over the fire (Pl. 131). In Manchester Cathedral, Beverley Minster and Bristol Cathedral, domestic strife has already broken out over the cooking pot (Pl. 12). In Manchester the pot has been smashed and broth spills from it; in Beverley Minster the man has been caught by the hair, and a dog taking advantage of the situation is diving for food in the pot; in Bristol the man has been caught in the very act of taking food from the cauldron. The meaning is that the kitchen is the woman's domain, and men enter it at their own peril, especially if driven by their greed for food.

In the power struggle between men and women, the shoe played a major role. Putting one's foot on someone else's brings them under control and subjugates them, as in an engraving by Israhel van Meckenem of the *Battle for the breeches*, where the woman enforces her power over the man in this manner. That is probably the meaning of the misericord in St Mary's, Fairford, where the man crouching

**131**. *Boston, St Botolph. A man and a woman sitting on opposite sides of a cauldron suspended over a fire; he is holding the bellows, she a dish and a ladle; behind her stands a broomstick and her distaff. It is not certain whether this is going to be a peaceful meal or a fight. I incline to the latter, as the woman is lifting the ladle quite high and the man is already putting a hand to his head, also, the bellows are a symbol of fanning the passions; nor do the monstrous headed supporters auger well.*

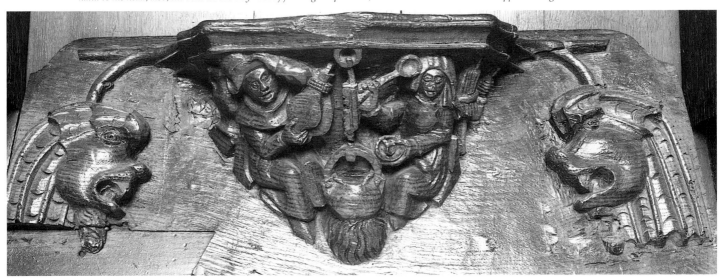

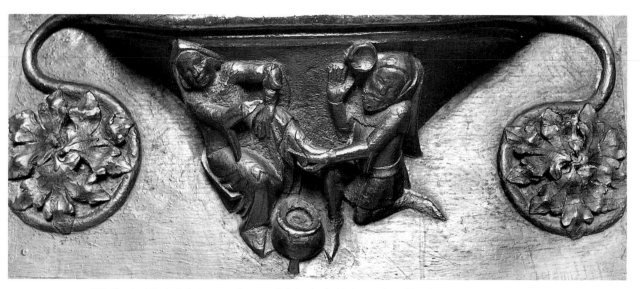

**132**. *Hereford Cathedral. A man and woman fighting in the kitchen, indicated by the cooking pot.*
*It looks as though the man was trying to unshoe the woman, i.e. to take advantage of her; she, however,*
*is fighting back and has already thrown a bowl at him.*

before a woman sitting above him on a stool and threatening with a ladle, seems to be doing homage to her by touching her outstretched shoe. The battle becomes fierce when the man tries to unshoe the woman as in Hereford Cathedral and Great Malvern Priory; she hits him with her distaff in the first example, and throws a dish at his head in the second (Pl. 132). The combat between the sexes could also be vividly satirised as a *Tournament*, as shown in Bristol Cathedral (Pl. 133).

The stereotyped, misogynistic image of women was the norm on misericords from the fourteenth century, but found its climax at the beginning of the sixteenth, in defamatory Humanist writings and satirical prints which were largely responsible for the dissemination of such images. An example is the *Woman transported in a wheelbarrow*, first found in Ripon Cathedral and then in Durham Castle Chapel

**133**. *Bristol Cathedral. The Battle of the sexes in the form of a tournament. The man charges on a sow with a, now broken staff, possibly originally a hay-fork, as a weapon, while the woman rides on a goose, armed with a broomstick (another one stands upright behind her). They are associated with the vices, because these traditionally ride on animals; the pig is a symbol of gluttony and lechery, and the goose stands for the female sex. The broomstick, like the distaff, is the housewife's tool and weapon and because of its roughness she is likened to it.*

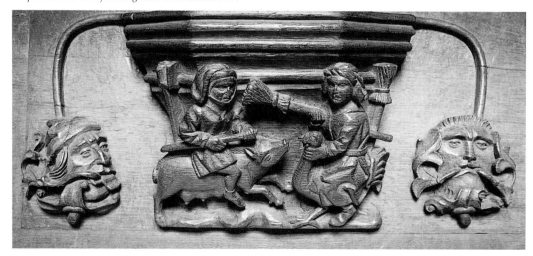

and Beverley Minster, ultimately based on an engraving by the German, 'Master bxg', active 1475–80 (Pls. 21, 22). Carrying a flask and a twig in Ripon and Durham, and hitting the man in Beverley, the woman is incapable of walking and has to be wheeled. The twig, which the woman uses in a belligerent manner in Durham Castle Chapel, is barren and associated with Carnival, and thus a symbol of foolishness.

The picture gained from misericords is one then of continual strife between men and women, where, the women were more often victorious. This seems to accord with Lawrence Stone's view of life in the Middle Ages, when he says: 'The extraordinary amount of casual inter-personal physical and verbal violence, as recorded in legal and other documents, shows that at all levels, men and women were extremely short-tempered. The most trivial disagreements tended to lead rapidly to blows and most people carried a potential weapon, if only a knife to cut their meat. The correspondence of the day is filled with accounts of brutal assaults at the dinner-table or in taverns, often leading to death... Quarrels, beatings and law-suits were the predominant pastimes of the village.'[10] However, in real life women probably suffered at the hands of the men, as husbands were legally allowed to beat their wives, in order to discipline them. They were at all times to keep a tight rein on their wives, and their greatest fear was to be humiliated by an adulterous wife. Women in general, and married women in particular, were viewed as potential sexual viragos, and even the most pious of them were thought to lust for power over men once they had experienced sexual intercourse.[11] In the supporters of a misericord in Stratford-upon-Avon a woman is seen both as aggressor and victim of a vicious beating (Pl. 134). Because marriages were based on economic considerations rather than love, there was always the danger of illicit relationships, and in art the theme of love for money is reflected in images of *Unequal couples*, in particular at the beginning of the sixteenth century, as in Henry VII's Chapel, Westminster Abbey, where the woman is selling her services to a lustful old man (Pl. 103). It was always woman who got the blame for man's

134. *Stratford-upon-Avon, Holy Trinity. In the centre, a man rides on a crowned beast, probably representing the vice of pride. In the left supporter, a woman kicks a soldier, while he grasps her wrist and long hair; in the right supporter, a nude woman, her bare bottom rearing up, is birched by a man who pins her head between his legs, while a dog has sunk its teeth into her legs. The whole misericord is probably a warning of the vices of pride, wrath and lechery, and the belief that one vice leads to another.*

**135**. *Bristol Cathedral. A woman leading apes into the jaws of hell. The apes she leads on a rope are her suitors, the fools. The woman who led an unchaste life on earth and is now being received by the devil personally, will be forced to continue her way of life in hell with rather unpleasant partners.*

downfall, because Eve, the first woman, tempted Adam, and since then, man has succumbed to women's wiles. In the nude, woman represents Venus, the temptress, and she is portrayed as the *Woman leading apes to hell* on a misericord in Bristol Cathedral (Pl. 135). Women's power lay in their ability to tempt and deceive men, and their love was not of the true, spiritual kind, but a means by which to rule men. A misericord in St George's, Windsor, has been interpreted as *St Zosimus visiting*

**136**. *Windsor Castle, St George's Chapel. A bald-headed man taking off his coat sits next to a nude woman in a rural setting. One interpretation of this scene is St Zosimus visiting St Mary of Egypt and giving her his cloak at her request. However, the fleshy nude sitting with her legs crossed on a throne with tasselled cushion is more likely to be Venus, Queen of the World. She pulls open the man's coat, while he points at her and looks at the viewer with an apish smirk, as though implicating the onlooker in his eager desires.*

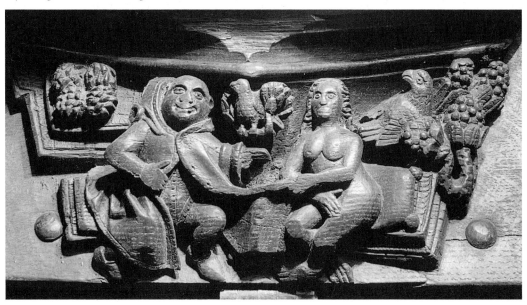

*St Mary of Egypt and giving her his cloak at her request,*[12] but considering contemporary opinion of women and the carving itself, this seems unlikely (Pl. 136). In another, similar misericord in Windsor Castle, a woman sits cross-legged next to a man unbuttoning his coat to expose his lower parts, and both are smiling. Such depictions can be compared to the engraving by the German Master E. S. (active *c.*1450–67) where a woman escorts a fool through a love garden and opens his coat in order to reveal his genitals.

Misogyny had long been traditional, and in their biting satire of women, misericords followed the spirit of the times. Woman as virago was the stock character popular in all the arts and in particular in prints, from which misericord carvers often took their designs. Women were an easy target for men's satire, because in real life they could not fight back. They represented human weaknesses and animal behaviour, thus allowing for a combination of humour and moral teaching. Also, the conflict between men and women was seen as a battle between God and the Devil for the supremacy of the World. How humorous was this image of *Woman beating man*? Did part of the laughter contain fear at the possibility of women taking control and thus turning the world upside-down in reality? Probably, the sight of a woman asserting such power over men was meant to be repulsive to both men and women, a warning to men to keep their trousers firmly on, and for women not to despoil the ideal picture of their sex. Certainly, any misbehaviour by women on earth had dire consequences, as is made frighteningly clear on a misericord in All Saints, Gresford, where two women are wheeled straight into the gaping jaws of hell by a demon (Pl. 137). In Holy Trinity, Eccleshall, Satan himself is enthroned on a beast of hell, and bears a nude woman, his trophy, on his shoulders.[13]

137. *Gresford, All Saints. Two women in a wheelbarrow driven into hell by a demon, while a man follows. The women could be nuns.*

**138**. *Lavenham, St Peter and St Paul. Detail of Pl. 140. Grotesque playing the bellows with a crutch.*

# 5

# Humour and Folly

HUMOUR IS THE QUALITY most associated with misericords, resulting in a less than serious look at the world of upside-down situations, including the interchangeability of animals and humans beings. Although gargoyles and grotesques, well known from Romanesque architecture and sculpture, were condemned by St Bernard of Clairvaux as follies,[1] they were more frightening than funny. With the rising importance of laymen and lay artists, religious art too became more human and humour was allowed to develop; human foibles began to be satirized, and daily life mocked. Even the monsters and devils were made to look ridiculous and could be laughed at. Although there was tension between the plain funny and the serious, didactic intent, all was overlaid with a new playfulness and exuberance, and certain topics, like love and sex, were always joked about.

From the beginning of the fourteenth century, above all, humorous situations were made more explicit, and the narrative expanded on misericords in parallel to marginal illuminations in manuscripts. In Chichester Cathedral, *c.* 1330, animals in human roles or animals and human beings interacting, with exaggerated poses and gestures, convey the humour of a situation: figures cart-wheeling, a young man playing the fiddle while at the same time bending backwards to kiss his wildly dancing partner, a nude man nonchalantly sticking his sword into an ape-like monster with a noose round its neck (Pls. 139). Many are the contorted figures on misericords, or half-human, half-animal, centaur-like creatures playing instruments. In St Matthew's, Walsall, the upper part of a hooded man playing the viol is embedded between the tail and head of a dragon. The sounds these creatures made must have become even more chaotic when, as in St Peter and St Paul, Lavenham, a creature, half-man, half-beast plays the bellows with a crutch, and his opposite a viol (Pl. 140).

Animal satires were the most popular, for by making animals act like human beings, animal qualities are conferred onto humans. Animals personify specific, usually negative, characteristics and vices which they pass on to the humans whose roles they have taken. In Hereford Cathedral a cat and a goat mimic human musicians, creating disharmony or a world upside-down, for the fiddle and flute, often played by angel musicians, have now fallen into the hands of sinners (Pl. 141). Animals making music are also popular subjects in St Botolph's, Boston, where, in the supporters of one misericord, hares play pipes decorated with banners, while on another bears and foxes are the musicians, playing the organ and working the bellows, beating the drum and playing the bagpipes. In the supporter of a misericord in Winchester Cathedral the sow plays the double pipe while she suckles her piglets, thus feeding song and dance into their very milk. The idea of animal

**139**. *Chichester Cathedral. A woman and a man playing the viol dancing in wild abandonment.*

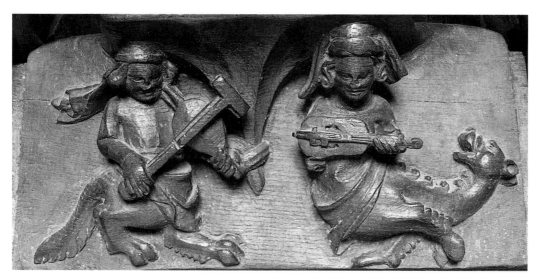

**140**. *Lavenham, St Peter and St Paul. A creature, half-woman, half-beast playing a viol, and another, half-man, half-beast playing on bellows with a crutch. This is a satire on the effect of music-making on human beings whose animal passions can be aroused by popular music.*

**141**. *Hereford Cathedral. A cat playing the viol and a goat playing the lute, standing upright. The goat was seen as a lecherous animal, and on the misericord its genitals are in prominent view. To the Christian the goat represented the devil and sinners were likened to the goat, and the Antichrist was sometimes shown in the shape of a satyr. The cat was considered lazy and lustful; the scraping of the fiddle suggests the cat's own mewing, which is complemented by the bleating of the goat.*

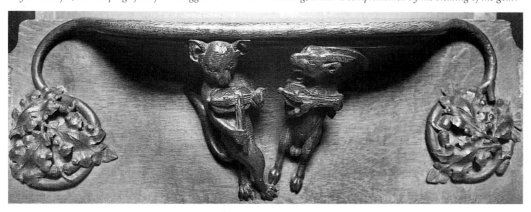

mothers teaching their young to dance is a favourite theme especially with sows and piglets, as in Ripon Cathedral, Manchester Cathedral and Beverley Minster (Pls. 80–82). The pig is a symbol of lust and gluttony, and its fitting instrument, the bagpipes, was considered 'low', associated with country fairs and bawdy behaviour. On a number of misericords animals were transformed into bagpipes pinned under the musician's arm and the melody played out on their hind legs (Pl. 153). In Lavenham, a man thus misuses a pig, and one can imagine its squeals. The association between pig and bagpipe is especially apt, for not only do they share the same negative symbolism, but bagpipes are made from pigs' stomachs. In seeing the animals behave like humans, people are reminded of their own failings, especially of their lecherous desires as in the characters of the animals most frequently portrayed: two cats walking upright, one leading the other to dance (only the outlines of a third cat remain) in All Saints, Gresford.

The prime representative of human foolishness and sinfulness is the *Ape*, mimicking people's expressions and actions, e.g. dressed in a flowing gown, with long fine fingers and toes, supporting the bracket of a misericord in Ely Cathedral. An ape with big ears in St Mary's, Gamlingay, holding up the bracket, looks both natural and foolish. The Ancients considered the ape ugly and evil, and the early Christians saw in its sinfulness a reason for eternal punishment. Uncontrolled sexuality was its greatest sin, and in sixteenth-century England the ape had the reputation of being the embodiment of male sexual rapacity.[2] In Chaucer's 'Friar's Tale' it was also seen as the devil, for the devil tells of how he comes to earth in different shapes: 'sometimes it's like a man, sometimes an ape'. This concept of evil embodied in the Ape is indicated by the *Ape holding an owl* as in Winchester and Wells Cathedrals, and on the ceiling of Peterborough Cathedral. Its devilish nature changed into one of foolishness at the end of the fifteenth century with the advent of Humanism. Sin then being considered the result of foolishness, the ape took on a more human mentality and was viewed with more tolerance.[3]

The playful humour relating to the ape was already well represented in marginal illuminations in manuscripts showing the ape parodying human behaviour. Its closeness to humans is seen in its fondness for human babies whom it steals, as found in the supporters of misericords in Manchester Cathedral and Beverley Minster (Pl. 145). In Norwich Cathedral a misericord of an ape balancing on a wheelbarrow and birching two others pushing it can be seen as a parallel to the unruly housewife being pushed in a wheelbarrow, incapable of walking and yet belligerent. Satire on contemporary society may also be expressed in a scene in Lincoln Cathedral where an ape riding on a horse carrying a mace, symbol of authority, faces an ape riding on a lion brandishing a club, on the other side of a tree.

Above all, the ape satirizes the profession of physicians, by lifting a urine glass against the light in order to diagnose an illness: supporters in Manchester Cathedral (Pl. 145), Beverley Minster; and in Cartmel Priory where the ape is seated between trees, holding the urine flask high, like an emblem. On a misericord in St George's Chapel, Windsor, an ape is active as a barber, a profession associated with sur-

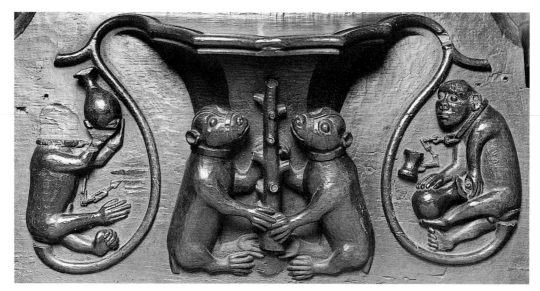

**142**. *Stratford-upon-Avon, Holy Trinity. In the centre, two bears 'counter rampant, muzzled and chained, supporting a staff ragulee', the badge of the Earls of Warwick. In the right supporter, an ape chained to a block takes a sample of its own urine, while in the left supporter an ape examines the urine flask. Apes, with their foolish, human characteristics are often portrayed satirizing physicians whose symbol is the urine flask held up against the light when diagnosing an illness.*

**143**. *Faversham, St Mary of Charity. An ape chained to a clog. Apes were considered highly sexual animals chained to their sexual passions, and thus, unable to break away from sin.*

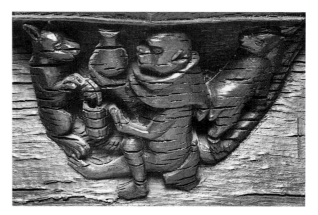

**144**. *Boston, St Botolph. An ape as physician to a fox. He holds up a urine flask, while the fox has brought along his droppings in a bucket to be examined. There is another fox behind the ape.*

**145**. *Manchester Cathedral. In the centre, apes rifle the pedlar's pack. He lies stretched out, asleep, committing the sin of sloth, while the apes take the opportunity to rob him of his goods. They admire themselves in mirrors, and make off with combs and other objects of luxury. The humour of the incident is increased because one of the apes is unable to resist delousing the pedlar's hair. In the left supporter, an ape is again depicted with a urine flask, and in the right supporter, another is nursing a human infant in swaddling clothes which he has stolen.*

geons. In the church of St John the Baptist, St Lawrence and St Anne, Knowle, the ape-physician even lectures to two foxes, pointing at the urine flask in his hand. In the supporters of a misericord of *Two bears representing the badge of the Earls of Warwick* in Stratford-upon-Avon, one ape urinates into his flask, while the other then examines his specimen (Pl. 142). Here, as in other examples, St Stephen's, Sneinton, and St Mary of Charity, Faversham, the apes are chained to a clog which adds a sense of hopelessness to their lives, especially in the case of the downcast-looking Ape in Faversham, for the chained ape represents humanity tied to its animal instincts without thought for spiritual salvation (Pl. 143). The best known example of apes in this state was painted by Pieter Bruegel the Elder (Berlin-Dahlem, Staatliche Museen): chained and imprisoned, with empty nutshells before them, they have given all for an earthly life which proved to be worthless, and will never be able to reach the distant shore of Antwerp. This may also be the idea expressed on a misericord in Sherborne Abbey, where a chained ape eats an acorn, surrounded by oak leaves and acorns. Generally, though, the moral is less philosophical and more humorously satirical on misericords. In St Mary's, Beverley, an ape holds up a large flask to a man with a coin or host in his hand (it is marked by a cross). If a coin, it may be in exchange for a promised cure, if a host, it may be a promise of salvation through Christ in a world of quackery. The ape was also shown as a friend of the fox, that most cunning of creatures, and their relationship is well expressed on a misericord in Chichester Cathedral, where the fox plays the harp, while resting his feet on a dead goose, and the ape dances to his tune. When the fox is ill, the ape is the only one to care for him, as in the right supporter of a misericord of a *Fox hunt* in Beverley Minster, where the ape makes the fox comfortable in bed. However, the physician's services are not free, and on a misericord in St Mary's, Beverley, the fox, shot by an arrow from a Wild Man, appears to hand a large purse to the ape examining the urine flask. In St Botolph, Boston, the fox comes for a consultation bringing a bucket full of his droppings (Pl. 144).

The vice of lust and lechery went hand in hand with pride and vanity to which apes were seemingly so prone; thus, objects such as mirrors and boots could be used as bait to trap them. A fourteenth-century Florentine Dante Commentary tells how a hunter left his boots as bait for apes, who, having put them on and laced them up, were unable to flee.[4] Apes were much given to self-adoration and grooming, and the story of their *Ransacking a pedlar's pack* with its mirrors, ribbons and belts is found on misericords in Manchester Cathedral, Beverley Minster, Bristol Cathedral and St George's Chapel, Windsor. The moral of this story was two-fold: the pedlar was being punished for his sloth and the apes' vanity would lead to their damnation, neither party recognising the devil at work (Pl. 145). The earliest pictorial representation of this scene is in the margins of the Smithfield Decretals, *c.* 1340:[5] this shows first the pedlar leaning against a tree, about to fall asleep, then the apes rifling his pack once he is fast asleep, and trying on and playing with the contents, such as gloves, hat, belt, towel and dish.[6] All the misericords showing this scene are from the end of the fifteenth and the beginning of the sixteenth centuries, and all have in common the pedlar lying on the ground

**146**. *Norwich Cathedral. An ape in a hood plays the bagpipes on a dog. He squeezes the dog's hind legs and blows into his tail. Another ape is ready with a birch and another dog is grinning at the discomfort expressed by the howling sounds coming from this 'instrument'. Here we have the ultimate in nonsense.*

with a large number of apes pilfering his goods and playing with them. The carvings in Manchester Cathedral and Beverley Minster are so similar that they must derive from the same model. In Beverley Minster, however, the situation is quite out of hand, because the apes have become aggressive and pull at the pedlar's hair, and the scene in Bristol Cathedral looks more like a violent assault or rude awakening, for the apes threaten the pedlar with sticks and rob him of the contents of his back-pack and purse. The pedlar in the Windsor Castle misericord rests before the city gate, while the apes distribute his wares among themselves. The apes have afflicted him with the further indignity of pulling down his trousers and pointing at his bare bottom, adding to the scatological humour of the scene. The theme is extended into the supporters, where on the left, a drunken man dances in top-boots and tries to keep his balance by clutching at a plant, a possible reference to the love of boots leading to damnation, while sitting on the right there is a jester as personification of all foolish and sinful behaviour. A Swabian woodcut of *c.* 1480–90 shows apes in the process of disrobing the sleeping pedlar, but it is an engraving by Pieter van der Heyden after a design by Pieter Bruegel the Elder, published 1562, which comes closest to the misericord: the pedlar's trousers have been pulled down and an ape holds his nose while sniffing at the pedlar's exposed buttocks. Manuscript illuminations, prints and misericords in England and on the Continent point to the internationality and lasting popularity of this scene which could be treated with various degrees of exaggeration, and which in the case of Bruegel's design lived on into the seventeenth century.[7]

The foolishness of the ape often releases pure laughter or at least permits tolerant forbearance because of its all-too-human behaviour. The ape may even evoke sympathy, as when depicted with a family feeding its young in Henry VII's Chapel, Westminster Abbey, or in the unusually sad scene in Lincoln Cathedral where a dead ape is carried on a bier by two others. Although the friend of the fox, the

difference between the two is clearly brought out by the fact that the ape too is often duped by the fox. The ape is punished for its sinful life, as on a misericord in Bristol Cathedral, where a nude woman leads her adoring suitors, the apes, into the jaws of hell (Pl. 135); the fox, however, always manages to extricate himself from life-threatening situations, except in art, and furthermore his tricks are dangerous. In a comparison between the two, the ape represents humanity, and the fox the devil who leads people into sin through deception. However, the general impression of the ape's life is one of frolicking foolishness, and laughter comes easily, as in the *Ape playing bagpipes on a dog*, as in the supporter of a misericord in Beverley Minster, and on a misericord in Norwich Cathedral (Pl. 146).

A popular figure of fun because of his pranks and his rude and even disgusting tricks is *Marcolf*.[8] The general enjoyment lies in the fact that Marcolf gets the better of wise men such as King Solomon through his down-to-earth, proverbial answers, and there is gratification in recognizing that the lowest of the low succeeds because of his earthy wit against those in high places.

Depictions involving Marcolf on misericords show a figure sitting astride a goat with one foot on the ground, the other in the air, and wearing a cloak of netting. Malcolm Jones found this figure, identified as 'Marculf', in a thirteenth-century Register of Writs in Latin.[9] On the misericords in Worcester Cathedral, St Mary's, Beverley and Norwich Cathedral, Marcolf also carries a rabbit (Pl. 147). The story is known in folklore as the 'Clever Daughter',[10] which tells of a riddle posed by a king asking the protagonist to appear before him neither riding nor walking, neither on horseback nor on foot, neither naked nor clad, neither barefoot nor shod, neither in the road nor out of the road, neither with nor without a gift. On the misericord in Worcester, the figure is a man, and therefore Marcolf, riding on a goat, dressed in a net, with only one foot on the ground, with no shoes but only a strap, and holding a rabbit, which when presented will jump away; in St Mary's, Beverley, King Solomon is included, and *Samson opening the lion's jaws* has been placed symmetrically opposite Marcolf; in Norwich Cathedral as in the other examples, Marcolf wears a net gown and hat, rides a stag and carries a hare.

**147**. *Beverley, St Mary. King Solomon between Samson and the lion, and Marcolf. Solomon is defeated in a contest of wits by Marcolf, who solves a riddle. The riddle asks for a person to come neither walking nor riding, neither dressed nor naked, neither out of the road nor in the road, with a gift and no gift. Marcolf therefore sits astride a goat with only one foot visible which is shod and wears a tight-fitting covering of netting. His gift of a rabbit will jump away when presented.*

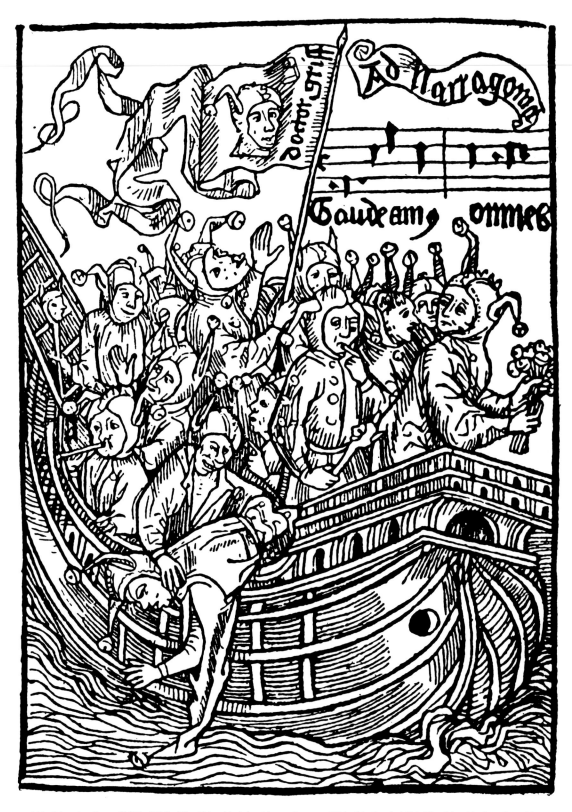

**148**. *Sebastian Brant (1458–1521). 'The Ship of fools', with woodcuts, published in Basel, 1494. The ship of fools sails rudder-less to never-never land with all humanity aboard. This print is the reverse of the title-page, and the same woodcut is re-used in a later chapter. The destination of the boat is given as 'Ad Narragoniam', the Land of Fools. Doktor Griff, the example of a scholarly fool, is the flag-bearer, and everyone sings 'Gaudeamus omnes', 'let us all be merry.'.*

# 6

# The Fool

THE FOOL, the very symbol of foolishness, observes human weaknesses and comments on the world upside-down, on its being out of joint; ruled by his passions in sexual matters, haughty, greedy, lazy and a glutton, he is the very opposite of a good burgher (Pl. 150). These all-too-human vices he has in common with the ape, and as Janson says, the ape as a domestic pet was the counterpart of the fool or jester; indeed, jesters were often put in charge of apes.1

The medieval fool has his origin in Psalms 14 (13) and 53 (52) which open with the words: *Dixit insipiens in corde suo: Non est Deus*, 'The Fool hath said in his heart: there is no God'. He therefore denies God and therein lies his foolishness. In thirteenth- and fourteenth-century psalters he is often portrayed inside the initial 'D', bald, with a club or stick and a round white object, disputing with a king. The fool was a lonely figure on the fringes of society, but in the fifteenth century he developed into the representative of humanity as the jester, characterised by his cap with asses' ears, bells and motley-coloured dress symbolising his lack of reason.[2] His stick, called a bauble, could either have a bladder attached, or his other self, a small fool's head. From the end of the fifteenth century and in particular with the advent of Humanism, the emphasis shifted from sinfulness to foolishness, that is to sinning because of lack of self-knowledge, rather than because of inherent evil. The devil himself was turned into a comic character, a fool, an object of laughter, at once funny and repulsive. Monsters still abounded, but the belief was that Christ would be able to overcome them, as illustrated by the large number of misericords showing the *Lion fighting the dragon*. The *Ship of fools* became a very popular theme, best known from Sebastian Brant's version of 1497, illustrated with woodcuts, many of them attributed to Albrecht Dürer. There, all humanity in fools' dress and bells set out on a rudderless boat for never-never land (Pl. 148). Sebastian Brant takes on board the foolish behaviour of the world in all its varieties, and both castigates and smiles at human weaknesses. His aim is to educate foolish humanity; his goal is wisdom, good sense and good manners. Fools, however, cannot resist temptation and are unable to foresee the result of their actions; concerned with the immediate present, they do not look ahead to the consequences of their sinful behaviour: damnation. They are driven by inner emotions and instincts, are always restless, looking hither and thither, and becoming totally confused and ensnared by life.

Fools are well represented on the misericords of Beverley Minster, in half-length, making faces and rude gestures or skipping about in their long-eared hoods, scalloped tunics, with their bauble, emblem and repository of the fool's innermost thoughts (Pls. 149). This predilection for fools in Beverley Minster may have its

**149**. *Beverley Minster. In the centre, three fools dancing. They wear their traditional costume and their movements are exaggerated. In the left supporter, the fool holds his bauble which could be a small balloon, made from animal bladder as here, or could be carved in the image of the fool, as seen in Pl. 152. In the right supporter, the fool plays pipe and tabor.*

origin in the Feast of Fools, celebrated there every Christmas, when the clergy and others dressed up as fools and held mock services.[3] The fool was first popularised in the Carnival plays of the fifteenth and sixteenth centuries, where he either acted a part or commented on the action as narrator or herald, and where he was an eager servant to Lady Venus, who represented Dame Folly. Carnival time was a period of unruliness, of the world upside-down, of dancing and dressing up, until the fool's rule came to an end on Ash Wednesday. The *Three fools in fools' caps and tasselled gowns dancing* in Beverley Minster (Pl. 149) are probably playing out their sexual desires, as a comparison with an engraving by Israhel van Meckenem, depicting a Morris Dance *c*. 1480, may show. There, the dancers, including a pipe and tabor player and a fool with his bauble, are incited to wild abandonment by a woman who tempts them with a ring which she holds out as prize. A similar

**150**. *Rotherham, All Saints. A fool's head with a big grin on his face wearing a fool's cap.*

**151**. *Israhel van Meckenem. Ornamental frieze of a woman venerated as Venus. The men girate wildly around the woman, engulfed by prickly tendrils, while she holds out an apple, symbol of carnal pleasure, as a prize. The fool himself stands at her feet, and the dog fiercely guarding a bone heightens the sense of contest over the woman.*

engraving of *c*. 1490 by Israhel van Meckenem is found in the form of an ornamental frieze (Pl. 151). Although there is no woman present on the Beverley misericord, a woman was probably meant to be the cause of the fools' contortions, as the fool was included increasingly often in the theme of the *Power of women*; he was well known as the servant of Venus. All the prints and drawings of similar scenes include the woman, and the carved Morris Dancers by Erasmus Grasser for Munich Town Hall, *c*. 1490, originally also had a woman temptress in their midst towards whom they directed their attention.

Every lordly household in the Middle Ages and the Renaissance had a jester. They acted as a reminder of the foolishness and vanity of all earthly power and glory. The misericords show the fool reacting to the world and laughing at it, making a fool of it and making a face at it. To pull a face and stick the tongue out

**152**. *Christchurch Priory. A jester with his bauble and staff. Here, the bauble is in his likeness, and one can imagine the fool conversing with it and speaking through it.*

is an expression of mockery and derision even today; in the Middle Ages it was a gesture also commonly used by Christ's tormentors, as seen in depictions of the *Mocking of Christ* or the *Carrying of the Cross*. In Henry VII's Chapel, Westminster Abbey, two fools in the supporter sit smirking with glee and pulling a face at the *Man being beaten by a woman*, in the centre.

Many of the contorted figures in Christchurch Priory wear peaked caps and look and behave like fools, but only one is definitely a jester, holding a staff in one hand and his bauble in the other (Pl. 152). The bauble is the spitting image of the jester, his other self which can speak for him. Fools' licence allowed jesters to convey unpalatable truths, and it is even possible that they spoke through their baubles like ventriloquists. This is indicated in Sebastian Brant's *Ship of Fools* (ch. 19), where the fool and his bauble both stick out their tongues to make apparent their senseless, incessant chatter, emphasised by the woodpecker knocking on the tree-trunk. The fool's favourite instrument is the ungodly bagpipes which he prefers to the lute and harp, as Sebastian Brant writes in his *Ship of Fools* (ch. 54). In Brant's woodcut, he stands playing the bagpipes, while the lute and harp lie by his feet; he rejects them just as he disregards all wise counselling. Misericords in St George's, Windsor, and St Mary of Charity, Faversham, show the fool playing the bagpipes (Pl. 33). Also jesters, like apes, play instruments on animals, so inverting the normal order of behaviour (Pl. 153).

Thus, the Fool is a fool, the more so because he points at the stupidity of others, without recognising his own failings, for he lacks self-knowledge and is for ever stubborn and deaf to advice; therein lies the humour in the Middle Ages, rarely pure but usually with a didactic purpose.

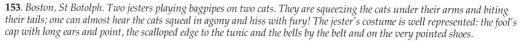

**153**. *Boston, St Botolph. Two jesters playing bagpipes on two cats. They are squeezing the cats under their arms and biting their tails; one can almost hear the cats squeal in agony and hiss with fury! The jester's costume is well represented: the fool's cap with long ears and point, the scalloped edge to the tunic and the bells by the belt and on the very pointed shoes.*

# 7

# Scatology

H UMOUR IN THE MIDDLE AGES seems to have been a two-edged sword, rarely eliciting pure innocent laughter. This is supported by the origin of its meaning: the imbalance of the four humours—blood, phlegm, choler and melancholy—resulting in illness or folly. How then do the most bawdy images fit into the concept of humour, where outrageous freedom is taken with the human form, in particular, the nude? Of course, there are inherent warnings against the temptations of the flesh, but were these to frighten or to amuse the viewer? Laughter and fear are undoubtedly related,[1] and with so much preaching on the dangers of carnal love, bare bottoms must have aroused a 'frisson', most of all for supposedly celibate monks. Also, bare bottoms were the ideal shape for choir-stall elbows on which monks would rest their hands, e.g. a man with an exposed round 'arse-hole' as handrest in St Mary Magdalene, Newark (Notts). The contorted figure of a man lifting his legs high above his head became very popular, for with the head thus peering through the legs both bodily orifices came into full view, e.g. Oxford, All Souls' College. This image also confronted the nuns of Swine nunnery, *c*. 1500 (Pl. 112). Did they laugh at it or were they shocked? Does the image demonstrate the robustness of medieval humour, or was it a warning to the nuns against carnal desires? Probably, it was meant to stun them, if their thoughts had been straying down the slippery slope of unchastity.

Images like language were coarse and outspoken in the Middle Ages, and 'scatological imagery of the medieval period had its origins in the blunt language found at times in Scripture'.[2] Even St Augustine used bawdy language and is supposed to have said: 'we are born between the places of defecation and urination'.[3] In general, life fluctuated between good and evil, without subtle nuances; penance and abstinence on one side, sinning and feasting on the other. The comic element was very low class, yet it was greatly enjoyed by the highest class of society. Philip the Good, Duke of Burgundy (ruled 1419–67), for example, employed the famous Jan van Eyck, but also took great care to have his 'amusement machinery' well looked after by his artists, and delighted in entertainment much given to slap-stick humour. Jan Huizinga describes a concert in Bruges performed by animals, put on in honour of Charles the Bold who was himself an accomplished musician.[4]

Bare-bottomed hybrid creatures of the centaur type, often with extra faces in their bottoms, abound on misericords, symbolising the onslaught of animal nature on humans (Pl. 9). The purely scatological, i.e. bum-exposing, bum-venerating and -kissing figures, as at Swine, occur less frequently, though in Wakefield, we find a nude figure bending down to look through its legs at the viewer from its two faces

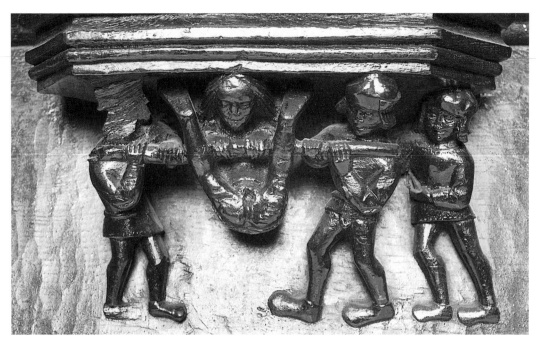

154. *Gresford, All Saints. An acrobat cartwheeling over a pole held by three men.*

with orifices.⁵ An acrobat turning over a pole in All Saints, Gresford, prominently displays his bottom (Pl. 154). In Tewkesbury Abbey a nude figure leans over and grabs its bottom, probably to release obnoxious stenches (Pl. 155). Exposing the bottom and breaking wind were gestures of defiance and contempt. Farting, in particular, was associated with the devil and the foul, sulphurous smells of hell. The devil would give himself away with such vile stenches, but he could also be kept at bay by farts inflicted on him. On a misericord in Malvern Priory, an ape-like nude is having bellows stuck up its arse, i.e. lustful passions are being fanned and

155. *Tewkesbury Abbey. A nude human figure, leaning forward and exposing its bottom.*

its carnal desires set alight (Pl. 17). Worse than farting is defecating, as seen on a misericord in St George's Chapel, Windsor Castle (Pl. 111), but faecal evacuation could also connote successful resistance to sin through the expulsion of temptation.[6] Judging from the criticism of monks' lives in the late Middle Ages, and the sheer volume of excrement being evacuated in the Windsor Castle example, however, the monk's demon, rather than being exorcised, is more likely forever multiplying. The belief in the power of both farting and defecating did not diminish with the Reformation, for even Luther combatted the Devil with the help of farting and evacuating, as documented in his table-talk, published in 1566, in which he says that when the words of the Scriptures failed to banish the devil, the stench of his excrement succeeded. Any time the devil troubled him, he would say to him: 'Devil, I have just defecated in my breeches. Did you smell it, and have you added it to those other sins of mine written down in your register?'[7]

Apes, above all, were associated with carnal passions as we have already seen to some extent in Chapter 5; to this can be added an example in Winchester College of an ape holding a horn to his buttocks (Pl. 76).

The corruption of the Church is expressed in scatological manner on another misericord in Swine (Pl. 156) and on one in the Historical Museum of Antiquities, Edinburgh, where a mitred beast has an extra, devious-looking head with long pointed ears, one of which this bishop-creature grasps. The misericords in Lancaster Priory have been much hacked about, and it is difficult to decipher much of the subject-matter, but the grotesque hybrids, mainly in the supporters, can be compared to those in the Luttrell Psalter of *c.* 1340. Some of these have gross sexual connotations, like the nude angel, sitting legs crossed and facing the viewer, playing with his genitals (Pl. 157). His counterpart in the other supporter is a nude female grotesque wearing only a head-dress, leaning over and touching her bottom. These may be fallen angels, like pagan idols. Another human-headed grotesque creature has a dagger-like penis between its legs.

**156**. *Swine, St Mary. A grotesque dragon-like monster with a human head wearing a bishop's mitre.*

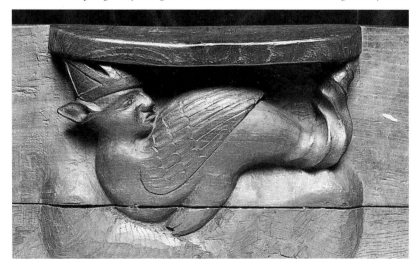

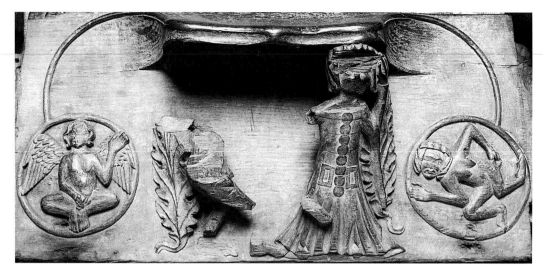

**157**. *Lancaster, Priory Church of St Mary. In the centre, an unidentified scene, badly damaged, of a man striding towards a woman. In the supporters, rude, naked figures, the one in the left supporter is a fallen angel.*

The misericords in Bristol Cathedral are noteworthy for their mainly nude figures and sexual connotations. Starting with the *Temptation* and consequent *Expulsion*, Woman is much in evidence as the temptress, and the male figures sport prominent penises and are totally nude when wrestling, or even when about to transport a bear in a wheelbarrow; in the same scene in Beverley Minster, on the other hand, the men are fully clothed. Most outrageous is the supporter of the *Fox taken up the gallows*, showing a female figure in a leafy pod holding a large penis with testicles (Pl. 158). She is thus in total command of the male organ and therewith man's virility, which she can destroy at will. One is reminded of Baldung Grien's drawings of Witches' Sabbaths, where sausages, i.e. male genitals, are being roasted. Although seemingly sacrilegious in the extreme, the Bristol penis is probably an apt reminder to monks of their vows of celibacy. As for the question of humour, it must lie in the exaggerated manner of tackling an excessive fear of one of the deadliest sins, and once more shows how closely fear and humour were linked.

Also related to sexual transgression is the scene of a *Nude man riding backwards*, found on misericords in the Cathedrals of Wells, Hereford and Bristol, and in All Saints, Hereford (Pls. 55–57). This was a punishment already established by the eighth century, but the exact date or place of origin of this motif cannot be discovered.[8] Apart from adulterers and whores, erring priests, henpecked husbands and cheats were thus punished. However, in her study of this motif, Ruth Melinkoff also quotes examples of men who beat their wives excessively having to ride backwards in dishonour. The examples of a *Man riding backwards* in Wells Cathedral, Hereford Cathedral and All Saints, Hereford, use a common model with slight differences; their nudity probably points to their humiliation for sexual offences. The man riding backwards on the Bristol misericord, for once, is dressed. He lifts up the horse's tail and thus comes into close contact with the basest part of

an animal already characterized by wild passions. The violent, base passions of
stallions when roused are explored in three woodcuts by the German Hans Baldung
Grien, 1534, and seen with relation to human beings. Melinkoff concluded that the
purpose of the rides was always humiliation but that the intensity varied and could
even be a prelude to death. Thus we are reminded, once more, that the foolish
behaviour depicted on misericords could have dire consequences, and that the arse,
above all, was the most favoured entrance for the devil. What we call scatological
humour must have been a reaction to the Church's persistent preaching on the
dangers of the flesh, and an awareness that rejoicing in animal nature and sin
brought with it a realization of subsequent punishments. Babcock maintains that
travesty, profanation and sacrilege were essential to the continuity of the sacred in
society.[9] Certainly, in contrast to the Church in the nineteenth century, when many
misericords were removed for reasons of prudery, scatological scenes were tol-
erated in the Middle Ages, and possibly even enjoyed.[10]

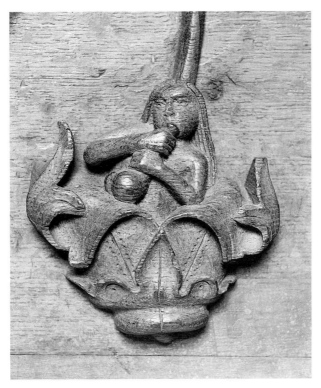

**158**. *Bristol Cathedral. A woman in a leafy pod, playing with a man's
private parts, the right supporter of Reynard the fox led to the gallows.*

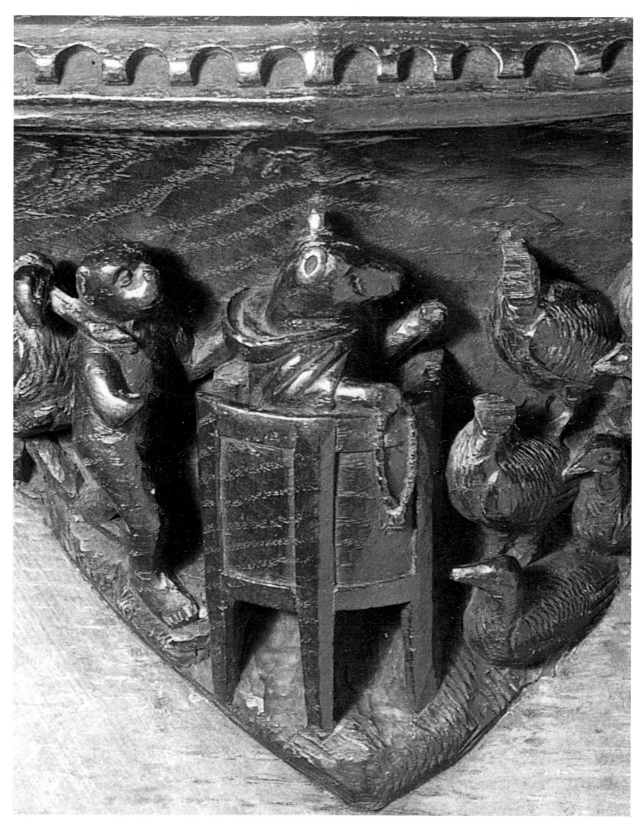

**159**. *Beverley Minster. Detail of Pl. 163. The fox preaching to the fowl.*

# 8

# Preaching

IN ORDER FOR PREACHING to be effective, a memorable sermon was of the utmost importance to a priest trying to persuade his flock to follow the narrow, rocky path to salvation rather than the wide, slippery slope to damnation. There was much inattentiveness at sermons, and people were looking forward to the eating, drinking and gambling at the taverns afterwards, so that sermons had to be spiced with vivid anecdotes, stories with characters and good plots, humour being a vital ingredient. Thus, from the thirteenth century, moral lessons clothed in humorous imagery, termed *exempla*, became the tools of preachers, in particular of the Franciscans and Dominicans. A humorous twist to a moral tale and the combination of sacred and profane are also the essence of misericords, thus relating them closely to sermon literature.[1] *Exempla* were drawn from literary sources, popular tradition and contemporary events, and in the twelfth century their iconographic scope was expanded to include Bestiary and fable themes in addition to the traditional theological and historical subjects.[2] Medieval preachers such as Jacques de Vitry (d. 1240) and the English Benedictine, Odo of Cheriton (d. 1247), compiled collections of *exempla* for following generations.[3]

On misericords no *exemplum* was more popular than that of the *Fox preaching to a flock of geese or fowl*, before running off with them slung over his shoulder.[4] Not only was he a warning to the corrupt clergy who neglected their duties, but he was also a reminder to all parishioners to be forever on their guard against the temptations of the devil in disguise.

Because of the importance of the fox on misericords, it is of interest to survey the history and iconographical development of this image. The origin of the story of the fox deceiving the cock by playing on his vanity goes back to Pierre de Saint Cloud's poem, the *Ysengrimus*, c. 1150, and the Fable of Marie de France[5] from around the same time. The fox taunts the cock to sing as well or even better than his father, with his eyes shut! The cock is thus tricked into crowing with all his might, eyes shut, and is of course caught by the fox.[6] The story first appears in English literature in Chaucer's 'Nun's Priest's Tale', c. 1390,[7] and it is thought that in England the gap between Saint Cloud and Chaucer was bridged by an oral tradition which stemmed partly from Pierre de Saint Cloud's poem and partly from a popular farmyard tradition.[8] Certainly, the many carvings and illustrations are evidence of the existence of an oral tradition. As described in the literary tale, the fox addresses and makes off with the cock, because the strutting cock was well known for its vanity. On misericords, and in the plastic and graphic arts generally, however, it is the goose that the fox has between his teeth and slung over his shoulder. The reason for this may be stylistic, as the slender outline of a goose is

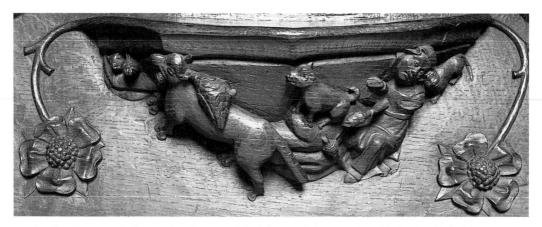

**160.** *Whalley, St. Mary. The fox carrying off a goose while the housewife sleeps—indicated by her distaff which has dropped into her lap—the dog, now awake and barking stands on a cushion, symbol of sloth, as is the sleeping cat behind the woman. On the very left, the fox's family is waiting in its burrow for his return.*

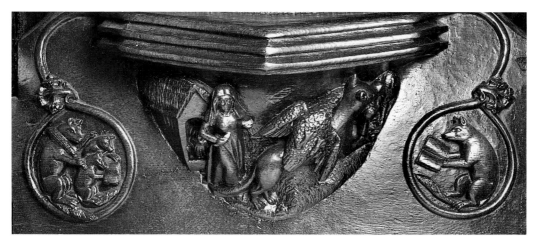

**161.** *Manchester Cathedral. The fox carrying off the goose, chased by the housewife with her distaff (now broken). New in this depiction is the inclusion of the house and the housewife's daughter in the doorway, who is also mentioned in Chaucer's 'Nun's Priest's Tale'. The supporters show very unusual scenes of the fox and his family as scholars; in the left one, the cubs are taught to read under the threat of the birch, while in the right one, the fox is reading a book.*

**162.** *Ripon Cathedral. The fox preaching from a pulpit to a duck and a cock.*

more suitable for carving and allows for a better impression of speed when the fox runs off with it. The carver in Wells Cathedral dedicates a misericord to the portrayal of a proud cock, standing in all his glory, while another is given to the scene of the fox who has closed his jaws around the neck of a goose that hangs heavily over his shoulder. Yet another misericord in Wells Cathedral portrays the cunning fox preaching to the geese, standing staff in hand, like a good shepherd. One goose in particular has bedded itself down by his feet, oblivious to the evil intentions of the fox, which will be its undoing. In Ely Cathedral, 1338, the narrative of the central scene is often augmented by spilling over into the supporters (Pl. 7). Here, the preaching scene and the fox escaping are illustrated on one misericord; furthermore, the story has been expanded by the addition of a housewife giving chase, and this time it is the cock and not the goose that has been caught by the fox, all of which accords with the story told by Pierre de Saint Cloud. From now on the housewife armed with her distaff giving chase becomes the norm, as in a large number of marginal illuminations, mentioned earlier in Chapter 2. In St Botolph, Boston, the fox escapes with the goose while ducks scatter, the housewife with her distaff in hot pursuit. In Ripon Cathedral, the running fox and goose take up the central part of the misericord, while the woman swinging her distaff over her shoulder sits in the left supporter, and the dog follows the fox from the right supporter. On a misericord in St Mary, Whalley, the moral of the story is more explicit; here, because of sloth, and a lack of watchfulness, the appearance of the fox (the devil) went unnoticed, with known, dire consequences (Pl. 160). In Norwich Cathedral, the fox has thrown a whole household into total disarray. This scene may have been influenced by Chaucer's episode in the 'Nun's Priest's Tale', where the housewife is considered untidy and lazy. In the misericord, the pig feeds from the pot, while other utensils are scattered, and the woman gritting her teeth, armed with her distaff and followed by her dog, races after the fox. Even closer to Chaucer's tale are the representations in Manchester Cathedral and Beverley Minster (Pl. 161). Here, a house has been added from which the woman rushes, while her little daughter looks out from the doorway. In Beverley, four of the geese quacking in panic have joined the one caught by the fox.[9] Not found in literary accounts are the carvings illustrating the scenes of the fox reading and teaching its young to read with the threat of a birch over them, which can be seen in the right and left supporters in Manchester Cathedral.

As already described in the supporter of the *Fox chase* in Ely Cathedral, the fox, the better to disguise his true nature, was dressed in a religious habit and went around preaching (Pl. 7). In the second half of the fifteenth century, a pulpit was introduced to the Preaching scene, as depicted in Ripon Cathedral (Pl. 162). [10] In Ludlow the fox wears bishop's robes and a mitre while standing in a pulpit. On a misericord in Beverley Minster, the fox, in friar's habit, prominently displays a rosary which probably refers to the Dominicans who had introduced its use (Pl. 159); their Order of mendicants was coming under increasing criticism because of the dissolute life of the friars who no longer adhered to their vows of poverty,

**163**. *Beverley Minster. The fox preaching from a pulpit. The fox is in a friar's habit and displays a rosary, the sign of his hypocrisy; an ape approaches the pulpit from the left, as the accomplice of the fox, with a goose dangling from a stick over his shoulder. In the left supporter is an owl, symbol of darkness and evil in the Middle Ages; in the right supporter, the proverb, 'Shoeing the Goose': see also Pl. 122 for another example of this.*

 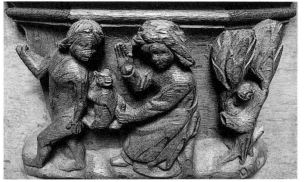

**164–166**. *Above left, Bristol Cathedral. A scene from the Romance of Reynard the fox, where Tibert the cat is deceived by the fox, and as a result gets caught in a snare in the priest's house. On the misericord, Tibert is seen held on a rope by the priest's son, while the priest's mistress in her nightshirt beats him with a broomstick, and the fox looks on gleefully; Tibert, desperate to get away, makes for the naked priest's genitals.*

**165**. *Above right, Bristol Cathedral. This scene is the continuation of the last, though not described in the Romance of Reynard the fox. The fox has now jumped up the priest's back and his mistress, now in dress and apron, tries to pull him off; again, the fox surveys the scene, this time from the fork of a tree.*

**166.** *Left, Wynkyn de Worde (working 1493–1532), woodcut. Episode from the Romance of Reynard the fox: Tibert the cat in self defence attacks the priest by his genitals. This scene can be compared with Pl. 164.*

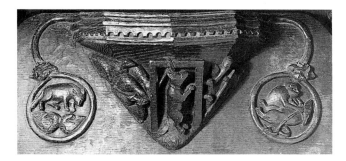 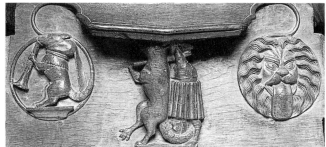

humility and chastity. The fox in the misericord may therefore illustrate the hypocrisy of the mendicant friars.

Five misericords in Bristol Cathedral (1520) are unique in relating incidents from a popular tale of *Reynard the fox*, known as Branch I of the *Roman de Renard* which was translated from the thirteenth century Netherlandish *Reinaert de Vos* by Caxton in 1481.[11] However, the carvings in Bristol are not based on Caxton's descriptions and are closer to the French than the Netherlandish tradition.[12] According to the story, the crimes of Reynard the fox had reached such a climax with the rape of wolf Isengrin's wife and a number of murders of the cock's relatives, that King Noble decided to call him up for judgement. Bruin the bear is sent to fetch Reynard to court. On the way, however, Reynard tricks the bear into looking for honey in a half-split log and then pulls out the wedge, thus trapping him. The misericord shows Bruin the bear with his head stuck in the log and the villagers, who have heard his cries for help, descend on him with sticks while the fox looks on with pleasure. The next animal to be sent out is Tibert the cat. The clever fox, however, knows well what will tempt Tibert the cat, that is to say, mice, and of these there are many in the priest's barn. Reynard, but not Tibert, also knows that there is a snare, and Tibert gets caught in it. The misericord (Pl. 164) once more shows the household having been wakened by the commotion, and Tibert in self-defence, going for the priest's genitals. Furthermore, the Bristol carver has given a minute-by-minute account of the events, in carving another misericord which shows Tibert jumping up the priest's back (Pl. 165). At a third attempt, Grimbert the badger, the fox's cousin and friend, is sent for and he manages to persuade Reynard to come before the king. The court's decision is to condemn Reynard to the gallows, and one misericord shows Reynard being led to the gallows while another depicts a muzzled bear and a wolf dancing, with an ape beating the drum in joyful anticipation of the fox's death. In the romance the fox escapes the gallows because, after one last attempt to plead for mercy, he promises to repent and go on pilgrimage as penance. Noble the king relents and the fox is allowed to go free on condition that he visits the Holy Land and never returns. On the misericords in Bristol Cathedral and Beverley Minster, however, the fox is hanged (Pl. 167). In Bristol Cathedral, where the geese pull at both ends of the rope and one at the fox's tail, the fox already had a forewarning of the gallows on the misericord showing the fox preaching, because the gallows are included at the side of the pulpit.

Much of the popularity of the fox must have been due to his ability to dupe others, resulting in a mixture of admiration for his cunning and fear at being caught by it oneself. This made him into an apt example of temptation and sin, ideal as a moral lesson tinged with humour. And in the misericord in St Nicholas, Castle Hedingham, where the fox has caught a man, probably a monk (Pl. 168), we also have another perfect example of the world turned upside-down.

**167, 168,** *(opposite, far left). Beverley Minster. The fox hanged by geese. This episode is not found in the Romance where the fox is reprieved. In the right supporter, the ape, the fox's friend, unties the noose after he has been hanged. In the left one, the fox prowls around two sleeping geese.*
**168,** *(opposite, left). Castle Hedingham, St Nicholas. A fox carries off a monk wearing a cowl, like a hunter his prey: upside-down, his feet tied to a pole so that his habit cascades downwards, exposing his legs and breeches, his head rests on the fox's tail. This reversal of roles between animals and humans, is the more ironic as the character of monks was identified with that of the fox. In the left supporter, a fox plays a trumpet.*

**169**. *Durham Cathedral. A seventeenth-century misericord showing the change of style and subject matter: a putto, hand in mouth, enveloped by foliage.*

**170**. *Windsor Castle, St George's Chapel. A supporter showing a glutton on earth being force-fed by a demon in hell.*

**171**. *Cartmel Priory. Satan enthroned, crowned and holding a mace, flanked by dragons. In the left supporter, a Lombardic initial T.*

# 9

# Conclusion

ALTHOUGH MISERICORDS were carved right up until the seventeenth century, their heyday was before the Reformation. After that time, their motifs were generally repetitive, decorative pattern of foliage and flowers, since the Council of Trent, 1563, forbade secular subjects in churches. The only misericords carved at the time of the Dissolution of the Monasteries (1536–39) which cross the threshold from the bawdy and crude hybrid monsters of the medieval world to the elegant grotesques of the Renaissance, are those in King's College Chapel, Cambridge, 1533–8 (Pls. 44, 45).[1] In England choir-stalls suffered greatly during the Cromwellian period; Richard Culmier, for example, hacked the misericords in Canterbury Cathedral to pieces.[2] The major seventeenth-century misericords in England are those in Durham Cathedral which were provided by Bishop Cosin in 1665 to replace those destroyed by Scottish soldiers imprisoned in the Cathedral in 1650. It is thought that they were carved by a local carver, James Clement, who did not hew the seats out of one block, but applied the rather roughly-worked subject-carvings which are top-heavy and have no supporters.[3] The subject matter is a combination of old and new, of mythical and natural animals, dragons, griffins, and lions, crab, horse and squirrel, as well as cherubs, mermaids and dolphins, centaurs and other classical hybrids amidst classical foliage, creating a decorative, rather than a narrative scene (Pl. 169). Thus, although misericords were still being carved in places like Durham Cathedral and some of the College Chapels in Oxford and Cambridge, they had lost their traditional function because of the re-organisation of Church ritual under Edward VI and Elizabeth I.[4] No longer was there any need for didactic messages dressed up in humour; the tradition was broken and the carvings became repeatedly ornamental.

The real importance of misericords lay in their subject-matter, and although shut away behind choir-screens, popular secular iconography reached the monks through their misericords. Even more importantly, it was the iconography of low life represented in the 'marginal arts' such as misericords which led to the arts of the future, to the genre painting of Pieter Bruegel the Elder (c. 1527–69), though Hieronymus Bosch (d. 1516) was the first to translate scenes from the margins of art into panel paintings, thus giving them monumentality and making them official. Bosch's material derived from drolleries, from bestiaries and from misericords, from all those sources which abounded in hybrid monsters, in dragons and in beasts half-human, half-animal. Bosch's fame resides in his monstrous, frightening creatures that torment the hermit saints, like St Anthony and St Jerome, and who inhabit Hell in his *Last Judgement*, *The Haywain* and *The Garden of Earthly Delights*. There are monsters with scaly or furry bodies, with claws or with talons, one body

with two faces or two bodies joined to one face; sometimes the faces are human, sometimes animal, usually evil and demonic, the very creatures so much at home on the misericords. Chichester Cathedral misericords, in particular, are rich in different combinations of human and animal parts, and in centaurs with extra heads (Pls. 9–11). Both in the work of Bosch and on misericords the theme revolves around the sinful nature of human beings, of the animal side that takes over and of the relentless battle between good and evil; they have in common most imaginative dragons as symbols of evil, and harpies as temptresses. Bosch's main concern was with the Seven Deadly Sins, with the Last Judgement and with gruesome retribution. Transgressors in life are horribly punished in their after-life, in particular gluttons who are force-fed, as depicted on misericords in St George's Chapel, Windsor Castle, and Beverley Minster (Pl. 170). Above all, the nude woman and the ale-wife, familiar on misericords, are found among the great sinners in Hell, in Bosch's *The Garden of Earthly Delights*, surrounded by scenes of gambling and drinking. There, as on the Ludlow misericord, the ale-wife still holds on to her tankard, and the horned head-dress is the give-away for all women of evil (Pl. 117). The devil enthroned, crowned and bearing a mace, and surrounded by evil beasts is the same in Bosch's *Last Judgement* (Vienna, Akademie der Bildenden Künste) as on a misericord in Cartmel Priory (Pl. 171). To Bosch's mind everyone was a sinner and he showed foolish humanity sailing away in the *Ship of Fools* (Paris, Louvre), as popularised in the text by Sebastian Brant. These were people unconcerned about their spiritual well-being, and intent on eating, drinking and fighting, the Fool sitting on the ship's mast their symbol. In this work and in many others the clergy come in for much criticism, in particular because of their lust and lechery. As we have seen, the excesses of drinking, the foolish behaviour of people and the sinful life of the clergy are also the butt of misericord carvers. Bosch's paintings, however, give the impression of extreme pessimism, all human beings seemingly damned, and it is often difficult to recognize any humorous intent or lighthearted laughter. For Bosch, fear predominates, whereas, in spite of their didactic messages, misericords are able to convey humour and keep a sense of balance (Pl. 172). That is why Pieter Bruegel the Elder comes closer to misericords in spirit, for in his paintings, sinful humanity has developed into foolish humanity, and in his hands even the Boschian monsters have become ridiculously funny. All the characters and symbols of low life known from misericords are monumentalised in the work of Pieter Bruegel: the peasants, the pedlars, the cripples. There is dancing, fighting and love-making, and the bagpipes, symbol of all the bodily vices, in their association with pigs, reign supreme. The domineering virago, so popular on misericords is personified in Bruegel's *Mad Meg fighting the devil*, (Antwerp, Museum Mayer van den Bergh) and she is also found on Netherlandish misericords tying up the devil, for example at Aarschoot. Most of all, contempt for the world is shown in Bruegel's paintings and on Netherlandish misericords going as far as to defecate on the globe of the World, again in an example from Aarschoot. Proverbs representing traditional wisdom turned upside-down by the foolishness of humankind—symbolised, in Bruegel's painting *Proverbs*, on a an ale-house sign by the

**172**. *Gayton, St Mary. The devil straddling a couple with large rosary. The devil in the guise of a (fallen) angel is very deceptive; only his hands, feet and tongs (only part remaining by the wing) are an indication of his true character. In the left supporter, a devilish beast, and in the right supporter, a devilish figure with a writing tablet.*

world hanging upside-down—were also well known to the carvers of misericords. Bruegel's paintings are not without moral teachings, but the robust humour expressed enables the onlooker to smile tolerantly at the foolish actions depicted. It is this ability to laugh at oneself which connects Bruegel and the medieval community with the Church and its clerics, who tolerated, and probably enjoyed, some of the most outrageous follies under their seats.

We can only conjecture what was considered humorous in the Middle Ages and what the people, the clergy in particular, laughed at. The topics that were joked about were male-orientated, as can be gathered from the popularity of misogynistic themes. Those to be laughed at were the weak in society, the losers, such as the cuckold who is at the centre of Bruegel's *Proverbs,* the frustrated lover and the peasant, who in Bruegel became the symbol of human foolishness. The relationship between the humour found in Bruegel's works and in medieval misericords demonstrates its longevity and universality, for in order to understand the humour or satire of a situation or a stock character, the story had to be known. Because people recognized symbols like the distaff as an emblem of conjugal quarrels, or the ape inspecting a urine flask as the quack physician, they were able to laugh. Some animals like the ape and the ass are still universally recognized for their characteristics of foolishness and stupidity. The ape, above all, the most human of animals, is comic, for humans can see themselves reflected in its behaviour. It is like holding up a mirror to oneself: an image both frightening and funny. Such are the world-upside-down situations, so common on misericords, many of them of animals behaving like human beings, such as the pigs playing bagpipes to their piglets or the hunter roasted by hares. But there can also be contented laughter when the underdog gets the upper hand and weak, subordinate animals usurp the roles of their tormentors, like the mice hanging the cat, geese hanging the fox or

hares roasting the hunter (Pls. 99, 120). Amusing as it is to see animals act like humans, there is nightmarish fear at the thought of the natural order being over-turned without warning, so that world-upside-down scenes highlight the precari-ousness of human existence. Schmidt takes this further when he says that laughing at these animals may lead to humility, making humour not inconsistent with piety.[5] According to Aristotle it is the ability to laugh which makes men and women human. It certainly keeps the human spirit alive and prevents it from breaking, as most poignantly expressed in our own times in Brian Keenan's account of his life in captivity.[6] While in isolation and on the brink of death, he found that deep despondency could be combatted with laughter and that laughter ultimately could not be resisted.[7] What is more, the laughter which resulted from the hostages' language was foul and quite medieval in its crudeness: 'You swear like a trooper and your imagination belongs to the dung-heap of a camel overcome with diar-rhoea.' The whole world of Bosch and medieval scatology is conjured up: 'The stokers in hell will be working overtime awaiting your arrival... Well in that case they won't find an oven big enough to get your fat arse through... I am convinced that the noise and smell of your farts will ensure your own arse is permanently employed as hell's own bellows.'[8] That is the language of low life, born out of the bottom of a hellish pit, well known to people in the Middle Ages, and as depicted on misericords it penetrated holy sanctuaries and kept the monks in touch with base humanity. Their visions of holy images were punctured by those of Carnival, of satire and by laughter, and as demonstrated by the hostages, the humour and laughter found under the seats of medieval choir-stalls is still alive today, a life-giving force to people in confined spaces, in solitude and seeking meditation (Pl. 173).

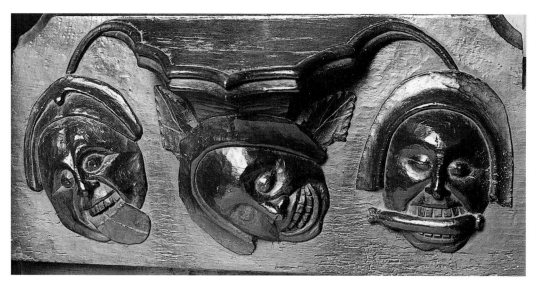

**173**. *Stratford-upon-Avon, Holy Trinity. Three masks with derisory expressions; the one in the centre laughing, the one in the left supporter putting out its tongue, and the one in the right biting on a sausage, associated with Carnival and lust.*

# Part II
# Themes

Part I has acquainted the reader with theoretical questions concerning the history of misericords, their style and stylistic relationships, as well as their sources. It showed that narrative content and humour were the means used by the carvers of misericords to convey lessons in morality and explored how far the boundaries of satire and of the World upside-down were stretched to achieve that end.

Part II concentrates on Iconography; on themes both serious and humorous, narrative and decorative, and popular or more arcane. This part is illustrated profusely, in order to give the reader a glimpse of the wealth and variety of subject matter, and of the imaginative ways it was treated.

The largest section of Part II is on the Bestiary, because animals, in particular the monstrous and mythological ones, were extremely popular with misericord carvers. Since this realm is so large it is impossible to treat all the beasts, so that only the most popular ones have been selected for presentation.

The section on Episodes from the *Bible and Lives of Saints* is long, considering the rarity of such subject matter on misericords, but the depictions are of special interest because of that, and need close scrutiny. *Sin and Mortality* has some unexpected examples.

*The World of Chivalry* illustrates the fact that misericords were also carriers of the Courtly tradition, and in the last section on *Everyday Life*, human activity comes alive on the misericords. On the whole, Part II demonstrates the wide-ranging interests of the carvers, who were well versed in all aspects of life, both religious and secular, and who encapsulated their whole world in the misericords.

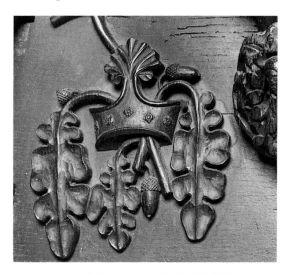

**174**. *Gayton, St Mary Detail of Pl. 182.*
*Supporter with crown and oak leaves.*

# Episodes from the Bible and Lives of Saints

Misericords are not generally associated with biblical subject-matter which was considered too spiritual for so lowly a position under clerical behinds. However, some Old and New Testament scenes, Saints, symbols of the Evangelists and a large number of half-length angels playing musical instruments or bearing shields are found on misericords.

## Old Testament subjects

Old Testament scenes are concentrated on the misericords of Worcester Cathedral, *c*. 1400, which has a biblical tradition.[1] These are the *Temptation* and the *Expulsion of Adam and Eve*, the *Circumcision of Isaac*, the *Bearing of the faggots* and the *Sacrifice of Isaac, Moses and the Brazen Serpent*, the *Presentation of Samuel* and the *Judgement of Solomon* (Pls. 92, 94, 175). Apart from the scenes of *Adam and Eve*, the *Sacrifice of Isaac* and the *Judgement of Solomon*, these carvings are unique to Worcester, but have parallels in thirteenth century manuscripts, in particular Eton College MS 177 and the Peterborough Psalter, *c*. 1400, as described in Chapter 2. The *Judgement of Solomon*, however, is not mentioned in the verses describing the Chapter House wall-paintings, and not illustrated in the Eton manuscript (Pl. 175). Probably the best known and most frequently carved of the Old Testament scenes is the *Temptation of Adam and Eve*. Apart from Worcester, it is found in the cathedrals of Ely, Blackburn and Bristol, where in each case, the devil has the face of a woman, not of a dragon, indicating the use of older prototypes as in Worcester. Generally, Adam and Eve stand on either side of the tree, but because *Adam and Eve hiding in the bushes* and the *Expulsion* are included in the central carving in Blackburn, they are placed in profile to the left of the tree in the *Temptation*, Adam eating the apple and Eve, smaller in size, clinging on to him from behind; apples hang from leafy branches in the supporters. In Ely, animals of paradise sit under fruit-bearing trees in the supporters: ape and lions on the left, birds and rabbits on the right, and the *Expulsion* is accompanied by life on earth (Pl. 176). A misericord from Blagdon, Somerset, now in the Victoria and Albert Museum, London,

shows Eve spinning and Adam delving, both nude, with a fruit tree between them. The only example of *Noah's ark* is in Ely Cathedral (Pl. 177). At the end of the fifteenth and beginning of the sixteenth centuries Old Testament scenes, copied from the woodcuts of the *Biblia Pauperum*, appear in Ripon Cathedral, Manchester Cathedral and Beverley Minster. All three places have the story of *Joshua and Caleb returning from Canaan bearing the grapes* and in addition, Ripon has *Jonah thrown into the jaws of the whale, Jonah coming out of the whale* and *Samson carrying the gates of Gaza* (Pls. 97, 178). *Samson tearing open the lion's jaws* is the most popular of all the Old Testament themes, probably because it involves action between man and beast, similar to knights or saints fighting evil monsters or wild men battling for supremacy over wild animals. Samson sits astride the lion and tries to tear the lion's jaws apart, exposing its teeth, and twisting its head, e.g. Ely Cathedral, where Samson is bearded with long, flowing hair. Often, Samson is a young, fashionably-dressed man, as in Worcester Cathedral, where he wears tight-fitting hose and buttoned jerkin, a low belt and pointed shoes.

## New Testament subjects

New Testament subjects are mainly concerned with the *Life of the Virgin*; Lincoln Cathedral has the largest number which can be compared with contemporary manuscripts and alabaster carvings. The beginning and the end of the Virgin's life are combined on one misericord: the *Annunciation* angel with a scroll stepping forth from the left supporter and the Virgin receiving his message, also with a scroll, standing on the right supporter, while the Virgin enthroned, in the centre, is lifted up into heaven by two angels, representing the *Assumption*. In the *Adoration*, the Virgin with Child sits up against two cushions in a bed, while the three Magi pay homage to her and the Child. Joseph is in the background and the ox and ass are placed below the bed in the foreground. The second king points to the star of Bethlehem, while the old, kneeling king has taken off his crown and placed it over his arm like a bracelet. An angel in the left supporter plays a

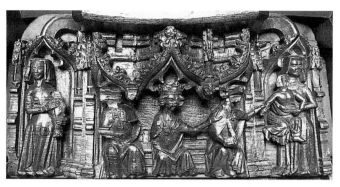

**175**. *Worcester Cathedral. The Judgement of Solomon (I Kings 3:16–28). The scene develops from left to right as though on a stage punctuated by doorways and arches. On the left, the dead child wrapped in swaddling clothes is brought in by one of the women; in the centre, the Queen, King Solomon and his Officer with sword at the ready sit next to each other. The Officer grabs the live child by the wrist, struggling in the other woman's arms, for in order to discover the true mother, King Solomon had threatened to have the living child cut in two, whereupon the woman who would rather lose the child than have it killed is recognized as its true mother.*

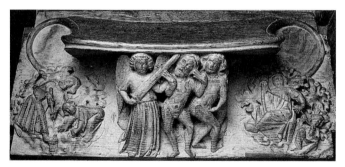

**176**. *Ely Cathedral. In the centre, the Expulsion from Paradise. In the supporters, life on earth; on the left, Adam digging helped by his son, who may be gathering stones, and on the right, Eve spinning, with her daughter holding the ends of the yarn.*

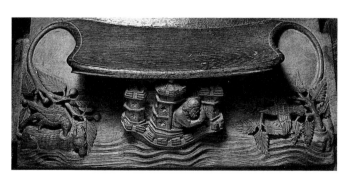

**177**. *Ely Cathedral. Noah's Ark. The ark is a floating, battlemented castle with three towers; Noah hails the dove returning with the olive branch from the right supporter, while in the left supporter, a raven pecks at the carcass of an ox.*

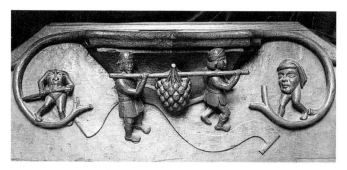

**178**. *Ripon Cathedral. Caleb and Joshua, who had been sent by Moses to spy out the Promised Land return from Canaan bearing grapes (Num. 13:23). Grapes were interpreted as a Eucharistic symbol, linked with the blood of Christ. This scene is copied from the 'Biblia Pauperum'. In the supporters, Blemyae, headless creatures with their faces in their chests.*

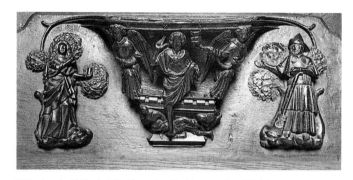

**179**. *Lincoln Cathedral. In the centre, the Resurrection. Christ blessing, flanked by two angels, one swinging a censer, steps out of the tomb on to one of the sleeping soldiers. The figures in the supporters represent the scene of 'Noli me Tangere': St Mary Magdalene with her ointment jar on the left, and Christ dressed as a gardener with his spade, on the right, the garden indicated by trees. Christ using one of the soldiers as a stepping stone and dressed as a gardener may point to the influence of mystery plays performed by the guilds.*

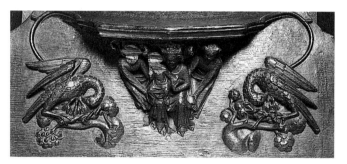

**180**. *Chester Cathedral. In the centre, the Virgin and Child enthroned; angels on either side of her throne seem to be lifting her into Heaven. Both supporters depict the Pelican in her Piety, showing the Pelican piercing her breast to feed her young with her blood, just like Christ who shed his blood for the salvation of humanity.*

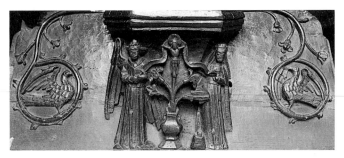

**181**. *Tong, St Mary and St Bartholomew. In the centre, the Annunciation. The scroll, signifying the greeting of the Angel and the Virgin's reply, frames the Crucifixion which sprouts from the vase of lilies. In the supporters, birds, probably doves, represent the Holy Spirit.*

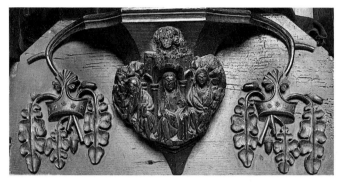

**182**. *Gayton, St Mary. Three Maries at the Sepulchre. The angel telling the women that Christ has risen from the tomb is seen above them. The supporters are crowns from which issue oak leaves with acorns.*

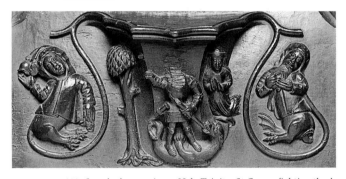

**183**. *Stratford-upon-Avon, Holy Trinity. St George fighting the dragon. The Princess whose life he is thus saving is kneeling nearby. In the supporters, half-human, half-animal creatures, the one on the left with a bell tied to its hood.*

**184**. *Canon Pyon, St Lawrence. St Catherine's wheel. This is the Saint's emblem of martyrdom, although she did not die on it.*

hand organ, but the one in the right supporter has lost his instrument. The *Coronation* takes place under a double-arched canopy of tracery, and the Virgin and Christ who crowns her sit facing the viewer. Musician angels play in the supporters.

Of the later life of Christ, the *Resurrection* and *Ascension* are depicted (Pl. 179). In the *Ascension*, only Christ's feet are visible under a ring of clouds, as though lifted heavenwards by the praying hands of the kneeling apostles, and angels swing censers in the supporters. Although many of the Lincoln misericords became patterns for those in Chester, of the New Testament subjects only the *Coronation* was transmitted. The *Resurrection* was carved in the nineteenth century and it is not known whether there was one as in Lincoln originally. Chester, however, has a *Virgin with Child enthroned*, associated with the *Pelican in her piety* in both supporters (Pl. 180).

Other choir-stalls have one or two New Testament scenes: St Mary Magdalene, Leintwardine, and St Mary with St Bartholomew, Tong (Shrops.), have similarly interesting *Annunciations* (Pl. 181) and, in addition, in Leintwardine a *Resurrection*. St Mary's, Gayton, is unique in its misericords of *Christ entering Jerusalem* and the *Three Maries at the Sepulchre* (Pl. 182); this may be related to the performance of mystery plays, a supposition further substantiated by the presence of two other misericords: the *Last Judgement* and the *Devil dressed in feathers*. Symbols of the Evangelists are also found on misericords but only St George's, Stowlangtoft, Suffolk, has all four evangelist symbols, with scrolls.

When considering the *Saints*, St George and St Michael are the most popular with the carvers, and many of the single saints found in various churches may have had local or personal associations. However, St George cannot always be definitely identified because of his similarity to a knight fighting the dragon, in particular the good Christian knight who has the same characteristics. One can only be certain if the Princess is included as in Holy Trinity, Stratford-upon-Avon (Pl. 183), or in St George's, Windsor, where the king and queen also watch from their castle, and where, of course, the chapel is dedicated to St George. The identification is more hazardous in St Mary's, Nantwich, and St Botolph, Boston, for example, where in the one a knight fights on foot, and in the other on horseback, both in con-

temporary armour, and therefore possibly knights. The dragon is evil personified, and when St Michael slays the dragon, he does battle with Lucifer, the fallen angel. In Norwich Cathedral *St Michael* slays a seven-headed dragon, representing the seven deadly sins. Often, St Michael, one of the Archangels, with powerful wings, is dressed in feathers, and he spears the dragon through its gaping mouth, e.g. in Carlisle Cathedral (Pl. 41), or in St Andrew, Greystoke, where St Michael, again, is in feathered dress but also wears a coronet with a cross. Of the very popular saints in the Middle Ages, *St Margaret*, patron saint of women in childbirth, is seen in Sherborne Abbey re-emerging from the belly of the Dragon, her hands folded in prayer. St Catherine is not found in person, but *St Lawrence*, Canon Pyon, has a Catherine wheel with sharp blades as the main theme of a misericord (Pl. 184). *John the Evangelist boiled in oil* is depicted on a misericord in Lincoln Cathedral, with two men stoking and fanning the fire under the cauldron containing the now destroyed figure of the Evangelist. In St Martin's, Fornham (Suffolk), only two misericords remain, of which one shows *St Martin*, the church's patron saint, dividing his cloak, and the other, the only *Martyrdom of St Thomas of Canterbury* on English misericords (Pl. 185). St Andrew's, Norton (Suffolk), has the *Martyrdom of St Andrew*, the patron saint, as well as the *Martyrdom of St Edmund*, where archers shoot arrows at him from the supporters. A misericord unique to Chester Cathedral tells the story of *St Werburgh performing a miracle*, because the Norman abbey was dedicated to this seventh-century abbess whose shrine still stands in the Cathedral (Pl. 186). Ely Cathedral misericords have the largest number of saints, their stories told with great attention to detail and narrative which extends into the supporters, such as the most dramatic of them all, the *Beheading of St John the Baptist* (Pl. 88). On another misericord, *St Giles* is shown sheltering underneath the bower of two oak trees, protecting the deer which has taken refuge in his lap with one hand and holding his rosary with the other, while hunters shoot at the deer with bows and arrows from the supporters. *St Martin*, on horseback, splits his coat to share with the beggar, while in the left supporter, God in heaven with two angels by his feet is sending his blessings, and in the right supporter, *St Martin* as

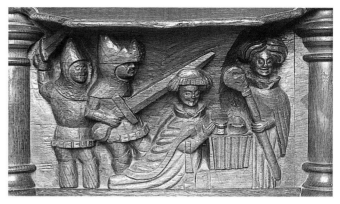

**185**. *Fornham, St Martin. The martyrdom of St Thomas of Canterbury. The carver has vividly portrayed the drama inside Canterbury Cathedral, while St Thomas is saying Mass.*

**186**. *Chester Cathedral. St Werburgh performing a miracle. The legend depicted tells of a flock of geese that had damaged the crops of the abbey lands of Weedon so that the Saint saw fit to have them penned in, as seen in the left supporter. When she came to let them out, the geese told her that one of them had been killed. The right supporter shows the goose-thief confessing that he had killed and eaten the goose. In the centre of the misericord, the Saint with the left-over bones in a basin on a stand, brings the goose back to life, whereupon it flies off to join the rest of the flock.*

**187**. *Hexham, Abbey of St Andrew. A cleric looking over a castellated corbel, holding two keys in his left hand and possibly a monstrance or a relic in his right hand. Although he is wearing a beret and not the tiara, he may be the Pope, because of the keys, and the scene may be of the showing of relics to the populace.*

bishop is exorcizing the devil from a nude woman. The scene of the man falling off his horse has been interpreted as part of the *Legend of St Withburga* (Pl. 39).[2] A very interesting misericord in Hexham Abbey shows a figure who may be a priest or even the Pope holding up relics of saints for veneration (Pl. 187).

A very large number of misericords bear *Angels*, full-length or half-length, mostly playing instruments or holding shields or scrolls (Pl. 188). In Chester Cathedral, a four-winged seraph in feather-dress sits holding instruments of the Passion, while in Boston, St Botolph, two angels hold the ends of the rope wound round the pillar at which Christ was scourged. Often, they are dressed in flowing robes, playing citterns, lyres or viols, and in Worcester Cathedral, many are framed by elaborate canopies, e.g. Angel playing a viol. One angel in Worcester Cathedral, standing under a canopy, head missing, has a flaming heart on his breast. The half-length angels are cut off by a band of stylised clouds, as in Carlisle Cathedral, where one plays a cittern, another a tabor. Some shield-bearing angels, also in Carlisle Cathedral, have the shields strapped over their shoulders with bands. The shields may be blank; they may have the cross of St George or identifiable arms. In Manchester Cathedral, for example, the arms of the Isle of Man, associated with the family of Warden James Stanley, who was responsible for the misericords, are to be found (see p. 75 in connection with the clergy's involvement with their choir-stalls).

Looking back over the use of religious subject-matter on misericords, it is sparsely distributed, with some cathedrals specialising in a series of related narrative scenes. In such cases, the clergy must have given special instructions on iconography to the carvers and supplied them with patterns. Interestingly, there are no carvings of the Death of Christ from the Passion, such as the Crucifixion, the Descent from the Cross or the Entombment, only the Emblems of the Passion. Probably, religious subject-matter was not considered characteristic misericord material, so that there had to be a specific reason for concentrating on it. In general, however, it was not the spiritual life of holy personages, but the low life of human beings that provided the inspiration for misericords.

**188**. *Bishop's Stortford, St Michael. In the centre, the bust of an angel holding a scroll; in the supporters, heads of angels. They are seen above rings of stylized clouds.*

# Sin and Mortality

In the preaching by means of *exempla* moral lessons were less often conveyed with the help of Bible stories; instead, sinning and foolishness on earth are associated with animal nature. Animal nature is the true subject matter of misericords. Thus, it was not the spiritual life of holy personages, but the temptations of the flesh, the human vices which provided the inspiration for misericord carvings, none so explicitly as the personifications of the *Seven Deadly Sins*, all seven of which are combined as the seven heads of a *Hydra* on a misericord in New College Chapel, Oxford (Pl. 189). Life was pictured as a constant combat between Good and Evil, as represented by the *Virtues fighting the vices*, or as a *Nude figure issuing from a shell fighting a dragon*, found on a number of misericords, as in Chester, Lincoln (Pl. 118), Manchester, and Beverley Minster. So, the battle begins from birth itself. Every vice was associated with an animal, for animals personify human weaknesses. Thus, *Lechery* is represented as a naked figure riding a goat, stag or ram, all personifying lust, as in Stratford-upon-Avon (Pl. 190). Whereas in the thirteenth century the virtues were more usually portrayed, by the fifteenth century the vices outnumbered the virtues; these were much more realistically depicted, often with a touch of humour—for instance *Gluttony* in Norwich Cathedral. A man sits on the traditional animal, the pig, but as is common, Gluttony is personified by a drunkard and the pot-bellied man sits precariously, leering into the large tankard he is emptying. Many misericords show people addicted to the barrel, for example in Ludlow Parish Church, where two men are seen venerating a barrel like an idol, and in All Souls College Chapel, Oxford, a man by the barrel is shown in a happy state (Pl. 26). The devastating effects of drink were much decried by preachers and found expression especially in early sixteenth-century prints. The fear was that one sin would lead to another; drink in particular, being associated with gambling, found in Manchester Cathedral, might lead to fighting. That leads on to the sin of *Anger* or *Wrath*, which is represented on a misericord in Norwich Cathedral (Pl. 191). A misericord in St George's Chapel,

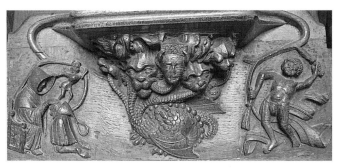

189. *Oxford, New College Chapel. In the centre, a hydra representing the Seven Deadly Sins. The head in the middle with human face and coronet-type head-dress probably represents Pride, closely related to all the other sins. In the left supporter, a man confesses to a priest who absolves him from his sins, indicated by the little devil leaving him. In the right supporter, a man is doing penance by flagellating himself.*

190. *Stratford-upon-Avon, Holy Trinity. The sin of lechery, showing a naked woman riding on a stag. She holds a flower in one hand, sign of the month of May, the month associated with the Children of Venus and therefore, love. Her other hand stretches towards a scroll, probably meant to convey seductive words.*

191. *Norwich Cathedral. The sin of wrath. This shows a man gritting his teeth, his eyes glaring, riding a fierce boar and about to draw his sword.*

Windsor shows two men on either side of a gambling table coming to blows, daggers drawn, while the cat has been rudely disturbed from its snooze. Three men in quilted jerkins in New College Chapel, Oxford, face two others in the supporters, all with drawn daggers and swords (Pl. 75). *Laziness* or *Sloth* is another sin that is often the result of too much drink, and in the fifteenth century usually indicated by a person reclining on a cushion, as in Fairford or St David's Cathedral. While drowsing or sleeping a person will be off his/her guard against the temptations of the devil, and the thoughts of men, in particular, may wander in the direction of sexual fantasies. On a misericord in New College, Oxford, a half-figure woman is resting her head on her hand and her elbow on a cushion. She is nude with prominent breasts and, with harpies in the supporters, gives a good indication of her powers of temptation. She thus personifies lecherous thoughts and is a combination of *Lust* and *Sloth*.

Wealthy merchants, above all, were prone to the sin of *Avarice*, the consequences of which were much feared in well-off countries like fifteenth-century Flanders. On a misericord in New College Chapel, Oxford, a contorted monster with bat-like ears holds himself closely as though trying to keep himself to himself, clutching small money bags in his hands. In Beverley Minster, *Avarice* is in the left supporter opposite *Gluttony* in the right supporter of a misericord showing a *Demon running after a woman* (damaged). A man sits before his money chest counting his money, while the devil lurks beneath, supporting it. If Death arrived at this moment, his soul would most certainly be damned. This drama of Death arriving to claim the wealthy man sitting among his possessions is well exemplified in St George's, Windsor (Pl. 192).

*Envy* is best recognized in scenes of dogs fighting over a bone, also known as a proverb. This is represented on a misericord in St David's Cathedral and on another in Windsor; the scene has become a tumultuous fight between several dogs competing for food from a pot on the boil.

*Pride* is best known from the proverb 'Pride comes before a fall' which may explain a representation in Ely Cathedral where a hunter topples head first from his horse, while a woman in the right supporter prays for his soul (Pl. 39).[1] With women, *Pride* and *Vanity* went hand in hand,

**192**. *Windsor Castle, St George's Chapel. The Dance of Death. In the centre, a rich man sits with all the accoutrements of his wealth; his official position is marked by his chain of office and the dagger placed across his knees, but Death will have him nonetheless, locking his bony hands around the miser's arm. His worldly possessions will count against him in the hour of death, for as the handbook on 'Ars Moriendi' (How to die well) teaches, humans must discard their worldly goods in order to gain admittance to Heaven. The supporters are not illustrated; in the left one, Death catches a labourer by the hair, while he is digging in the field, and in the right one, another man is caught while threshing (part of his flail remains).*

**193**. *Ludlow, St Lawrence. In the centre, the bust of a woman in a horned head-dress. She is bridled, which marks her as a scold. The 'horns' of the head-dress were associated with the devil, who could take up residence between them, as seen in Minster-in-Thanet, Pl. 126. The men in the supporters are probably fighting over the woman, as in Israhel van Meckenem's engraving, Pl. 151.*

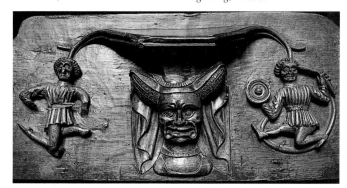

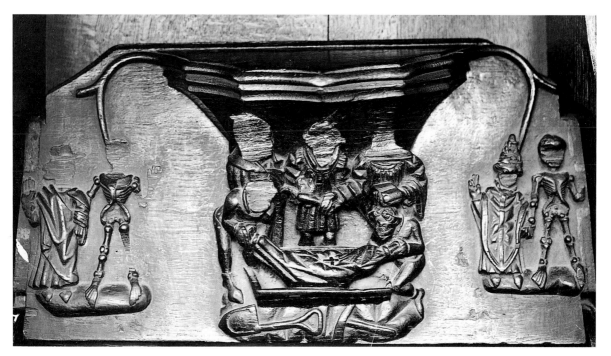

**194**. *Formerly in Coventry Cathedral, destroyed in the Second World War. A burial and the Dance of Death. The burial in the centre is one of the Seven Works of Mercy; the dead person is lowered into the grave in a shroud with a cross on it; underneath lie a shovel and a pick-axe. Three men stand over the grave, a priest with a book, swinging an aspergillum, on the right. In the left supporter, Death has grabbed a man who puts up his hand in resistance and looks away; he is possibly a King or an Emperor. In the right supporter, Death has taken hold of the Pope, who, quite unaware of his presence, is still blessing.*

given expression by the horned head-dress, the seat of the devil and his evil whisperings, as in St Lawrence, Ludlow, and St Mary's, Minster-in-Thanet (Pls. 126, 193). On another misericord in Minster-in-Thanet, a harpy in horned head-dress has taken up the centre and a bird-siren and a snake, the very epitome of evil, also wearing horned head-dresses are found in the supporters. On a misericord in New College Chapel, Oxford, a most attractive, smiling harpy personifies *Pride*; a ring hangs on a string of beads around her neck, with which to tempt men.

In the fifteenth century in particular, there was an obsession with *Sin* and *Death* and people were constantly warned of the dire consequences of death without repentance, not only in sermons but visually in depictions such as the Last Judgement, the Dance of Death and the Three Living and the Three Dead. Themes like these are rare on misericords, but the more noteworthy for their rarity. A good example was to be found in Coventry Cathedral where the misericords, destroyed in the war, had a Dance of Death as part of the Seven Works of Mercy, as well as a Last Judgement, a Tree of Jesse and a chained devil.

This emphasis on doom and death was probably due to the fact that Coventry Cathedral used to be the parish church of St Michael, a saint associated with Judgement.[2] The *Dance of Death* is seen in the supporters of three misericords treating the *Seven Works of Mercy*. In one, showing *The clothing of the naked* in the centre, Death leads a layman in a long cloak with a staff in his hand, in the left supporter, and a bishop in mitre and chasuble in the right supporter. In another, Death takes a cleric by the hand, in the left supporter, and possibly a layman in the right one, for the outline of a hat of the otherwise obliterated figure is still visible. The central carving here represents a *Man lying on his deathbed*, while a woman standing by his side makes him comfortable on his pillow; a rich man with a young boy is offering the sick man something, possibly money. On the third misericord, *The Dance of Death* surrounds a *Burial* in the centre (Pl. 194). A *Dance of Death* is still extant on a misericord in St George's Chapel, Windsor, already mentioned in connection with *Avarice*, where in the supporters Death comes to one labourer digging, another threshing (Pl. 192). All too often, though, death will come unexpec-

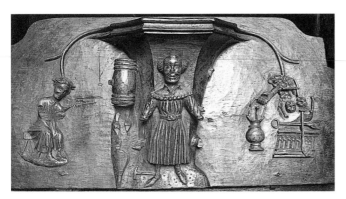

195. *Ludlow, St Lawrence. In the centre, a well-dressed merchant in the ale business stands next to a barrel, pattens, bellow and hammer beside him. A man sitting in the left supporter, originally pointed across at the 'memento mori', showing a tomb, spade, shovel, bones and skulls, and the hand of the sexton holding the holy water stoup with aspergillum, in the right supporter. This was a warning, even to the healthy and wealthy to always be prepared for sudden death.*

196. *Norwich Cathedral. A man and a woman holding hands; a dog at her feet, a lion at his. They can be identified as Sir William Wingfield of Letheringham, died 1378, and his wife Margaret Boville, by the coats of arms in the supporters: left, Wingfield, on a bend three pairs of wings; on the right, Boville, quarterly.*

tedly and the rich man, as in the misericord, and in one of Hans Holbein's woodcuts of the *Dance of Death*, is caught sitting in the midst of his treasures, desperately trying to hold on to them, and thus guilty of the sin of *Avarice*.

The skull as a symbol of death, a memento mori, is found in the left supporter of a misericord in Ely Cathedral, where a woman with bare feet kneels beside a man sitting, her hands clasped in ardent prayer. A more elaborate example of a memento mori is in Ludlow (Pl. 195). Sudden deaths were

kept alive in people's minds, not only through visual warnings of doom and damnation but because of the very realities of life, experienced in the frequency of famines and plagues. The sickbed is depicted on misericords in Malvern Priory (Pl. 58) and Tewkesbury Abbey, closely related in composition. A few misericords can even be compared to tomb sculptures or brasses, such as that in Norwich Cathedral, of Sir William Wingfield of Letheringham and his wife Margaret, identified by their coats of arms in the supporters (Pl. 196).[3]

# The Bestiary

By far the most popular subjects on misericords are animals: mythical, grotesque and natural. Not only do these beasts act as space-fillers on an enormous number of choir-stalls, but they also give meaning to the undersides of the seats, for most of them derive from the medieval Bestiary. The Bestiary is based on classical accounts of creatures in the *Physiologus* to which were added Christian morals.[1] An example from another classical source, Pliny's *Natural History*, is the *Blemyae*, a man with his head in his chest, found on misericords now in the Victoria and Albert Museum, in Norwich Cathedral holding a sword and in Ripon Cathedral (Pl. 178). The Bestiary was immensely popular in the Middle Ages, and because it was translated into the vernacular, everyone was familiar with the beasts and their moral connotations,[2] making classical mythology into an important source of Christian symbolism.[3] The Bestiary included a large number of animals, both real and imaginary, yet only a small selection of favourites was repeated on misericords, probably those of which the carvers understood the symbolic meaning[4] and for which they had patterns.

The *Pelican in her Piety* seems to have satisfied both these requirements, for it is found in a very large number of misericords representing positive, Christian qualities. The theme also illustrates very well to what extent a natural creature has been given meaning and transformed into a Christian symbol by the Bestiary. Generally, the Pelican is seen feeding its young with the blood from its own pierced breast, thus emulating Christ who shed his blood on the Cross for the salvation of humanity (Pls. 180, 197). More unusual is the depiction of the event preceding the feeding of the young as told in the *Physiologus*: the offspring strike the parent birds, whereupon the parents kill the fledglings, as depicted in Lincoln Cathedral (Pl. 197).

Another popular example of Christian virtue is the *Unicorn*, symbol of chastity, because according to the *Physiologus*, it will kill a maid who is not pure. It is exceedingly swift and therefore has to be caught by deceit after it has laid its head into the lap of a virgin. The Unicorn thus sym-

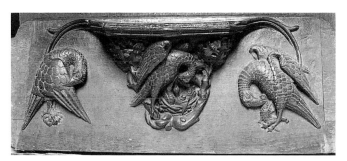

**197**. *Lincoln Cathedral. The Pelican in her Piety. In the right supporter, the pelican first slays the young bird by biting off its head and then in the central scene pierces her breast to revive her brood with her own blood, which is interpreted as a parallel to the Fall and the Redemption of man. In the left supporter, the Pelican preens its feathers.*

**198**. *Greystoke, St Andrew. Capture of the unicorn. The unicorn can only be caught after it has laid its head into the lap of a virgin; it is a symbol of Christ, born of the Virgin and crucified.*

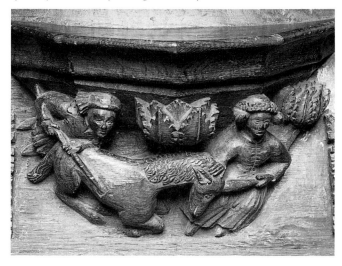

bolises Christ, born of the womb of the Virgin, crucified and resurrected. This is how it is illustrated on misericords, with a soldier spearing the Unicorn, as in Lincoln and Chester Cathedrals, St Mary's, Nantwich, and St Andrew's, Greystoke (Pl. 198). In Chester and Greystoke the young virgins hold the horn of the Unicorn, and in Lincoln a soldier in armour kills the beast, while in the other examples he is a huntsman. In Ely Cathedral, the maiden folds both arms around the small Unicorn in her lap like a pet dog, while the men approach from the supporters, the one on the left armed with axe, sword and shield, the one on the right with a long stick and a sword. A rarer method of capturing it is to taunt it from behind a tree so that it will charge and get its horn stuck in the tree. On a misericord in Cartmel Priory, it plunges its horn into water, symbolizing the new life given by Christian Baptism (Pl. 199). Unicorns are also represented alone, the best known example being in Durham Castle Chapel, where it tramples on a human headed Snake or Dragon. In St Mary's, Bampton (Oxon), St Mary, its horn is like a stump, and in Manchester Cathedral the horn is serrated.

The *Lion* could symbolise either good or evil, Christ or the Devil, depending on its associations in the various stories. It was very popular with carvers, and on a misericord in Exeter Cathedral it is seen prancing along on its own, tail lifted, demonstrating its great strength. The lion mask was a favourite motif for the supporters (Pls. 211, 232). One of the stories concerned the lion's powerful roar: as the cubs are born dead, the lion must roar over them on the third day and bring them to life with his breath, thus symbolising the Resurrection, as in Lincoln Cathedral. A large number of misericords show the *Lion fighting the dragon*, where the strength of the lion could be most effectively demonstrated, and the two interlocking animals grappling with each other would form a most suitable shape on the misericord. In this case, the meaning is of good (the lion) fighting evil (the dragon); examples can be found in almost every cathedral (Pl. 200).

A natural animal popular with misericord carvers, yet not known from life to most of them, was the *Elephant*. According to descriptions and illustrations in bestiaries, it had a long nose and carried a wooden tower on its back, from which Indians and Persians fought. This then is how

**199**. *Cartmel Priory. A unicorn plunging its horn into the water at the base of a tree. This represents the unicorn, another symbol of Christ, purifying the water.*

**200**. *Chester Cathedral. A lion fighting a dragon. This image often found on misericords symbolizes Good (the lion) fighting Evil (the dragon). In the supporters, wild men ride on dragons; being in tune with nature they are able to subjugate the wild beasts.*

**201**. *Garstang, St Helens. The Elephant and Castle. According to the Bestiary the elephant carried a wooden tower from which Indians and Persians fought. Elephants are rarely portrayed realistically, and were usually copied from patterns.*

most elephants are portrayed on misericords, with a variety of crenellated, fortified castles on their backs. In Gloucester Cathedral, the elephant has a high tower with battlements strapped to his back; this one has horse's hooves and tail. A camel joins the elephant in St Botolph's, Boston, in the supporter. It kneels down to be loaded, an action equated with Christ taking on the burden of the world's sins. In St Helen's, Garstang, the Elephant's trunk is lifted high and the castle consists of a gateway flanked by two high towers (Pl. 201). In Manchester Cathedral, the elephant (trunk broken off) carries a most elaborate castle with an octagonal, roofed keep encircled by curtain walls with corner towers. There are no fighting soldiers on any of these towers, probably because there was not enough room underneath the bracket. In Beverley Minster, however, the elephant is driven on by an ape, beating him with a stick, from behind; in the left supporter rests a camel, and in the right one a lion, both associated with Christ. The Bestiary also mentions that the elephant has no joints in its legs and therefore has to lean against a tree in order to rest. If, however, a hunter cuts through the tree, the elephant will fall and not be able to get up. After failed attempts by other elephants to raise it, a young elephant puts its trunk under the fallen elephant and lifts it up again. The symbolism here refers to Adam falling into sin through eating from the tree and being redeemed through Christ, coming after the prophets. This is the story of the elephant told in Cartmel Priory (Lancs.), where the elephant's belly rests on a tree-trunk. An exception to the fantastic depictions of elephants is the one in Exeter Cathedral, identified as African, because of the fairly correct portrayal (Pl. 202); it is probable that the carver obtained a pattern similar to the drawing of the elephant made from life by Matthew Paris.[5]

Many of the original accounts of animals by Pliny were given moral meanings in the Bestiary as warnings against the deceit of the devil. Such is the case of the *Tigress* whose cubs have been carried away by the hunter. In Pliny's version the hunter throws one cub at a time to the pursuing tigress until he has reached the safety of his ship. In the Bestiary, however, instead of throwing down cubs, the hunter throws down a mirror, thus deceiving the tigress into believing she has recovered her cub when she stops to look at her own reflection in the mirror, a scene illustrated on a misericord in Chester Cathedral (Pl. 203).

A vast array of lethal beasts such as the Dragon, Wyvern and Griffin was created out of parts of different animals. They had a long ancestry in Egypt, Assyria and Persia and are also vividly described in Ezechiel and the Apocalypse. Of the *Dragon* the Bestiary says that its teeth were less dangerous than its habit of lashing out with its

202. *Exeter Cathedral. This elephant is considered the most accurately depicted among the misericord carvings except for its feet. Few people had seen real elephants, but in 1255, when the Exeter misericords were being carved, Henry III was given one by Louis IX of France which was taken in procession to the Tower of London. It was drawn from life by Matthew Paris whose drawing might have been seen by the carver. Left supporter, the head of a woman in a 'barbette', the head-dress of the period; right supporter, the head of a monk with a tonsure.*

**203**. *Chester Cathedral. A galloping knight throwing a mirror to a pursuing tigress whose cub he has taken. This is a warning against the deceit of the devil and the love for objects of luxury, for as seen in the left supporter, the tigress has stopped to look into the mirror, licking it in the belief that she sees her cub, thus giving the knight time to get away.*

**204**. *Carlisle Cathedral. A wyvern, convulsed with laughter. The wyvern looks exactly the same as the dragon, except that it only has two legs.*

**205**. *Weston-in-Gordano, St Peter and St Paul. A wyvern with a barbed tongue. It has a head that looks both forwards and backwards, and the arrow in its front jaw indicates the barbed tongue. There are dragon heads at the ends of the supporters.*

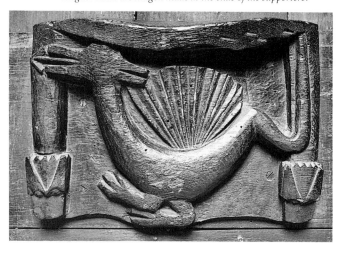

tail, and the Apocalypse speaks of 'a great red dragon having seven heads and ten horns'.[6] The descriptions of the dragon varied greatly, and in the end it was usually depicted with one head, rather than the seven of the Apocalypse, four legs and bat wings (Pl. 200), and it always represented the serpent, the devil. Almost indistinguishable from the dragon is the *Wyvern*, except that it has only two legs. A magnificent example of a wyvern is found in Carlisle Cathedral; another, more crudely carved, is in St Peter and St Paul, Weston-in-Gordano, (Pls. 204, 205). The dragon, wyvern and yet another monster the lindworm (a wyvern without wings, to be found in Christchurch Priory), can be distinguished only with difficulty, the more so as carvers are not consistent in their portrayals. A related beast is the *Griffin*, a quadruped like the dragon but with the head, neck, wings and talons of an eagle and the hindquarters of a lion. Griffins were considered immensely strong, and in the medieval imagination, the 'strong birds' that lifted Alexander the Great into the sky became griffins (Pl. 225). In Beverley, St Mary's, two Griffins flank the Tree of Life, and in Ripon Cathedral, a griffin is pecking at a human leg which is all that remains of a man.

Many other mythical beasts struck terror into the minds of people in the Middle Ages, against whose evil intent they felt totally powerless, in particular if they gained supremacy through deception. These were the real incarnations of the devil. One such example is the *Cockatrice*, also known as the *Basilisk*, of which there are impressive examples in Worcester Cathedral and Great Malvern Priory. (Pls. 59, 60) The cockatrice in Richmond (Yorks.), St Mary's, has been made doubly evil by an additional head at the end of its tail, also a characteristic of the *Amphisbaena*, to be found in Tewkesbury Abbey and St Mary the Virgin, Godmanchester (Pl. 206). The *Manticora* was known for its great hunger for human flesh. It has a human face, eyes and mane of a lion, scorpion's tail and the flight of an eagle. There are two specimens in Carlisle Cathedral: they have a man's bearded face and strong wings; one has human hands at the ends of lion's front paws and a lion's tail. The moral of having to be on guard against the devil is vividly expressed by a *Hyena is devouring a corpse* in Carlisle Cathedral (Pl. 86).

There are innumerable composite, grotesque creatures on misericords, loosely based on the

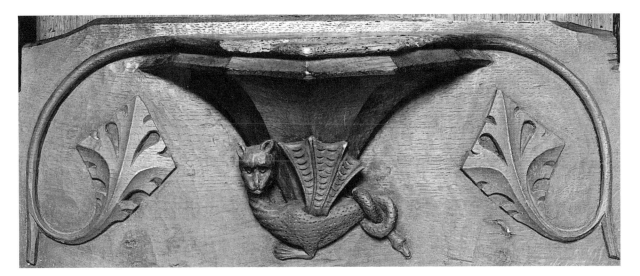

Bestiary but difficult to identify, due to the imaginative variations of the carvers. Basically, they represent evil. Chichester Cathedral, above all, has a large variety of quadrupeds with human heads or animal heads with human bodies, two heads with one body or two bodies joined by one head, and serpentine beasts intertwined and biting into each other (Pls. 9, 10, 207). There are several examples of two human heads on one body under a cowl; there is also a lion with two bodies, and sometimes the tails of certain beasts end up in the supporters where they gain second heads, either human or animal. Other beasts in Chichester are combinations of dog-like heads with wings, and all kinds of mutations of dragons. In Worcester Cathedral too, there is a concentration of hybrid forms, merging animal bodies, bird wings, hooves or claws and human or animal heads.

All these are the anthropomorphic and zoomorphic beasts of Romanesque sculpture against which St Bernard inveighed in his letter to William, Abbot of Thierry.[7] He mentions monkeys, lions, fighting knights, hunters, monstrous Centaurs, half-humans, many-bodies with one head or many heads with one body, all of which he recognises as obstacles to the monks' meditations on matters spiritual in the cloisters. These, however, form the very essence of misericords from the thirteenth to the sixteenth centuries, in particular in the thirteenth and early fourteenth centuries. St Bernard did however admit such crude, non-spiritual imagery in non-monastic sanctuaries such as cathedrals, and excluded the laity from his indictment, making concessions to their sensuous imagination.[8]

Early misericords, such as those in Exeter Cathedral are still close to the designs on Romanesque sculpture and historiated initials of manuscripts, and apart from the mythical beasts already considered, they reveal a predilection for Sirens and Centaurs, also taken from classical sources. *Sirens*, also known as *Harpies*, are birds in body with human faces, of which a great variety exist on the misericords of Exeter Cathedral, singly or in male/female pairs (Pl. 36). Their sweet music would charm gullible human beings and lead them astray. The siren's beauty and power to enchant are supremely well expressed

**207**. *Chichester Cathedral. Two cowled heads back to back without bodies.*

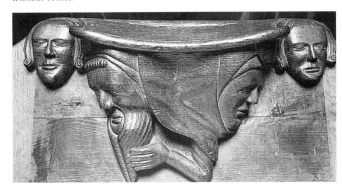

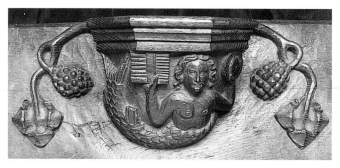

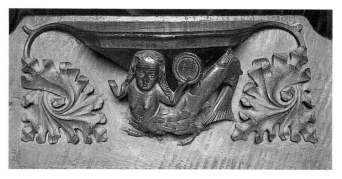

208. *Halifax, St John. A mermaid with comb and mirror. The mermaid is the symbol of temptation, her vanity and pride seducing sailors who forget about the sea and its rocks when listening to her.*

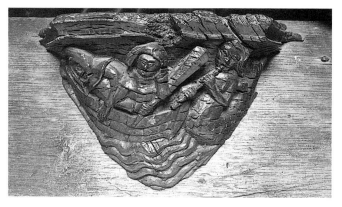

209. *Carlisle Cathedral. A mermaid whose body is half-bird, half-fish, indicating her association with the harpy. She is holding a mirror but the comb is now missing.*

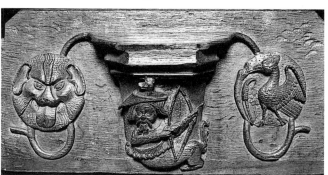

210. *Boston, St Botolph. A mermaid piping to the sailors. Here, we see the mermaid at work, seducing the sailors to sleep with her sweet music.*

211. *Walsall, St Matthew. A centaur shooting at a bird in the right supporter which in turn attacks a snake. The centaur wears a rather cocky hat. In the left supporter, a lion mask.*

in a misericord in Lincoln Cathedral, where a swan with a crowned female head raises itself majestically out of the water. Bird-sirens came to be confused with fish-sirens, the *Mermaids* who took on the same characteristics and are still well known for luring sailors to their doom. Many of the misericords show alluring mermaids holding comb and mirror, symbols of vanity and lust, with which they lead man to damnation (Pl. 208). Renaissance carvers, in particular, delighted in giving expression to their sensuous qualities, as in Henry VII's Chapel, Westminster. Misericords of mermaids became very popular, possibly because of their adaptable shape which could be easily fitted into the underside of the seat. They provided the challenge of carving sensuous forms to express a moral. In Cartmel Priory the mermaid has two fish-tails for symmetry, out of which her body rises; in Ripon Cathedral the mermaid holds a comb and a mirror, as she does in Ludlow Parish Church, where she is flanked by two dolphins in the supporters. The transformation from siren to mermaid can be seen on a misericord in Carlisle Cathedral (Pl. 209); in All Saints, Hereford, two mermaids of this type have come together and in St Botolph, Boston, it is the bird-siren who causes the sailors' downfall (Pl. 210). In Exeter Cathedral, a mermaid and a merman, she in a thirteenth century tight-fitting head-dress, a 'barbette' and fillet, and he in a coif, are beating a tabor over a painfully contorted face, as though celebrating the descent of a human being into their watery realm. In Tewkesbury Abbey a complete choir-stall is given over to the subject-matter of the *Temptations of Mermaids*: two mermaids face each other and one hands the other her comb; they are not half-woman, half-fish, but their heads and arms emerge from the mouths of large dolphins, and the backing of the choir-stall is decorated with two serpents. Sometimes, mermaid and merman appear as couples, as in Exeter Cathedral, or in Holy Trinity, Stratford-upon-Avon, where the merman holds a stone, while the mermaid combs her hair and holds the handle of a now broken mirror. The merman on his own is a rare occurrence, but he is found in St Mary's Hospital, Chichester, where he wears a hood and short cape. Instead of comb and mirror, the mermaid often holds a fish in her hand, as in Winchester and Exeter Cathedrals. The fish signifies the

Christian soul, and thus, the temptress has caught the human being who failed to guard against evil. She deceived him with her sweet talk, leading him to sin and damnation. Whereas the mermaid in Lincoln Cathedral is placed between two lions in the supporters, the mermaids in Wells, Hereford and Norwich Cathedrals and St Mary the Virgin, Edlesborough (now a copy of the original one which was stolen) suckle a lion (Pl. 31). The meaning of this is baffling, but must have been known to the carvers who had probably heard some moral story and been supplied with a pattern. As we have seen, the lion stands for both good and evil, Christ or the devil. Here, he is being nurtured by the mermaid, a creature half-animal, half-human and a symbol of pride. Unless it is another image of the world upside-down, the lion must surely be sucking in negative qualities, such as vanity and pride.

The *Centaur*, well known in Greek and Roman mythology, was represented as half-human, half-horse, although the *Physiologus* describes the creature as half-human and half-ass. Because of its animal body, it is seen as a personification of unbridled passions and impulses; it is often represented galloping along shooting with a bow and arrow. One of the centaurs in Hereford Cathedral is unarmed, while another is locked in fierce combat with a lindworm, putting a spear through its breast. In Exeter Cathedral, a Centaur shoots backwards (Pl. 6). As the dragon always stands for evil and the devil, the centaurs in the last two examples must symbolise virtue, and the scenes may even represent the *Harrowing of Hell*.[9] Also in Exeter Cathedral can be found the rare depiction of a female centaur shooting with bow and arrow. On a misericord in St Matthew's, Walsall, the centaur is cockily dressed (Pl. 211). Uncontrolled passions and undisciplined impulses were also associated with feasting and merry-making in the Middle Ages; this explains why so many centaurs on misericords are seen playing instruments, as in Worcester and Chichester Cathedrals (Pls. 9, 246). Other examples of centaurs are in the supporters of the Ely Cathedral misericords and on the misericords in New College Chapel, Oxford. The extent to which mythical beasts as moral warnings can be subverted on misericords is well expressed in Lavenham Parish Church, where a male and a female have taken on the lower parts of beasts; she plays

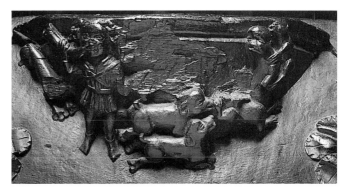

212. *Blackburn, St Mary. A mother ape pursued by hunters. This illustrates the story told in the Bestiary of a mother ape being forced to drop her favourite offspring while the neglected one, used to fend for itself, holds on to her back tenaciously. On the misericord the huntsman blowing his horn is on the left surrounded by his dogs, in hot pursuit of the apes. The dogs have caught up with the loved ape (damaged), while the mother with the clinging child is on the far right. The moral behind this tale is that it is easy to lose one's prized possessions, while it is impossible to rid oneself of the devil.*

the viol and he scrapes the bellows with a crutch (Pl. 140).

As already noted in Chapter 5, the *Ape*, personification of human foolishness, is usually shown satirizing and mimicking human foibles, but one of the more rarely-depicted episodes mentioned in the Bestiary concerns the ape favouring one of its offspring to the detriment of the other, with dire consequences, as shown on a misericord in Blackburn Cathedral (Pl. 212).

The Bestiary described not only mythical and exotic beasts but also common animals such as the fox, cat and dog, and yet, rather than carve these from life, the carvers turned to the Bestiary for inspiration. The *Fox* is a case in point. Well known to farming communities, he was nevertheless given a personality created from medieval literary tales such as the *Romance of Reynard the fox*, as described in Chapter 8. The Bestiary characterizes the fox as very crafty and cunning, and so he is found on misericords in Chester Cathedral and St Mary's, Nantwich (Pl. 213). A parallel can be drawn between the behaviour of the fox and the devil who in his craftiness will entice people into the sins of the flesh, including adultery, covetousness, lust and murder, and thus lead them to death and damnation. Carvings of the Bestiary fox are very rare, and even in these examples in Chester and Nantwich, it is combined with Reynard the fox from the Romance, making the two easily interchangeable. Evidence

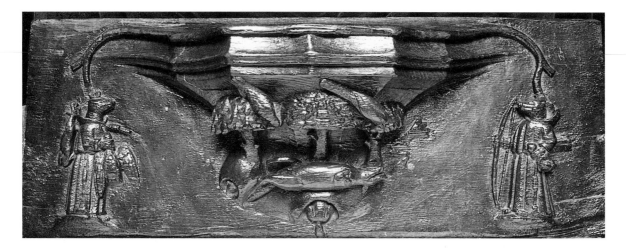

**213**. *Nantwich, St Mary. In the centre, the fox feigns death. This story comes from the Bestiary, and, as the misericord shows, the fox lies on his back, tongue lolling, feigning death in order to deceive the birds that are already pecking at him. That is the moment at which he will pounce and snap them up (as seen in Chester Cathedral). In the supporters, the fox, in friar's habit, is seen as a cunning hunter; in the left one with trophies of geese and a rabbit; in the right one with an enormous bow, arrows under his right arm, and something hidden in a bag in his left hand. This is a wicked satire on mendicant friars, who are not what they seem when preaching to their congregation.*

for this includes the presence of foxes as Friars and their cunning attempt at bribery, seen in the supporters of the Nantwich misericord.[10]

The *Owl*, inhabitant of farmhouse barns, and described as catching mice in the *Physiologus* is associated with the forces of evil all through the Middle Ages because of its ability to see well at night and not by day; in the Bestiary this is interpreted as Jews blind to the light of Christ's teaching. The owl is therefore seen mobbed by little birds on misericords in Gloucester Norwich Cathedrals and Beverley Minster.

### Natural fauna and flora

Although the majority of animals carved on misericords are monstrous beasts, many belonging to the dragon family, a large number of common, natural animals joined them as space-fillers, transforming the empty surfaces of the many misericordsintomeaningful,imaginativecarvinngs. Even then, however, patterns were used rather than observations from life—for example the deer resting or scratching its head with its hind hoof as in St Mary the Virgin, Godmanchester or Beverley Minster. There are, however, attempts at natural representations even for the owl, e.g. the tufted species in Bishop's Stortford, a fluffy one walking sideways at St Mary's, Old Malton (Pl. 214), one catching a mouse as in Ely Cathedral, or with a mouse in its beak as in Norwich Cathedral.

Winchester Cathedral misericords, of about 1308, are the earliest to demonstrate a new naturalism in both fauna and flora: the cat has caught a mouse (Pl. 49); squirrels sit on a leafy branch formed by the supporters and gnaw at hazelnuts; a rabbit feeds on leaves; a bulky dog with prominent nostrils takes a nap; a fox emerges from behind foliage (the cocks are in the supporters); an owl flaps its wings. The leaves, berries and nuts, mostly in the supporters, are also identifi-

**214**. *Old Malton, St Mary. An owl walking sideways. In the Middle Ages, the owl was associated with the forces of darkness, unable to see the light of Christianity.*

able for the first time. The portrayal of natural animals and foliage is developed in Wells Cathedral, *c.* 1335. Here too, a cat has just pounced on a mouse (Pl. 50) and a puppy bites a cat. There are two goats butting, a ewe suckling its lamb; we find a dog resting and a cat sleeping, a rabbit, a wood-pigeon, a cock crowing. Again, much of the foliage in the supporters can be identified, such as roses, watercress, oak leaves with acorns, nut leaves and nuts or hawthorn. In Godmanchester, the speckled cat looks attentively, waiting for a mouse, and one can almost see its whiskers twitch, while a rabbit is embedded on a star-shaped bed of leaves. Rabbits are very popular, seen crouching at St Mary's, Old Malton.

Of *Birds*, there are particularly good examples of the crane in Lincoln and Chester Cathedrals (Pls. 66, 67) and the swan swimming naturally in water can be found in St Michael's, Bishop's Stortford. On a misericord in St Botolph, Boston, a buck is seated between two trees, while in the supporters, two birds are pecking at snails. A hen with her chicks is represented in Beverley Minster, noted for its wealth of agricultural scenes, and at Tewkesbury Abbey, a hen pecks from a dish on the ground while the cock looks on. *Bats* are numerous but usually very stylised, and associated with the forces of darkness, e.g. Hereford Cathedral and St Martin's, Herne (Pl. 215). As we have seen, animals like the pig are often used in satirical scenes, symbolizing gluttony and lechery, but in an examples in Chester and Worcester Cathedrals sows suckle their large litters as in life. In Hereford Cathedral, two naturalistic pigs walk past each other.

*Leaves and Flowers* are mostly used to decorate the supporters, and the rose, the oak leaf with acorns and vine leaves with grapes are the most dominant. The rose above all with a single or double row of petals, alone or in bunches, tends to be very stylized. Apart from the *Pelican in her piety*, all the misericords in Ashford, St Mary the Virgin, have plants: oak, juniper, grape-vine, sycamore and a number which cannot be identified with certainty (Pl. 216). The misericords at Wingham, St Mary, which have no supporters, also concentrate on foliage and have good examples of vine leaves and grapes. At the end of the fifteenth century, columbines become popular in Ripon Cathedral (Pl. 97) and are applied to the supporters of other churches such as Manchester Cathedral and Beverley Minster. A fruit-like flower with seed pods in a ring of leaves also becomes a favourite design for supporters at this time (Pl. 215).

The plants mentioned are only a small selection of the great abundance of natural foliage and flowers seen on English misericords, which reflect a love of nature common to other art-forms, such as sculpture, manuscript illuminations and tapestry. Southwell Minster (Notts.), in particular, is well known for its naturalistic plants carved in stone on the capitals of the Chapter House and vestibule, *c.* 1290. The misericords there, *c.* 1330, are engulfed by foliage, which is even growing out of some of the figures' skirts. Manuscripts have flowers strewn over their borders, and towards the end of the fifteenth century, Flemish illuminators delighted in creating three-dimensional illustrations of plants, seen from different angles, often with insects resting on them, waiting to be brushed aside. Also in the fifteenth century, flowers, exclusively, were the subject of *mille-fleurs* tapestries, giving the impression of enormous meadows of many colours.

**215**. *Herne, St Martin. A bat, another animal of darkness like the owl. It is never realistically portrayed.*

**216**. *Ashford, St Mary the Virgin. Juniper foliage and berries. Most of the misericords in Ashford are of natural plants.*

# The World of Chivalry

A rich courtly culture developed in the courts of Europe in the fourteenth century, and references to tales of chivalry became widespread in all the minor arts. Romance stories of heroic knights and noble ladies, of adventure and great feats of strength increased in popularity, and misericord carvers too, participated in this expression of a world of chivalrous deeds in search of pure love. One of the most interesting characters whose behaviour was greatly affected by the noble influence of the court was the Wild Man, frequently depicted on misericords.

## The Wild Man

Wild men and women lived in the woods; all but their feet and hands were covered in shaggy hair, and in the case of the wild woman her breasts. The Wild Man, also called *wodehouse*, has his origin in the classical satyr but his name derives from the Anglo-Saxon 'wudewasa', wild man. His shaggy beard and hairy skin obtained by killing a lion was associated with physical power. In the folklore of high mountainous regions such as the Tyrol, the Swiss Alps or Bavaria, wild men and women are gigantic in size and extremely ugly, as awe-inspiring as the rugged mountains themselves. Because of this close relationship with the forces of nature, wild people were easily associated with demons, in particular the wild woman was likened to a witch. In the Alps the giantess Faengge was considered the devil's bride and associated with the 'wild horde', and in ancient myth the Wild Woman also had an insatiable desire for the love of mortal men and could change shape from a monstrous creature to a tempting young woman.[1]

In the Middle Ages there were 'wild men' plays all over Europe, and even nowadays the 'wild man' dance is a major element in the Carnival festivities of Basel, Switzerland. These plays would be held at the end of winter and just before Lent, the wild man representing the driving out of winter, by enacting the theme of death and resurrection. They were also performed on the occasion of weddings, such as the famous 'Bal des Ardents', 28 January, 1392, when the costume

of the wild men caught fire, and Charles VI of France was nearly burned alive.[2]

Although wild men and women were hairy and lived with the animals in the woods, roaming about without settled abode, they were classed as human because of their upright stance. According to Lucretius and Vitruvius they were considered exotic races that had come into existence at a time when human beings lived in harmony with animals before the invention of fire. They were thought to have come from India, Ethiopia and Libya; indeed, in his *De Civitate Dei*, St Augustine speaks of monstrous races also as true men deriving from Adam's seed. Wild people, however, had no knowledge of any God, they could not speak, and they behaved in total contrast to the accepted, civilized norm. In particular, in relation to women, wild men did not behave like chivalrous knights who worshipped them, but forcefully abducted them in their uncontrollable lust. Wild men always acted impulsively and irrationally, and thus represented the dark, uncontrolled side of life.

The picture from folklore is of a frightening race of people liable to create havoc in a well-ordered society. In art, however, most of all during the fifteenth century when their popularity was at its height, the impression given of them is of

*217. Hereford Cathedral. Wild Man fighting a lion. In overcoming the lion the Wild Man demonstrates his great prowess, for the lion himself is a symbol of enormous strength and loyalty, and by subjugating it, he makes these qualities his own.*

quite the opposite, for although their characteristics remained the same, they had become more human. This is most noticeable in the new image created of a close family relationship between the wild man, the wild woman and their offspring. Also, there was a change of attitude towards 'wildness' at the courts and in the new urban environment. The forests had shrunk and wildness came to be seen as a kind of liberation from the constraints of a controlled life at court or within the city walls. Wild people lived unfettered by urban controls, in tune with nature; the wild man was Lord of the Beasts for which he also cared, and with whom all lived in harmony. As the fifteenth century progressed, the fascination with wild people intensified and by the early sixteenth century, new, virtuous wild people had been created, resulting in a widespread nostalgia for their way of life.

On English misericords the wild man is generally portrayed on his own, and the emphasis is on his strength; he is seen as Lord of the Beasts with whom he lives or whom he overpowers (Pl. 217). The earliest and simplest example is found on a misericord in Winchester Cathedral, c. 1305, where the wild man is covered in shaggy tassels of fur and curled up under the bracket of the seat, looking outwards with deeply-drilled eyes, big

**218**. *Chester Cathedral. In the centre, a Wild Man rides a chained lion, while brandishing a knobbly club. Not only does this represent the taming of wild animals but it is also associated with the taming of the passions of love. The lions are tied to the supporters with a knot, probably referring to love-knots which keep the passions in bounds.*

teeth protruding from his mouth; he is bearded and his hair is short. A misericord from Gloucester Cathedral shows a hairy man sleeping propped up on his elbow, his head resting on his hand, and flanked by large birds in a tree (the lower part of the misericord is missing). This may be a wild man, although generally, wild men are more active, giving an impression of strength, and wielding a club or the branch of a tree. It could be Adam as the first wild man, from whose seed, according to St Augustine, all monstrous races derived. He would then be reclining in Paradise, at one with nature, and able to understand the birds chirping by his head. A typical wild man is shown on a misericord in St Nicholas, North Walsham (Frontispiece); in St John's, Halifax, he pulls out a whole tree-trunk to be used as a weapon, and on another misericord in Halifax, a dwarf-like wild man spears a griffin. The picture of the wild man in the midst of his natural environment of bountiful oak trees is shown on a misericord in Lincoln Cathedral (1370s), where, as in *the Labours of the Months,* in the centre, he is seen thrashing through the trees, swinging a branch above his head. In the supporters, boars at the foot of a tree are feeding on the acorns that he has beaten down. Characteristic portrayals of the wild man show him fighting wild or mythical beasts, often the lion as on a misericord in Hereford Cathedral (Pl. 217). On a misericord in Lincoln Cathedral, a wild man and a lion face each other in an upright position, lashing out at each other with hands and feet and paws. Another Lincoln misericord continues the story. The lion

has been tamed by the wild man who has become its master and rides it holding it on a chain. Ten years later, many of the patterns of the Lincoln misericords were introduced in Chester Cathedral (late 1380s), including those of the *Wild man riding a chained lion* (Pl. 218). Similarly, a wild man with a large club sits cross-legged by his chained lion on a misericord in Holy Trinity Church, Coventry. Other mythical opponents of wild men were griffins, as in St Nicholas, North Walsham and in Lincoln Cathedral or dragons in Chester Cathedral (Pl. 200). A further example in Chester Cathedral even has a wild man balancing on top of an ordinary man, squashing him beneath him, to prove that he is lord and master of his woodland kingdom with which no human must interfere. He balances with ease on leaves and branches as in the supporters of other misericords in Chester or sits cross-legged like a king, as in Lincoln. At times, the wild man has to defend his territory against another of his kind, as demonstrated on a misericord in Norwich Cathedral, where two wild men fight each other with clubs and tear at each others' beard and hair. Worse, but rare, is the wild man as victim of an animal; this occurs on a misericord in St Andrew's, Norton, where the wild man is devoured by a lion (Pl. 219). The taming of wildness was understood not only as simply taming wild animals but also referred to the taming of undisciplined passion to which the wild man, above all, was prone. In his great passion for noble ladies, he might in his great passion abduct them, but would consequently be tamed by them. On a misericord in Norwich Cathedral of a *Wild man taming two lions*, an inscription has been added: 'Man, beware of folly'. This may be a warning to the wild man to curb his passions and his lust in the same way as he is taming the lions. By restraining undisciplined passions, false, faithless love was replaced by true faithful love; this is the thought underlying much of the wild man iconography. Faithful love was a favourite topic at the courts of Europe, in particular at the court of King Wenceslas IV of Bohemia. There the iconography of love-knots is the hallmark of illuminated manuscripts such as the Bible of Wenceslas IV, commissioned by him, *c.* 1390 (Vienna, Bibl. Nat. Cod. 2759). I believe that one of the Chester Cathedral misericords can be connected with this idea more closely (Pl. 218).

219. *Norton, St Andrew. A Wild Man devoured by a lion. Here, the rarely depicted, precarious side of the Wild Man's life is shown.*

220. *Whalley, St Mary. A Wild Man and a Lady. He lies stretched out looking longingly at the lady, his head resting on his hand. She holds a scroll inscribed: 'Penses molt et p(ar)les pou' 'Think much and speak little'. The object in her other hand, now gone, may have been a birch with which to reinforce her lesson. As for the message of the inscription, it is well personified by the Wild Man: he could not speak as he had no experience of civilization, whereas the Lady spoke the language of culture and romance, and his gesture of propping up his head with his hand is characteristic of deep melancholic thought probably brought about by his unrequited love and the sensuous, passionate yearnings which he must tame. According to the Minnesänger, wildness was a state prior to amorous involvement and it was well known that men unhappy in seeking love would lose themselves in the woods and become wild.*

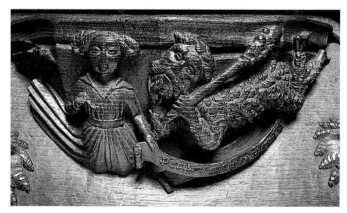

The amorous relationship between a wild man and a lady is the subject of a misericord in St Mary's, Whalley Abbey, c. 1435 (Pl. 220). The association of the wild man with love and faithfulness becomes especially cogent in his relationship with a wild woman. The image of the wild woman changed even more decisively than that of the wild man when translated from folklore into art; instead of the ugly demonic creature craving the love of normal men, she is seen as the humble helpmate of her husband; he hunts for the food, she looks after the children, and they profess faithful love to each other. This is the picture propagated most of all on the narrow tapestries produced in Strasbourg and Basel at the end of the fifteenth century, commissioned by the urban middle classes, often as wedding presents, because of the allegories of love represented on them. On English misericords, however, wild women are rare. An example illustrating the early sixteenth-century nostalgia for the happy, carefree life of a wild family, unfettered by conventions of morality and the laws and regulations of an organized society, is found on a misericord in King Henry VII's Chapel, Westminster Abbey (Pl. 43). This and other carvings of wild men illustrate the shift to the Renaissance; the wild man is muscular and nude and sometimes develops into a satyr. In one example, he fights a bear,

associating him with the wild man of mythology; in other examples, wild men fight each other with clubs. Most interesting is the *Wild man fighting two dragons* with a knobbly club and dressed in a tight garment made of feathers with a buttoned, belted jerkin. Depicting wild men in shaggy furs with plaited belts made of twigs, as though they were dressed in a costume that needed holding up, was a characteristic of the late fifteenth and early sixteenth centuries, found on many Swiss tapestries and on misericords such as one of c. 1480 in Norwich Cathedral, and one in Manchester Cathedral, c. 1508. This is an image probably based on the artists' familiarity with plays and dances performed by wild men.

The popularity of the wild man and woman was a phenomenon of the flowering of late medieval urban society, and because of their great strength and fertility they came to be used as shield-bearers, guarding a family's coat of arms and therewith assuring fecundity. This idea is expressed on a misericord in St Paul's, Bedford (Pl. 221).

What had been at first an ambivalent attitude towards wild people turned to ever greater admiration for their family life: a Utopia was created that stood in stark contrast to real life. The misericord of the *Wild family* in Westminster Abbey comes closest to this yearning for Paradise, but in general the misericord carvers had a preference for scenes of combat and triumph over the animals and monstrous beasts, emphasising the wild man's great strength. In true misericord fashion, however, there is also mockery, as on

**221**. *Bedford, St Paul. In the centre, a castle with a portcullis. In the left supporter, a man in armour tensioning his crossbow by thrusting his foot through its stirrup. In the right supporter a Wild Man with shield and club. The coat of arms on the shield is that of the town of Bedford, and the Wild Man must be seen as its protector.*

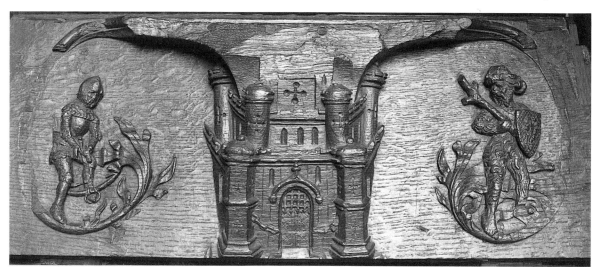

misericords in Manchester Cathedral or St George's Chapel, Windsor, where a wild man and a wild woman tilt at each other riding on exotic beasts. It is the battle of the sexes transferred to wild people, shattering all notion of harmony.

## Courtly Romances

The wild man's abode, the dense forest, was also associated with illicit lovers who met there secretly, escaping from the confining moral laws of society. Many Romances tell of lovers who live in forests like wild men and women, oblivious to all hardship because of the strength of their love for each other. In the Arthurian Romances, heroes such as Lancelot, Perceval, Yvain and Tristan represented the international ideal of chivalry, the cult of love, associated with the courtly tradition. Their stories were at the height of their popularity in the twelfth and thirteenth centuries, and far from dying out with the demise of knights and chivalry, had a revival in fourteenth-century art, in particular in manuscript illuminations, tapestries, ivory caskets and enamels.

One of the unwedded couples depicted on misericords is *Tristan and Isolde*; their clandestine meeting in the forest is found in Lincoln Cathedral (1370s), and Chester Cathedral (1380s), (Pls. 222, 223). The great similarity between the two carvings is explained by the dissemination of the Lincoln pattern to Chester, discussed in Chapter 1, yet slight differences point to the fact that the Chester carver did not copy slavishly from the

*222. Lincoln Cathedral. The clandestine meeting of the lovers Tristan and Isolde by a pool beneath a tree, while King Mark, Isolde's husband, spies on them from within its crown. According to the story, the lovers notice the Kings's face reflected in the calm surface of the pool, and are consequently able to feign innocence. On the misericord, however, instead of drawing attention to King Mark's face, Tristan and Isolde touch it. The lovers are dressed in the fashion of the 1370s: he in a tightly-fitting 'gipon' with closely-set buttons, a girdle round his hips and pointed shoes, while Isolde wears a gown with a low-cut, close-fitting bodice and full skirt, and a goffered veil as head-dress, its ruching framing her face. The rosettes that decorate Tristan's girdle and the neckline of Isolde's dress are also found around the bracket of the misericord itself. Tristan's dagger is placed in a strategic, phallic position between his legs. In the left supporter, a squire (head destroyed) holds a sword, and in the right one, a waiting-woman carries a pet dog.*

Lincoln pattern. In Lincoln, contrary to the story, Tristan and Isolde touch King Mark's face—which M. D. Anderson believes to be a misunderstanding brought about by the veneration of St Hugh in Lincoln,[3]—and in Chester, Tristan turns towards Isolde to offer her a ring, possibly as a love token, whereas in the story Isolde gives her ring to Tristan when he leaves the royal court.

The Lincoln and Chester misericords are the only ones showing Tristan and Isolde known in England, and although the Arthurian Romance is well represented in English literature, the carvers, as we have seen, were not totally familiar with the story. England contributed very little to the history of Arthurian iconography,[4] but the theme was very popular on French ivory love caskets, *c.* 1325–1340, and is found in German textiles from *c.* 1370.[5]

223. *Chester Cathedral. The clandestine meeting of the lovers Tristan and Isolde, as in Pl. 222, with minor differences: Isolde is crowned as Queen; Tristan turns towards Isolde to offer her a ring, possibly as a love token; Isolde's little dog laps up the water thus destroying the image of King Mark in the pool, and therewith the whole point of the story.*

224. *Enville, St Mary. Yvain trapped by the portcullis trying to get through the gate when entering the enemy castle. His leg and the hooves of his horse which is sliced in two are still visible. The heads of soldiers look out of the windows above, but the heads at the very sides of the gate tower (not visible on the illustration) could be those of women, for according to the story, it was a woman who saved Yvain from his enemies. Two full-length soldiers guard the subsidiary gates in the supporters; the one on the right carries an axe and a sword (lower part broken off), and the one on the left also holds a long axe.*

One hero who is, however, found on several misericords is *Yvain*, trapped inside the city gates, after the portcullis sliced his horse in two and tore his spurs from his heels, while he was pursuing the enemy. There are examples in Lincoln Cathedral, Chester Cathedral, St Botolph, Boston, New College Chapel, Oxford and St Mary's, Enville (Pl. 224). In the Romance, a young woman plays an important part, helping Yvain out of his predicament, yet apart from the misericord in Enville, none of the other misericords pick out this episode, but instead include the heads of the armed soldiers who tried to seize Yvain. The carvers, therefore, must have followed well-known patterns, rather than the story, and once more, the Chester carver followed the Lincoln example: the horse cut in two by the portcullis, its hindquarters sticking out of the city gate, framed by soldiers in chain-mail and helmets, with drooping moustaches. In New College Chapel, Oxford, there are two misericords on the theme: one before the arrival of Yvain, concentrating on the fortifications, with the portcullis lowered and a chain across it for extra defence, and helmeted heads of soldiers in the supporters; the other of Yvain and the horse trapped, with one of Yvain's feet still discernible, and the heads of soldiers with their banners peeping over the top of the crenellated gates in the supporters.

Another legendary Romance character is the *Swan Knight* carved on a misericord in Exeter

Cathedral, where combats between knights and monsters and a great variety of mythological beasts, all popular in medieval tales, are prevalent. In the Middle Ages the Swan Knight was thought to be an ancestor of the eleventh-century crusader and King of Jerusalem, Godfrey of Bouillon, and the two stories came to be conflated.[6] The Swan Knight is also mentioned by Wolfram von Eschenbach in his story of *Parzifal*, resulting in the legend becoming interwoven with the quest for the Grail.

One of the great heroes of Antiquity who gripped the medieval imagination was *Alexander the Great* and it was his *Celestial Journey* above all which was represented in art. This popularity is borne out by the numerous carvings of the theme on misericords. The story tells of Alexander's journey through the air to the end of the world, where the sky sloped down, curious to discover what lay beyond. He therefore had a basket and wooden frame constructed, in order to be lifted up into the air by griffins. These he enticed by holding up two spears with pieces of meat on their points. He was thus able to view the earth, encircled by a great serpentine ocean. He then turned the spears downwards in order to descend. The literary transmission of the story derives from a Latin translation made by the archpriest Leo of Naples, *c.* 951–959, of the lost Greek Alexander Romance known as the *Pseudo-Callisthenes*. However, it is thought that the legend was already known in the West by the ninth century.[7] *The Flight of Alexander* is the only episode in Alexander's life that is found on its own outside the context of Alexander cycles in illustrated manuscripts.[8] However, this independent image dies out in the thirteenth century except on misericords, all located in England, which revive it in the fourteenth and fifteenth centuries. Whereas new pictorial types are created from the thirteenth century onwards for the episodes from literature illustrated in secular manuscripts, the misericord carvers retain the old composition.[9] In general the misericord carvings show Alexander as King enthroned, firmly on the ground, and flanked by two griffins rather than the sixteen large birds called for in the legend. He is dressed in contemporary costume, and often in the regal position with his legs crossed, as in Wells and Lincoln Cathedrals and St Mary's, Beverley (Pl. 225). On a Chester Cathedral misericord, Alexan-

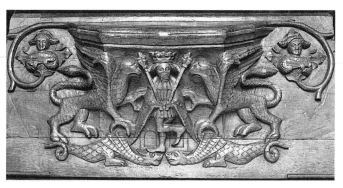

**225**. *Beverley, St Mary. The flight of King Alexander.*
*Alexander wanted to explore the heavens at the boundaries of the world, and in order to do so, he used griffins to take him up.*
*He can be seen enthroned, his throne resting on the heads of two dragons, and two griffins at his sides; he holds two sceptres, rather than spears, with meat on them to entice the griffins to carry him upwards.*

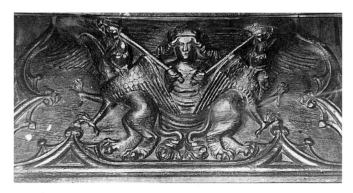

**226**. *Gloucester Cathedral. The flight of King Alexander. Here, the pigs' heads, impaled on Alexander's spears to entice the griffins to fly, are clearly visible.*

**227**. *Whalley, St Mary. The flight of King Alexander. Here, Alexander is crowned but not enthroned; rather, he seems to have sunk into a sheet wound around the necks of the griffins; they, their necks twisted with the effort of becoming airborne, are tempted by large chunks of meat.*

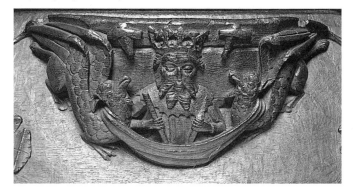

der points upwards with one hand, and the Griffins, attached to his board-type seat, seem to lift him with their beaks by his wavy hair. In many cases the shafts of the spears are broken, but often, the chunks of meat at their points are still extant: large pig's trotters and pig's heads in the two versions of the *Flight of Alexander* in Gloucester Cathedral (Pl. 226). In the one example, Alexander is enthroned like an angular Gothic king, in the style of Edward II on his tomb in the same cathedral, while the other example is more vivacious and forceful; the impression given being of Alexander carried at speed in a chariot, related to classical sources.[10] On a misericord in St Mary's, Whalley Abbey, Alexander is lifted up in a sheet wound around the necks of the griffins (Pl. 227). The *Flight of Alexander* has been interpreted in both a positive and negative light, either as man hungering for the beauty of Heaven or as an example of ambition and pride.[11] Although the story does turn up in some collections of *exempla* to illustrate a moral lesson, pride is not mentioned, as Schmidt found,[12] and nothing in the image itself suggests condemnation. It must be remembered that the *Flight* is only through the air and not to Heaven. Its main interest must therefore be in the marvels done and seen, just as in tales of travel with their exotic races and beasts.

**228**. *Lincoln Cathedral. A knight resting in the lap of a lady. The knight lies stretched out with his head in the lady's lap, while she holds the reins of his horse. In the left supporter, a helmet with a griffin's head as a crest, and in the right supporter, the half-figure of a squire pulling his sword; both surrounded by foliage.*

Schmidt reaches a tentative interpretation concerning the meaning of the image, 'as the expression of a longing for heaven and hence a reference to the heavenly bliss enjoyed by the faithful in the hereafter'.[13] The image of the *Flight of Alexander* disappears at the beginning of the sixteenth century, after it had lost its moralistic and symbolic meanings, and a more scientifically probing age dismissed the legend as fallacious.[14] Instead of being lulled by embroidered legends, the Humanists now studied classical sources.

In Lincoln Cathedral another misericord which cannot be identified looks like a scene from a Romance. A knight, resting stretched out, has laid his head in the lap of a lady (head missing) who holds the reins of his horse (Pl. 228). The scene is thought to refer to an incident in the life of Sir Perceval of Galles described in the Thornton Romances, where a knight found a lady tied to a tree, and after releasing her, rested for a while with his head in her lap.[15] Apart from identifiable Romance subjects there are many scenes of adventurous knights on misericords, all living up to the courtly ideal. Lincoln misericords again take their share in these, among them *The perfect knight coming to harm* (Pl. 229). On a misericord in Chester Cathedral, a *Knight on horseback* rides triumphantly between two wyverns in the supporters (Pl. 230).

A major part of a knight's life was taken up by tournaments or jousts which were again closely associated with courtly love and literary Romance. A knight would travel from place to place

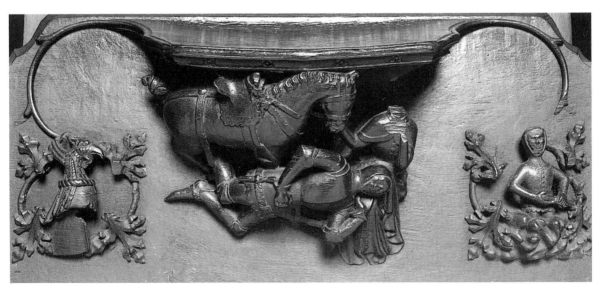

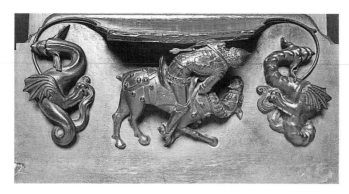

**229**. *Lincoln Cathedral. The perfect knight coming to harm. The mounted knight in the armour of the period of the Black Prince is on the point of spearing the wyvern in the right supporter with his lance, when an arrow pierces his back. He falls forward and slides off his horse, whose neck twists in a V-shape and whose legs buckle under it. This carving, demonstrates, above all, the great skill of one of the Lincoln carvers. This can be seen in the detail of the knight's armour and the horse's trappings as well as in the total harmony of the movement of horse and rider which create a strong emotional impact.*

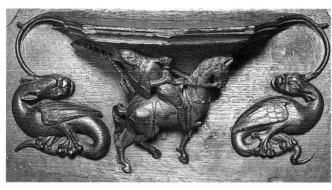

**230**. *Chester Cathedral. Knight on horseback. His horse prances proudly and strains at the reins; his coat of armour is incised with fleurs-de-lis, and a tasselled lance rests on his shoulders. He may represent the steadfast crusader, for it was a knight's duty to uphold the Christian faith, and fighting the infidel would prove his courage and endurance. Wyverns in both supporters.*

**231**. *Worcester Cathedral. The joust. This takes place on undulating ground. One knight charges his opponent with his lance and throws him off his rearing horse, while a drummer and bugler in the supporters add to the excitement with their din. The knights sport drooping moustaches, and the shield of the winning knight is embossed with a floral pattern. As the helmets are without visors the full horror on the face of the tumbling knight is revealed.*

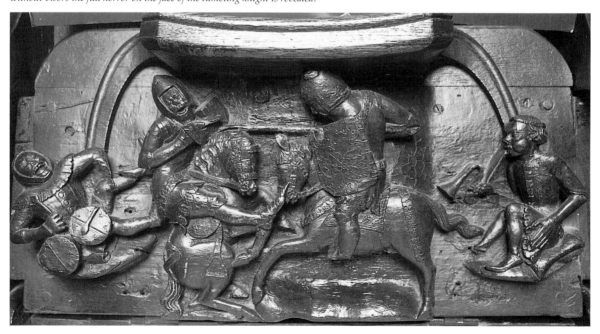

challenging his opponents in honour of his Lady. Jousts involved single combat between two knights, and were therefore more suited to misericords, than tournaments which were chaotic mêlées and more like real battles. These occasions were supported by the royal courts, in particular under Edward III who took every opportunity, such as births, marriages and political triumphs to hold jousts.[16] Participating knights had to provide their own horses and arms at great expense, but would be able to gain fighting experience, and above all, individual glory and hero worship if successful. A misericord in Worcester Cathedral represents a joust which gives a good impression of the excitement and genuine danger experienced at the real spectacle (Pl. 231). A comparative scene can be found in the margin of the Luttrell Psalter (BL, Add. MS 42130, f. 82), *c.* 1325–35, showing a knight charging and unseating a Saracen.

A knight's character was equated with virtue and success in arms was part of the equation. The *Knight fighting mythical beasts* is therefore to be interpreted as virtue overcoming evil, and on many misericords knights are seen fighting dragons, wyverns, griffins or other monstrous animals, as in Lincoln Cathedral (Pl. 232). Many of the scenes showing a knight spearing a dragon from horseback or on foot may represent *St George fighting the dragon*, as discussed on p. 128, taking the virtuous knight one step further in order to create a saint, a saint furthermore who has no documented history, and is believed to have had his roots in the Crusades. Possibly best adapted to the shape of the misericord and most suggestive of a powerful struggle between man and beast is the *Left-handed man slaying the dragon* in Wells Cathedral (Pl. 52).

The examples of knights fighting mythical beasts are innumerable, but by the end of the Middle Ages knights became impoverished and turned into robber knights; as their image became tarnished chivalrous jousts came to be satirised on misericords: men and women on beasts symbolising vices were used to mock the favourite occupation of knights (Pl. 133).

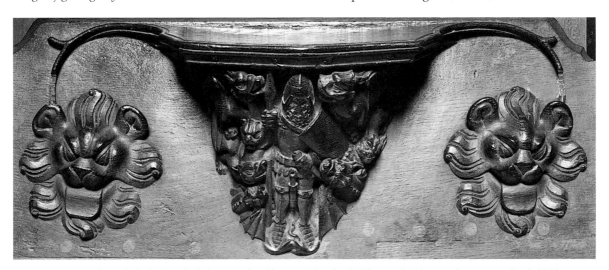

**232**. *Lincoln Cathedral. A knight fighting mythical beasts. A doughty knight armed with spear, dagger, sword and shield stands firmly against the onslaught of a large number of dragons surrounding him on both sides. He is probably the Christian knight, constantly confronted by evil on his difficult path to virtue, an ideal also illustrated in the engraving The Knight, Death and the Devil, of 1513, by Albrecht Dürer.*

**233**. *Soham, St Andrew. The head of a man, his mouth wide open, teeth showing and hand lifted to his cheek, probably shouting.*

# Heads, Portraits and Fashion

There are a large number of misericords with carved heads, of which some have individual traits and may be portraits; the majority, however, are heads full of expression: shouting, smiling and grimacing, comparable to the bosses high above them (Pl. 233). Winchester Cathedral misericords, *c.* 1305, are an early experiment with a variety of facial expressions, whose drilled eyes result in piercing looks (Pl. 234). Many of them smile or smirk, and the mouth can widen to a cry or scream as when a man is attacked by a wolf. The expressions of two men tied together over the back of a horse are most comical, their faces like masks from Greek comedies (Pl. 235). Lips can be distorted or actively squeezed into contortions. Such play with facial features is typical of the Winchester misericords, and in one extreme example, a hooded man's head has a hinged tongue which really wags! On many misericords, mouths pulled wide open or tongues stuck out are the height of rudeness, turning human heads into grotesques (Pl. 236). Most ordinary heads on misericords are very stylised, as in St Luke and All Saints, Darrington (Pl. 237), St Andrew's, Clifton Campville, New College Chapel, Oxford or in Bishop's Stortford, where heads are large and have thickly curled hair, big noses and drilled eyes. Three stylised heads, a larger central one accompanied by two similar ones in the supporters occur on a number of misericords, with good examples in New College Chapel, Oxford and St Mary's, Higham Ferrers. The form can be varied by having the central head facing and those in the supporters in profile, as in Lincoln Cathedral (Pl. 63), and this can develop into a triple face as in New College, Oxford, where a satyr-like face with wings rising from its temples puts out its tongue, and the profiles of large, misshapen noses protrude from the sides. In St Mary of Charity, Faversham, three bearded faces stare out at the spectator with four eyes (Pl. 238). Some heads do give the impression of being portraits yet cannot be identified, like the bust of a man with curly hair in a high buttoned coat, in Winchester College Chapel. The bust of a queen being crowned by two angels in St Botolph's, Boston, may be Anne of Bohemia, wife of Richard II, or else the Virgin Mary (Pl. 239). The face is a large oval as Anne of Bohemia's was known to be; Queen Anne had documented associations with Boston.[1] The misericords in St Margaret, King's Lynn, have a number of heads with individual characteristics; one of these wearing a mitre can be identified as Henry Despencer, Bishop of Norwich, from the coats of arms in the supporters (Pl. 47).[2] In St Mary's, Higham Ferrers, the bishop portrayed, flanked by two clerics, must be Archbishop Chichele who founded a chantry college there in 1422. He is, however, identified more by his elaborate mitre than by individual features, and the clerics in skull-caps, accompanying him in the supporters, have a lively expression but are cut from the same model. Bishop Richard Courtenay of Norwich is identifiable on a misericord in the Cathedral there by the letters R C above him.

In general, though, it is difficult to speak of portraiture in misericords. The faces are stylised and they easily become grotesques. The emphasis is on the humorous intent, rudeness and bawdiness never being far away. This is well

234. *Winchester Cathedral. Three faces. In the left supporter, a woman's head in wimple and gorget, and in the centre and right supporter, men's heads smiling. All have deeply drilled eyes.*

235. *Winchester Cathedral. Two acrobats. They hang on either side of a horse, their ankles tied together over its back. They grimace, their cheeks puffed and have thick lips, one grins from ear to ear.*

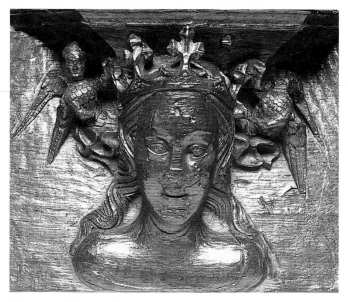

239. *Boston, St Botolph. The bust of a woman crowned by angels. This may be the Coronation of the Virgin or may possibly be a portrait of Anne of Bohemia, wife of Richard II, because of the large oval face, and her associations with Boston.*

236. *Sherborne Abbey. The head, arms and shoulders of a man spreads across the whole misericord, he pulls his mouth wide open with his fingers, in a mocking, derisory gesture.*

237. *Darrington, St Luke and All Saints. A very stylised head of a man.*

238. *Faversham, St Mary of Charity. A triple face. Possibly a representation of Janus, with one face for the past, one for the present and one for the future.*

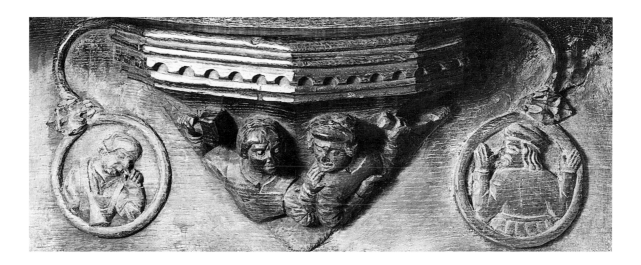

240. *Beverley Minster. Two workmen fighting. They seem to be sculptors or carvers because of the mallet and chisel they use as weapons; they may even be the carvers of the Minster's misericords! From the supporters, two men make provocative gestures at them.*

demonstrated by a misericord in Beverley Minster which has as its subject two carvers (or sculptors) fighting (Pl. 240). However, as is typical of misericords, the realism is not in the individualisation of the faces but in the choice of a situation which lent itself to mocking comment. An interesting comparison is Schongauer's engraving of two apprentice goldsmiths fighting and pulling each other's hair.

Faces of pagan nature are the *Foliate masks* and *Green men*, associated with fertility rites which have their origins in tree worship. They are exceedingly numerous on misericords, in particular as motifs in the supporters. The pagan associations had probably been lost, yet carvers must have delighted in the variety of designs of these masks, reflected not only on misericords, but also bosses, capitals, corbels and spandrels. The typical pattern is of a face peering through a thicket of foliage issuing from stems in the mouth. An early example is in Winchester Cathedral, where two leaves grow out of either side of a toothy mouth and more leaves, like hair, out of the forehead. In many other examples in Winchester a foliate mask forms the supporter, and leaves sprout from the nose or the mouth which may be open or shut, with teeth showing or tongue protruding. The leaves can be natural or conventionalised; most frequently found is the oak, the holy tree of pagan faiths, and the habitat of wild men. In Exeter Cathedral, oak leaves and acorns spring

from the forehead of a satyr's mask; in Lincoln Cathedral, they issue from the open mouth of a face with prominent teeth. New College Chapel and Winchester College Chapel have similar foliate masks with conventional foliage and varying expressions; one in New College Chapel even has the eyes covered with leaves; the foliate masks in Lincoln Cathedral, St Margaret's, King's Lynn, St Katherine's, Loversall and Holy Trinity, Coventry, are closely related. Like the foliate mask the Green Man is surrounded by foliage and was part of fertility processions until the twentieth century.[3] A face in Chichester Hospital Chapel which has foliage only curving round the lower rims of the eyes may be a Green Man, as may be the broad-shouldered man in New College Chapel, crouching and holding branches of large oak leaves with acorns. Above all, the sculpture of Southwell Minster Chapter House is known for the exuberance of its naturalistic foliage; all the figures on the misericords there are surrounded by or hold large leafy branches; among them is a Green Man (Pl. 241). The misericords in Southwell taken together create a feeling of spring, growth and fertility, in particular the misericord of the happy, dancing couple, with grape-vines and flowers growing out of their short dresses.

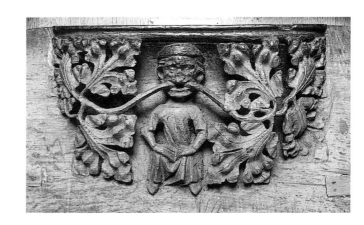

241. *Southwell Minster. A Green Man, a symbol of fertility related to the Wild Man. Enormous leaves on stems grow out of his mouth.*

## Fashion

Misericords portray a most interesting array of fashions, which often help to date them. Head-dresses especially can be quite flamboyant. The women in Exeter and Winchester Cathedrals wear their plaited hair in nets over their ears and a 'barbette' as headdress fastened under the chin (Pl. 202). Also, in Winchester Cathedral there are many examples of women's heads in wimples with a veil that covers their throats, chins and mouths and often even the tips of their noses, yet revealing the bone structure underneath (Pl. 234). A female head in Wells Cathedral is most elegantly covered in a veil held by an ornate head-band. In the supporter of the *Double-eagle*, in St Botolph, Boston, a man in profile wears the headdress of *c.* 1400, a loose 'chaperon', which is a wide, soft hat with scarf-like ribbon attached. The misericords in St Mary's, Higham Ferrers, show a variety of headdresses, both male and female, as in the supporters of the *Sudarium* (Pl. 242). Another example there has two female heads on either side of a king's head, one with hair bobbed over the ears and held in a caul, the other in a wimple with a high, pleated neck covering. Three female heads on a misericord in St Mary's, Tansor, show similar head-dresses for the heads in the supporters. The woman in the centre wears the popular 'hennin' with a veil, the so-called 'horned head-dress', like that in St Lawrence, Ludlow, against which there was much invective by moralists because of its associations with the devil (Pl. 193). Although the horned head-dress was fashionable between *c.* 1420 and 1440, it could be used in later examples in order

**242**. *Higham Ferrers, St Mary. In the centre, the Sudarium; this is the cloth on which the imprint of Christ's face was left after St Veronica gave it to him to wipe the sweat off his brow on the way to Calvary. The supporters show interesting head-dresses of the early fifteenth century: on the left, a woman with a veil arranged over a fillet and tight templers; on the right, a man in a bag-shaped hat.*

to make a moral point. Male headgear developed into caps at the end of the fifteenth century, and a man in St Mary's, Richmond (Yorks.) sports a large, floppy feather on his cap at the beginning of the sixteenth century (Pl. 243).

As for figures in full length, Gloucester Cathedral gives good examples of dress of the 1330s in portrayals of young men playing dice or ball; they wear shoulder hoods with 'liripipes', their coats are tightly buttoned and have scalloped hems (Pl. 270). Belts round their waists hold their purses. This develops into the bodiced dresses or jerkins fastened with tightly-set buttons of the 1370s and 1380s in Lincoln and Chester Cathedrals, e.g. Tristan and Isolde (Pls. 222, 223). The men's belts are worn on their hips, and the women's head-dresses are square wimples. Shoes become more and more pointed, and extra lengths of sleeves with dagged edges dangling from the elbows also become the rage. This fashion was to continue up to the end of the

**243**. *Richmond, St Mary. Head of a young man in feathered cap of the Tudor period.*

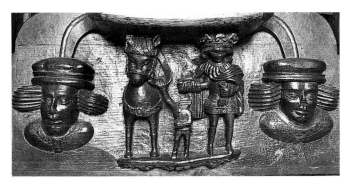

244. *Worcester Cathedral. A prince, about to ride out, accompanied by a page-boy who holds the reins of his horse. All three are facing forward, so that the foreshortened horse seems only to have two legs. The prince wears a short cloak, holds gloves in his left hand and a falcon (now destroyed), a symbols of nobility, on his right wrist. This scene probably represents the month of May, when the aristocracy used to ride out, as depicted in the 'Très riches heures', c. 1416 (Chantilly, Musée Condé). Two male heads in the supporters.*

fourteenth century, and is well represented in Worcester Cathedral (Pls. 92, 244). The bulk of material used to make up dresses becomes more and more voluminous in the first half of the fifteenth century, as exemplified in Carlisle Cathedral, especially noticeable in the wide sleeves and bag-like chaperons of a young man holding down two dragons. The man being beaten by the woman wears the same type of chaperon ornamented with a flower and his tunic has dagged edges. The elongated figures shaped by fifteenth-century fashion became more square towards the end of the century, as in Ripon Cathedral (Pl. 178). Misericords in St Mary's, Fairford, *c.* 1500, give a good impression of the new style: caps for the men and square headdresses for the women, square-toed shoes, and belts that have moved back to the waist (Pls. 84, 264). Dresses and coats are wide, and the emphasis is on bulging shoulders for men. The change to puffy sleeves with slits, typical of the Tudor period, can be seen in Christchurch Priory at the beginning of the sixteenth century (Pl. 262).

Distinction in dress between the nobility and working people is not clear-cut on misericords. In Worcester Cathedral the workers are just as well dressed as the nobility, in pointed shoes, buttoned jerkins and hats (Pl. 246). That is also the case in St Mary Magdalen, Brampton (Pl. 254) where the young man cutting the corn with a sickle wears not a hat but a finely ornamented head-band. Only the labourers from King's Lynn, now in the Victoria and Albert Museum,[4] are plainly dressed, the men in very short shifts (chemises). The shepherd in Winchester College Chapel wears good shoes and is well wrapped up, and even the crippled beggar has a bulging purse on his belt, possibly because he is a false beggar (Pls. 76, 258).

Armour can be studied on misericords from Exeter Cathedral, *c.* 1250, and later examples in Lincoln Cathedral, Chester Cathedral, Nantwich, St Botolph's, Boston and Worcester Cathedral, all fourteenth-century; then representations of knights on foot and on horseback were in their prime (Pls. 25, 229–230), culminating in The Meeting of Edward IV and Louis XI in St George's, Windsor of 1477–83 (Pl. 42). In Boston, some misericords have helmets only carved on them as heraldic devices, giving the impression of being on show for inspection before a tournament (Pl. 245 ).

245. *Boston, St Botolph. Three helmets: they are all bedecked and have large visors and chin pieces. The one in the centre faces forward and is surrounded by a wreath, the two in the supporters are in profile.*

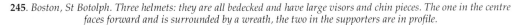

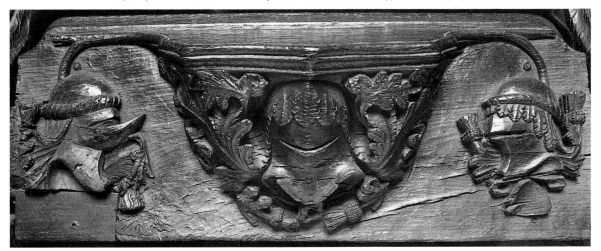

# Everyday Life

## The Labours of the Months

In the Middle Ages life was governed by the seasons, especially in the countryside where the sowing and harvesting of crops depended on changing weather conditions. A pattern of 'labours' to be undertaken each month was established by the twelfth century, associated with the Signs of the Zodiac; Burnham Deepdale font (Norfolk), dated between the eleventh and twelfth century, is an early example showing these Labours in England. Illustrated cycles became common in the calendars of Psalters and, later, Books of Hours. One of the occupations peculiar to English representations was Weeding in June, introduced in the Burnham Deepdale font; also, the depiction of Mowing, Reaping and Threshing in July, August and September became characteristic. The York Psalter (Glasgow, Hunterian Museum, MS Hunter 229), *c.* 1270, contains a good example of the Labours of the Months: *January*, a man sitting at a table eating; *February*, a man sitting warming himself by the fire, another carrying in wood; *March*, a man digging up a tree; *April*, two standing figures; *May*, a lady riding out of the gateway; *June*, two men holding tools for weeding; *July*, two men holding scythes; *August*, two men cutting corn with sickles; *September*, two men picking grapes; *October*, treading grapes; *November*, a man shaking down acorns for the pigs; *December*, a man killing a pig from behind. Possible variations in other examples can be Janus for January and threshing in September, rather than the Mediterranean grape harvest.

Examples of the Labours of the Months on English misericords are concentrated in Worcestershire, and only Ripple has a complete cycle devoted solely to this theme. In Worcester Cathedral the Labours may have been based on a twelfth-century manuscript cycle because of the close relationship of the Old Testament scenes there to such a cycle, as discussed in Chapter 2, p. 62; also, the figures stand frontally without much movement as in many of the early manuscripts. Not all the scenes can be read with certainty as Labours of the Months but a reconstruc-tion can be undertaken tentatively, when comparing the extant scenes to the representations in Great Malvern Priory: *January*, missing, possibly feasting, as at Great Malvern. *February*, a man warming his feet by the fire and stirring a pot, while his dog looks on expectantly from the left supporter and two halves of a pig hang from the right supporter. *March*, a man, two sacks at his side and a bag around his shoulder, sowing. Birds in the supporters, one diving downwards, the other flying across. *April*, a man with a long cloak fastened around his neck, a hat and sword between his legs, standing facing forward, large branches of roses in each hand. *May*, a prince, about to ride out, his horse held by a page-boy, (Pl. 244). *June*, three men in buttoned jerkins and hats, weeding. This is the occupation recognised as characteristically English (Pl. 246). *July*, three men in buttoned jerkins and hats holding scythes (Pl. 247). *August*, three men in buttoned jerkins with uncovered heads cutting corn with sickles. Bales of corn tied together in the supporters. *September*, missing, possibly a figure holding a bunch of grapes as in Great Malvern. *October*, a man with sword between his legs, dagged sleeves and cap covering his ears, blowing a large hunting horn coiled around him. Double-headed eagles in the supporter. *November*, a swineherd beating down acorns for two pigs. Oak leaves in the supporters. *December*, a man in a long apron killing an ox with the blunt end of an axe.

The scene of pruning or planting a tree for March is found neither in Worcester nor Great Malvern. The woman sitting spinning and the man digging in Worcester are more likely to be Adam and Eve. Although manuscripts usually depict the killing of a pig, the killing of an ox is also found in the Sion College Psalter of Simon of Meopham, Archbishop of Canterbury, 1270, as well as on a fourteenth-century capital in Carlisle Cathedral, and these may represent local traditions.

Usually in illustrations of the Months, the peasants do the hard work, while the nobility are out enjoying themselves at the beginning of spring picking flowers, bringing in the fresh

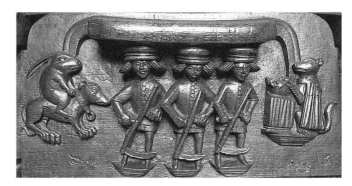

**246, 247**. *Worcester Cathedral. Left, three men weeding, representing June. They stand facing forward and use the 'falca-strum' which consisted of a long rod to which was attached a sickle to cut the weeds which were held down with a forked stick. In the supporters, angelic centaurs play musical instruments.*
**247**. *Right, three men cutting hay with scythes, representing July. In the left supporter, a hare rides on a dog; in the right supporter, a fox says Mass over a lamb's head, the lamb being the symbol of Christ and here represents the host.*

greenery or hunting, which may also take place in autumn. What is unusual in Worcester Cathedral is that the peasants doing their work are most fashionably dressed, a large number of buttons decorating their tight fitting jerkins. They also wear low belts, tight hose, pointed shoes and hats. Nevertheless, the nobility, although wearing the same style of dress, sport further signs of status such as wide cloaks, a sword for the man representing April and a glove and falcon for the one representing May, as well as being crowned and accompanied by horse and page-boy. However, I do not think that the carver is making any political statement in depicting such elegantly dressed labourers as even Adam wears a hat, but rather that he is dressing all his figures in the fashion of the last quarter of the fourteenth century for which he probably had patterns. The

hairstyle and the hats, in particular, can be found in manuscripts of the reign of Richard II.

Close to Worcester Cathedral in distance, style and iconography is one section of the choir-stalls of Great Malvern Priory which contains the Labours of the Months, as mentioned in Chapter 1. The narrative has been reduced to one figure representing each Occupation. *January*, missing in Worcester, has a well-dressed man looking out from behind a table, lifting up two enormous drinking cups with his hands. *February* is missing in Great Malvern. In *March*, a man takes seed out of one sack and has a bag slung around his shoulder, and birds fly in the supporters. A man holding two large branches of roses as in Worcester Cathedral may stand for either *April* or *May*. One man cuts the weeds in *June* (Pl. 248) and one mows with a scythe in *July*. *August* is missing and

**248**. *Great Malvern Priory. One man weeding. See Pl. 246. Two birds in flight in the supporters.*

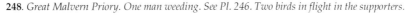

*September* shows a man harvesting grapes (Pl. 249). *October* is missing. *November* shows the swineherd knocking down the acorns from a tree in the centre, while the pigs have been relegated to the supporters. In *December*, the ox sitting upright, its back to the butcher, is being killed with an implement, now missing.

The one remaining complete cycle of Labours of the Months is in St Mary's, Ripple, and can be dated to the beginning of the sixteenth century because of the change of fashion to square shoulders and square shoes. It consists of fifteen scenes including the Sun, the Moon and Aquarius pouring out two jugs of water, and may originally have had further Signs of the Zodiac. The Labours are not easily arranged in order, because, although they have parallels in manuscript illuminations, some are most unusual and quite different from the Worcester tradition.[1] My reconstruction of their order is as follows[2]: *January*, a man and a woman sitting by the fire well wrapped up; he even wears mittens, she holds a distaff. *February*, two men splitting logs. *March*, two men pruning branches. *April*, two men running with sticks and banners, thought to be bird-scaring (Pl. 250). *May*, a woman sitting holding two bunches of flowers with flowers growing on either side of her. *June*, a young man out on his horse hawking, accompanied by his dog. *July*, a bakery being guarded, representing Lammas, the Loaf Mass (Pl. 251). *August*, a man and a woman cutting corn. *September*, two men removing corn for malting in sacks and long corn bins. *October*, a man sowing seed and his horse pulling the rake. *November*, a man knocking down acorns for the pigs. *December*, two men killing a pig.

The variations in the Labours of the Months may be due to local traditions, the climate or the availability of patterns. Thus, the grape harvest was often represented, as in Ely Cathedral, Gloucester Cathedral and Great Malvern Priory, although this must have been quite foreign to the carvers compared with sheep-shearing, which is not, however, found as a definite Labour of the Months on misericords.

*Signs of the Zodiac* as the central motif with Labours of the Months in the supporters occur on two of the remaining misericords from Whitefriars, Coventry. One is of *Sol in Libra*, the sign for September, depicting scales, now in King Henry

**249**. *Great Malvern Priory. A man harvesting grapes, probably the month of September. A truly spectacular bunch of grapes for an English summer!*

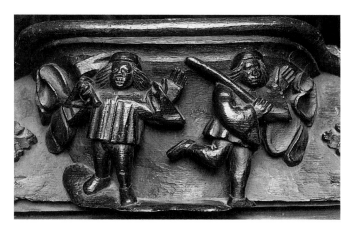

**250**. *Ripple, St Mary. Two men running, waving streamers probably to scare birds away, representing April.*

**251**. *Ripple, St Mary. Two men guarding a bakery. The opening of the oven is shown above the loaf of bread. This probably represents Lammas, or Loaf Mass in June, which is still celebrated in country places like Ballycastle in County Antrim.*

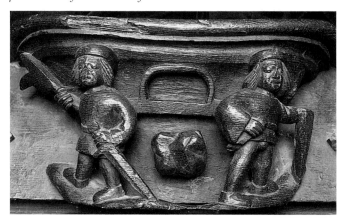

VIII's School in Coventry (Pl. 252); the other, of *Sol in Capricorno*, the sign for December, showing a goat with the sun in glory on its flank, standing on its hind legs in order to reach the leaves in a tree. King David playing the harp sits in the left supporter and a man feasting at a table, in the right one. This is now in the Herbert Art Gallery in Coventry. These misericords were probably part of a series of *Signs of the Zodiac*, and it is known that the zodiacal Taurus existed, flanked by a ploughman, for the month of April.[3]

There are a number of single misericords representing agricultural pursuits though it is not always clear whether they were once part of a cycle of the Labours the Months, for instance, reapers in short smocks with a wheat sheaf between them in St Mary's, Fairford, or mowing and reaping on two misericords in St Mary Magdalene, Brampton. The reaping scene is totally devoted to that occupation, whereas in the mowing one, a carver and weaver are included (Pl. 254). Misericords rarely adhere to one theme as in Ripple, and carvers may have inserted single representations of Months if they had patterns for them. This was probably the case in St Lawrence, Ludlow (Pl. 253) where a man sits warming himself by the fire, very much as in Worcester Cathedral, in St Matthew's, Walsall, where a well-dressed man holds up flowers in each hand, probably depicting April or May, or in Bristol Cathedral, where two men have heaved a pig onto a table and are about to kill it for the December feast. In St Wilfred's, Screveton, the one remaining misericord is of a man sitting warming his bare feet by the fire and holding his upturned

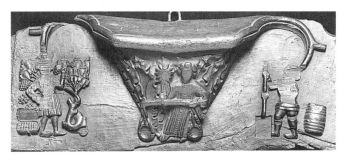

**252.** *Coventry, King Henry VIII's School (originally from the Whitefriars, Coventry). 'Sol in Libra', the sign of the Zodiac for September. In the centre, a figure in a long gown holding scales which have the sun blazing above the handle. In the left supporter, a mutilated figure in a short tunic picking grapes and putting them into a basket; in the right supporter, another mutilated figure standing in front of a barrel crushing grapes with a pole.*

**253.** *Ludlow, St Lawrence. In the centre, a man, well wrapped up, sits by the fire warming himself, representing one of the winter months. In the left supporter, a cooking-pot stands over a fire, and in the right, two flitches of bacon for the winter larder.*

**254.** *Brampton, St Mary Magdalene. In the centre, a man mowing the grass which a woman rakes up. The man's bag probably contains the whetstone to sharpen his scythe. In the left supporter, a carver carving little arches of a wooden screen; a wallet and knife hang from his belt. In the right supporter, a weaver cutting a bale of material with an enormous pair of shears.*

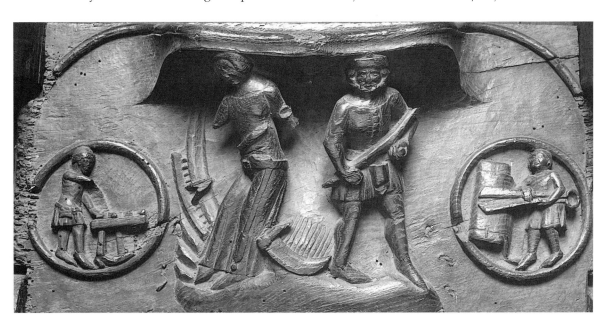

**255**. *Ely Cathedral. The rabbit hunt. In the left supporter, the hunter blowing his horn walks through an oak forest followed by his dog, while a rabbit flees through the oak-leaf thicket in the right supporter. In the centre, the successful hunter is homeward bound, his two dogs by his side and the dead rabbit over his shoulder.*

**256**. *Greystoke, St Andrew. Shoeing and grooming a horse. While one man holds the horse's head, another leans over its back to brush it, and a third lifts its rear hoof.*

**257**. *Lincoln Cathedral. Two men ploughing with two horses and two oxen. Here, the carver has ingeniously fitted an elaborate scene into a tiny space. In the left supporter, a horse draws a harrow, and in the right supporter, a man sows seed taken from two large sacks.*

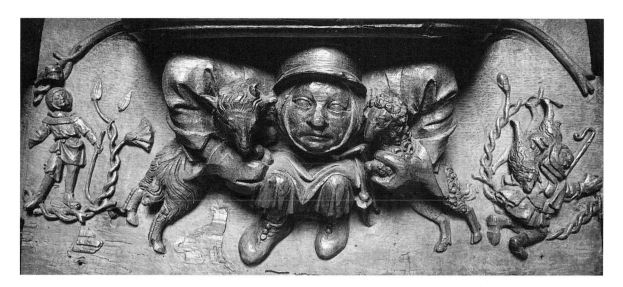

258. *Winchester College Chapel. In the centre, a shepherd squats on the ground, protectively clasping a ram and a ewe under his arms, holding them tight in his gloved hands; the outline of his dog sitting by his feet is still visible. In the left supporter, a shepherd stands on the tendrils of a flowering convolvulus; in the right one, another shepherd with his crook carries a sheep over his shoulder.*

boot over the flames; and there are three misericords in the Victoria and Albert Museum[4] which depict the corn harvest, and which must have been part of a now lost series. In one, a man ties up the corn into bundles and a woman carries them on her shoulders and hand. Then, the corn is being stacked onto a horse-drawn cart by the woman and driven away by the man. The last misericord shows two men threshing the corn.

The earliest known narrative scenes associated with life around the farm are found in Ely Cathedral, *c.* 1340. On one misericord, a man and woman sit grinding corn, jugs and dishes at their side, and a hunting scene has been extended from the centre into the supporters (Pl. 255). On another misericord in Ely, a horse is being shod and groomed, while couples dance in the supporters, a theme also shown on a misericord in St Andrew's, Greystoke (Pl. 256). Lincoln Cathedral has a most elaborately carved scene of *Two men ploughing* (Pl. 257). The agricultural scenes here can be related to the Luttrell Psalter (BL, Add. MS 42130), as already discussed in Chapter 2. *Shepherds* are depicted in Winchester College Chapel (Pl. 258) and in Gloucester Cathedral, where they follow the Star of Bethlehem, well wrapped up in hoods and boots. They carry their shepherds' crooks, and carry the tools of their trade, including tar boxes, round their waists. A sheep goes before them, a dog follows behind. This is a good

example of the biblical story being placed in a contemporary setting, and originally, there may have been a misericord of the *Adoration of the Magi* which is now a nineteenth-century carving.

Beverley Minster above all is rich in illustrations of life on the farm, as well as other sports and pastimes. Here, the common, yet rarely depicted, scene of *Sheep shearing* is shown on a misericord (Pl. 8). One of the misericords shows a wintry scene: a man warming himself by the fire, while another in an apron chases a dog who has been stealing food from a cauldron. In the left supporter, a man wearing an apron kneels to wash dishes, while another sits in the right supporter putting on warm leggings, his shoes on the ground and his purse on the wall. Another wintry scene shows one man blowing the bellows to keep the fire going, while another chops up a log with an axe; between them stands a woman, her top broken off, holding what may have been her distaff. In the left supporter of the *Woman beating her husband* sits a woman grinding corn, and in the right one, a boy hacks at a sausage with an axe.

*Hunting* is one of the most popular outdoor occupations depicted on misericords reflecting its everyday occurrence in real life, both as entertainment for the nobility and as provider of food (Pl. 255). Much of the countryside was still covered in dense forests harbouring deer, stags, bears and boars. The importance of, and even obsession with hunting is exemplified by the *Hunting Book* of Gaston Phébus (Paris, Bibl. Nat. MS fr. 616) at the end of the fourteenth century.[5] The manuscript gives information on wild and tame beasts, illustrates the use of traps and wea-

pons in the chase and killing of wild animals, goes into the training of huntsmen, and pays much attention to the care of the dogs which have different but decisive roles in the hunt. Not only did the nobility spend much of its time out riding and hunting but they also liked to surround themselves indoors with representations of these outdoor activities, as demonstrated by the Devonshire Tapestries in the Victoria and Albert Museum, a set of four tapestries probably made in Tournai, *c.* 1440, and illustrating the Deer hunt, the Swan hunt, the Otter hunt, the Boar hunt and the Bear hunt.

The largest number of misericords are concerned with the *Deer hunt.* A vivacious scene is depicted in Gloucester Cathedral, involving only a stalking huntsman with bow and arrows and a fleeing stag. No huntsman is included in the hunt in New College Chapel, Oxford, but the interest lies in the wooden fence which encloses the running deer within a deer park. On a misericord in King's Lynn Museum, a dappled stag is chased by two hounds (Pl. 259), and in Holy Trinity, Coventry, the stag has been brought to bay, and a dog sinks its teeth into the stag's snout, while a rabbit looks on and a tiny hunter stands behind. In St Botolph, Boston, a hunter shoots at the stag

**259**. *King's Lynn, Museum. Stag hunt. In the centre, a dappled stag is chased by two hounds; at the side, a rabbit can be seen in its burrow. The huntsman's presence is imaginatively indicated by his horn and arrow in the supporters incorporated into the initials V and U, respectively.*

pursued by a dog, with an enormous bow and arrow. In Chester Cathedral the scene has been extended into the supporters and, with the use of small lively figures engulfed by trees, conveys a sense of excitement; the stag in the left supporter chased by a hound bounds towards the arrow about to be shot by the knight in the centre, assisted by a servant and further hounds, while a squire gallops towards the centre from the right supporter. In Beverley Minster the stag, already nipped in its hindquarters by the pursuing dogs, runs straight into the path of the advancing hunter; a second hunter galloping along and blowing his horn is found in the left supporter while a deer scratching its head with its hind leg, a well-known pattern, is in the right one. In Bristol Cathedral, a proud stag looks back from behind trees at the hunter and his dog following cautiously. On one misericord in Manchester Cathedral the hound has caught the stag by its throat, while on another the subsequent event is depicted: the disembowelling and skinning of the stag. The animal lies on its back, its throat slit, while the hunter kneeling by its side, cuts open its stomach. This scene is also found in Beverley Minster (Pl. 24). Also important and most dangerous was the *Boar hunt,* infrequently found on misericords, but of which there is an example in St Mary's, Beverley (Pl. 260); Hereford Cathedral, which also has a stag hunt, shows a man piercing a boar's back behind its head with a spear, from the far side of a thicket. Although usually the fox

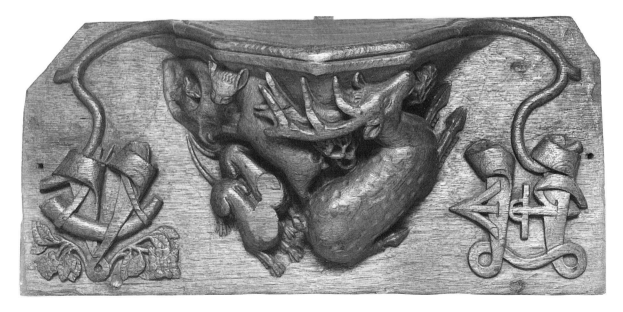

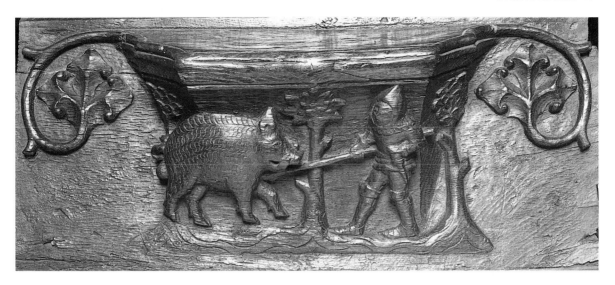

260. *Beverley, St Mary. A boar hunt. A knight in full armour faces a boar with prominent tusks from the other side of a tree, and spears it through its breast.*

is the hunter on misericords, there are a few examples of the fox as victim. In Gloucester Cathedral, he has been chased up into a tree by two dogs, their long sharp claws scratching frenetically at the trunk of the tree, while an archer is about to shoot at him from the left. In Ripon Cathedral the fox has already been caught by two dogs, and in Beverley Minster three dogs and a man with bow and arrow move in on him in his earth. Rabbits of course were also hunted, and one example in Ely Cathedral has already been mentioned (Pl. 255). Most interesting is the *Rabbit hunt* in the right supporter of a Worcester Cathedral misericord, with a nun writing at a lectern in the centre. Here, the hunter who already carries a dead rabbit over his shoulder on a pole uses a weasel to flush rabbits from their burrows. Rabbits are also caught by birds of prey such as the eagle pouncing on a rabbit on a misericord in King's Lynn Museum. The pattern for this composition was also used for hawks and falcons catching ducks. *Falcons* denoted wealth and nobility and noble lords and ladies can often be seen riding out to hunt carrying falcons on their wrists. In the illumination for August in the *Très riches heures* (Chantilly, Musée Condé, MS 65), *c.* 1416, falcons, their heads hooded, are carried along to the hunt on a pole by their warden. Examples of falcons being taken out to hunt are to be seen on misericords in Lincoln and Worcester Cathedrals (Pls. 66, 244).

The forests were still full of danger in the late Middle Ages with wild animals freely roaming in them. This is brought out on a misericord in St Botolph's, Boston, where a pack of wolves is tearing apart a man who is still alive and holding his useless sword. A great number of misericords reflect the interest in hunting as an everyday occurrence, and as illustrated the theme was interpreted in many different ways, in order to convey a sense of adventure.

**Trades and Crafts**

Scenes of everyday life on misericords are not much concerned with serious matters and most domestic occupations are satirically portrayed, most of all kitchen scenes, where frequently a woman beats a man over the top of a cooking pot. These brawls are most popular in 'world upside-down' situations with women (see p. 91). Rarely is the housewife seen demurely spinning as in Worcester Cathedral, where she probably represents *Eve spinning next to Adam digging*. In a supporter in Winchester Cathedral, a *Woman spinning*, with her hair in a net sits with a large cat behind her, and another *Old woman spinning* is the main theme of a misericord in New College Chapel, Oxford (Pl. 261). A misericord in St Mary's, Minster-in-Thanet, shows a cook at work in the kitchen (Pl. 263). Dogs scavenging for food must have been a daily occurrence in the kitchen. This is well expressed on a misericord in St Mary's, Fairford, where a woman hits a dog that has his head well inside a cauldron, with a large distaff. A rare, intimate scene is found on a misericord in

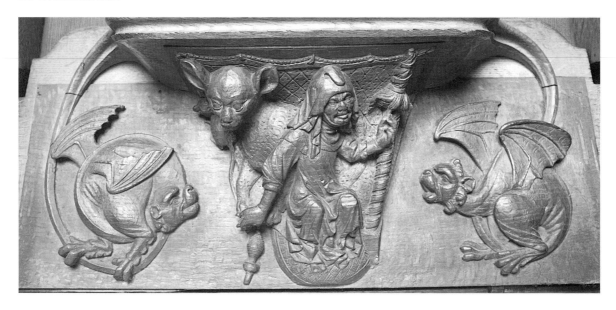

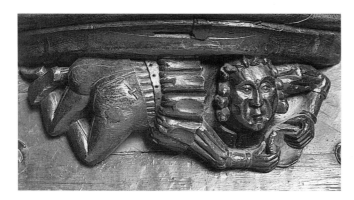

**261**. *Oxford, New College Chapel. An old woman spinning, an enormous cat with a mouse sleeping under its head looms behind her. The emphasis on the cat, symbol of sloth and lechery, and the fact that the woman sticks her tongue out, intimate that she is a lazy gossip or scold.*

**262**. *Christchurch Priory. A beggar supporting himself on his knees and elbows, holding a begging-bowl. His doublet is turned up, revealing his hose pierced and fastened with a pin, and the laces to fasten his collar are missing; he may have come down in the world or be wearing cast-off clothes.*

**263**. *Minster-in-Thanet, St Mary. A male cook, stirring a pot, flanked by a basting ladle and a baker's shovel. He puts his hand to the side of his face, as though shouting out orders. The ducks in the supporters may be destined for the table.*

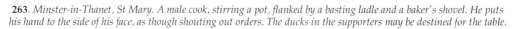

Ely Cathedral where a child puts its hands on its mother's shoulders to hug her. The *Pedlar*, a familiar character moving from one hamlet to another with his wares, is usually made fun of; having gone to sleep his pack is ransacked by apes (Pl. 145); in All Souls College Chapel, Oxford, and St Lawrence, Ludlow, he is seen sitting with his pack tied round his back, putting on his footwear (Pls. 4, 79). The *Beggar*, another common sight in towns, is found on a misericord in Christchurch Priory (Pl. 262), and a *Cripple* is most realistically portrayed on a misericord in Winchester College Chapel (Pl. 76).

It is interesting that of the different craftsmen, the *Carver* is most frequently portrayed: few examples of other craftsmen survive. The Northamptonshire examples in St Nicholas, Great Doddington, and All Hallows, Wellingborough, show the carver sitting at his workbench making a rosette (Pl. 28). The Great Doddington carving is more roughly hewn than the one in Wellingborough; the carver is flanked by two lions; he wears a plain jerkin and hat, and a compass and gouge are placed before him, while the mallet is only outlined. St Mary Magdalene, Brampton, has a carver in the left supporter of the misericord with a man mowing and a woman raking the hay (Pl. 254). A very sophisticated portrayal of a carver's workshop is in the Victoria and Albert Museum.[6] The carver in working clothes and cap sits bent over his workbench, his dog at his feet, while

two apprentices are at work behind him and one in front of him. Examples of their work are placed at the back of the workshop. A saw has been incorporated into the initial U on the left supporter, and a gouge into the initial V on the right supporter. A misericord in Beverley Minster shows, not carvers at work, but two carvers or sculptors, armed with mallet and chisel, fighting, mocked by the workmen in the supporters (Pl. 240)! A craftsman working with wood of another sort is the *Boat builder* in St David's Cathedral (Pl. 264). On a misericord in Bristol Cathedral, a woman rides towards a windmill, bearing a sack of corn on her head. Of all the trades and crafts, one would have expected more examples dealing with the wool trade, in particular in Suffolk churches, known for their wealth of wood carvings. However, only one misericord shows a *Woman carding wool* as its centre piece, in St Andrew's, Norton.

There are a few depictions of *Men of learning*: a cleric reading his Office in the supporter of what used to be the rector's stall in St Botolph's, Boston, and an academic in skull-cap in New College Chapel (Pl. 265). In scenes of the *Schoolteacher*, he is not declaiming before eager schoolchildren but spanking the slow or unwilling as in St Botolph, Boston, Norwich Cathedral, Sherborne Abbey (Pl. 266), and Henry VII's Chapel, Westminster Abbey. All these scenes show the master with his victim over his knees, beating the child's bare bottom with a birch, while other boys reading or writing look on. Scenes like this one demonstrate the true characteristics of misericords, where the interest is not in the professional knowledge of a

**264**. *St David's Cathedral. Two boatbuilders, one chiselling away, while the other is refreshing himself with drink from a bowl, his adze resting behind him.*

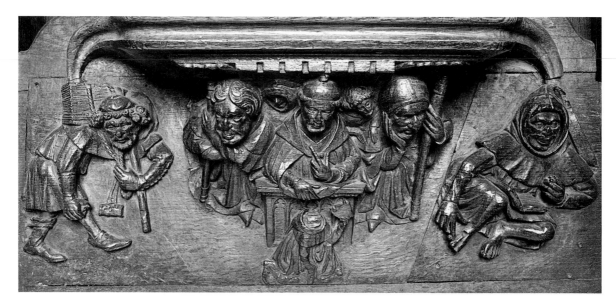

265. *Oxford, New College Chapel. An academic lecturing to a crouching figure at the foot of his lectern, who looks as if he is being admonished. Four other figures, two of them with staffs of office, listen attentively behind the lecturer. In the left supporter, a man is bent over under a load of books strapped together; in the right supporter, a cowled man in bare feet sits on the ground.*

266. *Sherborne Abbey. In the centre, a schoolmaster birches the bare bottom of a schoolboy sprawled across his knees. In the left supporter, two boys, one with an open book, the other with his book in a bag fastened to his belt; in the right supporter, a boy writing on a scroll over his knee.*

learned man but in a humorous situation, where not scribes, but teachers losing their tempers, are depicted at work.

*Sports and Pastimes* were popular with misericord carvers; they have counterparts in the margins of manuscripts, such as the Luttrell Psalter (BL, Add. MS 42130) and the Romance of Alexander (Oxford, Bodleian Library, MS Bodley 264), so often used nowadays to illustrate medieval life. On misericords, scenes of eating and drinking as in St Mary's, Fairford, and St David's Cathedral are often suspect because of their associations with gluttony and lechery. Certainly *Alehouse scenes* represented a life of sinfulness,

drinking often being combined with gambling; it was feared that this in turn would lead to fighting which could end up in murder, one sin thus leading to another (see pp. 131, 132). In Fairford, a man and woman sitting on either side of a barrel are getting quite merry, and in All Souls College Chapel, Oxford and Ludlow Parish Church a tapster happily fills a flagon from a barrel (Pl. 267). In Ely Cathedral two men are sitting round a table playing with dice in the centre of a misericord, while a figure sits next to a barrel in the left supporter and a man bearing cup and flagon advances from the right one. In Gloucester Cathedral two youths are gambling with dice by a rosebush and in Manchester Cathedral two men are playing tric-trac or backgammon (Pl. 268). In Ludlow, in particular, there is a predilection for scenes associated with drink: not only is there a drunken tapster drawing ale from a barrel but a whole misericord is given over to the veneration of the wine barrel, and it is here that the famous ale-wife is carted off to hell by the devil (Pl. 117). *Dancing and music-making* too were considered bawdy and lustful, for music and in particular the bagpipes were deemed to arouse the passions, as the *Bagpipe Player* in All Souls College Chapel or St Mary of Charity, Faversham (Pl. 33) shows. A

268. *Manchester Cathedral. Two men playing tric-trac or backgammon while a woman draws ale for their refreshment on the right, and another woman on the left cards wool. Games were frowned on by moralists, especially if played for money, for helped by the consumption of beer they would often end in brawls.*

misericord in Winchester Cathedral shows a pipe player whose cheeks are puffed out to bursting point, and a misericord in Exeter Cathedral has a pipe and tabor player clearly depicted. Because of the sinful nature of many instruments, they are often found in the hands of animals or hybrids such as centaurs as in New College Chapel: a centaur playing pipe and tabor, flanked in the supporters by a centaur blowing a horn and another a bell-mouthed pipe. One misericord in Chichester Cathedral shows two men sitting sedately, playing the harp and the pipe, whereas another has a couple kissing while dancing vigorously to the tune of the fiddle (Pl. 139). Moralists disapproved of dancing because it was boisterous and uncouth; hands and legs would be flung into the air and all sense of decorum lost, as in All Souls College Chapel, where men are hopping about, arms and legs flying.

Of sports, *Wrestling* is the most frequently found on misericords. In Ely Cathedral two men in loose gowns stand face to face, pulling each other by scarves around their necks. The scene is more lively in Gloucester Cathedral, where two men grapple with each other, characteristically stripped to the waist and wearing medieval breeches, clasping the scarves wound like ropes around their necks. This is also how two wrestlers fight in Hereford Cathedral. In Ludlow, two pairs of wrestlers are fighting, while a referee adjudicates. As in Gloucester Cathedral, they wear nothing but breeches and while the one pair fights using scarves, the other two men try to lift each other off the ground by the waistband of

267. *Ludlow, St Lawrence. A tapster fills a flagon from a barrel and holds the bung in his left hand. He looks very merry, and is probably not too steady on his feet.*

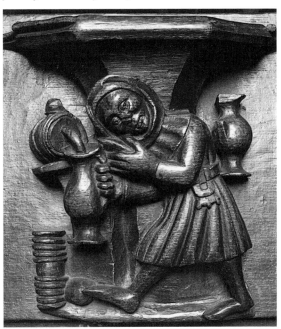

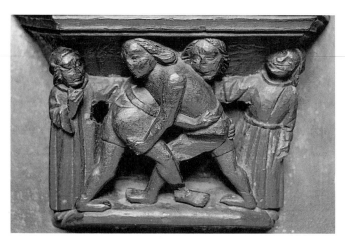

269. *Halsall, St Cuthbert. A wrestling match. The combatants only wear short pants and try to lift each other off the ground by the girdle around their waists, two schoolboys cheer them on.*

their breeches. This is also the method used by two wrestlers in Nantwich. In Bristol Cathedral the wrestlers are totally naked, pulling at their neck-ropes, while a third stands by and puts his hand on the shoulder of one of the combatants. In St Cuthbert, Halsall, the wrestling is much enjoyed by two schoolboys looking on (Pl. 269). A game of *Ball* appears on a misericord in Gloucester Cathedral, an activity more frequently found later in the margins of Flemish manuscripts at the beginning of the sixteenth century, illustrating the Labours of the Months (Pl. 270).

Judging from the number of misericords *Bear-Baiting* must have excited people's imagination enormously; it was a very widely practised sport for entertainment at fairs and in the streets of medieval towns, where the bear would also have

270. *Gloucester Cathedral. A ball game played by two people, both dressed in cotes-hardies with hoods ending in liripipes, and tight hose.*

performed dances. As the misericords show, the bear would be chained and dogs set on it. In Gloucester Cathedral, a chained bear and dog sitting on their haunches face each other, their open jaws with jagged teeth ready for the kill. In St Mary's, Beverley, the bear is both muzzled and chained, and attacked by two dogs from the front and the back. In Boston, two bears are chained to the supporters, while in the centre a bear grapples with a dog; its keeper, having chained it to a pole, moves in on it from the back with another dog. In St Mary's, Enville, two dogs attack a muzzled bear (Pl. 271), and on a misericord in Manchester, five dogs pounce on the chained bear, but it has already crushed one of them with its paws. Beverley Minster has two interesting scenes concerned with the transport of a bear, expressing the difficulties of heaving such a heavy beast into a wheelbarrow on one misericord and carting it away in a basket on another (Pl. 23). Nude men trying to drag a bear into a wheelbarrow are shown on a misericord in Bristol Cathedral.

Also associated with fairs and festivals were the *Acrobats* or *Contortionists* of which a large number are found on misericords, probably because they could be bent into a variety of shapes and made to fit imaginatively into the space available on misericords. Winchester Cathedral has a number of misericords with figures suspended from the brackets heads down. There also are two grimacing men, hanging from either side of a horse, their ankles tied together over its back (Pl. 235). Another contortionist at Winchester has his legs crossed over the top of his head, exposing his cleavage. The misericords of Wells Cathedral, a development from those in Winchester Cathedral in themes and style, have acrobats who tumble backwards most gracefully. In

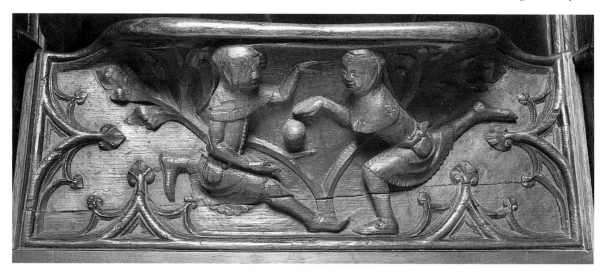

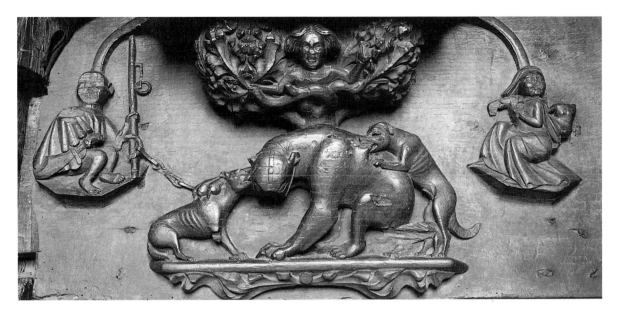

**271**. *Enville, St Mary. Bear-baiting. In the centre, two dogs attack a muzzled bear, while a man watches from a tree above. In the left supporter, a barefooted man seated on the ground, a sabre at his side, holds a pole to which the bear's chain is attached; in the right supporter, a woman is watching, carrying her baby in a shawl on her back. The figures in the supporters have the appearance of itinerant travellers coming from afar.*

Chichester Cathedral, by contrast, roughly hewn men contort their limbs or cartwheel (Pl. 38); the same happens on a misericord in New College Chapel, where the two acrobats have four bodies (Pl. 73); in Ely Cathedral two tumblers somersault, locked together, one face at the top, the other upside-down at the bottom; in Hemington, a tumbler balances on his head, his feet holding up the bracket, and in All Saints, Gresford, All Saints, an acrobat swings over a pole held by two men (Pl. 154). In the Middle Ages, tumblers were part of the theatrical scene, and a defaced misericord in Stratford-upon-Avon, very probably a

tumbler, is flanked by two masks suspended from the supporters, apt here in the birthplace of England's most famous bard (Pl. 272). A tragic mask, bearded and with open mouth askew, furrowed brows and enormous ears is the centrepiece of a misericord in All Souls College Chapel. One can imagine it being used to represent characters like King Midas.

In general, the ordinary activities depicted most frequently on misericords are those of the fairgrounds, the life of enjoyment, the bawdy, excessive life of feasting. Scenes of serious house- or professional work do occur, but the emphasis is on entertainment or satire, especially in the domestic realm of the house, dramatised with brawling or fox chases. Misericords are not in general concerned with the realistic depiction or description of everyday life but with a subversive view of everyday events that can both entertain and teach.

**272**. *Stratford-upon-Avon, Holy Trinity. In the centre, a defaced figure which was a tumbler. Masks, which give a good idea of those used in medieval theatrical performances, hang from the supporters.*

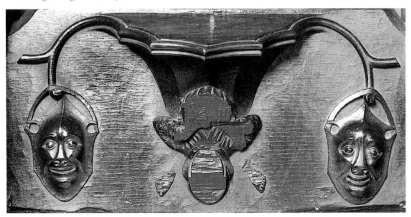

# Notes

## Introduction

1. Bosses are key-stones at the intersecting-points of vault-ribs; stall ends are the side panels at the ends of a run of stalls; poppy heads are ornamental tops to the ends of the seats, often in the shape of seed pods; stall elbows are the hand rests projecting from the seat divisions.

2. St Benedict 480–555/60. The Offices said were Matins, soon after midnight, followed by Lauds, Prime, Terce, Sext, Nones, Vespers and Compline. There was also High Mass every day, attended by the whole community. When not standing, kneeling was prescribed and the only times that sitting down was allowed was at the Epistle and the Gradual during Mass, and during the responses at Vespers.

3. C. Tracy, 1987, p. xx and n.6.

4. Germany. Chapter XXIX; also, see C. Tracy, 1987, p. xx.

5. The Hemingborough misericords probably originated in Selby Abbey and according to tradition those in Kidlington come from Osney Priory. Only one misericord remains from the 13th century in Westminster Abbey, *c.* 1255. The Durham Cathedral misericords were formerly in St Oswald's Church.

6. Accompanying text: *se v(os) voles bien ovrer d'une bone poupee a uns estaus a cesti v(os) tenes.* (If you want to carve a rich choir-stall end you must keep to this one). Paris, Bibl. Nat. MS fr. 19093.

7. H. Hahnloser, *Villard de Honnecourt*, Vienna, 1935. Hahnloser thinks that Villard copied the better example from a pattern, rather than from life, p. 158.

8. P. Draper, 1987, p. 84.

9. Gerona misericords, *c.* 1350, must have had supporters, judging from the one remaining stall, and the master carver responsible for the Barcelona stalls, Pere Sanglada, may have seen these: D. and H. Kraus, 1986, p. 107.

10. U. Bergmann, 1987, vol. I, pp. 168–76.

11. C. Tracy, 1990, pp. 47 and 54.

## Chapter 1: The Carvers and their Workshops

1. M. D. Anderson, 1967, p. 6.

2. The Exeter misericords were being carved when the Norman Cathedral was still standing; the Cathedral was rebuilt at the beginning of the 14th century; the choir was refurbished by Bishop Stapeldon who employed John of Glastonbury in 1309 for 14 weeks to remove the old stalls, probably because they did not fit into the modern choir; the seats however, were retained. M. Glasscoe and M. Swanton, 1978, p. 11.

3. C. Tracy, 1987, p. 26 and C. M. Church, 1894, p. 308.

4. C. Tracy, ibid., p. 2.

5. Mentioned in 1341 and many times later and 1343, respectively, *A Picture Book of the Misericords of Wells Cathedral*, Friends of Wells Cathedral, 1981, p. 2.

6. 1336–37, 1339–40, 1345–46 and 1349–50; he died 1354.

7. C. Tracy, ibid, 1987, p. 54.

8. Ibid.

9. C. Tracy, 1990, p. 47.

10. J. Purvis, 1935, pp. 107–28.

11. C. Tracy, 1987, p. 27.

12. Hanover, Niedersächsisches Landesmuseum; from the former Praemonstratensian Monastery of Pöhlde in the Harz mountains; commissioned by Heinrich Probst in 1284.

13. C. Tracy, 1987, pp. 62–9 on joinery techniques.

14. C. Tracy, ibid., p. 14.

15. One has three heads, two hooded male ones on either side of a veiled female one, above two animals lying on their backs. The large faces and harshly incised features are also found on some of the misericords, e.g. of the men tumbling on top of a horse (Pl. 38), or of the men playing harp and pipe, where in the left supporter a woman's veiled head is exactly the same.

The second boss is of a beast with talons, a human upper part and a tail that ends in another human head; a third head, bearded, appears above the hind quarters of the beast, and the ground may be strewn with bones (C. J. P. Cave, Sussex Archaeological Society, 1930, vol. LXXI). Cave dates these to the end of the 14th century because he thinks they were let into their present position after the vaulting had been completed, p. 7. They must, however, be of the same period as the misericords. This hybrid creature is closely related to the centaur playing the tabor on a misericord, possibly by a second master whose faces are smaller and figures more smoothly modelled.

16. C. Tracy, 1987, p. 34, believes that the stalls were designed by William Hurley who is mentioned in the accounts at Ely for the first time in 1334–35, and that, possibly, the sculptors were working in both wood and stone and transferred to the stalls after the Octagon was finished (Tracy, p. 38). On the other hand, Nicola Coldstream sees 'the self-contained decoration' of Ely as 'the architectural equivalent to the feast of detail on a page of an East Anglian manuscript': in 'Art and architecture in the late Middle Ages', *The Later Middle Ages*, ed. S. Medcalf, London, 1981, p. 188.

17. Anderson, 1967, p. 12.

18. Comparisons with other stone sculpture in Lincoln Cathedral must remain tentative, as the comparable row of kings from the west front, *c.* 1360s (L. Stone, *Sculpture*

*in Britain in the Middle Ages*, Harmondsworth, 1955, p. 181) has been heavily restored; the thick lip, long nose and empty eyes of one of the kings is the same as the head of a man with beard, moustache and headband on one of the misericords. This type of head can be compared to that of Edward II in Gloucester Cathedral, carved a generation later and thought to be the work of London artists (Stone, p. 181).

19. C. Tracy, 1990, pp. 19 and 20.

20. Nudes not only in the *Temptation*, but in scenes where they are not necessary, e.g. for men transporting bears; for men wrestling who usually wear pants, and in scenes of the *Romance of Reynard the fox*.

21. J. Summerson, 1963, p. 29.

22. Summerson, ibid., p. 31, considers those of San Lorenzo, Genoa, begun 1514, as the closest comparison.

23. Already noticed by G. Druce, 1913–14, p. 60.

24. There are earlier and later types of misericords, possibly disturbed by the Black Death; Tracy, 1987, p. 31.

25. There are two distinct styles of misericords in Malvern Priory: those illustrating the Labours of the Months being among the later ones, *c.* 1400.

26. Renamed the College of Assumption in 1343.

27. G. L. Remnant, 1969, p. 165.

28. Anderson, 1967, p. 10.

29. J. H. Harvey, 1947, p. 56.

30. C. Tracy, 1987, p. 71.

31. Anderson, 1967, p. 10 and 1971, p. 167.

32. Originally in St Katherine's by the Tower, where Queen Philippa, wife of Edward III founded a chantry in 1350.

33. Two hands can be clearly differentiated in King's Lynn, from external evidence alone: hand (1), the supporters curve downwards on long branches, some of them acting as hooks for shields, and hand (2) the supporters immediately turn into roundels which frame roses or leaves. There are no many-figured narrative scenes in King's Lynn, and style (1) in particular is a portrait gallery. The heads are very sculptural, with pronounced chins and even a dimple in one woman's chin. The heads of hand (2) are wider and more integrated with the background, often through spreading hair or leaves. The foliage and roses too, do not stand out so harshly. It is hand (1) which has most similarities with the misericords in St Katherine's, London, in the harder treatment of faces and hair.

34. Only one remaining from the 13th century, an Eagle of St John with scroll.

35. New dating by Tracy, 1990, pp. 9 and 10.

36. Tracy, 1990, p. 18.

## Chapter 2: Misericords and their Models

1. See C. Grössinger, 1975, vol. XXXVIII, for a detailed discussion.

2. Cambridge, Corpus Christi College MS 2, f. 201v, where the only difference is that the dragons are griffins, see C. Grössinger, 1975.

3. E. G. Millar, 1937 and L. Randall, 1966, p. 9.

4. M. R. James, 1901, pp. 99–117.

5. M. R. James, 1895, pp. 178–94, p. 183ff.

6. Mrs T. Cox, 1959, p. 170.

7. J. Alexander, *Age of Chivalry*, 1987, p. 402.

8. J. Alexander, ibid., p. 402.

9. U. Jenni, 1978, No. 3, p. 145.

10. C. Grössinger, 1989, pp. 186–94.

11. The Small Playing Cards, *c.* 1460, 98.6mm, and the Large Playing Cards, *c.* 1463, between 110.8mm and 130.8mm.

12. First described by Canon J. S. Purvis, 1935, pp. 107–28.

13. Mutilated in Manchester, where there is another even more damaged scene which may also relate to the *Carrying of the Grapes*.

14. C. Grössinger, 1989 , p. 79 and 82.

15. J. Goossens, 1983, pp. 10, 11.

16. Ibid., p. 12.

17. K. Varty, 1967, p. 48.

18. The connection was discovered by M. D. Anderson, 1971, p. 215.

19. The same pattern was copied in stone in the De la Warr Chantry in Boxgrove, Sussex, including the foliate background, excluded on the misericord.

20. Anderson, 1971, pp. 215, 216.

21. The more so as the upper parts of the ape and man have been destroyed.

## Chapter 3: The Audience

1. In the Ghent altarpiece by the Van Eycks, the Virgin's answer in the Annunciation is written upside-down, for God to read.

2. Edward IV refounded St George's Chapel.

3. Letter, or 'Apologia', to William, Abbot of Thierry, written by St Bernard of Clairvaux, *c.* 1125, see G G. Coulton, 1930, Vol. IV .

4. G. R. Owst, 1933, p. 163.

5. G. R. Owst, 1926, pp. 187–8.

6. G. R. Owst, 1961, p. 512, says that the leading devils like Tutivillus were already known by their nicknames in pulpit manuals from the 13th century.

7. The story goes, that a deacon reading the Gospel let forth a great laugh, because he had seen two women engrossed in idle talk, while a fiend noted down their every word. Needing more space, he extended his 'rolle' by tugging at one end and gnawing at the other. But it burst and the scribbler hit his head against a wall. No-

ticing that he was being laughed at, he smashed up his remaining roll with his fist and left.

8. P. Klein, 1986, p. 3.

9. M. D. Anderson, 1971, p. 163.

10. K. P. Wentersdorf, 1984, p. 7.

11. cf. I Corinthians 6:19. Wentersdorf, ibid., p. 12.

12. Wentersdorf, ibid., p. 7 and n.24.

13. Owst, 1961, p. 473.

14. L. Randall, 1957, vol. 39, p. 97.

15. Owst, 1961, 425.

## Chapter 4: The World Upside-down

1. H. Grant, 1973, p. 104.

2. C. Grössinger, 1989, p. 75.

3. Information from Dr Malcolm Jones.

4. From Whittington, 'Vulgaria', 36, 2–3.

5. W. Coupe, in *The Topsy-turvy World*, Exh. cat., Goethe-Institut, London, 1985, pp. 41 and 42, Munich, 1985.

6. Information from Dr Malcolm Jones.

7. L. Randall, 1962, 358–67.

8. OED, under 'goose'; information Malcolm Jones.

9. S. M. Taylor, 1980, pp. 98–124.

10. L. Stone, 1973, p. 93.

11. L. Roper, 1989, p. 85.

12. M. R. James, 1933, p. 38

13. Carving partly damaged but the figure was, originally, an ale-wife bearing drinking vessels.

## Chapter 5: Humour and Folly

1. G. G. Coulton, 1930, pp. 169–74.

2. H. W. Janson, 1952, p. 208.

3. Janson, ibid., p. 199.

4. Janson, ibid., p. 218.

5. London, BL, MS Roy. 10 E. IV, ff. 149r–151r. K. Varty, 1967, p. 73.

6. For a possible medieval literary model for the incident of robbing the pedlar and its connections with Reynard the fox, see Varty, ibid., pp. 73 and 74.

7. For more examples and Janson's thoughts on the origin of the iconography, see Janson , ibid., pp. 216–25.

8. Researched by Malcolm Jones, 'Marcolf the Trickster in Late Mediaeval Art and Literature or: the Mystery of the Bum in the Oven', 1991. Malcolm Jones identified the misericords, otherwise thought to represent the 'Clever Daughter'.

9. M. Jones, ibid., p. 149. Pierpont Morgan Library MS M. 812, f. 30r.

10. M. Jones, ibid., p. 150.

## Chapter 6: The Fool

1. H. W. Janson, 1952, p. 211.

2. On the misericord in Fotheringhay Parish Church (on the font), the Fool has a bell through his nose.

3. F. Bond, 1910, p. 110. The Feast of Fools was finally abolished throughout England by royal proclamation in 1524. Chambers, *Medieval Stage*, I, London, OUP, 1963, pp. 321–3. Feast of Fools seems not to have been of great importance in England, although statutes of Lincoln and Beverley prove its celebration there.

## Chapter 7: Scatology

1. E. H. Gombrich and E. Kris, 1940, pp. 6–7.

2. K. P. Wentersdorf, 1984, ed. C. Davidson, p. 5.

3. Wentersdorf, ibid.

4. J. Huizinga, 1924, p. 242.

5. The leaf now covering his bottom was probably added later.

6. Wentersdorf, 1984, p. 7.

7. Wentersdorf, ibid., p. 7. Luther is here addressing Tutivillus specifically.

8. R. Melinkoff, 1973, pp. 153–76.

9. B. A. Babcock, 1978, p. 164.

10. C. Tracy, 1990, p. 40, n.25

## Chapter 8: Preaching

1. The homogeneity of marginal subject matter and the rapidity of its expansion has been ascribed in large part to a development in the history of preaching during the first half of the 13th century. L. Randall, *Art Bulletin*, vol. 39, 1957, pp. 97–107.

2. L. Randall, 1957, pp. 97–107.

3. Tutivillus the choir devil, for example, is already mentioned in Jacques de Vitry: Ch. XIX, f. 20r and CCXXXIX. Alphabetical lists of *exempla* were arranged according to subject matter from the second half of the 13th century, to be used in sermons: L. Randall, ibid., p. 99.

4. Illustrations of the beast epic *Reynard the fox* are only found on the Bristol misericords, and are rarely alluded to in sermons. M. D. Anderson, 1971, p. 153.

5. Attached to the Court of Henry II.

6. In Marie de France's fable the story ends well for the cock, for while escaping with him, the fox is tricked by the cock into opening his jaws, thus dropping the cock and enabling him to fly into a tree.

7. K. Varty, 1967, p. 34. On the Continent, there were numerous imitations and translations of Pierre de Saint Cloud's poem, e.g. the Flemish *Reinaert de Vos*, first half 13th century.

8. K. Varty, ibid., p. 37.

9. K. Varty, ibid., p. 40: it has been shown that Chaucer drew on the *Roman de Reynard* for this tale in the 'Nun's

Priest's Tale' and therefore the influence of the French epic extended to these carvings.

10. In literature, Reynard's earliest appearance to the cock as a holy man goes back to the Ysengrymus of *c*. 150 and he also appears as such in the 13th century Flemish *Reinaert de Vos*, K. Varty, ibid., p. 52.

11. K. Varty, ibid., 44. Branch I of the *Roman de Renard* was further incorporated into the German *Reinhart Fuchs*, *c*. 1200 and the Flemish *Reinaert de Vos*, 13th century.

12. K. Varty, ibid., pp. 45–8. For the visual sources, see the Chapter 2.

## Chapter 9: Conclusion

1. The complete stalls, misericords, canopies of the returned stalls with their panelling and desks were carved between 1533 and 1538, probably 1536–8 (R.C.H.M., City of Cambridge, Part I, London, 1959, p. 131).

2. The present misericords are by Sir Gilbert Scott, made in 1879, and based on existing models, such as the misericords in New College, Oxford.

3. Died 1690; Remnant, 1969, p. 43.

4. Cambridge, Pembroke College Chapel, *c*. 1665, has thirty misericords all with acanthus leaf motifs; there are two in Peterhouse Chapel, *c*. 1632; Oxford, Lincoln College Chapel, *c*. 1631 has thirty-four misericords with very similar foliage design.

5. G. Schmidt, 1984, p. 28 and n.61.

6. B. Keenan, *An Evil Cradling*, Hutchinson, London, 1992.

7. B. Keenan, ibid., p. 269.

8. B. Keenan, ibid., p. 127.

## THEMES

### Episodes from the Bible and lives of Saints

1. Worcester Library MS F.81 has verses from the end of the 12th or beginning of the 13th century describing ten typological wall paintings in the ten bays of the Chapter House. See: M.R. James, 'On two series of paintings formerly at Worcester Priory', *Cambridge Antiquarian Society*, 1901, pp. 99–17.

2. By Anna Hulbert, conservationist.

3. London, BL, Royal 10.E.IV, ff. 230, 232v and 233. C. Grössinger, 1975, p. 103.

### Sin and Mortality

1. For another interpretation see p. 129 under Saints, Ely Cathedral.

2. Mary Dormer Harris, 1927, pp. 246–66.

3. Coats of arms of Sir William Wingfield of Letheringham, d. 1378, and his wife Margaret; left: Wingfield, *on a bend three pairs of wings*; right: Boville, *quarterly*. The date of the misericord is *c*. 1420, and the figures on it can be compared to the Brass of Sir John and Lady Harsick, *c*. 1384, in St George's, Southacre (Norfolk).

### The Bestiary

1. The Bestiary describes the habits of natural and mythological animals, and interprets them in a moral manner. It developed from the *Physiologus* (the Naturalist), a collection of descriptions of about 50 fabulous beasts, compiled towards the end of the 4th century, which itself has its source in Pliny's encyclopaedic *Natural History*, to which were added passages from the Bible concerning a particular animal, with a moral drawn. Many of the additions to the *Physiologus* were made by Isidore of Seville (d. 636). The Bestiary was most popular in England in the first half of the 13th century, when the manuscripts were profusely illustrated.

2. F. Bond, 1910, p. 22.

3. Ibid., p. 5.

4. M. .D. Anderson in G. L. Remnant, 1969, p. xxvi.

5. Cambridge, Corpus Christi College MS 16, Chronica Majora.

6. Revelation, 32:33.

7. Apologia XII.

8. Otto von Simson, 1956, p. 43. Secular Cathedrals are Salisbury, Lincoln, Wells and York; see: P. Draper, 1987, pp. 83, 84.

9. M. D. Anderson, 1971, p. 249.

10. K. Varty, 1967, pp. 93 and 94.

### The World of Chivalry

1. R. Bernheimer, 1952, p. 37.

2. Ibid., p. 59. The oldest Wild men plays on record are in Padua (1208) and Aarau, Switzerland (1339); ibid. p. 51.

*Courtly Romances*

3. M. D. Anderson, 1967, p. 24.

4. R. S. Loomis, 1938, p. 138.

5. Examples of French ivory carvings in Paris, Louvre and New York, Metropolitan Museum of Art; German Embroidery, London, Victoria and Albert Museum (Loomis, 1938, pp. 54–5, Pl. 86) and a related tablecloth in Erfurt Cathedral from a Benedictine nunnery in Würzburg (Loomis, 1938, p. 54, Pls. 83–5).

6. M. Glasscoe and M. Swanton, 1978, p. 14.

7. V. M. Schmidt, 1988, p. 223.

8. Schmidt, ibid.

9. Schmidt, ibid., p. 226.

10. Vienna, Nat. Bibl., Cod. 2576, f. 101. Compare with a French *Histoire ancienne jusqu'à César*, mid 14th century which has many Byzantine assimilations, and where Alexander rides the sky in a chariot. On a misericord in Tewkesbury Abbey, the outlines only of the *Flight of Alexander* are discernible.

11. M. D. Anderson in Remnant, 1969, p. xxxiii.

12. Schmidt, ibid., p. 224.

13. Schmidt, ibid., p. 225.

14. Schmidt, ibid., p. 230.

15. M. D. Anderson, 1967, p. 26.

16. R. Barber and J. Barker, 1989, p. 36.

## Heads, Portraits and Fashion

1. She was granted the Manor of Boston for three years, and on her petition the Guild of St Mary was incorporated. G. L. Remnant, 1969, p. 86.

2. Left, shield charged *diapered, three mitres*, (arms of the See of Norwich); right, shield *parted quarterly, 1st, 2nd, 3rd, 4th, diapered, 1st and 4th, a bend, 2nd and 3rd, fretty* (arms of Despencer). G. L. Remnant, ibid., p. 102.

3. He still rides in procession in Castleton, Derbyshire, as the Garland King with his Queen, bedecked with flowers. M. D. Anderson, 1971, p. 18.

4. London, Victoria and Albert Museum, Inv. Nos. W8, W.53 and W.7; C. Tracy, 1988, cat. nos. 69, 70, 72.

## Everyday Life

*The Labours of the Months*

1. For manuscript illustrations of the Labours of the Months, see: Wilhelm Hansen, *Kalenderminiaturen der Stundenbücher. Mittelalterliches Leben im Jahreslauf*, Munich, 1984.

2. See M. D. Anderson, 1971, p. 243 for a different arrangement.

3. F. H. Metcalf, *King Henry VIII School* 1545–1945, Appendix 6, The Ancient Stalls and Misericords, p. 74.

4. From the Royal Architectural Museum, Westminster, provenance unknown.

5. Gaston II, Count of Foix and Viscount of the Béarn, d. 1391. Several copies exist but Paris, Bibl. Nat. MS fr. 616 is considered best.

*Trades and Crafts*

6. C. Tracy, 1988, cat. 78, Inv. No. W.54.1921.

# Bibliography

Adolf, H., 'On Medieval Laughter', *Speculum*, XXII, 1947, 251–53.

Agate, J., *Benches and Stalls in Suffolk Churches*, Suffolk Historic Churches Trust, 1980.

Aldis, E., *Carvings and Sculptures of Worcester Cathedral*, London, 1873.

Alexander, J. and P. Binski, eds, *Age of Chivalry. Art in Plantagenet England 1200–1400*, London, 1987.

Anderson, M. D., *The Medieval Carver*, Cambridge, 1935.

Anderson, M. D., *Animal Carvings in British Churches*, Cambridge, 1938.

Anderson, M. D., *The Choir Stalls of Lincoln Minster*, Friends of Lincoln Cathedral, Lincoln, 1967.

Anderson, M. D., *Misericords*, London, 1954.

Anderson, M. D., *Drama and Imagery in English Medieval Churches*, Cambridge, 1963.

Anderson, M. D., *History and Imagery in British Churches*, London, 1971.

Anderson, M. D., 'Twelfth century design sources of Worcester Cathedral misericords', *Archaeologia*, XCVII, 1959, 165–78.

Babcock, B. A. *The Reversible World: Symbolic Inversion in Art and Society*, Ithaca/London, 1978.

Backhouse, J., *The Luttrell Psalter*, London, 1989.

Bakhtin, M., *Rabelais and His World*, Bloomington, 1965.

Baltrusaitis, J., *Le Moyen Age Fantastique*, Paris, 1955.

Barber, R. and J. Barker, *Tournaments*, Woodbridge, 1989.

Barolsky, P., *Infinite Jest. Wit and Humor in Italian Renaissance Art*, Columbia/London, 1978.

Bax, D., *Hieronymus Bosch: his picture-writing deciphered*, Rotterdam, 1979.

Bennett, B., *The Choir Stalls of Chester Cathedral*, Chester, 1st edn 1965.

Bergmann, U., *Das Chorgestühl des Kölner Domes*, vols. I and II, Neuss, 1987.

Bernheimer, R., *Wild Men in the Middle Ages*, Cambridge, Mass., 1952.

Bevers, H., ed., *Meister E.S.*, Exh. cat., Munich and Berlin, Munich, 1987.

Billington, S., *A Social History of the Fool*, Brighton, 1984.

Bond, F., *Wood Carvings in English Churches:I. Misericords*, London, 1910.

Brant, Sebastian, *The Ship of Fools*, ed. W. Gillis, London, 1971.

Bridham, L. .B., *Gargoyles, Chimeras and the Grotesque in French Gothic Sculpture*, New York, 1930.

Brighton, C., *Lincoln Cathedral Cloister Bosses*, Lincoln, 1985.

Bröker, E., 'Israhel van Meckenem und der deutsche Kupferstich des 15. Jahrhunderts', *Unser Bocholt*, 3+4, 1972, 1–136.

Brundage, J., *Law, Sex and Christian Society in Medieval Europe*, Chicago, 1987.

Buren, A. H. and S. Edmunds, 'Playing cards and manuscripts: some widely disseminated fifteenth-century model sheets', *The Art Bulletin*, LVI, 1974, 13–30.

Butsch, A. F., *Handbook of renaissance ornament*, New York, 1969.

Camille, M., 'Seeing and reading: some Visual Implications of Medieval Literacy and Illiteracy', *Art History*, VIII, 1985, 26–49.

Camille, M., 'Labouring for the Lord: The Ploughman and the Social Order in the Luttrell Psalter', *Art History*, X, 1987, 423–54.

Camille, M., *The Gothic Idol: Ideology and Image-Making in the Middle Ages*, Cambridge, 1989.

Camille, M., *Image on the Edge*, London, 1992.

Cave, C. J. P., *Roof Bosses in Medieval Churches*, Cambridge, 1948.

Chambers, E. K., *The Medieval Stage*, Oxford, 1903.

Champfleury, J., *Histoire de la caricature au moyen âge*, Paris, 1871.

Church, C. M., *Chapters in the Early History of the Church of Wells*, London, 1894.

Coldstream, N., 'Art and architecture in the late Middle Ages', in: Medcalf, S., ed., *The Later Middle Ages*, London, 1981.

Coppens, M., *Koorbanken in Nederland, Gothiek I & II*, Amsterdam & Brussels, 1948 & 1949.

Coulton, G. G., *Life in the Middle Ages*, Cambridge, 1930.

Cox, J. C. and Harvey, A., *English Church Furniture*, London, 1907.

Cox, Mrs.T., 'The Twelfth-Century Design Sources in the Worcester Cathedral Misericords', *Archaeologia*, 1959.

Cronin, G.,Jr., 'The Bestiary and the medieval mind', *Modern Language Quarterly*, 1941, 191–98.

Crossley, F.H., 'Stallwork in Cheshire', *Transactions of the Historical Society of Lancashire and Cheshire*, LXVIII, 1916, 85–106.

Crossley, F. H., 'On the Remains of Medieval Stallwork in Lancashire', *Transactions of the Historical Society of Lancashire and Cheshire*, LXX, 1918, 1–42.

Crossley, F. H., *English Church Craftsmanship*, London, 1941.

Crossley, F. H. and Ridgway, M. H., 'Screens, Lofts and Stalls situated in Wales and Monmouthshire', *Archaeologia Cambrensis*, XCIX, 1947.

Davenport, S. K., 'Illustrations Direct and Oblique in the Margins of an Alexander Romance at Oxford', *Journal of the Warburg and Courtauld Institutes*, 34, 1971, 83–95.

Davidson, C., ed., *Word, Picture and Spectacle*, Kalamazoo, 1984.

Dodgson, C., 'Alexander's Journey to the Sky', *Burlington Magazine*, 1904/5, 395.

Draper, P., 'Architecture and Liturgy', in *Age of Chivalry*, ed. J. Alexander and P. Binski, London, 1987.

Druce, G. C., 'Animals in English woodcarvings', *Walpole Soc. Annual*, III, 1913–14

Druce, G. C., 'Some abnormal and composite human forms in English Church Architecture', *Archaeological Journal*, LXXII, 1915.

Druce, G. C., 'Misericords: their form and decoration', *Journal of the British Archaeological Association.*, N.S. XXXVI, 1931, 244–64.

Fowler, J., 'On the sculptured Capitals in the Choir of the Cathedral at Carlisle', *Transactions of the Cumberland and Westmoreland Antiquarian and Archaeological Society*, II, 1876, 280–96.

Evans, J., *English Art 1307–1461*, Oxford, 1949.

Farley, J., *The Misericords of Gloucester Cathedral*, Gloucester & Cheltenham, 1981.

Filedt Kok, J. P., *Livelier than Life; the Master of the Amsterdam Cabinet or the Housebook Master, c. 1470–1500*, Exh. cat., Rijksmuseum, Amsterdam, Maarssen, 1985.

Forster, J. R., *Beverley Minster. A Brief History*, Hull, London, 1973. (revised and ed. by G. P. Brown).

Friedman, J. B., *The Monstrous Races in Medieval Art and Thought*, Cambridge, Mass., 1981.

Gaignebet, C. and J.-D. Lajoux, *Art profane et religion populaire au moyen âge*, Paris, 1985.

Ganz, P. L. and Seeger, T., *Das Chorgestühl in der Schweiz*, Frauenfeld, 1946.

Gardner, A., *English Medieval Sculpture*, Cambridge, 1951.

Gardner, A., *Minor English Wood Sculpture 1400–1550*, London, 1958.

Geisberg, M., *The German Single-leaf Woodcut 1500–1550*, I–IV, New York, 1974 (revised and ed. by W. Strauss).

Gifford, D., 'Iconographic Notes Towards a Definition of the Medieval Fool', *Journal of the Warburg and Courtauld Institutes*, XXXVII, 1974, 336–42.

Glasscoe, M. and M. Swanton, *Medieval Woodwork in Exeter Cathedral*, Exeter, 1978.

Goethe Institute, Exh. cat., *The Topsy-Turvy World*, Amsterdam, Paris, London, New York, 1985.

Gombrich, E. and Kris, E., *Caricature*, Harmondsorth, 1940.

Goossens, J., *Die Reynhaert-Ikonographie*, Darmstadt, 1983.

Grant, H., 'The World Upside-down', in: R. O. Jones, *Studies in Spanish Literature of the Golden Age*, London, 1973,

Grössinger, C., 'English Misericords of the Thirteenth and Fourteenth Centuries and their Relationship to Manuscript Illuminations', *Journal of the Warburg and Courtauld Institute*, XXXVIII, 1975, 97–108.

Grössinger, C., *The Misericords of Manchester Cathedral*, Manchester.

Grössinger, C., 'Humour and Folly in English Misericords of the First Quarter of the Sixteenth Century', in: D. Williams, ed., *Early Tudor England*, Woodbridge, 1989, 73–85, Pls.1–19.

Grössinger, C, 'The Misericords in Beverley Minster: their Relationship to other Misericords and Fifteenth-Century Prints', *Journal of the British Archaeological Association*, 1989, 186–94, Pls. XXXIIA–XXXVH.

Grössinger, C., *Ripon Cathedral—Misericords*, Ripon, 1989.

Grössinger, C., 'Misericords', *Medieval World*, 3, 1991, 3–8.

Hahnloser, H., *Villard de Honnecourt*, Vienna, 1935.

Hamann, R., 'The Girl and the Ram', *Burlington Magazine*, 60, 1932, 91–97.

Harpham, G. Galt, *On the Grotesque*, Princeton, 1982.

Harthan, J., *The Book of Hours*, London, 1977.

Harris, M. D., 'Misericords in Coventry', *Birmingham Archaeological Society Transactions*, LII, 1927, 246–66.

Harvey, J. H., *Gothic England. A Survey of National Culture 1300–1550*, London, 1947.

Hayman, R., *Church Misericords and Bench Ends*, Shire Publications, 1989.

Hayter, W., *William of Wykeham*, London, 1970.

Heers, J., *Fêtes des fous et carnivals*, Paris, 1983.

Henry, A., *Biblia Pauperum*, New York, 1987.

Howard, F. E. and F. H. Crossley, *English Church Woodwork, 1250–1550*, London, 1917.

Hudson, H.A., *The Medieval Woodwork in Manchester Cathedral*, Manchester, 1924 (reprinted from the Transactions of Lancashire and Cheshire Antiquarian Society, XXXVI, 1918).

Huizinga, J., *The Waning of the Middle Ages*, Peregrine Books, Harmondsworth, 1982, 1st ed. 1924.

James, M. R., 'On the paintings formerly in the Choir of Peterborough', *Cambridge Antiquarian Society*, 1895, 178–94.

James, M. R., 'On two series of Paintings formerly at Worcester Priory', *Cambridge Antiquarian Society*, 1901, 99–117.

James, M. R., *St. George's Chapel Windsor: The Woodwork of the Choir*, Windsor, 1933.

Janson, H. W., *Apes and Ape Lore in the Middle Ages and the Renaissance*, London, 1952.

Jeavons, S. A., 'Medieval Stallwork in South Staffordshire', *Birmingham Archaeological Journal*, LXVII–LXVIII, 1947–8, 42–54.

Jenni, U., 'Vom Musterbuch zum Skizzenbuch', in *Die Parler und der Schöne Stil 1350–1400*, Cologne, 1978.

Jervis, S., 'Woodwork of Winchester Cathedral', Winchester, 1976.

Jones, Malcolm, 'Folklore Motifs in Late Medieval Art, I: Proverbial Follies and Impossibilities', *Folklore*, 1989, 201–17.

Jones, Malcolm, 'Marcolf the Trickster in Late Mediaeval Art and Literature or: the Mystery of the Bum in the Oven', in: G. Bennett, ed., *Spoken in Jest*, Sheffield, 1991.

Jones, M. and C. Tracy, 'A Medieval Choirstall Desk-End at Haddon Hall: The Fox-Bishop and the Geese-Hangmen', *Journal of the British Archaeological Association*, 1991, 107–15, Pls. XII–XV.

Jong, M. de and I. de Groot, *Ornament prenten in het Rijksprentenkabinet I*, 15de & 16de Eeuw, Amsterdam, 1988.

Joy, E. T., *Woodwork in Winchester Cathedral*, Winchester, 1964.

Katzenellenbogen, A., *Allegories of the Virtues and Vices in Medieval Art*, London, 1939.

Keenan, B., *An Evil Cradling*, London, 1992.

Klein, P., *The Misericords and Choir Stalls of Ludlow Parish Church*, Ludlow, 1986.

Klingender, F., 'Grotesque Ornament in Mediaeval Art', *The Connoisseur*, LXXXII, 1928, 131–6.

Klingender, F., *Animals in Art and Thought to the End of the Middle Ages*, Cambridge, Mass., 1971.

Kolve, V. A., *The Play Called Corpus Christi*, Stanford, 1966.

Kraus, H., *The Living Theatre of Medieval Art*, Philadelphia, 1967.

Kraus, D. and H., *The Hidden World of Misericords*, London, 1976.

Kraus, D. and H., *Le Monde Caché des Miséricordes*, Paris, 1986.

Kraus, D. and H., *The Gothic Choirstalls of Spain*, London and New York, 1986.

Kris, E., 'Ego Development and the Comic', in *Psychoanalytic Explorations in Art*, New York, 1974, 204–16.

Kunzle, D., *The Early Comic Strip*, Berkeley, London, 1973.

Kunzle, D., 'World Upside Down: the Iconography of a European Broadsheet type', *The Reversible World: Essays in Symbolic Inversion*, ed. B. Babcock, Cornell, 1978.

Laird, M., *English Misericords*, London, 1986.

Le Goff, J., *The Medieval Imagination*, Chicago, 1980.

Lehmann, P., *Die Parodie im Mittelalter*, Munich, 1922, Stuttgart, 1963.

Lehrs, M., *Late Gothic Engravings of Germany and the Netherlands*, New York, 1969.

Lethaby, W. R., *Westminster Abbey and the King's Craftsmen*, London, 1906.

Letts, E. F., 'Misereres in Manchester Cathedral', *Transactions of the Lancashire and Cheshire Antiquarian Society*, IV, 1886, 130–44.

Loomis, R. S., 'Alexander the Great's Celestial Journey', *Burlington Magazine*, XXXII, pp. 177–85, 1918,

Loomis, R. S., *Arthurian Legends in Medieval Art*, London, New York, 1938.

Loose, W., *Die Chorgestühle des Mittelalters*, Heidelberg, 1931.

MacColl, D. S., 'Grania in Church: or the Clever Daughter', *Burlington Magazine*, VIII, 1905, 80–7.

McCulloch, F., 'Medieval Latin and French Bestiaries', in *University of North Carolina Studies in the Romance Languages and Literatures*, no. 33, Chapel Hill, 1960.

McCulloch, F., 'The Funeral of Renart the Fox in a Walters Book of Hours', *Journal of the Walters Art Gallery*, XXV–XXVI, 1962–63.

Maeterlinck, L., *Le genre satirique dans la peinture Flamande*, Brussels, 1907.

Maeterlinck, L., *Le genre satirique, fantastique et licencieux dans la sculpture Flamande et Wallonne*, Paris, 1910.

Mâle, E., *Religious art in France of the Thirteenth Century: A Study of Medieval Iconography and its Sources*, Princeton, 1984.

Mâle, E., *Religious art in France: the late Middle Ages: a Study of Medieval Iconography*, Princeton/Guildford, 1986.

Marle, R. van, *Iconographie de l'art profane*, I–II, La Haie, 1931.

Mateo Gomez, I., *Temas profanos en la Escultura Gotica Espanola*, Madrid, 1979.

Mathew, G., *The Court of Richard II*, London, 1968.

Melinkoff, R., 'Riding Backwards: Theme of Humiliation and Symbol of Evil', *Viator*, 4, 1973, 153–76.

Mezger, W., *Narrenidee und Fastnachtsbrauch*, Konstanz, 1989.

Millar, E., *English Illuminated Manuscripts, Fourteenth and Fifteenth Centuries*, Paris and Brussels, 1928.

Millar, E., ed., *The Rutland Psalter*, Roxburghe Club, Oxford, 1937.

Mode, H., *Fabulous Beasts and Demons*, London, 1973.

Morgan, F. C., *Hereford Cathedral Church Misericords*, Hereford, 1966.

Newton, S., *Fashion in the Age of the Black Prince*, Bury St Edmunds, 1980.

Nordenfalk, C., 'Drolleries', *Burlington Magazine*, CIX, 1967, 418–21.

Nürnberg, Exh. cat., *Die Welt des Hans Sachs*, Nürnberg, 1976.

Oosterwijk, S., 'Fourteenth Century Sculptures on the Aisle Walls in the Nave of York Minster', *York Historian*, 9, 1990, 2–15.

Owst, G. R., *Preaching in Medieval England*, Cambridge, 1926.

Owst, G. R., *Literature and Pulpit in England*, Cambridge, 1933 and Oxford, 1961.

Pächt, O., 'Early Italian Nature Studies and the Early Calendar Landscape', *Journal of the Warburg and Courtauld Institutes*, XIII, 1950, 13–47.

Pächt, O., *Book Illumination in the Middle Ages: An Introduction*, Oxford, 1986.

Perry, M. P., 'The Stall Work of Bristol Cathedral', *Archaeological Journal*, 2nd Ser., XXVIII, 1921, 233–50.

Pevsner, N., *The Leaves of Southwell*, London/New York, 1945.

Phipson, E., *Choir Stalls and their Carvings*, London, 1896.

Plummer, J., *The Hours of Catherine of Cleves*, New York, 1966.

Pollard, A., *English Miracle Plays, Moralities and Interludes*, Oxford, 1927.

Prache, G., *Les Stalles de la Cathédrale d'Amiens*, Lyon.

Prior, E. and A. Gardner, *An Account of Medieval Figure-Sculpture in England*, Cambridge, 1912.

Pritchard, R. E., *The Choir and Misericords of St.Mary's Nantwich*, Nantwich.

Purvis, J. S., 'The Use of Continental Woodcuts and Prints by the Ripon School of Woodcarvers', *Archaeologia*, LXXXV, 1935, 107–28.

Randall, L., 'Exempla as a Source of Gothic Marginal Illumination', *Art Bulletin*, 39, 1957, 97–107.

Randall, L., 'A Medieval Slander', *Art Bulletin*, 42, 1960, 25–40.

Randall, L., 'The Snail in Gothic Marginal Warfare', *Speculum*, XXXVII, 1962, 358–67.

Randall, L., *Images in the Margins of Gothic Manuscripts*, Berkeley, 1966.

Randall, L., 'Humour and Fantasy in the Margins of an English Book of Hours', *Apollo*, LXXXIV, 1966, 482–88.

Remnant, G. L. (with an introduction by M. D. Anderson), *A Catalogue of Misericords in Great Britain*, Oxford, 1969.

Remnant, M., *Musical Instruments of the West*, London, 1978.

Rickert, M., *Painting in Britain in the Middle Ages*. Pelican History of Art, Harmondsworth, 1965.

Roper, L., *The Holy Household. Women and Morals in Reformation Augsburg*, Oxford, 1989.

Rouse, E. C. and K. Varty, 'Medieval Paintings of Reynard the Fox in Gloucester Cathedral and some other related examples', *The Archaeological Journal*, 133, 1976, 104–117.

Rudwin, M., *The Devil in Legend and Literature*, Chicago, 1931.

Rushford, G. McN., *Medieval Christian Imagery* (as illustrated in the painted windows of Great Malvern Priory Church Worcestershire), Oxford, 1936.

Sandler, L. Freeman, 'Reflections on the Construction of Hybrids in English Gothic Marginal Illustration', *Art the Ape of Nature: Studies in Honor of H. W. Janson*, New York, 1975, 51–67.

Sands, D. B., *The History of Reynard the Fox*, London, 1960.

Saward, J., *Perfect Fools* (Folly for Christ's Sake in Catholic and Orthodox Spirituality), Oxford, 1980.

Scheller, R. W., *A Survey of Medieval Model Books*, Haarlem, 1963.

Schindler, H., *Chorgestühle*, Munich, 1983.

Schmidt, G., 'Worüber lacht das Publikum im Theater?', in *Festschrift zum 90. Geburtstag von Heinz Kindermann*, ed. M. Dietrich, Vienna/Cologne, 1984.

Schmidt, V. M., *De Luchtvaart van Alexander de Grote in de Verbeelding der Middeleeuwen*, Groningen, 1988.

Sekules, V., 'Women in the English Art of the Fourteenth and Fifteenth Centuries', in: J. Alexander, and P. Binski, eds., *Age of Chivalry: The Art of Plantagenet England*, London, 1987.

Shapiro, M., 'Marginal Images and Drolerie', *Late Antique, Early Christian and Medieval Art*, New York, 1979, 196–98.

Sheridan, R. and A. Ross, *Gargoyles and Grotesques: Paganism in the Medieval Church*, London, 1975.

Shestack, A., *Master E. S.*, Exh. cat., Philadelphia, 1967.

Shestack, A., *Fifteenth Century Engravings of Northern Europe (from the National Gallery of Art Washington, D.C.)*, Washington, 1968.

Shuttleworth, C. B., *The Cathedral Misericords*, manuscript in Worcester Cathedral.

Simson, O. von, *The Gothic Cathedral: the Origins of Gothic Architecture and the Medieval Concept of Order*, London, 1956, Princeton, 1974.

Smith, J. C. D., *Church Woodcarvings:A West Country Study*, Newton Abbot, 1969.

Southern, R., *The Making of the Middle Ages*, London, 1953.

Steer, F. W., *Misericords in Chichester Cathedral*, Chichester, City Council, 1961.

Steer, F. W., *Misericords in St.Mary's Hospital*, Chichester, Chichester, City Council, 1963.

Steer, F. W., *Misericords at New College, Oxford*, Chichester, 1973.

Stone, L., *Sculpture in Britain: The Middle Ages*, Pelican History of Art, Harmondsworth, 1972.

Stone, L., *The Family, Sex and Marriage in England 1500–1800*, London, 1973.

Strutt, J., *Sports and Pastimes of the People of England*, London, 1833.

Stuvel, H. J., *Koorbanken in Nederlandsche Kerken*, The Hague, 1946.

Summerson, J., *Architecture in Britain 1530–1830*, Harmondsworth, 1983.

Swain, B., *Fools and Folly during the Middle Ages and the Renaissance*, New York, 1932.

Swanton, M., *Roof-Bosses and Corbels of Exeter Cathedral*, Exeter, 1979.

Tatlock, J. S., 'Mediaeval Laughter', *Speculum*, XXI, 1946, 289–94.

Taylor, S. M., 'Monster of misogyny', *Allegorica*, 5, 1980, 98–124.

Tietze-Conrat, E., *Dwarfs and Jesters in Art*, London, 1957.

Tracy, C., 'Medieval Choir Stalls in Chichester: A Re-Assessment', *Sussex Archaeological Collections*, 124, 1986, 141–55.

Tracy, C., *English Gothic Choir-Stalls, 1200–1400*, Woodbridge, 1987.

Tracy, C., *A Catalogue of English Gothic Furniture and Woodwork*, Victoria and Albert Museum, London, 1988.

Tracy, C., *English Gothic Choir-Stalls 1400–1540*, Woodbridge, 1990.

Tubach, F. C., *Index Exemplorum. A Handbook of Medieval Religious Tales*, Helsinki, 1969.

Varty, K., 'Reynard the Fox and the Smithfield Decretals', *Journal of the Warburg and Courtauld Institutes*, 26, 1963.

Varty, K., 'The Pursuit of Reynard in Medieval English Literature and Art', *Nottingham Medieval Studies*, 8, 1964.

Varty, K., *Reynard the Fox: A Study of the Fox in English Medieval Art*, Leicester, 1967.

Verspaandonk, J., *Misericorde-reeks*, I–IV, Amsterdam, 1972–1984. (Haarlem, De Grote of Sint Bavokerk; Bolsward, De Martinikerk; Breda, Grote of Lieve Vrouwekerk; Amsterdam, De Oude Kerk)

Verspaandonk, J., 'Het vreemde houten gezelschap', *Antiek*, 9/2, 1974–75, 121–40.

Verspaandonk, J., 'Die merkwürdigen Hausgenossen der Chorherren', *Unser Bocholt*, Heft 418 (Sonderdruck).

Verspaandonk, J., 'De Koorbanken van de Janskerk', *Maandblad Oud-Utrecht*, 57/3, 1984, 25–9.

Verspaandonk, J., 'Grafische voorbeelden voor de zittertjes van het koorgestoelte in de Leuvense kerk van Onze-Lieve-Vrouw-ter-Predikheren', *Arca Lovaniensis*, 15–16, 1986–87, 145–221.

Verspaandonk, J., 'Laatgotische Zuidnederlandse misericorden in het Victoria & Albert Museum te Londen', *Antiek*, 21/1, 1986, 12–21.

Verspaandonk, J., 'De kraagstenen van de stadhuistoren', *Oud Alkmaar*, 1991, 3–12.

Verspaandonk, J., *Misericorde-reeks*, V, VI, VII–VIII, Venlo, 1993. (Sittard, St. Petruskerk; Venlo, St. Martinuskerk; Weert, St. Martinuskerk and Nederweert, St. Lambertuskerk)

Vignau Wilberg-Schuurman, T., *Hoofse minne en burgerlijke liefde in de prentkunst rond 1500*, Leiden, 1983.

Weir, A. and J. Jerman, ImagesofLust: SexualCarvings on Medieval Churches, London, 1986.

Welsford, E., *The Fool*, London, 1935.

Wentersdorf, K. P., 'The Symbolic Significance of Figurae Scatologicae in Gothic Manuscripts', in C. Davidson, ed., *Word, Picture and Spectacle*, Kalamazoo, 1984, 1–20.

Wieck, R., *The Book of Hours in Medieval Art and Life*, London, 1988.

White, M. F., *Fifteenth Century Misericords in the Collegiate Church of Holy Trinity*, Stratford-upon-Avon, Stratford, 1974.

White, T. H., *The Book of Beasts*, London, 1954.

Whittingham, A. B., *The Stalls of Norwich Cathedral*, Nowich, 1961.

Whittingham, A. B., *Norwich Cathedral Bosses and Misericords*, Norwich, 1981.

Whitworth Art Gallery, Manchester, *Medieval and Early Renaissance Treasures in the North West*, Exh. cat., 1976.

Wildridge, T. T., *Misereres in Beverley Minster*, Hull, 1879, republished by Honeyfields Books, Hutton Driffield, E. Yorks., 1982.

Wildridge, T. T., *The Grotesque in Church Art*, London, 1890.

Williamson, P., *An Introduction to Medieval Ivory Carvings*, London, 1982.

Wiltshire, K. F., *Christchurch Priory. The Choir Stalls and Misericords*, Christchurch, 1991 (re-written and revised by C. I. Covell).

Witkowski, G. J., *L'Art profane à l'église*

Witsen Elias, J. S., *De Nederlandsche koorbanken tijdens gothiek en renaissance*, Amsterdam, 1937.

Witsen Elias, J. S., *Koorbanken, koorhekken en kansels*, Amsterdam, 1946.

Wright, Thomas, *A History of Domestic Manners in England during the Middle Ages*, London, 1862.

Wright, Thomas, *A History of Caricature and Grotesque in Literature and Art*, London, 1865.

Wolfgang, A., 'Misericords in Lancashire and Cheshire Churches', *Transactions of the Historical Society of Lancashire and Cheshire*, LXIII, 1911, 79–87.

Young, K., *The Drama of the Medieval Church*, II, Oxford, 1933.

# Misericords by Location

Places preceded by an asterisk (*) indicate a misericord mentioned in the text but not illustrated.

**Ashford** (Kent), St Mary the Virgin. Pl. 216. Juniper foliage and berries.

**Astley** (War), St Mary. Pl. 62. A boar.

**Bedford**, St Paul. Pl. 221. Castle with a portcullis.

**Beverley** Minster (Yorks). Pls. 8. Sheep shearing; 23. Bear dragged into a wheel-barrow; 24. Stag disembowelled; 82. Sow playing the bagpipes to four piglets; 121. Proverb: 'Putting the cart before the horse'; 123. Bust of a Jester; 149. Three fools dancing; 163. Fox preaching from a pulpit; 167. Fox hanged by geese; 240. Two workmen fighting.

**Beverley**, St Mary. 147. Solomon between Samson and Marcolf; 225. Flight of Alexander; 260. Boar hunt.

**Bishops Stortford** (Herts), St Michael. Pl. 188. Bust of an angel holding a scroll.

**Blackburn** (Lancs), St Mary. Pl. 212. Mother ape pursued by hunters.

**Boston** (Lincs), St Botolph. Pls. 34. Stall elbow, man arriving at city gate; 131. Man and woman sitting around a cauldron; 144. Ape physician to a fox; 153. Two jesters playing bagpipes on cats; 210. Mermaid piping to sailors; 239. Bust of a woman crowned by angels; 245. Three helmets.

**Brampton** (Hunts), St Mary Magdalene. Pl. 254. Man mowing while a woman rakes.

**Bristol** Cathedral. Pls. 12. The battle of the sexes; 105. Two-faced dragon chasing three boys; 106. Ape riding pursued by a man; 133. The battle of the sexes in the form of a tournament; 135. Woman leading apes into hell; 158. Woman playing with a man's private parts; 164, 165. Scenes from the Romance of Renard the fox.

**Cambridge**, Kings College. Pls. 44, 45. Renaissance misericords.

**Canon Pyon** (Hereford & Worcs), St Lawrence. Pl. 184. St Catherine's wheel.

**Carlisle** Cathedral. Pls. 41. St Michael fighting the dragon; 86. Hyena killing a man; 125. Bigorne swallowing a good husband; 204. Laughing wyvern; 209. Mermaid, half-bird, half-fish.

**Cartmel** Priory (Cumbria). Pl. 171. Satan enthroned; 199. Unicorn plunging its horn into water.

**Castle Hedingham** (Essex), St Nicholas. Pl. 168. Fox carrying off a monk, head down.

**Chester** Cathedral. Pls. 64. Crowned head with flowing beard; 67. Two cranes back to back; 180. Virgin and child enthroned; 186. St Werburgh performing a miracle; 200. Lion fighting a dragon; 203. Galloping knight throwing a mirror to a tigress; 218. Wild man riding a lion; 223. Tristan and Isolde; 230. Knight on horseback.

**Chichester** Cathedral. Pls. 9. Centaur playing the tabor; 10. Two dragons intertwined; 11. Bodyless head supporting the seat; 38. Two men cartwheeling over a horse; 139. Woman and man playing the viol; 207. Two cowled heads.

* **Chichester**, St Mary's Hospital. Two dragons issuing from a lion's head p. 38; Merman p. 141.

* **Clifton Campville** (Staffs), St Andrew. Stylized head p. 155.

**Christchurch Priory** (Hants). Pls. 35. Two dragons entwined; 152. Jester with bauble and staff; 262. Beggar holding a begging-bowl.

**Coventry** Cathedral (formerly in). Pl. 194. Burial and Dance of Death.

**Coventry** (War), Holy Trinity. Pl. 70. Bearded and moustached man in profile.

**Coventry** (War), King Henry VIII School. Pl. 252. *Sol in Libra*.

***Darlington** (Co. Durham), St Cuthbert, p. 53.

**Darrington** (Yorks), St Luke and All Saints. Pl. 237. Stylized man's head.

**Durham** Cathedral. Pl. 169. 17th-century misericord with *putto*.

***Eccleshall**, Holy Trinity (Staffs). Satan carrying a nude woman, p. 95.

***Edlesborough** (Bucks), St Mary the Virgin. Mermaid suckling a lion (copy), p. 141.

**Ely** Cathedral. Pls. 2, 7. The romance of Reynard the fox; 39. Legend of St Withburga; 88. The beheading of St John the Baptist; 110. Tutivillus; 116. Tutivillus; 127. Man and woman fighting; 176. Expulsion from Paradise; 177. Noah's Ark; 255. Rabbit hunt.

**Enville** (Staffs), St Mary. Pls. 14. Tutivillus; 224. Yvain trapped in the portcullis; 271. Bear-baiting.

**Etchingham** (Surrey), The Assumption and St Nicholas. Pl. 48. Floriated column with keys on chains on supporters.

**Exeter** Cathedral. Pls. 6. Centaur shooting backwards; 25. Knight fighting a leopard; 36. Male and female bird-sirens; 202. Elephant.

**Fairford** (Glos), St Mary. Pls. 84. Two women with a large fowl between them; 130. Woman beating a man.

**Faversham** (Kent), St Mary of Charity. Pls. 33. Jester playing the bagpipes; 143. Ape chained to a clog; 238. Triple face.

**Fornham** (Suffolk), St Martin. Pl. 185. Martyrdom of St Thomas of Canterbury.

**Ripon** Cathedral (Yorks). Pls. 22. Woman in a three-wheeled barrow; 80. Sow playing the bagpipes to two piglets; 97. Jonah cast into the jaws of the whale; 162. Fox preaching from a pulpit to a duck and cock, and detail; 178. Caleb and Joshua.

**Ripple** (Hereford and Worcs) St. Mary. Pls. 250. Two men running; 251. Two men guarding a bakery (Labours of the Months).

**Rotherham** (Yorks), All Saints. Pl. 150. Grinning fool's head.

**St David's** Cathedral (Dyfed). Pls. 83. Man being served a calf's head; 264. Two boatbuilders.

**Salisbury** Cathedral. Pl. 5. 13th-century trefoil misericord.

**\*Salle** (Norfolk), St Peter and St Paul. Monks' heads in cowls, p. 28.

**\*Screveton** (Notts). St Wilfred. Man warming his feet by the fire, p. 163.

**Sherborne** Abbey (Dorset). Pls. 128. Woman beating a man; 236. Head, arms and shoulder of a man; 266. Schoolmaster birching a schoolboy.

**\*Sneinton,(Nottingham)**, St Stephen. Fox riding a hound, p. 85, Ape chained to clog, p. 101.

**Soham** (Cambs), St Andrew. Pl. 233. Head of a man.

**Southwell** Minster (Notts). Pl. 241. Green man.

**\*Stowlangtoft** (Suffolk), St George. Symbols of Evangelists, p. 128.

**Stratford-upon Avon** (War), Holy Trinity. Pls. 119. Woman and soldier fighting; Pride: man riding on a crowned beast; 142.Two bears and a ragged staff, arms of the Earls of Warwick; 173. Three masks with derisory expressions; 183. St George and the dragon; 190. Lechery: naked woman riding on a stag; 272. Tumbler (defaced) and theatrical masks.

**\*Sudbury** (Suffolk), St Gregory. Bat at junction of stalls, p. 28.

**Swine** (Yorks), St Mary. Pls. 112. Man showing his cleavage; 156. Grotesque wearing a bishop's mitre.

**\*Tansor** (Northants), St Mary, pp. 38, 53, Fetterlocks, Female head with head-dress, p. 158.

**Tewkesbury** Abbey (Glos), Pls. 129. Woman beating a man; 155. Human figure exposing its bottom.

**Throwley** (Kent), St Michael and all Angels. Pl. 107. Ape riding, followed by a nude man.

**Tong** (Salop), St Mary and St Bartholomew. Pl. 181. The Annunciation.

**\*Wakefield** (Yorks), Cathedral Church of All Saints. Scatological misericords, p. 109.

**Walsall** (Staffs), St Matthew. Pl. 211. Centaur shooting a bird.

**Wellingborough** (Northants), All Hallows. Pl. 28. Carver carving a rose.

**Wells** Cathedral. Pls. 20. Figure bending backwards; 30. Unfinished misericord of a mermaid; 31. Mermaid suckling a lion; 50. Cat with mouse; 51. Contorted man killing a dragon; 52. Left-handed man fighting a dragon; 53. Two perching parrots; 55. Man riding backwards.

**Weston-in-Gordano** (Somerset), St Peter and St Paul. Pl. 205. Wyvern with a barbed tongue.

**Whalley** (Lancs), St Mary. Pls. 122. Proverb: 'To shoe a goose'; 160. Fox carrying off a goose; 220. Wild Man and a Lady; 227. Flight of Alexander.

**Windsor** Castle, St George's Chapel. Pls. 42. Meeting of Edward IV and Louis XI of France; 111. Monks defecating their sins; 114. Three monks wheeled into hell; 136. St Zosimus meeting St Mary of Egypt; 170. Supporter: glutton force-fed by a demon; 192. Dance of Death.

**\*Wingham** (Kent), St Mary. Misericord without supporters, p. 37.

**Winchester** Cathedral. Pls. 37. Contorted man supporting the bracket; 49. Cat with mouse; 234. Three faces; 235. Two acrobats.

**Winchester**, Winchester College Chapel. Pls. 74. Curly headed man in a quilted tunic; 76. Crippled beggar; 258. Shepherd clasping a ram.

**Worcester** Cathedral. Pls. 59. Basilisk; 61. Boar; 92. Circumcision of Isaac; 94. Presentation of Samuel; 175. The Judgement of Solomon; 231. A joust; 244. Prince accompanied by a page-boy; 246. Three men weeding; 247. Three men cutting hay.

**Worle** (Somerset), St Martin. Pl. 124. Proverb: 'Two fools under one cap'.

## Continental Misericords

**Amsterdam**, Oude Kerk. Pl. 15. Proverb: 'Falling between two stools'.

**Cologne** Cathedral (Germany). Pls. 18. Dancing woman seen from the back; 19. Female bell ringer.

**Breda** (Netherlands), Grote Kerk. Pl. 16. Bird catcher.

**Hanover** (Germany), Landesgalerie. Pl. 27. Monk carving.

**Hoogstraten** (Belgium), St Catherine. Pl. 13. The battle of the trousers.

# Index

# Acknowledgements

Most of the photographs were specially taken for this book. The author and publishers thank all those who helped this photographic campaign and specifically the following for permission to reproduce misericords in their charge or who provided supplementary photographs as follows:

Boston (Lincs), St Botolph. Pls. 34, 131, 144, 153, 210, 239, 245, by kind permission of the Vicar and Churchwardens of the Parish of Boston; British Library. Taymouth Hours MS. Y.T. 13, fols. 106v–107v, Pls. 89, 90, 91, by permission of the British Library; Cambridge, Magdalene College. Peypsian Model book, Pl. 85, by permission of the Master and Fellows, Magdalene College, Cambridge; Cambridge, Kings College. Pls. 44, 45, by permission of the Provost and Scholars of Kings College, Cambridge; Carlisle Cathedral. Pls. 41, 86, 125, 204, 209, by kind permission of the Dean and Chapter of Carlisle Cathedral; Chester Cathedral. Pls. 64, 67, 180, 186, 200, 203, 218, 223, 230, By permission of the Dean and Chapter of Chester Cathedral; Chichester Cathedral. Pls. 9, 10, 11, 38, 139, 207, by permission of the Dean and Chapter of Chichester Cathedral;Ely Cathedral. Pls. 2, 7, 39, 88, 110, 116, 127, 176, 177, 255, by permission of the Dean and Chapter of Ely Cathedral; Enville (Staffs), St Mary. Pls. 14, 224, 271, by permission of the Rector and Churchwardens of Enville Parish Church; Eton College MS. 177, Pls. 93, 95, reproduced by permission of the Provost and Fellows of Eton College, photographs copyright the Conway Library, Courtauld Institute of Art, London; Exeter Cathedral. Pls. 6, 25, 36, 202, by permission of the Dean and Chapter of Exeter Cathedral; Gloucester Cathedral. Pl. 226, 270, by permission of the Dean and Chapter of Gloucester Cathedral; Gorleston Psalter. Pl. 87, by permission of the Conway Library, Courtauld Institute of Art, London; Great Malvern Priory (Worcs). Pls. 17, 58, 60, 120, 248, 249, 255, by kind permission of the Vicar and Churchwardens of Malvern Priory; Hereford Cathedral. Pls. 54, 56, 57, 132, 141, 217, by permission of the Dean and Chapter of Hereford Cathedral; Kidlington (Oxon). Pl. 4, by permission of the Parochial Church Council; King's Lynn, Museum. Pl. 259; National Monuments Record, London. Pls. 43, 102, 103, 115; Niedersächsisches Landesmuseum, Hannover, Germany. Pl. 27; Oxford, New College Chapel. Pls. 73, 75, 189, 261, 265, by permission of the Warden and Fellows, New College, Oxford; Rheinisches Bildarchiv, Cologne. Pls. 18, 19;St David's Cathedral (Dyfed). Pls. 83, 264, by permission of the Dean and Chapter of St David's Cathedral; Salisbury Cathedral. Pl. 5, by permission of the Dean and Chapter of Salisbury Cathedral; Lucy Sandler. Pl. 96; Southwell Minster (Notts). Pl. 241, by permission of the Provost of Southwell; Tewkesbury Abbey (Glos). Pls. 129, 155, by kind permission of the Vicar and Churchwardens of Tewkesbury Abbey; Mr Jan Verspaandonk. Pls. 13, 15, 16; Wells Cathedral. Pls. 20, 30, 31, 50, 51, 52, 53, 55, by permission of the Dean and Chapter of Wells Cathedral; Windsor Castle, St George's Chapel. Pls. 42, 111, 114, 136, 170, 192, with permission of the Dean and Canons of Windsor; Winchester, Winchester College Chapel. Pls. 74, 76, 258, by kind permission of the Warden and Fellows of Winchester College; Worcester Cathedral. Pls. 59, 60, 61, 92, 94, 175, 231, 244, 246, 247, by permission of the Dean and Chapter of Worcester Cathedral.